AUSTRIAN EXPRESSIONISM ■ THE FORMATIVE YEARS

■■ AUSTRIAN

THE SOCIETY FOR THE PROMOTION
PALO ALTO

EXPRESSIONISM ▪▪

THE FORMATIVE YEARS

▪ **Patrick Werkner**

Translated by Nicholas T. Parsons

OF SCIENCE AND SCHOLARSHIP
CALIFORNIA

The Society for the Promotion of Science and Scholarship, Inc. Palo Alto, California

© 1986 Herold Druck- und Verlagsgesellschaft m.b.H., Wien English translation © 1993 The Society for the Promotion of Science and Scholarship

Originally published in German in 1986 by Herold Verlag as *Physis und Psyche: Der Österreichische Frühexpressionismus*
Printed in the United States of America. Funded in part by the Austrian Cultural Institute in New York

The Society for the Promotion of Science and Scholarship is a nonprofit corporation established for the purposes of scholarly publishing: it has special interests in British and European studies.

Library of Congress Cataloging-in-Publication Data

Werkner, Patrick.
 [Physis und Psyche. English]
 Austrian expressionism: the formative years / Patrick Werkner : translated by Nicholas T. Parsons.
 p. cm.
 Includes bibliographical references and index.
 ISBN 0-930664-11-6 (cloth)
 ISBN 0-930664-13-2 (paper)
 1. Expressionism (Art)—Austria. 2. Art, Austrian. 3. Art, Modern—20th century—Austria. I. Title.
N6808.5.E9W4713 1993
709'.436'1309041—dc20 93-12104
 CIP

To the memory of my father,
SIGMUND WERKNER
(1916–1992)

Preface to the American Edition

The present work appeared in German at a time when the art of fin de siècle Vienna attained an unprecedented level of popularity, in part as a result of major exhibitions in Venice, Vienna, Paris, and New York. It was one of the intentions behind the book to reveal the darker side of the Vienna of the Secession, which so often appears to us as intoxicated with the sensual and the beautiful. It was thus partly intended as a corrective to the overemphasis on the decorative and the aesthetic in the current perception of Viennese fin-de-siècle art. The decidedly disturbing elements within early Austrian Expressionism resist the sort of mindless commercialization to which, for example, the works of Klimt have increasingly been subjected. It can be seen, therefore, that the book's original motivation has not lost its relevance since the publication of the German edition but has, perhaps, gained in validity through the further marketing and popularization of the concept of "Vienna in 1900."

Since both art historians and cultural historians in the United States, together with museum curators and collectors, have played an important part in gaining international recognition for Viennese art of this period, I am especially pleased that an edition of this book will now appear there. American students, whom I encountered as guest professor at Bard College, in Annandale, New York, and at Stanford University, also displayed a lively interest in its theme.

The American edition has been revised to take account of current scholar-

ship, and some of the observations that appeared in reviews of the book have had a positive influence on the revised text. In this respect I am grateful to Edwin Lachnit, Ilona Sármány-Parsons, and James S. Shedel for their constructive criticisms. I would also like to thank Johann Winkler for his practical assistance.

I owe a debt of gratitude to my friend Nicholas Parsons who has labored to make this first American edition of the work accessible for an English-speaking public.

Certain parts of the book I would have written differently today, and I would also have attempted to include other perspectives on, and approaches to, my theme. Happily, the opportunity to do so has presented itself in the form of a publication on Egon Schiele that will appear at the same time as this work and that is also published under the auspices of SPOSS. The two books, I hope, will be seen as complementary, or rather, as stimulating extensions of each other's themes. There remains only the pleasant duty of expressing my thanks to the Society for the Promotion of Science and Scholarship for taking this book into their publishing program. In particular, Kurt Steiner and Peter Stansky have engaged themselves vigorously on behalf of its publication. To Janet Gardiner I am indebted for supervising the project for SPOSS, not always an easy task when author and publisher are operating on different sides of the globe.

Without the support of the Austrian Minister for Science and Research, Erhard Busek, the American edition would not have been possible. Likewise, the friendly cooperation of Herold Verlag has enabled the project to be realized. I offer them both my heartfelt thanks. I am also deeply indebted to the Austrian Cultural Institute in New York and its Director, Wolfgang Waldner, for financial support in the printing of this work.

Patrick Werkner

Vienna, July 1992

Preface to the German Language Edition

In a book published three decades ago, *Modern Painting in Austria*, Professor Gerhard Schmidt wrote of the "unfolding of early Expressionism" that it was perhaps "the most enthralling period of all in the history of modern Austrian painting." For his commitment to the realization of the present study I am deeply indebted to Professor Schmidt—on the one hand, I have benefited from his numerous perceptive criticisms and observations; on the other, I owe much to his support for the planned work in his capacity as supervisor of a project carried out under the auspices of the governmental Fund for the Promotion of Academic Research, in the context of which this study was brought to completion. I would like to thank Professor Otto Pächt for including the theme in the program of the Commission for Art History in the Austrian Academy of Sciences.

Many friends, colleagues, and artists, as well as departmental specialists in museums and academic institutions, provided me with inspiration and fruitful lines of investigation. In Vienna I am especially grateful to the following: Martin Bergant; Georg Eisler; Gabriele Hammel; Almut Krapf-Weiler and Michael Krapf; Oswald Oberhuber; Dieter Route; Werner J. Schweiger; and Turi Werkner. In addition thanks are due to: Otto Breicha (Salzburg); Jelena Hahl-Koch (Munich); Jane Kallir (New York); Jerry McBride (Los Angeles); Walter Methlagl (Innsbruck); Marie-Agnes von Puttkammer (Bonn); Sigurd Paul Scheichl (Innsbruck); and Thomas Zaunschirm (Salzburg).

Last but not least I would like to thank Herold Verlag, and in particular Kristian Sotriffer.

I dedicate this book to Beatrix.

Patrick Werkner

Vienna, March 1986.

Contents

AUSTRIAN EXPRESSIONISM ■ THE FORMATIVE YEARS

EARLY EXPRESSIONISM

For some two decades fin-de-siècle Austrian art and culture have provided the subject matter for international exhibitions, symposia, and publications. As a result, the influence of the Austrian achievements of this period on our twentieth-century culture has become ever more widely appreciated. Vienna, the capital of the Habsburg empire, has been revealed as the focus of forces that led to a spiritual breakthrough; at the same time, it has been seen as providing the backdrop for Hermann Broch's much-quoted "joyful apocalypse," or as the decadent scenario of Karl Kraus's celebrated aphorism "an experimental laboratory for world endings." The ambivalent picture that emerges from a study of fin-de-siècle Austria is thus a fundamentally important aspect of the fascination that it holds for us today.

This ambivalence also reflects the diverse motives that have led to a preoccupation with the Austria of 1900—a hankering after a federal, multiracial state, such as was mapped out, by no means in purely utopian form, for the fissiparous Danubian empire; or a transfiguring longing for the idyll of the "good old days"; or nostalgia for a now scarcely conceivable diversity of outlook—ethnic, political, cultural, individual—in contrast to the creeping advance of uniformity in the present; or fascination with the concept of *Gesamtkunstwerk* [total work of art], as realized in the work of the Viennese Secession; or enthusiasm for such torchbearers of culture as Mahler, Schönberg, Hoffmann, Loos, Freud, Wittgenstein, Klimt, Kokoschka, Schiele, Boltzmann, Mach, Hofmannsthal, Schnitzler, Kraus, Kafka, Trakl, or Musil.

Moreover, parallels between the present cultural climate and that of the Austrian fin de siècle have substantially contributed to the degree of international interest in this period: in particular, one may mention the tension between the rationalist-positivist world view and an opposing tendency to stress the role of irrationality, spirituality, and mysticism. Then there is the dilemma of the individual's relationship to society as a whole, together with the recurring clash between euphoria generated by progress and pessimism stemming from a fundamentally eschatological view of existence. The oft-evoked "dance of death" of the late Habsburg monarchy appears to offer numerous parallels to contemporary scenarios of destruction. "I live in an era of decline and inhabit a doomed domain," wrote Karl Kraus, and it is no accident that this sentence, taken from his poem "Fear," crops up again and again among our contemporaries.

This widespread feeling of being under threat, together with the unresolved social questions and the numerous other acute problems of Austria at the turn of the century, should not, of course, be reduced to some facile apocalyptic formula. Nevertheless, the ambivalent uncertainties of the period can surely provide some clues to the conundra of our own time. The long-heralded existential crisis, which reached its apotheosis at the turn of the century—the shattering of the old order and its replacement by industrialization, metropolitan culture, and their attendant social problems, the latter aggravated by reciprocal aggression among ostensibly civilized peoples—this crisis, of which Austria was a remarkably acute barometer, has persisted in its most fundamental aspects up to the present day.

The answers to these problems that were suggested at the time offer not so much solutions as orientation points, and these with special clarity in the context of the differing approaches of the individual protagonists. Such clarity, however, is today often weakened by an aestheticized mediation that has proved to be effective in the "marketing" of these topics and that derives its inspiration and legitimacy from the Viennese Secession itself. Tensions, contrasts, and conflicts tend to be blurred thereby. The engagement with this period is turning into a sort of cultural potpourri, with Austrian Expressionism thrown in as an afterthought. If, however, one examines its creative achievements in depth, it becomes clear how much they resist such treatment, especially in the eruptive early phase of Expressionism.

It is this first phase that is dealt with in the present work. During it, the heavy emphasis on expression in the approach to artistic creation appeared in such an extreme form that it was almost inevitable that it should be toned down in the further development of Austrian Expressionism. That emphasis can only be understood in the context of the crisis in which the artists found themselves, and in their uneasy relationship with a society intoxicated by beauty, for which a celebration of its own existence was sufficiently satisfying and fulfilling.

The approach of the present study is not primarily that of the history of

style, although of course special attention is bound to be paid to stylistic development. The linear development from Symbolism to Jugendstil to Expressionism has already been exposed as the artificial construction that it is, such clear distinctions of periodization, content, and form being hardly sustainable.[1] It is far more worthwhile to uncover the common, highly expressive impulse of creation that binds together the artists concerned. The demarcations between "Early Expressionism" and "High Expressionism" are inexact, but what is important is not so much stylistic demarcation as the illustration of shared impulses. As will be shown, this common factor is manifest in the work of Richard Gerstl probably as early as 1904, and certainly by 1907–8. In the case of Oskar Kokoschka and Egon Schiele it is apparent from 1909, and of Arnold Schönberg from some time between 1908 and 1910. Around 1911–12 this impulse exhibits a pronounced change, so that these years may be said to mark a caesura. In the case of Alfred Kubin, the question is posed as to what extent his works may be identified with the same artistic approach as that of the artists already mentioned. Similar queries are raised about the work of a number of other artists, among them Albert Paris Gütersloh and Max Oppenheimer.

Since the overlap between art, literature, and drama is a characteristic of early Expressionism, nongraphic manifestations of it cannot be excluded from the present study, with the literary dimension simply left to the literary historians. However, one should add that the comments offered here should be understood as extensions of the critical examination of the pictures, rather than as contributions to literary history. Letters, too, constitute a valuable source for illuminating the attitudes and motivations of the artists concerned and are therefore substantially drawn upon. Sources outside the relevant period are used extremely sparingly in order to avoid the distortions so seductively offered by hindsight (one thinks of Kokoschka's *Autobiography*). Catalogues and catalogues raisonnés prepared by art historians, editions of letters and archive material, especially those that have been published in recent years, now make fully informed access to the relevant artists possible; this is true of all of them except Gerstl, a factor that had to be taken into account in the writing of this book, along with the fact that the source material relating to Kubin and Schönberg is as yet far from being completely researched.

From a bewildering array of detail a presentation of early Expressionism has been distilled. It attempts to substitute for a heroizing treatment of individual artists an integrated overview that pays as much attention to the common factors in their work as to the contrasts and differences.

ON THE RECEPTION
OF MODERN PAINTING
IN VIENNA

To what extent were the exhibitions held in the first phase of modernism in Austria seminal for a new artistic attitude that later came to be known as "Expressionistic"? It is clear that the shows in the Secession and the Galerie Miethke played the leading role in bringing before the Viennese public the new artistic impulses of the day; in addition, there was the activity of the Hagenbund, and that of the state-owned Moderne Galerie, not to mention initiatives in the sphere of private collectors. Between 1898 and 1905 the Secession put on a total 23 exhibitions, all of them extremely comprehensive for their time. The Galerie Miethke had been a champion of modernism since 1904, and after the withdrawal of the Klimt group from the Secession in 1905 it continued the substance of the Association's earlier exhibitions policy. Several enterprises not connected with the Secession also enlarged the spectrum of what was on show of new art in Vienna. Who, then, were the European artists who were displayed as a result of this new artistic fermentation in Austria, and represented as pioneers of the new art? And to what extent was their work well received by the consumers of art?

These questions involve us inevitably in a discussion of the attitudes of contemporary art critics. One can describe a number of critics as ideological harbingers of modernism—or at any rate of what they took to be modernism. Such heralds and avatars were prominently involved in the development of the Secession and of new art over the following years. It was the critic Ludwig Hevesi who formulated the slogan over the portal of the Secession

building—"To the age its art; to art its freedom"—and who, together with
Hermann Bahr and Berta Zuckerkandl, could be counted among the most
assiduous propagators of the Association's claims. In the foreword to Zucker-
kandl's collection of essays entitled *Zeitkunst* [The Art of the Day], which was
published in 1908, Hevesi wrote: "It was in the salon of the present work's
author that the idea for the Vienna Secession first arose."[1] The monitors of
cultural renewal were fully aware of their own importance. Hermann Bahr
saw in the critic an interpreter whose function was to mediate between the
artist and his public. Including himself in the ranks of such mediators, he
described "Muther or Helferich or Hevesi" as "such interpreters who convey
the intentions of the creative artists to those who are exposed to their work,
enabling the latter to find their bearings in the artists' world; and what can-
not be conveyed by the intellect alone they at least impart by means of an
awakening of the senses."[2] These critics lent each other support for the sake
of the cause and for several years set aside their traditional rivalry. This is
evidenced by Hevesi's dedication of his book *Altkunst-Neukunst* [Old Art-
New Art] to Richard Muther, by the enthusiastic review by Muther himself of
Hermann Bahr's *Secession*,[3] by Zuckerkandl's praise for Hevesi's commit-
ment to the new art in her writings, or by Hevesi's foreword to Zuckerkandl's
book *Zeitkunst*. Of course, at the same time there was a large number of
critics in opposition to these, propagandists for whom modernism was auto-
matically suspect.

Even before the Secessionists from the "Austrian Society of Fine Arts"
under Klimt's leadership could occupy their new building on Karlsplatz, they
held their first exhibition between March and June 1898 in the building of the
Society of Horticulture on Parkring.[4] The star attractions were the cartoons
by Puvis de Chavannes for his triptych of Saint Geneviève for the Pantheon in
Paris. However a more enduring impact on Vienna was produced by several
artists who were to return again and again to subsequent exhibitions of the
Secession. Giovanni Segantini was represented with 10 pictures at this first
show, Fernand Khnopff with a collection of 20 pictures, Constantin Meunier
with 29 works, Auguste Rodin with 12 sculptures, Arnold Böcklin with 2,
Max Liebermann and Franz von Stuck with 4 pictures each, and Max Klinger
with a number of drawings, to mention only some of the more prestigious
exhibits. Individual works of these artists had previously been seen in exhi-
bitions at the Künstlerhaus, but the show as a whole displayed the modern
"isms" of Symbolism, Impressionism, and Naturalism with a comprehensive-
ness that had hitherto not been possible in Vienna. The method of exhibiting
artworks at this show was also completely new: instead of the traditional
overfilled exhibition halls, where crowded walls were tapestried with pic-
tures, paintings were hung and sculptures placed in a manner that enabled
the viewer to concentrate on individual works, the backgrounds harmonizing
with the pieces on display.

The very first exhibition of the Secession was extraordinarily successful.

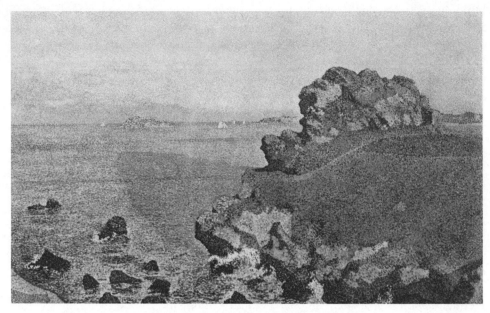

1. Theo van Rysselberghe, *Crags near Roscoff*, 1889.

It attracted 57,000 visitors, and from a total of 534 objects shown 218 were sold.[5] Hermann Bahr said enthusiastically, "an exhibition like this we have never seen."

> An exhibition in which there is not a single bad picture, an exhibition in Vienna that is in effect a resumé of the whole of modern painting. . . . A marvel! At the same time it is a source of considerable glee: for it demonstrates that one can make a good business in Vienna out of art, which is to say out of *pure* art. This will have the mercantilists of the Society of Fine Arts gnashing their teeth. . . . It is a sheer joy to see the public streaming in! It demonstrates that the Viennese are culturally mature! How terribly they have been sinned against! But the purity of their feeling has remained alive. Give them the necessary education and in a few years we need not hang our heads before any other city in the world.[6]

In November of the same year the second exhibition followed, this time held in the just-completed Secession building. The third exhibition, which was opened at the beginning of the following year, 1899, had an even more lasting influence.[7] The main hall was dominated by Max Klinger's huge painting, *Christ on Olympus*. Other rooms were dedicated to Walter Crane, Constantin Meunier, and Félicien Rops. The Pointillist pictures of Theo van Rysselberghe aroused particular interest (Figure 1). He sold eighteen pictures altogether, among them two to Ludwig Hevesi, who eulogized him in his critiques as a "painterly genius."[8] *Ver Sacrum* published an essay on Rysselberghe by Emil Verhaeren and eighteen reproductions of his pictures.[9] For many Viennese the encounter with Rysselberghe's work was a bewildering

experience. "When Rysselberghe's pictures were shown at the Secession, one could constantly hear the plaintive question: 'Who on earth would hang such a picture in his own home?'"[10] Bahr wrote in February 1899:

> When one enters the green room of the Secession, where Theo van Rysselberghe's paintings are hung, one feels as if one has stepped into the sun itself. Colors of such intensity and joy. . . . Never before has an artist shown us the light with such vehemence. . . . This radiance, this burning and blazing— our language is not sensual enough to describe its effect! We have no word to evoke what Rysselberghe makes us see.[11]

Through Rysselberghe Vienna was made acquainted with Pointillism. In the very next year, at the seventh exhibition of the Secession in March 1900, a collection of thirteen paintings and watercolors by Paul Signac was exhibited.[12] Hevesi judged Signac on this occasion as "lacking in talent." He considered him a "good technician but a weak painter."[13] Once more there were pictures by Fernand Khnopff on display and for the first time some by Jan Toorop. Most of the 35,000 visitors to this show, however, went to the Secession to see the controversial panels by Klimt, which had been given the place of honor in the main hall. His *Philosophy* (Figure 2), the first of the three faculty pictures for the University of Vienna, provoked a major "art scandal" that unleashed a furious press campaign against Klimt and led to protests from the professors, ministerial intervention, and even a parliamentary inquiry. Klimt had dared to interpret the theme of *Philosophy* not as a formal celebration of the faculty and its noble endeavors, but as a study in mysticism and pessimism; theosophical ideas and the philosophy of Schopenhauer seem to have been his main inspiration in the work.[14] The Professor Ordinarius for History of Art in Vienna, Franz Wickhoff, defended Klimt's picture in a lecture to the Philosophical Society of the University of Vienna under the title "What is Ugly?" Wickhoff faced on this occasion an opposition consisting not only of enraged critics, who described his lecture as "Jewish insolence,"[15] but also of the majority of his colleagues at the university. Against these professors Hevesi sharpened his pen and wrote an article under the title "The Iconoclasts of Vienna," attacking those who "fall back into a way of thinking prevalent a thousand years ago and strain every nerve to deny [the evident truth] that they are in reality nothing other than a chastity commission."[16] The affair petered out six years later with Klimt's repurchase of the faculty pictures, which were later burned in the confusion of the Second World War. A caricature by Bertold Löffler, later to be Kokoschka's teacher at the School of Applied Arts, appeared in 1904 on the cover of the satirical magazine *Der liebe Augustin* (Figure 3). It shows a critic, armed with Lessing's *Laoköon*, standing before Klimt's painting entitled *Goldfisch* and self-righteously exclaiming: "Avaunt thee, Satan!"

In the autumn of 1900, international and Austrian applied arts were the focus of the next Secession exhibition, the eighth to be held.[17] The success

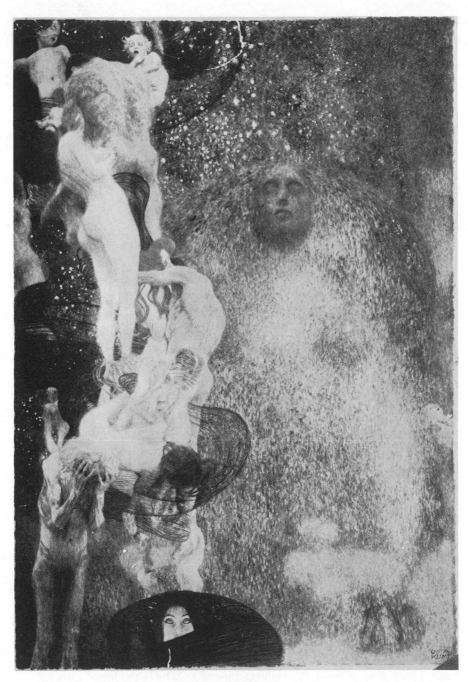

2. Gustav Klimt, *Philosophy*, version of 1906–7.

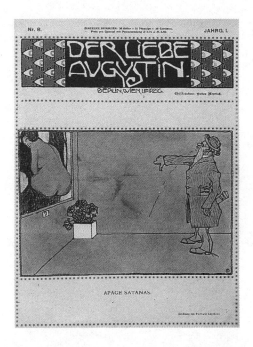

3. Bertold Löffler, *Avaunt thee, Satan!* Caricature on the title page of *Der liebe Augustin*, no. 8, 1904.

of this show was a major factor in the founding three years later of the Wiener Werkstätte, or Vienna Workshop. Among the painters shown were once more Rysselberghe and Khnopff, with respectively eight and four works exhibited, together with, among others, Degas, Böcklin, Menzel, and Liebermann. Two artists exhibited for the first time, their contribution being of the greatest significance both for their own subsequent development and for the art culture of Vienna. Ferdinand Hodler showed two pictures, which provided an effective introduction to his work and was to lead to his astonishing success four years later at the nineteenth exhibition of the Secession. As part of the presentation of French applied art, one room was devoted entirely to the sculpture of the Belgian George Minne (Figure 4). His gaunt, youthful figures, depicted with crossed arms, were to have a marked influence on Austrian artists.[18] The success of Minne—both aesthetic and commercial—led to his participation in the fifteenth exhibition of the Secession with a monument to the poet Rodenbach. Berta Zuckerkandl dedicated an essay to him.[19]

Giovanni Segantini enjoyed a major retrospective at the ninth Secession show, at which Auguste Rodin and Max Klinger were each represented with fourteen works.[20] The main hall of the building had been turned into a sort of octagonal shrine by Alfred Roller, in which mementos of the recently deceased Segantini were displayed as relics. The shrine was dominated by the artist's magnum opus, the three paintings entitled *Becoming*, *Being*, and *Passing Away*, which the Secession hoped would be purchased by the state. Segantini had already been exhibited at the Künstlerhaus in 1896. On that occasion his painting *Both the Mothers* had won the gold medal as a result

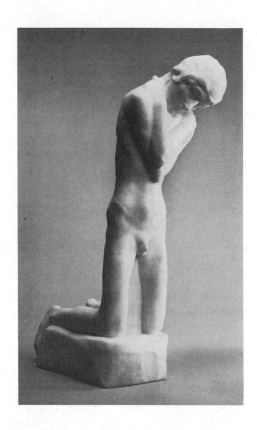

4. George Minne, *Kneeling Boy*, 1896.

of pressure from the younger artists, and to the disgust of the conservatives: "The members of the Academy crossed themselves, the professors in the jury were enraged" (Hevesi).[21] *The Evil Mothers* (Figure 5) was acquired as the first purchase for the state's Moderne Galerie, and remains to this day one of the most important works in the collection. The retrospective provided the impulse for a Segantini monograph by Franz Servaes, the moving spirit behind which was Kolo Moser: "Following the monumental Segantini Exhibition in Vienna the Imperial and Royal Ministry for Culture and Education decided on the publication of this monograph, which should be the means whereby one of the most brilliant sons of Austria should be duly celebrated."[22] Five years after the appearance of this book, in 1907, a popular edition of Servaes's work was produced. Segantini's extraordinary success in Vienna was primarily due to the impression created by his systematic Luminism, within which his private world of mythological nature took shape. With these effects he struck a chord not only with Klimt, Carl Moll, and Adolf Boehm, but also with many other artists in their circle.

The enthusiasm for the Divisionist painting of Segantini was all of a part with Vienna's fascination with Rysselberghe's Pointillism. Bahr gave expression to this enthusiasm for a form of painting that broke up the particles of color equally in figures and landscapes and melded them together again into

a harmonious whole before the viewer's eyes. As early as the first Secession show, Bahr drew attention to the connection between the sensual effects of Segantini's paintings and their underlying monistic-pantheistic inspiration.

> The greatest works that can be seen in this exhibition, and as far as I'm concerned the greatest that modern painting has hitherto produced, are the paintings of Segantini. . . . This painter exhibits that great and ancient love for the natural world that the simple pagans once possessed . . . the permanent instinctive feeling of being at one with nature in all her aspects . . . with stones, trees, animals, men and angels—all are of the same order of being, all are part of sacred life![23]

Richard Muther was similarly enthusiastic about the Segantini retrospective in 1901. He wrote that the formerly controversial prizewinning picture *Both the Mothers* "now appears to us as the work of an old master," while the hall with Segantini's cycle "has an atmosphere that is ceremonial and demanding of reverence like the side chapel of a church. One feels oneself drawn up into those divine realms, where life withers away, where everything takes on the dimensions of the superhuman and the heroic."[24]

In early 1901 the Secession held an exclusively Austrian exhibition. The scandal of Klimt's *Philosophy* was repeated with his version of *Medicine*. One painter who influenced Klimt at this time, Jan Toorop, was particularly prominent at the 12th show, with 21 works exhibited; Swiss painters were also well represented, among them Hodler, who sold his picture *The Chosen One*.[25] Edvard Munch was represented for the first time with his paintings *Angst* (Figure 6) and *Beach*. "The Norwegians appear to be very modern-oriented," wrote Hevesi. "Edvard Munch unsettles the public with his pic-

5. Giovanni Segantini, *The Evil Mothers*, 1894.

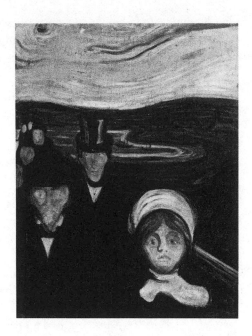

6. Edvard Munch, *Angst*, 1894.

ture *Angst*. One sees a mass of people who seem to be descending on the viewer. One can distinguish ten faces, all pale with appalled eyes, convulsed with fear, travesties of the human countenance. Carrière-wise the features dissolve in blurred outlines." Hevesi summed up his impression thus: "Carrière mixed with Toorop."[26] Just how outlandish Munch's expressive pictures seemed to the critics can be seen from Richard Muther's reaction: "In front of Edvard Munch's *Angst* I find myself at a loss. A symbolic theme seems to have been executed in the manner of a genre painting."[27] A year later Munch exhibited his etchings. They were distributed around the Secession building in three groups; the catalogue gave no further information about their selection.[28]

The fourteenth Secession exhibition in 1902 undoubtedly represented a peak in the activity of the Artists' Association. The central focus was on Max Klinger's recently completed statue of Beethoven, which in its polychromatic design and exploitation of diverse materials represented the composer in a pose redolent of pathos. To honor both Klinger and Beethoven the artists of the Secession created a comprehensive scheme of decoration for the rooms that was conceived solely for this single exhibition. Of the paintings done for the exhibition hall's wall surfaces, only Klimt's Beethoven frieze has survived.[29] The principle of harmonization between art objects and their surroundings was further refined in the Beethoven exhibition in that the entire setting of the show was presented as a work of art in itself, clothed, as it were, in the raiment of the Secession.

The realization of the idea of the *Gesamtkunstwerk* now occurred at the point of intersection between the conventional symbolism of the previous

century and the new phenomenon of artistic schemata resulting from creative individualism—the latter being most noticeable in the work of Klimt, who had broken free from the conventions of historicist representational painting at an early stage. The Beethoven exhibition commands our respect as an achievement of artistic cooperation, even if the individual contributions to it were of variable quality. Its catalogue was also conceived as a work of art in itself and printed for the first time with numerous illustrations, some in two colors, a departure from the usual format of Secession catalogues.[30]

The Secession staged this show as a kind of cult "happening." Ludwig Hevesi, who returns to the Beethoven exhibition in numerous articles, had already written of the preview: "In the choir of the left-hand nave, [the Imperial Opera] Director Mahler stood together with his brass ensemble, and vigorously rehearsed a theme from the Ninth Symphony that he had arranged for trombones. In the evening, before the Klinger banquet in the Grand Hotel, there will be a strictly private reception in the Secession. The members will ceremonially greet their honored guest and these strains of Beethoven will thunder about his head."[31] The quasi-religious idea of salvation for mankind through art provided the leitmotiv of the Beethoven exhibition. It reoccurred in the explication of the symbolic scheme of the Klimt frieze in the catalogue. "The yearning for happiness is only assuaged in poetry. The arts lead us into the realm of the ideal, in which alone we can find pure joy, pure happiness, pure love."[32]

In Klinger's Beethoven statue the Viennese saw a work of art endowed with a sacral meaning. In contrast, Klimt's contribution again unleashed a storm of indignation, which was chiefly directed at his representation of the "evil spirits" in his 27-meter-long frieze. The critics saw the figures as "artistic self-defilement in the fullest sense of the word,"[33] as "an offense against the most sacred feelings of mankind,"[34] as "the most revolting and disgusting forms and objects . . . that the brush of an artist has ever depicted,"[35] as "obscene art," as "painted pornography," and as "depravity dreamed up by an apocalyptic imagination."[36] Hermann Bahr collected reviews of Klimt's Beethoven frieze and published them in 1903, together with the remarks of hostile Viennese critics on his faculty pictures, in a book entitled *Against Klimt*. Availing himself of the technique adopted by his great adversary, Karl Kraus, Bahr extracted individual sentences or groups of words from the reviews that, torn from their context, revealed all the more their poverty of thought and verbal obliquity.

From January to March 1903 the Secession held its great Impressionist show. There was never to be another presentation on this theme in Austria that matched this one for quality of art shown or for comprehensiveness. Two hundred and fifty-nine art objects brought before the public the "Development of Impressionism in Painting and Sculpture." The exhibition was divided into five sections. The first was designed to show "The Origins and Development" of Impressionism; under this heading were subsumed Tinto-

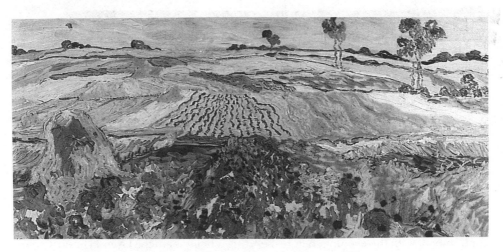

7. Vincent van Gogh, *The Plain at Auvers-sur-Oise*, 1890.

retto, Rubens, Vermeer, El Greco, Velazquez, Goya, Delacroix, Corot, Daumier, and others. The second section, with the title "Impressionism," showed principally Manet, Monet, Renoir, Degas, Cézanne, Pissarro, Sisley, and Morisot. The third section dealt with "The Further Development of Impressionism," and included works by Liebermann, Slevogt, and Whistler, together with artists designated as "Neo-Impressionist," such as Seurat and Rysselberghe, and sculptures by Rodin and Meunier. The fourth section was dedicated to Japanese art and the fifth to the "Transition to the Style." This displayed pictures by van Gogh (five), Toulouse-Lautrec (six), Vuillard (seven), Bonnard (twelve), Denis (twelve), Vallotton (ten), Roussel (fourteen), Redon (ten), Gauguin (two), and Valtat (one). The catalogue supplied information about the selection of the works and the system of presentation.[37]

Despite the impressive choice of works, as well as introductory lectures by Julius Meier-Graefe and Richard Muther, and also ecstatic reviews, the exhibition was a commercial failure. Precisely three pictures were sold: a sketch by Manet to the collectors Gottfried and Hermann Eissler,[38] Monet's portrait *The Cook (Monsieur Paul)* to the Moderne Galerie, and van Gogh's *The Plain at Auvers* (Figure 7). The Secession actually acquired it in order to bestow it on the Moderne Galerie. Unfortunately, however, the lack of understanding that had greeted Munch's work was now directed at van Gogh. This is evident from Hevesi's report on the "Lectures on Impressionism," in which he wrote of Meier-Graefe's talk: "The two so-called eccentric personas, van Gogh and Toulouse-Lautrec, who are in their very nature tragic, products of the sins of the fathers, are rated almost impossibly highly by Meier-Graefe. No doubt he is right in this, but he has his work cut out to persuade the average Viennese, who formed much of the audience at this gathering."[39] (Three years later Hevesi showed himself to be an "average Viennese" when he discussed the van Gogh exhibition at the Gallery Miethke.)

In the following two years the Secession organized another ten exhibitions. At the end of 1903 a show was exclusively dedicated to the work of Gustav Klimt, at which for the first time the three faculty pictures could be seen together. In the following 19th exhibition, Edvard Munch was represented with 20 pictures, Hans von Marées with 10, and, among others, Cuno Amiet with 30 works.[40] The comparatively large collection of Munch's paintings was now received a little more positively by the critical establishment, although still with considerable coolness. "The Edvard Munch room makes a powerful impression," wrote Hevesi; "his bold dreams of color are sometimes realized, sometimes not. It is worth the effort to enter into his world, and many will succeed in doing so this time round." About pictures such as *A Summer's Night in Aagaardstrand*, *Death and the Child*, or the group portrait of Dr. Linde's four children, his remarks were conspicuously neutral, limited to the observation that they would certainly find their public.[41]

The main hall of the exhibition nearby was dominated by Ferdinand Hodler with a collection of 31 pictures. His show was a remarkable success, and he sold no fewer than 12 pictures. Hodler was a friend of the exhibition's organizers, Carl Moll and Kolo Moser, and stayed in Vienna for several weeks. The Galerie Miethke planned a comprehensive publication of Hodler's work and concluded a contract with him for the reproduction rights in 1905. His success in Vienna contributed substantially to the building of his international reputation.[42] His art had considerable influence there, particularly on the work of Kolo Moser. Indeed, some of the latter's paintings, both landscapes and figurative pictures, seem almost to be paraphrases of Hodler. Moser called him "a splendid original, highly strung, wild, mastering in his pictures all facets of expression."[43] Klimt also was inspired by the Swiss artist, as can arguably be seen in the severe rhythmic patterning of the Beethoven frieze, which perhaps owes something to an earlier encounter with Hodler's painting. In particular, Hodler's language of gestures, like that of George Minne, was to have an impact on the works of Kokoschka and Schiele, where pantomimic qualities are most evident.

The Secession had a massive influence on the Viennese art scene, and not only through its exhibitions policy; two of the Association's members—Hoffmann and Moser—were the founders of the Wiener Werkstätte; the School of Applied Art was also infiltrated by Secessionist artists who were appointed professors there, thus transforming it into an institution that promoted the new artistic aims of the Artists' Association and led to their wider dissemination. Interdisciplinary experiments and *Gesamtkunstwerk* were encouraged at the School of Applied Art, while on the other hand, at the Academy of Fine Arts, Klimt's appointment to a professorship was blocked through the intervention of the heir to the throne, Franz Ferdinand. While Gerstl and Schiele left the Academy after coming into conflict with their teachers, Kokoschka was able to become a lecturer at the School of Applied Art.

The international contacts built up by the Secession, and much expanded

as a result of its exhibition activity, together with its refined artistic and applied art products, contributed to the recognition it received throughout Europe. However the more its success grew, the more the Association itself was thrown into turmoil. After violent confrontations between the so-called painters' group around Josef Engelhardt and the Klimt group, the latter decided to leave the Secession in early 1905. That a chapter in the development of modern Austrian art was thereby concluded was fully appreciated by contemporaries. Ludwig Hevesi published in 1906 his book entitled *Eight Years of the Secession*, which included the majority of his reviews dating from the founding of the Secession in 1897 until June of 1905. He dedicated it to "our friends and foes . . . in memory of a turbulent and for both sides fruitful period."[44] The rump of the Secession that remained in Olbrich's building on Karlsplatz after the exodus of the Klimt group was unable to build on the achievements of this epoch. In 1907 Bertha Zuckerkandl was to complain of this artistic decline, remarking that the artists who remained in the Secession "have not noticed that the Secession has in effect left them. . . . However, the Secessionists are dying a beautiful death. They perish in the fulfillment of their aims."[45]

The years between 1897 and 1905 were rightly described as "the heroic years of modernism in Vienna."[46] The 23 exhibitions of the Secession that were put on between its founding and the departure of the Klimt group, exhibitions at which thousands of art objects were shown, were a major factor in the "sacred springtime flowering of art." In Vienna, on the traditionally recalcitrant soil of Viennese cultural life, this flowering brought forth very pronounced preferences and a corresponding neglect of other artistic currents.

"That the public is besotted with Khnopff and Segantini" was already a matter of record in 1898.[47] As early as December of its first year of publication, an entire number of *Ver Sacrum* was dedicated to Khnopff, and also featured Maurice Maeterlinck's puppet play *The Death of Tintagel*, which Khnopff had illustrated. Like Khnopff, Rodin, Klinger, and Böcklin were repeatedly exhibited. The symbolic content of these artists' works resonated with that of Segantini, whose Divisionist technique, together with his symbolic approach to the natural world, left a deep and lasting impression on Viennese art. The extraordinary impact of Segantini is evidenced by the fact that he was comprehensively exhibited in Austria before the Neo-Impressionists, and even before the Impressionists themselves. At the same time, he was not too revolutionary in form and content to appeal to a somewhat wider public than connoisseurs and critics.[48] The same factors were undoubtedly at work in the success enjoyed by Rysselberghe with his Pointillist works.

The indifference shown with regard to Munch's work may be contrasted with the early appreciation of George Minne or the success of Ferdinand

Hodler. Toorop, also, was repeatedly exhibited, while the show of French Impressionists evoked a minimal response both from the state's purchasers of art and from private collectors. Just as it proved impossible to win appreciation for Munch's *The Scream*, the "bourgeois" painting of the Impressionists also failed to strike a chord among Viennese art lovers. Both seemed to lack the refined elegance of Viennese Jugendstil, and the required degree of pathos and allegorical suggestiveness. What was most valued was a somewhat stilted combination of Symbolism and Jugendstil. However, as soon as the artist began to depart from the norms of "good taste," as Klimt had done in his faculty pictures and in the Beethoven frieze, the public and press tended to react with outrage.

With the withdrawal of the Klimt group from the Secession, the relative importance of the exhibitions in Vienna also underwent a marked change. One of the original causes of the rupture had certainly been Carl Moll's commercial relationship with the Galerie Miethke. Under Moll's artistic direction of the gallery, an exhibition hall designed by Kolo Moser was set up in the Dorotheergasse and a subsidiary outlet designed by Josef Hoffmann was opened on the Graben.[49] In these halls dance performances were also periodically on offer, as is indicated by the guest appearance of Rita Sacchetto in 1906.[50] The Galerie Miethke displayed not only the works of the Secession artists and products of the Wiener Werkstätte, but also, in a series of shows, those of modern European artists and their precursors in the nineteenth century: Aubrey Beardsley (1904–5), Edward Gordon Craig (1905), Goya (1908), Honoré Daumier (1908), Monet and Manet (1910). Shows with particular significance to our theme were those for Anton Romako (1905), who was thereby rescued from oblivion, for Alfred Kubin (1906), and above all those for van Gogh (1906), Gauguin (1907), and Toulouse-Lautrec (1909). The Galerie Miethke also once again exhibited Hodler in Vienna, in 1909. In 1911, with the exhibition of Egon Schiele, the gallery threw open its doors to the very latest in Austrian art, and in 1913 it showed the collection of Oskar Reichel. (The exhibition of Pablo Picasso in 1914 at Miethke's was the belated first one-man show of the artist in Vienna.)

The comprehensiveness of the shows, together with the record of sales at the Secession exhibition, throw a good deal of light on the financial means available for the purchase of art in the Danubian metropolis. Not untypical was the Gauguin exhibition, which presented 72 works of the artist, among them numerous wood sculptures and ceramics as well as 41 oil paintings. In addition, in order to demonstrate the artistic context of Gauguin's work, a further 65 works by French artists were shown, including paintings by Cézanne, Matisse, Denis, Signac, Seurat, and Rysselberghe.[51] The van Gogh show contained 45 pictures,[52] Goya's contained 104,[53] and Toulouse-Lautrec's included 178 pictures, drawings, and graphics.[54] The introductions to the respective catalogues offered either short commentaries or a basic

introduction to the artist and his work—as for instance in the case of the Aubrey Beardsley show,[55] where the text was written by the art historian Hugo Haberfeld, the business manager of the gallery.

The Gauguin and van Gogh exhibitions at Miethke in 1906 and 1907 established these two painters as lodestars for the Viennese critics in coming to terms with the artistic impulses opposed to Jugendstil (or *Stilkunst*, as Hevesi called it). Hevesi himself defended Gauguin in this context against the charge of affected primitivism: "It is not barbarism. There are now once again explosions of elemental nature, even within the most dense layers of culture."[56] On the other hand, he saw in van Gogh

> forms of an eternal searching—and one that is destined to be eternally frustrated; the grim lyricism of a mood painter of tomorrow's world, who must, however, already suffer eclipse in the present, and all because of the incomprehensibility of his vision, a vision that has left behind the solid earth of reality with one great convulsive kick. Van Gogh is a painter of bewildering sensuality, an ineffable manifestation in paint of the vibrating nerve ends. . . . [His work] comes close to that of Munch, for whom nature is simply an elementary school for the imparting of angst.

In the final analysis, van Gogh's vision was alien to Hevesi, and its turbulence incomprehensible: "In Arles and Auvers-sur-Oise, where stand the picturesque haystacks depicted by our compatriot Jettel, he painted such despairing scenes. He would have shot himself even in paradise."[57] Van Gogh and Gauguin thus became the artistic forefathers of the young Austrian painters who, a little later, broke with the orthodoxy of Viennese Jugendstil. For Franz Servaes, "the youthful Oskar Kokoschka" was "a still terribly unruly talent who explores further the roads opened up by van Gogh and Gauguin and lurches from one extreme to the other. In his case everything will have to be achieved through mastery of the self . . . until such time as he should awaken from his barbaric wallowing in ugliness into a purified awareness of form."[58]

From the hundreds of works each year that introduced the new art of Europe in Viennese exhibitions, several were acquired direct by the newly founded Moderne Galerie or received by it in the form of bequests—although it should be added that the purchasing policy was extremely conservative. Besides important works like Klinger's *The Judgement of Paris*, Böcklin's *Sea Idyll*, Monet's *The Cook (Monsieur Paul)*, and Segantini's *Evil Mothers*, the collection offered a colorful mixture of works of extremely variable quality. Paintings that touch our theme most directly were only later acquired by the Moderne Galerie. Van Gogh's *The Plain at Auvers*, donated by the Secession in 1903, constitutes the sole exception. The earliest acquisitions of Munch or Corinth were made in 1916, of Toulouse-Lautrec and Ensor in the 1940s. A few French Impressionist paintings were purchased in the first decade of the century. In fact, the authorities had been somewhat halfhearted right from

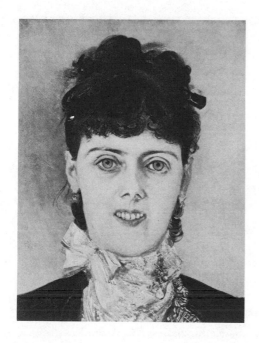

8. Anton Romako, *Portrait of Isabella Reisser*, detail, 1885.

the beginning about the foundation of a modern gallery. In May 1900 the Art Commission of the Ministry of Culture decided to nominate a committee to plan setting one up; three years later the new institution was provided with provisional hanging space in the Schloss Belvedere, but only in 1909 was a director appointed (Friedrich Dörnhöffer), from which time a systematic acquisition policy was pursued.[59]

In contrast, the 1913 exhibition at Miethke of the private collection of the physician Oskar Reichel gathered together a rather characteristic mixture of nineteenth-century Viennese painting, French Impressionism, works by Gauguin, van Gogh, Toulouse-Lautrec, and Munch, as well as Kokoschkas, Oppenheimers, Schieles, Güterslohs, and Faistauers. This show apparently had a considerable impact on the younger generation of Austrian painters. Reichel, who can be regarded as the first collector of Expressionism in Austria, had at that time the largest collection of the works of Romako (Figure 8), about whom he had also written a monograph.[60] From 77 works from Reichel's collection exhibited at Miethke, 41 were by Romako, with whose painting the early work of Kokoschka shows a remarkably close affinity. The industrialist Carl Reininghaus, probably the greatest private collector of modern art in Austria, similarly exercised considerable influence on the young Austrian painters, and specifically on Schiele, through his collection, which included works by van Gogh, Munch, Minne, and a whole series of pictures by Hodler. In addition, the Hagenbund, an artists' association moderately oriented toward modernism, put on exhibitions in Vienna, of which it is worth mentioning those of Max Liebermann (1905), Constantin Meunier

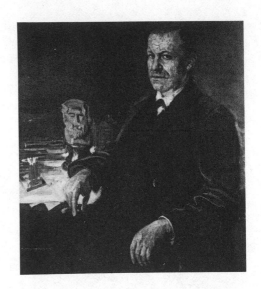

9. Max Oppenheimer, *Portrait of Sigmund Freud*, 1909.

(1906), Theo van Rysselberghe (1908), and Edvard Munch (1912). In 1911 the Hagenbund put on a show in the Zedlitzhalle of work by Kokoschka, Anton Faistauer, Franz Wiegele, Anton Kolig, and Paris von Gütersloh.[61]

Another relatively marginal promoter of modernism, but one that now seems to us of fundamental importance, was Hugo Heller's bookshop in Vienna. It was here that Arnold Schönberg's artistic productions were shown in 1910, after Carl Moll had refused an exhibition in the Galerie Miethke; here, also, a one-man show of Alfred Kubin was held in 1914. Hugo Heller was a follower of Freud's psychoanalytic theories; thus it was not by chance that his publishing house's program included the *Journal for the Application of Psychoanalysis to the Humanities*, which bore the title *Imago*. Heller took part in Freud's Wednesday salons as an interested layman and managed to persuade him to give his only recorded address to a nonacademic audience: in December 1907 Freud spoke in Heller's bookshop on the subject of "The Poet and the Imaginative Faculty." Which Viennese literati and artists were present at this talk is not recorded. Among the poets who took part in a series of similar gatherings with readings from their work were Rilke and Hofmannsthal.[62]

Finally, the two now-legendary Kunstschau exhibitions organized by the Klimt group in the summers of 1908 and 1909 should also be mentioned. At these, the generation of the future Austrian Expressionists were represented for the first time.

Klimt described the Kunstschau of 1908 as "a passing in review of the artistic strengths and aspirations of Austria"; it contained the products of 179 Austrian artists in a specially erected temporary building designed by Josef Hoffmann on what is now the site of the Konzerthaus.[63] The show on the same site the following year added a European dimension with the participation of

artists from other nations, among them Amiet, Barlach, Bonnard, Corinth, Denis, de Fiori, Gauguin, van Gogh (with eleven pictures), Klinger, Liebermann, Mackintosh, Matisse, Minne, Munch (with four sketches for Ibsen's *Ghosts*), Slevogt, Toorop, Vallotton, Vlaminck, and Vuillard.[64] The Austrians were represented by a number of already well-known artists and also by a string of more or less unknown ones, including Paris von Gütersloh and Egon Schiele. Likewise, Oskar Kokoschka and Max Oppenheimer (Figure 9) were exhibited, having already participated in the Kunstschau of 1908. With the performances of his two dramas in the exhibition's garden theater, Kokoschka became the "enfant terrible" of the whole event. That these young artists were included in an international show of around 480 works of European modernism demonstrates the open-mindedness of Klimt and his comrades in arms, Hoffmann, Moll, and Moser—even if the revolutionary artistic element in their work was as yet only clearly visible in Kokoschka. However the name of Richard Gerstl is conspicuous by its absence, both from the show of 1908 and from that of 1909. In November 1908 he committed suicide, apparently without the event being noticed by anyone in the artistic world of Vienna outside his immediate circle of acquaintances.

A few months after the Kunstschau of 1909, which may be regarded as the last major undertaking of the Klimt group, in December of the same year, an exhibition was held in the Pisko Kunstsalon. Without the backing of either the Secession or the Wiener Werkstätte, the participants announced their own program. The New Artists [*Neukünstler*] exhibition showed works of a colorful group of young artists, united primarily by their opposition to the stiff orthodoxy of the Academy as practiced in the classes of Christian Griepenkerl.[65] Among the exhibitors were to be found Schiele, Gütersloh, Faistauer, Wiegele, Rudolf Kalvach, and Hans Böhler as well as a number of other artists whose names are virtually forgotten today. The spokesman for the group, which was never consolidated into a real artistic association, was Egon Schiele. In a manifesto, he demanded for the "New Artists" a complete artistic independence from all other artistic movements and from tradition, and elevated to an absolute imperative the concept of subjective creativity. It will be interesting to compare his demand "purely . . . and unconditionally to be oneself"[66] with the basic principles espoused by the Secession.

"MEMENTOS OF BEAUTY" AND "HOSTILE POWERS"

"Beauty and art [are] not merely an ornament . . . but . . . the only true form of life itself. . . . [W]e should not simply beautify our lives with lovely things, but we should instead, in some delightful way, contrive to be surrounded by mementos of our innate beauty, so that we may take fresh heart from them and never again sink back into the mire." These words were written by Hermann Bahr in 1899 in his review of the fourth Secession exhibition.[1] The faith that he here enunciates, that the aestheticization of life equally implies the moral improvement of mankind, was one of the fundamental tenets of the Secession.

The salvation of art as the salvation of the world: this idea also inspired the journal *Ver Sacrum*, the organ of the Secession, at its inception in 1898. In its first number Max Burckhard explained the choice of *Sacred Spring* for the journal's title in appropriately lofty terms:

> When the fatherland was threatened with danger, the entire people conse-
> crated to the gods all living things that the next springtime brought, a sacrifice
> for the sacred spring—the *ver sacrum*; and when those born in the sacred
> spring were of age, they formed a youthful band, itself the incarnation of sacred
> springtime; they left their homeland for foreign parts to found a new commu-
> nity, drawing on their own resources, and fixing their own aims. . . . For [the
> band of artists] held that not their own personal interests, but the holy cause
> of art itself was in danger, and in their dedicated passion were ready to make
> every sacrifice on its behalf, as they still are; and want nothing more than to

attain their aims using their own strength; and therefore they have taken as their inspiration the idea of *ver sacrum*.[2]

The beginnings of the Secession exhibited distinct signs of an impulse toward social reform and mass education. In the very first number of *Ver Sacrum* the question was posed "Why are we publishing a journal?" and the answer given that without one "it had not been possible hitherto for artists to bring their endeavors to the notice of a wider public."[3] The pedagogic motivation was particularly evident in the attempts to reform the crafts. The disposition toward mass education of the English Arts and Crafts movement was one of the main inspirations behind the journal. Bertha Zuckerkandl published in the seventh number of the first year an essay on "The New Folk Art." She wrote in this article that

> people should be brought up to find a bare room intolerable, and to react with physical unease to inharmonious colors and ugly proportions. Only then will they make such demands in the future as will determine the artistic quality of utilitarian objects—this applies especially to women, whose aesthetic sense is matched by their practicality. Such things will henceforth be cheap, rational, and pleasing to the eye. At the present time applied art is still far too precious. It must become fundamentally more robust, and thus adapted to the daily needs of the family.[4]

In the same number Adolf Loos published his essay entitled "The Potemkin Villages," in which he polemicized against the boastful "absurdities" of the architecture of the Viennese apartment blocks of the late *Gründerzeit*; their ostentatiously sumptuous character seemed to him to be "immoral."[5] Loos's insistence on artistic integrity, and Zuckerkandl's faith in the beneficial effects of "education" for ripening the individual and improving artistic quality, were both aspects of the early Secession's consciousness of the artist's social responsibilities.

Nevertheless, the increasing aestheticism of the Secession soon suppressed these impulses. A few years later Loos was to be found castigating the "rage for Indian-type decoration among the cultural barbarians employed by the state,"[6] a reference to Josef Hoffmann and Kolo Moser in their capacities as teachers at the Viennese School of Applied Arts. (The antagonism between Hoffmann and Loos had its parallel in the previous artistic generation, in the rivalry between Hans Makart and Anselm Feuerbach—although no similarity is here implied between Hoffmann and Makart. Feuerbach once described Makart's studio as an "Asiatic junkshop.")[7] Later, Karl Kraus was to make fun of the Secessionist interiors, remarking that "the dirt from the streets they have in their homes, and even that has been designed by Hoffmann."[8]

Loos formulated his tract entitled *Ornament and Crime* out of the impressions formed at the Kunstschau of 1908, which represented in many aspects the apotheosis of the Wiener Werkstätte. At the opening of this show Klimt

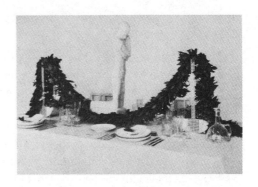

10. Photograph from the
exhibition *The Laid Table*,
Wiener Werkstätte, 1906,
with a marble sculpture by
George Minne.

had once again proclaimed the indivisibility of beauty and human progress. He expressed the conviction that "cultural progress is based upon the increase of beauty on earth . . . and . . . on the progressive imbuing of life with artistic purposes."[9] In fact, the Secessionists in the course of their development never quite escaped the danger of elevating ornamentation to an end in itself.

That this development was programmed right from the beginning of the Secession may be seen from statements by Hermann Bahr, who for a brief while acted as a sort of self-appointed chief ideologue for the Artist's Association. In 1898 he wrote of his concept for an ideal house:

> Above the threshold I would have some verses inscribed: the verses should encapsulate my whole being, and what they portrayed in words should also be faithfully reproduced in colors and shapes; each chair, each wallpaper, each lamp should draw its inspiration from the same verses. In such a house I would everywhere see my soul reflected as in a mirror. That would be my ideal house. There I could live, contemplating my own visage, listening to the music of my soul.[10]

This mixture of narcissism and aestheticism (with a lurking danger of totalitarianism)[11] was not in fact characteristic of Bahr's later development, but was indeed so for the broad spectrum of Secessionist art. It was evident, for instance, in the manner in which the Wiener Werkstätte took over George Minne's early sculptures of attenuated youths: one of their publicity photographs (Figure 10) shows a sumptuously laid table adorned with their products and luxuriously decorated with garlands, in the center of which the crowning touch is a marble sculpture by Minne. Such figures, which had a major impact on early Austrian Expressionism, are here used simply for decorative effect.

It was not surprising that it was *The Hostile Powers* (Figure 11) in Klimt's Beethoven frieze that made their creator the target of critical abuse. The presentation of "Disease, Madness, Death, Voluptuousness, Lechery, and Excess"[12] in this realistic manner broke with the existing conventions of beauty and harmony. Their appearance was only tolerated if disguised as allegory in

such a way that nobody could be disturbed by it. The importance of Klimt for Austrian Expressionism lay in his pioneering struggle for the "emancipation of dissonance."[13] The introduction of the ugly and the diseased, the unvarnished presentation of the dark and threatening side of life, which was also apparent in his faculty pictures, was not tolerated in fin-de-siècle Vienna. The suppression of the negative aspects of life and society, which were to be perpetually hidden under a veil of stylization, mirrored an essential anxiety about life as a whole.

In self-defense, the doctor in Schnitzler's play *The Lonely Road* avoids getting to know people too well—otherwise one would become "mad from pity, or disgust, or fear."[14] Musil makes the character of Josef in his play *The Fans* say: "One should not have too much feeling; or at least only for the sublime and the great, where it can do no damage."[15] It is no accident that suppressed feelings and the themes of death and sexuality that so often recur in Austrian Expressionism are reflected in the basic theses of Freud. "Half-suppressed sexuality has brought confusion to many households"; wrote Karl Kraus in 1911, "totally suppressed sexuality, however, has disturbed the world order."[16] The reaction to this suppression of anxiety, of suffering, and of human desperation led directly to Expressionism. It responded almost automatically with a shift of focus "from the façade to the psyche."[17]

It should not, however, be overlooked that the Secession had already given expression to a climate of feeling that sought to oppose a society ori-

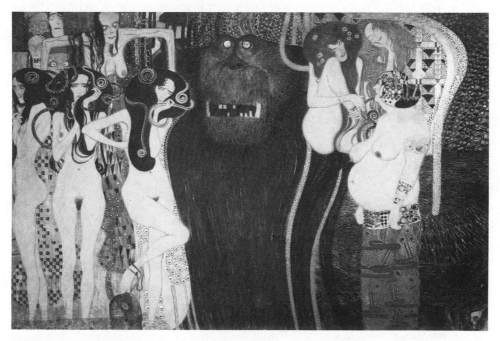

11. Gustav Klimt, *The Hostile Powers*, from the Beethoven frieze, 1902.

ented toward patriarchy and rationalism with the "matriarchal" impulses of the soul.[18] In contrast to the dominant currents of the turn of the century, the feminine element is, in general, positively handled in the art of the Viennese Secession. Nature and feeling are merged in the image of woman, all of which is somewhat remarkable, given the men's club character of the Artists' Association. The stress on the feminine that is so marked in the imagery of the Secession may be seen as "a vivid metaphor of . . . erotic availability."[19] The identification of the female with nature itself, and with the emotional element in mankind, represents an attempt at self-healing by an ailing society suffering from an overemphasis on rationalism. Suppressed facets of existence, the emotional or irrational elements, sought an outlet in the dynamic vegetable forms of Jugendstil, in its sometimes rampant floral ornamentation. Jugendstil's "rationalization" in the course of its stylistic development led to severe, geometrically abstractive lines and forms. Manifestations of the unconscious were now once again kept at bay by the control mechanism of the intellect; stylization served as a means to ward off dangerous elements below the surface.[20]

It is also indicative of the new tendencies that the artists of the Secession were captivated by expressive free dance, which took both Europe and the United States by storm at the turn of the century. (It will be shown that its influence is correspondingly marked both in the work of Kokoschka and Schiele.) The Secession building was repeatedly used as a venue for dance performances. In 1902 the guest star was Isadora Duncan,[21] who in 1903 also spoke about the new art of movement in a lecture, and who in 1904 was again guest artist at the Carltheater.[22] As early as 1898 Loïe Fuller appeared in Vienna, and 1906 saw performances by Maud Allan[23] and Mata Hari[24] (Figure 12) at the Secession. In the same year Rita Sacchetto performed at the Galerie Miethke.[25] A little later the dancing of Ruth Saint-Denis met with an enthusiastic reception from the reviewers[26]—which in turn provoked satirical comment from Karl Kraus, who polemicized in *Die Fackel* less against the "serpentine gestures" of the artist than against the "stylistic sleight of hand" of the critics.[27] In Vienna it was the Wiesenthal sisters who broke with the ballet tradition and revolutionized dance—in close association with the Secessionists, as their first appearances at the Kabarett Fledermaus and in the garden theater of the Kunstschau indicate. The human body as a vehicle of expression, a concept that already had great importance in symbolist art, also provided fundamental inspiration for the new currents in the fine arts. The preoccupation with the human body was to be one of the main characteristics of the expressive tendencies in Austrian art of the twentieth century and could already be seen in the works of early modernism in Austria.[28]

The emphasis with which the language of gesture and mimicry was transferred to the expressive art of Kokoschka and Schiele united with a language of forms from which the fragile elegance of the Secession was driven out.

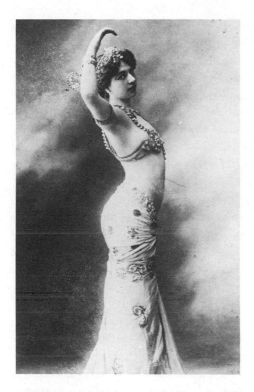

12. Mata Hari, posed
photograph.

The place of "mementos of our innate beauty" was now taken by the "hostile powers." Their appearance in the new art was accordingly seen as a disturbing threat. The influential critic of the *Neue Freie Presse*, Adalbert Franz Seligmann, delivered a characteristic warning on seeing the works of Kokoschka shown at the Kunstschau of 1908: "People of taste are in for a shock here."[29] Seligmann included in his 1910 book *Art and Artists* a chapter on "The Development of Modern Painting." In this he wrote that "The ever-increasing tendency among artists of outstanding gifts and exceptional technique to indulge in senseless doodles of line and color, and to paint obscene and disgusting objects" was a symptom of mental disease. "The historian of modern painting [must] make clear . . . to what extent the dilettante-barbarian manner of the new school has its origins in the mental abnormality of its mentors [Gauguin, van Gogh, Cézanne]."[30]

The aggressive rejection by Seligmann of Impressionism, and in particular of Expressionist tendencies, was, of course, not the expression of a Secessionist aestheticism, but of a rationalist-positivistic world view that stubbornly adhered to Naturalism and Realism. Schiele's "Manifesto" of the New Artists set against this a subjectivity linked to the consciousness of the creative genius, of the heroic individual. But his position was also alien to that of the beauty-intoxicated Secession, which continued to preach its mission of world improvement—an improvement, however, that was more and more limited to the world of their supporters and customers. In this respect,

the positions of Loos and Karl Kraus were close to the ethically absolutist individualism of Schiele, Kokoschka, or Gerstl, and shared the creative subjectivity of Schönberg, Gütersloh, or Kubin. Barely two years after the New Artists exhibition, Albert Paris Gütersloh referred to "the polemical character of that new art" whose protagonists "had rather unmasked an enemy, against whom they aimed their creations, than found a friend." Gütersloh stressed above all the antirational aspect of the "new art." "For mankind, being scientifically enlightened, seeks to protect itself from the irruptions of the mystical through 'l'art pour l'art.'" By these means "the subversive power of art would be effectively paralyzed." [31]

The culturally combative tone of Gütersloh's early texts, which is not found in the same form among Schiele's pronouncements and is totally absent from those of Kubin, accords with the motto of *Die Fackel* promulgated by Karl Kraus in the first number of his journal: "No resounding statement of *what we will be bringing our readers*, but an honest promise of *what we will annihilate*." [32] For Kraus, art "could only arise from rejection. Only from outcry, not from appeasement. Art, when summoned as a comfort, leaves the deathbed of mankind with a curse." [33] Kraus is here paraphrasing an aphorism of Arnold Schönberg's, who likewise demanded that the artist face up to the hitherto suppressed "hostile powers": "Art is the stricken cry of those who experience within themselves the fate of mankind . . . who do not blindly serve the primal force, the 'dark powers,' but who instead rush to understand how they are constituted. Who do not turn away their eyes to shield them from emotions, but who open them wide in order to confront what must be confronted." [34] These quotations demonstrate vividly, when they are compared with the proclamations of the Secession, to what extent the emphasis had now shifted to an art of subjective expression that no longer concerned itself with the attainment of the Promised Land of joy through the medium of beauty.

RICHARD GERSTL

Before his suicide in November 1908 Richard Gerstl destroyed all his personal notes and a large number of paintings and drawings. The details of his life are based almost entirely on information and anecdotes that were collected more than two decades after his death. Because of this time lapse and the consequent unreliability of the evidence, it is only possible to sketch a very incomplete picture of Gerstl's character and personality, one that is significantly less precise than for any other important Austrian painter of the twentieth century.

The art dealer Otto Nirenstein, at that time owner of the Neue Galerie in Vienna, was introduced to the work of Richard Gerstl by the latter's brother, Alois, in 1931. His surviving work was retrieved from the warehouse of a moving company, where it had languished for 23 years. The pictures were packed into a chest, with the result that "the canvases were often torn, some pictures even being cut up into pieces, all of them covered in dirt,"[1] and several were entirely ruined. Around 60 paintings and 8 drawings by Gerstl have so far been identified, of which the majority came from this hoard. Shortly after its discovery, Nirenstein put on the first exhibition of Gerstl's work in his gallery between September and November 1931. The verbal reports that Nirenstein gathered on this occasion from Gerstl's friends and acquaintances, the reminiscences that Alois Gerstl summed up in 1954, and the memoirs of Gerstl's colleague at the Academy, Viktor Hammer, written in 1963, provide the basic information that is available to us about his personality (Figure 13).[2]

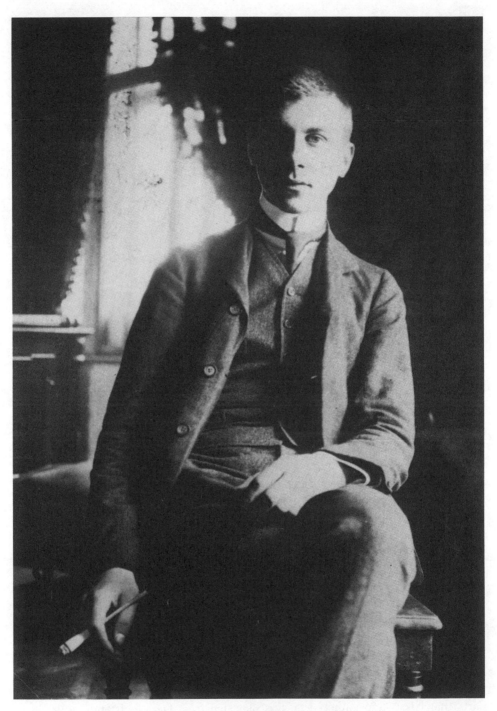

13. Richard Gerstl, photographic portrait.

▪ The Academy ▪

The artistic ambitions of Richard Gerstl had already brought him into conflict with his father during his school years. The father was evidently a successful businessman and came originally from Neutra, then in Hungary, while the mother came from the vicinity of Budweis. Richard attended the prestigious Piarists' *gymnasium* in Vienna and subsequently was sent to a different private school after causing disciplinary problems for the Piarists. He was even at that time being prepared for the entrance examination of the Viennese Academy of Fine Arts by an Academy student. For the same purpose, in the summer of 1898 he attended for two months the drawing school known as "Aula," which was run by Ladislaus Rohsdorfer.

At the age of fifteen, in 1898, Gerstl was accepted by the Academy.[3] He enrolled in Christian Griepenkerl's general painting course, eight years before Egon Schiele attended the same classes. Gerstl was soon just as much in conflict with Griepenkerl as he had been with his schoolteachers. He was unable to profit from his professor's insistence on severely academic historicism and portraiture. He spent the summers of 1900 and 1901 in the Hungarian painters' colony of Nagybánya, participating in Simon Hollósy's open summer school. The latter had already founded a private school in Munich in 1886, which had "successfully asserted the legitimacy of a lyrically inspired Naturalism."[4] A decade later he moved his school to Nagybánya, and in this way the painters' colony had come into existence.

In Nagybánya Gerstl encountered a strongly coloristic *plein air* style of painting that contrasted sharply with the somewhat musty academicism of Griepenkerl. At the time Gerstl studied with him Hollósy was mainly occupied with figurative themes. For example, his *Rákóczi March* of 1899 (Figure 14) is hardly identifiable as an example of history painting, but rather presents an expressive array of Hungarian folk types that dramatically emerge from a swirling mass of light and color as they advance on the dusty road. Hollósy's work, with its emphasis on expression, already shows strong psychologizing tendencies. Apart from the trips to Nagybánya, we only know of two other journeys by Gerstl—a summer holiday spent on the Traunsee and a visit to Munich.

Gerstl's artistic skills were consistently marked as "satisfactory" by the Academy.[5] In the fourth year he was no longer accepted by Griepenkerl. Apart from the winter semester of 1904, when he was once again enrolled with Griepenkerl, he interrupted his studies for the whole period between 1901 and 1906.[6] He appears to have devoted the time to language studies, to the study of philosophy, and above all to the study of music. Gerstl seems to have taught himself Spanish and Italian and to have read scientific literature in these languages. Unfortunately there is no information on the nature and direction of his philosophical studies. He was, in Hammer's words, "quite exceptionally well-read and educated."[7] He admired Ibsen and Wedekind[8]

14. Simon Hollósy, *The Rákóczi March*, 1899.

and knew the works of Otto Weininger and Sigmund Freud, whose recently
published *Interpretation of Dreams* especially interested him.[9] During a walk
with Hammer "he continually spoke about the shape of the human head; he
mentioned a book by Moebius dealing with the breadth of the female head,
in which he claimed that narrow heads were a sign of inferiority. I asked
him: 'Have you read Moebius's book?' He said that he had and had thereby
realized that his head had become 71 cm wide." [10] The reference is appar-
ently to a book entitled *On the Physiological Basis of Feeblemindedness in
Women.*[11] Its author, the Leipzig neurologist Paul Moebius, had become well
known as a result of his work on the pathological features in the characters of
geniuses, his so-called "pathographies." Together with Hammer, Gerstl also
visited the house in the Schwarzspanierstrasse where Beethoven had lived
and where the 23-year-old Otto Weininger had committed suicide.

Gerstl's passion for the new currents in contemporary music has often
been stressed. It led him to make the acquaintance of Gustav Mahler—who
refused to have his portrait painted by him—and also of Arnold Schönberg
and his circle. He enormously admired the compositions of the latter, whose
radicalism as a musician certainly influenced Gerstl in his art. Through
Schönberg he got to know Alexander von Zemlinsky, Alban Berg, and Anton
von Webern. He was also friendly with the Berlin pianist Conrad Ansorge.
Gerstl's commitment to music was so profound that at one point he was offered
a job as music critic. By comparison, he seemed to have very much less

contact with artistic colleagues; Viktor Hammer, with whom Gerstl shared a studio for some time, was apparently the sole exception. He was the same age as Gerstl, but had little in common with him artistically speaking. Hammer painted mainly portraits and nudes with precise, old-masterly realism. Later he was an extremely fashionable society painter, and in particular a renewer of type design; for a short while he taught at the Academy before emigrating to the United States in 1938.[12] Gerstl seldom showed him his pictures. Hammer also reported, without saying exactly when, that he and Gerstl enrolled in a private school of painting on the Kohlmarkt for a short while, the school being run by two Secessionist artists.[13] This was apparently a reference to the school of Franz Hohenberger and Ferdinand Kruis, which Gerstl and Hammer attended with Jules Pascin.

Through the intercession of Hammer, Gerstl was accepted in 1906 by Heinrich Lefler's "Special School" at the Academy. During the period that he had not attended any formal classes he had not given up his painting, but in fact considerably developed his skills. Lefler now happened to see the portrait of the Fey sisters, which apparently impressed him greatly. Gerstl's acceptance by Lefler for his classes implied a degree of recognition for his work; the Special School, according to the statutes of the Academy, was charged with "the further preparation of artists up to the level of the independent exercise of their profession."[14] Gerstl attended four semesters of classes from Lefler, who between 1903 and 1910 directed a "systematized special school for landscape painting"[15] and was a founding member of the "Viennese Hagenbund."[16] In 1908 Lefler was busy with the preparations for the 60th Jubilee celebrations of Franz Joseph, which were intended to be staged with much pomp and circumstance on the Ringstrasse. Gerstl regarded this as an unworthy activity for a painter, since such a grandiloquent procession was in his opinion a hangover from the Makart era. It seems that he did not keep this opinion to himself, and this would appear to have led to his dismissal by Lefler from his class.

As a result of this, the artist addressed a complaint on July 22, 1908, to the Ministry of Culture and Education (Figure 15). In this way, a relatively lengthy handwritten document of Gerstl's has come down to us, there being no other autograph of any significance extant.[17] Gerstl complains that his pictures were excluded from the School Exhibition that opened on July 19, 1908. He was thus unable to compete for the Special School's prize, which was in fact won by his colleague Ignaz Schönfeld. Gerstl's indignation was primarily directed at Lefler, who had described the winner, by comparison with Gerstl, as "completely without talent," while to Hammer he had remarked of Gerstl: "He is carving out an entirely new path for himself; one can hardly follow what he does, but I can do nothing for him." The Ministry immediately forwarded the complaint to the Rector of the Academy, of whom Gerstl had written that he was a nobody; the complaint, not very surprisingly, received short shrift from that gentleman, who contented himself with the

437–1908. Traunstein 22. Juli 1908.

An das Ministerium für Cultus und Unterricht.

Ich bin seit fünf Semestern Schüler der Specialschule an der Akademie der bildenden Künste in Wien des Herrn Prof. Lefler. In der am 19 d. M. eröffneten Schulausstellung wurde keines meiner Bilder ausgestellt; die Schulausstellung hat den Zweck über die Leistungen jedes Schülers Rechenschaft zu geben; umso mehr hätte ich nicht nur das Recht gehabt, dass meine Bilder ausgestellt werden, als Hr. Prof. Lefler einem meiner Collegen gegenüber folgende Äußerung über mich machte: „Er (nämlich ich) geht ganz neue Wege, man kann ihm schwer folgen, aber um Kenntnis für ihn nicht". Dadurch das Nichtausstellen meiner Bilder ohne mein Wissen u. meine Zustimmung, war ich von der Concurrenz um den Specialschulpreis ausgeschlossen, den Herrn Ignaz Schönfeld zuerkannt wurde; Herr Prof. Lefler hat diesen Schüler mir gegenüber wiederholt u. zum letzten Mal vor 4 Wochen für vollkommen talentlos erklärt.

Da für mich der Rector der k. k. Akademie keine Instanz bildet; so er bitte ich das Unterrichtsministerium mich für diese Handlungsweise, die sider mehr als incorrect ist, zu entschädigen.

Richard Gerstl

d. 27. Traunstein Nr. 18. bei Gmunden.

Herr Prof. Lefler hat die oben angeführte Bemerkung über mich zu Herrn Victor Hammer gemacht.

15. Richard Gerstl's letter of complaint to the Ministry of Culture and Education, July 22, 1908.

laconic comment, "This communication, if only because of the unacceptable manner in which it is presented, requires no further action, and may be filed. (Signed) L'Allemand."

▪ Rejection ▪

Although Gerstl spoke frequently and at length about music and literature, he seldom expressed his views on painting. From occasional remarks it can be gleaned that he admired the Spanish and Dutch old masters. He rejected contemporary Austrian painters, even if the roots of his own art lay in the painting of the Secession. Alois Gerstl reported that his brother "had no great opinion of the painters then prominent, while being convinced of his own genius."[10] In contrast to Schiele and Kokoschka, Gerstl dismissed Gustav Klimt's work. The main reason for this was Klimt's strong preference for decorativeness and his affinity with Symbolism. With his later emphasis on the subjective-emotional quality of visual experience, Gerstl also displayed a sharp antipathy to the work of most of the artists of the Secession. Whether or not he knew the spontaneous "visionary" paintings of Schönberg is impossible to decide, since the first knowledge of them we have dates from 1910. Like Alois Gerstl, Hammer also records that "the Austrian artists made no impression on Gerstl. On the other hand he was highly impressed by the Spanish painter Zuloaga. Of Munch, whose influence on Gerstl is nowadays claimed, I never heard him speak. But he did discuss van Gogh, whose painting was just beginning to be a topic in Vienna at that time."[19]

Hammer's reference to the now almost forgotten Ignacio Zuloaga is significant. He was represented with eight pictures at the ninth exhibition of the Secession at the beginning of 1901. The catalogue of this show featured the following titles of his works: *Bull-fight*, *The Street of Love*, *Sereno*, and *The Temptation*, as well as four portraits.[20] The seventeen-year-old Gerstl had apparently seen these pictures and was as forcibly struck by their atmospheric coloring as by their themes. In this he was not alone, for Richard Muther also confessed to having looked on Zuloaga's painting "and feeling my pulses begin to race."

> Here is the real local color of the Iberian peninsula brought to life. At first glance the eye is offended. Refinements of light or exquisite color harmonies may be sought in vain in Zuloaga's work. As on a poster, he places next to each other coarse, almost raw tones of bilious yellow and sickly reds. With brutal verisimilitude he paints the rouged cheeks and heavily penciled eyebrows of his whores, making no attempt to endow their movements with grace or to give their dress a touch of fashionable chic! With what boldness and with what broad brushstrokes does he fix his images on the canvas![21]

Between the lines one catches the pleasurable *frisson* that Muther gained from these pictures. Hevesi also dedicated a lengthy paragraph to the Span-

16. Ignacio Zuloaga, *The People's Poet, Don Miguel of Segovia*, 1898.

ish painter in his discussion of the Secession exhibition;[22] *Ver Sacrum* published an illustration after an etching of Zuloaga.[23] In 1898 Hermann Bahr had visited Ignacio Zuloaga in his studio in Barcelona and proclaimed that, together with Klimt, he was far superior to the majority of European artists.[24] In 1903 Karl, Count Lanckoronski, donated to the Moderne Galerie Zuloaga's portrait of the vernacular poet, Don Miguel of Segovia (Figure 16).

Individual paintings by Gerstl, portraits in particular, remind one of the early work of the Italian Futurists. Boccioni or Balla, for example, painted similarly "urbane" portraits in a light-flooded, highly colored Pointillist manner. Their origin in Divisionist painting is consistent with the influence that Segantini and individual Pointillists had on Gerstl when their works were shown in Vienna. In the same year (1898) that Gerstl was accepted by the Academy, he could see ten of Segantini's pictures at the founding exhibition of the Secession. Three years later, as previously mentioned, Segantini was the star attraction of the ninth Secession exhibition in 1901,[25] and the Secession itself acquired his painting, *The Evil Mothers*, in order to donate it to

the Moderne Galerie. Gerstl, whose precociousness needs to be constantly stressed, could have been significantly influenced by the Pointillist works of Rysselberghe, at the third Secession exhibition of 1899, and then of Signac at the seventh Secession exhibition of 1900. Rysselberghe was once again exhibited at the eighth Secession show, at which eight pictures by Zuloaga could be seen.

The light and color effects of the vast French Impressionist exhibition of 1903 also had a major impact on Gerstl. The building up of the pictorial structure of many of his works through specks and dots of color continually reminds one of Vuillard or Bonnard, who were represented in that show. Equally fundamental would appear to have been the influence of Munch, even if the sources provide no corroborating evidence for this. After the Secession had already shown several pictures of Munch in 1901 and 1902, the nineteenth show in 1904 exhibited a collection of his work amounting to twenty items. However the painter with the strongest impact on Gerstl was van Gogh. The five pictures by him at the sixteenth Secession exhibition of 1903, and above all the one-man show in the Galerie Miethke in 1906, greatly strengthened Gerstl in his artistic radicalism. Van Gogh's *The Plain at Auvers-sur-Oise* (Figure 7) was in the possession of the Moderne Galerie from 1903, after the Secession bestowed it on the gallery as a foundation gift.

There are parallels also to other artists. In many pictures Gerstl gives a foretaste of Chaim Soutine, who was born eleven years after him. Gerstl's work also has affinities with that of Lovis Corinth. Similar painterly attitudes are to be observed in Slevogt or Liebermann, who were exhibited by the Hagenbund in 1905 in the Zedlitzhalle. The Moderne Galerie acquired Liebermann's *Garden of a Hospital in Edam* (Figure 17) in 1904, a picture that may be compared to Gerstl's work in its painterly technique and its light-filled, agitated colorism. Schönberg later noted of Gerstl: "His ideal and model was at that time Liebermann,"[26] a remark, however, that falsely implies an exclusive preoccupation on Gerstl's part.

What condemned Gerstl to outsider status in Vienna was not only the elemental ferocity of his later painting but also a complete absence of symbolism in his work. The content of the picture is identical with its expression. The artistic statement is not to be found—as so often with Klimt, and in a different way with Kokoschka and Schiele—on another level from what is represented. Gerstl's painting has nothing literary about it, and hence never becomes allegorical. In the eyes of the Viennese it was also lacking in the desired preciosity. While in Gerstl's Pointillist pictures there are still traces of exquisite decoration, his other paintings, measured by the standards of contemporary taste, rigorously excluded the requisite elements of eye-pleasing sensuality.

Gerstl's rejection of his Austrian fellow artists must at least partly explain why he was never exhibited during his lifetime. An offer to exhibit at the Galerie Miethke he rejected because he refused to have his work shown

17. Max Liebermann, *The Garden of a Hospital in Edam*, 1904.

alongside that of Klimt. He also cancelled (for reasons unknown) an exhibition of his work that the "Wiener Ansorgeverein," which was active on behalf of the musical avant-garde in Vienna, wanted to organize on his behalf. Viktor Hammer could recall only a single portrait commission received by his friend.[27] Failing such commissions, he painted mostly friends and acquaintances; almost all of the pictures that have been preserved come from the collection found in the mover's warehouse because Gerstl evidently neither could nor would sell them. The artist is described as precocious, touchy, and easily roused to anger.[28] One of his brother's anecdotes also lends support to this picture of the oversensitive and uncompromising painter: on one occasion, when a visitor came to his studio and particularly praised a picture, he proceeded to cut it into pieces on the grounds that it could not possibly be good if it had managed to please the eye.[29]

One of the very few who believed in Gerstl's talent was Arnold Schönberg, even if he was later to deny this. He repeatedly allowed Gerstl to paint him, and beginning in 1906 even learned painting technique from him. The friendship with Schönberg became more intimate, and in 1907 and 1908 Gerstl spent the summer holidays with the composer and his circle in the Upper Austrian village of Traunkirchen on the Traunsee. Gerstl did several portraits of Mathilde, Schönberg's wife (Figure 18), with whom a love relationship in

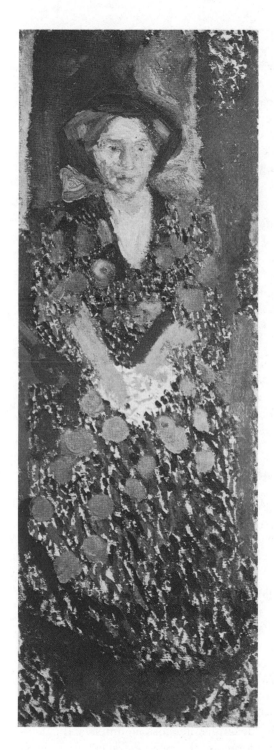

18. Richard Gerstl, *Portrait of Mathilde Schönberg II*.

due course developed. Mathilde left her husband in the summer of 1908 to live with Gerstl, but soon returned to Schönberg, apparently as a result of intervention by the composer's friends.[30] It is impossible to say with certainty whether this tragic relationship and the destruction of his friendship with Schönberg were the proximate causes of Gerstl's suicide, or whether it was primarily his isolation as an artist that drove him to such a step. His letter of complaint of July 1908, however, is the outburst of a painter who feels himself neglected and cheated of the recognition he feels is due to him, and who therefore was clearly not indifferent to acceptance by his peers and the public. On November 4, 1908, Gerstl burned in his studio all his letters and notes, together with most of his pictures and drawings; then he put a noose around his neck and stuck a knife into his breast.

No one, outside the circles of his family and friends, took the slightest notice of the 25-year-old painter's demise. All the pictures still in his studio were delivered to the warehouse of the moving firm, where they remained until 1931. It is idle to speculate how Gerstl's life and career might have developed had he, like Kokoschka and Schiele, managed to be included in the Kunstschaus of 1908 and 1909. His work simply appeared several years too early for its full importance to be recognized in Austria. It is equally pointless to speculate about the content and value of the works destroyed by him and of the other works that have been lost.[31] The fate of Richard Gerstl is a classic case of "neglected genius" with tragic consequences. These considerations compel us to treat his oeuvre as a surviving fragment of something that was potentially very much greater.

▪ Self-Portraits ▪

Self-portraits play a dominating role in Gerstl's work. The tendency of self-examination and self-exhibition he shares with Egon Schiele, although he lacks the latter's narcissism and private symbology. Gerstl would seem first to have portrayed himself at the age of 21 [32] as a half nude before a blue background (Figure 19).[33] Rigid frontalism, uncompromising axial presentation, and the reductionism of color into the intense blue of the background, together with the vivid whiteness of the cloth and the flesh tints of the body, impart hieratic effects to his appearance in this portrait. The attitude and setting of the figure recall archaic representations of human and divine figures. Gerstl's piercing gaze strengthens the impression of concentrated energy, which is further intensified by the aura around the head. This picture is the most "metaphysical" of his portraits. It contrasts sharply with the self-portrait with palette.[34] The elegantly dressed young man here appears somewhat unsure of himself, viewed from the side on, holding his paintbrush and palette in his hand; the elevated, slender format of the canvas strengthens the impression of fragility. As against this, in another self-portrait Gerstl appears self-confident, almost domineering:[35] before a blue background, dressed in

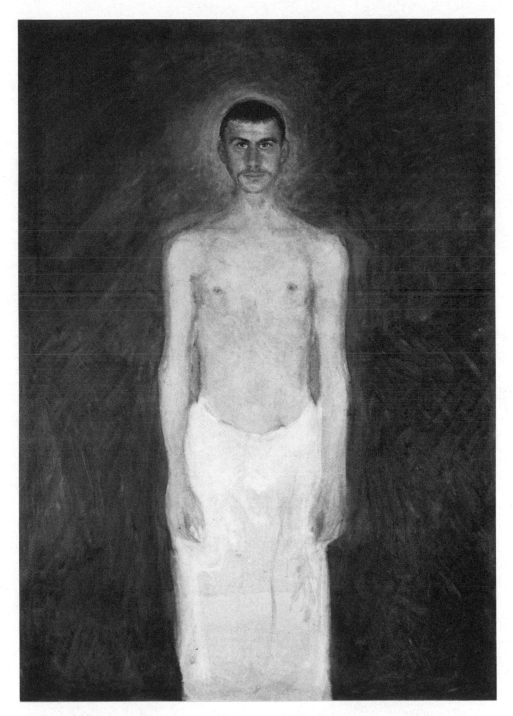

19. Richard Gerstl, *Self-Portrait as a Half Nude in Front of a Blue Background.*

a dark suit, and sporting a bow tie, he stands with legs apart staring at the viewer. Thus, to the self-worshipping pose of the half nude and the fragility of the nude portrait with palette is added a third type of the artist as a dynamic figure. The vivid background of azure blue, the hastily applied drops of color, which extend even onto the suit, substantially contribute to the creation of this image. Gerstl further developed the Pointillist analytic color combinations of Signac and Seurat according to his own ideas in order to produce his desired effects. The spots of color are not those of fragmented light, as in Divisionism, or the individual elements that in Pointillism coalesce to produce the whole. Instead, they achieve their effects as concentrations of energy, spreading across and penetrating the displayed figure.

Two further explorations of his own identity by Gerstl are among the most remarkable self-portraits of early modernism. The small *Self-Portrait, Laughing* (Figure 20) is a cynical settling of accounts by the artist with himself and with the world.[36] Gerstl's head, with close-cropped hair, sparse beard, and wispy moustache, appears ghostlike, as if lit from below. The bitter laugh with the gaping mouth distorts his features into a grimace; the long neck emerges from a collarless, open shirt, over which a jacket envelops the sloping shoulders. The painting is quite evidently a rejection of the genre portraiture of Secessionist painting.

The second notable work, Gerstl's self-portrait as a whole-figure nude, bears the date September 12, 1908 (Figure 21).[37] It is thus the only one of his pictures that can be exactly dated. Gerstl's slender, gaunt figure is seen partly from the side, his right hand resting on his hip, the left arm bent at the elbow, and leading the brush toward the canvas. The picture is cut off above the head and at the lower legs, which creates an effect of inescapable immediacy—the image cannot be contained within the parameters of the canvas. The light breaks in from above and is transformed into a dizzying spiral of color, which permeates the atmosphere of the painting. Gerstl's hands evanesce in thick smearings of color. Such a picture, in the Vienna of 1908, not only was aesthetically "unacceptable," but also disqualified itself on the grounds of its uncompromising presentation of nakedness, which was not legitimized through stylization or allegorical pretext. When one considers that Klimt's realistic nudes for the faculty pictures a few years before—even though they could be justified by reference to symbolic content—had provoked Austria's greatest art scandal ever, it is easy to see that Gerstl's nude self-portrait went well beyond what would have been acceptable in Vienna at that time.

The spectrum of Gerstl's self-portraits ranges from the archetypal qualities of his half nude to the bitter grimace of *Self-Portrait, Laughing*. The physiognomy of the features is so markedly different in each case that at first one is inclined to doubt whether the same young man is being portrayed: the connections only become apparent when all the portraits are viewed together. To the portraits mentioned above should be added Gerstl's *Self-Portrait in Front*

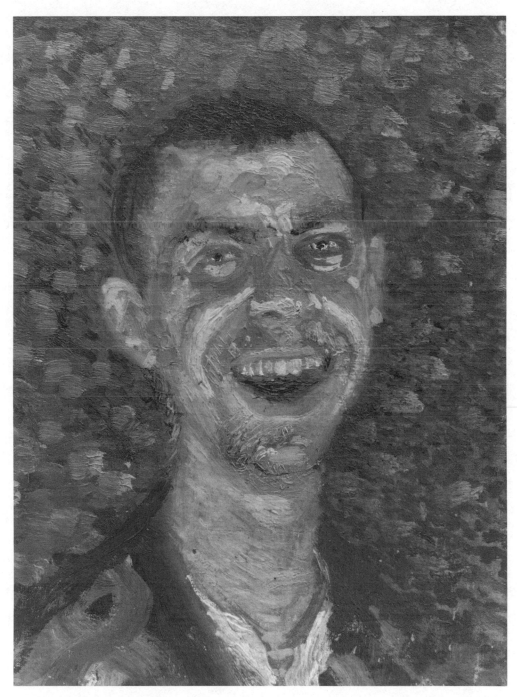

20. Richard Gerstl, *Self-Portrait, Laughing*, 1907–8.

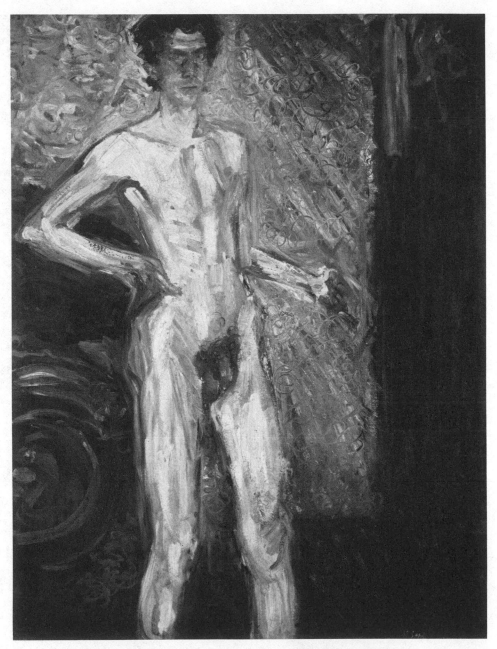

21. Richard Gerstl, *Nude Self-Portrait as a Whole Figure*, 1908.

of a Stove,[38] together with the study for a self-portrait on its rear,[39] the fragment of a self-representation as nude,[40] the so-called *Small Self-Portrait*,[41] and the remains of a self-portrait cut into pieces by the artist.[42]

In addition, there are the only known drawings by Gerstl, which had been preserved by his family rolled up in a bundle that apparently also contained life-size depictions.[43] There are altogether eight drawings that present variations of Gerstl's frontally depicted head. Four of these use a Pointillist technique.[44] They are certainly of much earlier date than four further drawings dated September 15 and 29 (Figure 22).[45] Kallir refers these to 1908, probably based on information from Gerstl's friends, so that these four drawings may be regarded as being among the very last works of the artist, dating to immediately after the *Self-Portrait as Nude* of September 12, 1908. They are ferociously embittered self-depictions that, together with the facts of Gerstl's biography, document his highly developed disdain for the world. Their realism is surprising when one views them in the light of the previous, dematerialized figures. The attention to detail and the bodily presence seen in these sketches, however, is nevertheless fully consistent with the last *Self-Portrait as Nude*. It is noticeable that Gerstl in this picture wears his hair long, while on the sketches of September 15 and 29 he appears with cropped hair. On the rear of the September 15 sketch, however, the considerably faster and more agitated inking of the hair portrays it as even longer than in the painting, creating thus a link between this sketch and the *Self-Portrait as Nude*. In the light of the knowledge supplied by these last drawings, it becomes ever more likely that his *Self-Portrait, Laughing* was the very last painting created by Gerstl. Unrazored, with cropped hair, collarless, and with an open shirt under the jacket, and also set within the same pictorial framework as in the sketch, he presents himself in the same way here as he does in the drawing. If the inference drawn is correct, the *Self-Portrait, Laughing* can be seen as Gerstl's last testament.

▪ Between Pointillism and Autonomous Painting ▪

Gerstl was primarily interested in two genres: portraiture and landscape. In both cases he was more concerned to describe his subjective experience than to supply "objective" representation, stylization, or allegory. The spontaneity of his approach also meant that Gerstl was opposed to making sketches and preparatory drawings: all his pictures were painted in one go. Apparently he used "meter-long brushes in order, even at the inception of the picture, to calculate its effect at a distance."[46] The systematically sustained Pointillism of some of the pictures was thus soon replaced by a freer working with color. In the portrait of Gerstl's father, the light and color application is rigorously systematic,[47] but it is already looser in the Kahlenberg landscape (Figure 23).[48] A few apparently early pictures demonstrate that Gerstl's

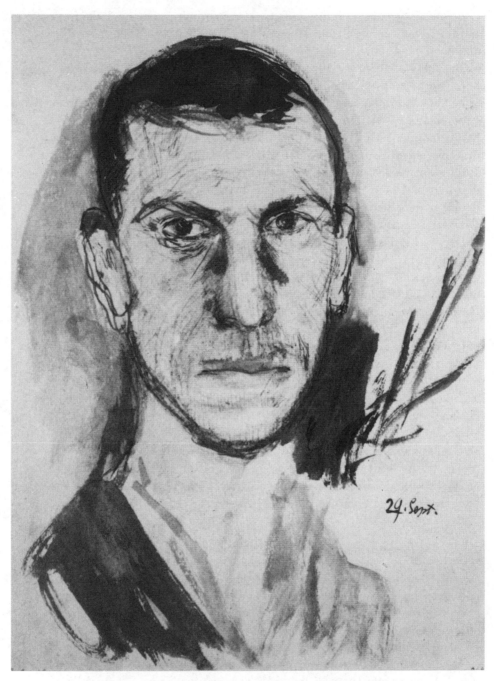

22. Richard Gerstl, *Self-Portrait*, September 29, 1908.

23. Richard Gerstl, *The Cogwheel Railway on the Kahlenberg.*

adoption of Divisionism and Pointillism led at the start to results similar to those produced by the Secession. The portrait of Smaragda Berg, the sister of Alban Berg,[49] reminds one of Carl Moll's portraits with interiors. The fluorescent Pointillism of Leopold Blauensteiner, one of Gerstl's Academy colleagues from Griepenkerl's class, also shows similarities with this phase of his painting.

Gerstl's portrait of Arnold Schönberg[50] (Figure 24) is conceived in a comparatively realistic manner, the Pointillist technique here, as in several other pictures, playing a relatively minor role. The *Tree with Ladder*[51] (Figure 25) or the portrait of his brother as a lieutenant[52] (Figure 26) show the further development of Gerstl's technique from dots and spots of color to energized patches, wavy lines, and spirals. Although the decomposition of color by the Italians and French was taken over and refined by Klimt, for Gerstl it constituted the starting point for the emotionalization of his pictures. The women portrayed by Gerstl are always presented as "middle class" and appear as more realistic by comparison with Klimt's "aristocratic" and always flattering female portraits. The preferred decor of a Gerstl picture is one of abstract color patches that contribute to the force of the representation, while Klimt

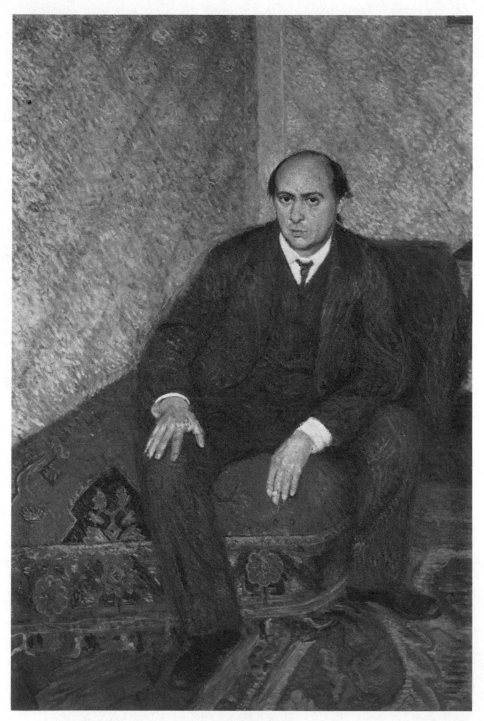

24. Richard Gerstl, *Portrait of Arnold Schönberg*.

25. Richard Gerstl, *Tree with Ladder*.

26. Richard Gerstl, *Portrait of Alois Gerstl.*

27. Edouard Vuillard, *Married Life*, detail, 1900.

liked to envelop his women in a swirl of Byzantine ornament or to show them poised before something exotic, like a Japanese carpet. In landscape painting, too, the approach of the two artists was markedly at odds. In contrast to Klimt's expansive and blooming meadows like sumptuous carpets, Gerstl's landscapes are masses of glimmering light that become progressively less decorative in the course of his development.

In landscape, as in city views, Gerstl's interest was concentrated on a more absolute representation of light than in the portraits. The numerous landscape paintings are mostly on a small scale and often focus on a tree or group of trees that totally fill the picture, and indeed sometimes seem to burst its bounds. However there are also one or two pictures that encompass a whole landscape and permit the intrusion of a horizon. In particular, the painting of deciduous trees, the leaves of which reflect and break up the light, proved to be an appropriate vehicle for the further development of Pointillism in Gerstl's idiosyncratic manner.

In contrast with such pictures, there is a whole string of works in which his painting of light is replaced by a much flatter, color-keyed technique. An example of this is the portrait *Mathilde Schönberg II* (Figure 18), a work that looks particularly "French";[53] the color field of the dress with its flat handling and bright splashes of color especially recalls Vuillard (Figure 27) and

Bonnard. Gerstl's portrait of Ernst Diez[54] (Figure 28) is reminiscent of the male portraits of Munch;[55] the spreading contours of this representation of an elegant gentleman with a penetrating stare give a foretaste of the Traunkirchen pictures of 1907 and 1908. Similar treatment of contours was to be a feature of such works as the portrait of Zemlinsky. (Ernst Diez, a cousin of Anton von Webern, was Assistant Lecturer to the Viennese Professor of Art History, Josef Strzygowski, and was later well known as an expert on the art of East Asia.[56])

The same compelling quality that the Diez portrait or Gerstl's half-nude self-portrait possess is also evident in the double portrait of the sisters Karoline and Pauline Fey, attributed to 1904–5 (Figure 29).[57] It evokes the same atmosphere of threatening ambivalence as the later Schönberg group portrait. Symmetrically presented, almost as mirror images, the two ladies sit in their white dresses against a brownish-black background that provides no spatial orientation for the viewer. The picture has a ghostly quality that is not simply due to the sharp contrast of light and dark. As is often the case in Gerstl's painting, the effect of the two figures is in large measure due to the treatment of the eyes; one can hardly conceive of a more dramatic antagonism than that in the look of the two sisters. The painterly technique is reminiscent of Manet and his color-keyed rendering of the painting's surface. The picture certainly did not fail to make an immediate impression on viewers; as already mentioned, it was this work that convinced Heinrich Lefler to accept Gerstl in his special school.

In several additional portraits, Gerstl departed even further from naturalistic precepts; his brushwork now tended toward the extreme limits of freedom achievable in the context of representational painting. As the overture to a heightening of dramatic tension, the double portrait of an old married couple may be cited.[58] Again, in the portrait of his mother,[59] the plastically modeled head is surrounded by tangles of wild color, while the sitter's hair is rendered with a few broad, mellow brushstrokes. Similarly, Gerstl's *Nude in the Garden* (Figure 30)[60] demonstrates the continuing tendency toward a dissolution of form. (Only two of Gerstl's nude studies have survived: the one just mentioned and a study of a sitting woman.[61] The status of the female nude in Gerstl's oeuvre thus remains unclear.)

If these pictures are comparatively close in technique to the portraits of Ernst Diez or of Mathilde Schönberg II, that of Alexander von Zemlinsky[62] (Figure 31) exhibits an already pronounced stage of dematerialization in Gerstl's work. The nearly life-size portrait of the composer (Mathilde Schönberg's brother) shows him in a light summer suit, with straw hat and walking stick, standing bathed in sunlight on the edge of a lake. The nervous, vibrating quality of the picture, the aura around Zemlinsky, the insubstantiality with which both the human body and nature are rendered, give to the whole a curiously transparent quality—and indeed the waves of the lake show through the figure itself. The subject, the water, and the shore are painted

28. Richard Gerstl, *Portrait of
Ernst Diez.*

29. Richard Gerstl, *Portrait of the Fey Sisters*, 1904–5.

with a few broad brushstrokes, giving the impression of an impulsive and hastily executed work. It is one of the pictures done during the summer holidays with Schönberg and his family on the Traunsee in 1907 and 1908.

Landscapes that share some of the qualities of these pictures include *Tree in a Garden* [63] and the two views of the Traunsee. [64] In the smaller of the two lake views [65] (Figure 32), the same violence of the brushstrokes is to be seen on the mountains at the far side of the water, and the same running together

of thickly applied color;[66] this does not occur again in Austrian painting until the twenties, in the work of Jean Egger. Gerstl's picture of the front garden of the Palais Liechtenstein [67] transforms trees and flower beds into energized fields of light and color that nevertheless retain their tactile qualities. However a picture like that of the Traunsee at Altmünster and its surrounding

30. Richard Gerstl, *Nude in the Garden*.

31. Richard Gerstl, *Portrait of
Alexander von Zemlinsky*,
1907–8.

landscape goes much further, the landscape being virtually an indistinguish-
able phenomenon that simply affords an opportunity for the pure exercise of
the painter's brush. Thus, in this case it inspires the artist to produce a piece
of autonomous painting, from which elements of natural description have
been almost entirely erased; the result borders on abstract art and comes
close to Abstract Expressionism.

Almost equally vehement in its approach, and showing an ever-more-
pronounced dissolution of form, is the Schönberg family portrait[68] (Figure
33), which depicts the composer, his wife, and their two children. Drenched

in bright sunlight, the scene vibrates with the remarkable intensity of the colors. The figures sit in a billowy green meadow, which dissolves upward into a wide band of golden yellow. The thickly encrusted layers of paint, and its grooves apparently hollowed out with the fingers, provide an appropriate medium for the schematically conceived outlines of the human figures and the picture's fiercely elemental language of forms.

Only the group portrait of the Schönberg circle[69] (Figure 34) goes further than this. The six individuals are in this case presented merely as searingly intense clusters of individually applied colors that flow into each other, or as tangles of iridescent, color-keyed, broad brushstrokes. On the left one

32. Richard Gerstl, *View of the Traunsee from Altmünster*, 1907–8.

33. Richard Gerstl, *Family Portrait of the Schönbergs*, 1907–8.

can identify Schönberg next to a young man, and in front of him is apparently his brother-in-law, Zemlinsky. Whether the latter's neighbor is really Alban Berg, whose full head of hair seems to be indicated here, can only be guessed at. Beside him, on the right, is certainly Mathilde Schönberg, and then comes another, unidentifiable person. The same garish golden yellow of the Schönberg family portrait surrounds the figures and also spills over into the dark green of the meadow. The six friends and acquaintances of Gerstl stare blankly at the viewer. The paroxysm-like effects of the thick layers of color created by the slashing movements of the painter's brush betray a mood of extreme agitation. Together with only a few other of his paintings, this work represents the high point of his dematerializing technique.

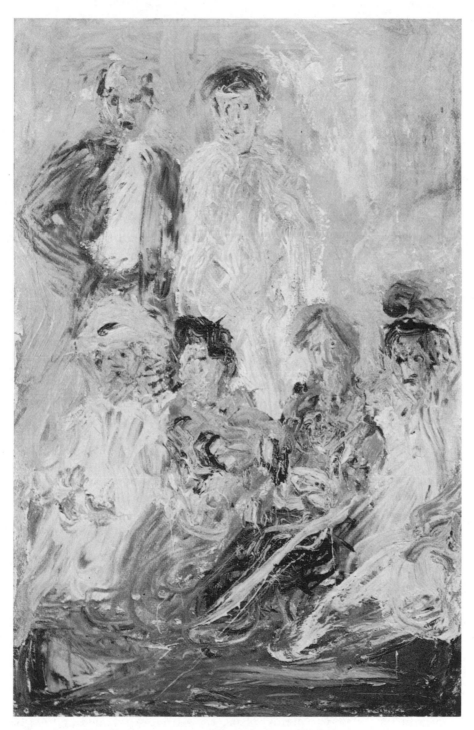

34. Richard Gerstl, *Group Portrait of the Schönbergs*, 1907–8.

■ On the Chronology of Gerstl's Works and ■
Their Critical Reception

The question of which of the visits to Traunkirchen produced the works discussed above, whether it was that of 1907 or of 1908, remains impossible to answer because of the inadequacy of the sources available. The *Portrait of G. P.*, featuring a young man with whom Gerstl shared rooms in Traunkirchen in the summer of 1907,[70] is signed on the reverse and dated "1907." It is considerably more realistic in approach than those pictures, and would thus suggest a date of 1908 for them. In the context of Gerstl's life, they might be interpreted as the expression of his psychological crisis in the summer of 1908. The handwriting of Gerstl's letter of complaint in July of that year shows a tendency toward the dissolution of form that is similar to his Traunkirchen pictures, an impression that is reinforced by the wavy underlinings. All this tends to suggest that Gerstl's *Nude Self-Portrait as Whole Figure* of September 1908 was painted only a few weeks after those works. Here, though, Gerstl endows himself once again with a much more distinct bodily presence. Whether or not the "elemental" Traunkirchen pictures were created in 1907 or 1908, this self-portrait contradicts the frequent assertion that Gerstl's painting exhibited a progressive dissolution of form, and that it parallelled his psychological development, which eventually led to the logical conclusion of suicide.[71] Skepticism with regard to this view is also bolstered by the evidence of the previously mentioned final drawings, which likewise retreat from the earlier dissolution of form.

The chronology of Gerstl's works presents one of the major difficulties in any study of his oeuvre. The earliest possible date for surviving pictures was initially fixed by Kallir, who was still in a position to question Gerstl's contemporaries, as 1904,[72] although he later revised this to 1900.[73] The claim that Gerstl's Pointillist pictures date from 1906 runs counter to the illuminating references to the impact of the Impressionist exhibition of 1903, so that one is inclined to place them three years earlier.[74] However we may be fairly certain that Gerstl from the very beginning of his career took notice of the latest developments in painting. Even if he rejected the Viennese Secession, their international exhibitions still offered him artistic points of reference that the art of Vienna itself lacked.

If one tries to put into a chronology the dates of creation of all his works, the results are meager indeed. Gerstl himself dated only one picture exactly, the *Nude Self-Portrait as Whole Figure* completed on September 12, 1908. The *Portrait of G. P.* is likewise signed and dated 1907. The three drawings bearing the dates September 15 and 29 are, according to Kallir, to be ascribed to 1908. The portrait of the Fey sisters was painted in 1904 or 1905, "as stated by the sitters themselves" according to Wolfgang Born;[75] it cannot, in any case, have been painted later than 1906, since it was in that year that Heinrich Lefler saw it in Viktor Hammer's studio. The portraits

of Zemlinsky, the Schönberg family, and the Schönberg circle were painted in 1907 or 1908, as their Traunsee settings show. The known facts thus do not permit a chronology much more precise than the ascription of the Fey Sisters portrait to 1904 or 1905, and another group of pictures to 1907 and 1908. Equally, the attempt to construct a chronology from the internal evidence of his self-portraits does not bring us much further, especially because only a few photographic portraits exist, and those too are undated.[76] Gerstl's oeuvre therefore evades any precise chronological ordering, and moreover is not susceptible to dating on the basis of stylistic criteria, any such being necessarily speculative.

Many questions concerning Gerstl's life remain open. Some of these (for example the details of the tragic relationship with Mathilde Schönberg) were first addressed in the biography of the composer after his death.[77] All one can say with certainty is that Gerstl's oeuvre was completed before November 1908, at a time when Kokoschka's work was just beginning to make the breakthrough to Expressionism, and while Schiele was still immured in the forms of Jugendstil.

Gerstl's work was not shown in the years that followed and therefore had no influence on the development of other Austrian painters. When the Neue Galerie exhibited the completely unknown artist in 1931 the astonishment and reverberations provoked by his work were extraordinary. The show was subsequently repeated at the Caspari Galerie in Munich, the Gurlitt Gallery in Berlin, at the Artists' Association in Cologne, and in the city of Aachen's Suermondt Museum. In 1933 it was again to be seen in the Galerie Welz in Salzburg. However before Gerstl's name could be established internationally his work fell victim to the Nazi campaign against so-called "degenerate art." After 1945 his recognition was still slow in coming. Comprehensive exhibitions of his work were shown only in 1957 in the Galerie Würthle[78] in Vienna, and in 1966 in the Viennese Secession building and the Kunstpavillon of Tyrol in Innsbruck;[79] it was not until 1983 that a survey of his work was organized in the Historical Museum of the City of Vienna.[80] There is still no monograph on him. The evaluation of his oeuvre has lagged behind his notoriety because of the small number of works that have survived, the paucity of his representation in public collections, the lack of scholarly literature about him, and the infrequency with which his works are shown at international exhibitions.[81]

When Gerstl's works were exhibited in the Austrian pavilion of the Venice Biennale in 1956, they were looked at through the lenses of Tachism and Informal Painting. The editor of the journal *Kunstwerk*, in introducing a discussion of the show, commented as follows: "We see in Gerstl, as also in Soutine and Corinth . . . a principle of forms at work that today has become topical through Tachism."[82] This was primarily a reference to Gerstl's dematerializing pictures. His importance as a precursor of Abstract Expressionism can hardly be rated too highly; his significance, however, also lies

in his emotionalized light painting, developed from Impressionism, which is to be found equally in his landscapes and in his portraits.

Gerstl is the only Viennese painter of the fin de siècle who can be described as a Fauve; in this respect he anticipated a number of the so-called picturesque Expressionists[83] in Austria, although none of these, with the possible exception of Jean Egger, can be compared to him in terms of passionate commitment and painterly qualities. Gerstl is to be evaluated not so much in the context of the collapsing Dual Monarchy and its attendant cultural manifestations—as are both the early Kokoschka and Schiele—but more in that of European Impressionism and the emphatically expressive painting that developed from it. In the few years of his creative career he staked out an increasingly clear position opposed to the activity of Klimt and the Secession. Against their decorative ideal of the enhancement of life through aestheticism he set an artistic vision that subordinated the sensuality experienced through the eye to the direct experience of the human psyche.

OSKAR KOKOSCHKA

▪ Dreams and Exoticism ▪

In contrast to Gerstl, Schiele, or Kubin, Kokoschka's early artistic training was not at an academy but in a school of applied art (Figure 35). No doubt the profession of his father, a goldsmith who had moved to Vienna from Prague, played a role in this; his mother came from an Austrian peasant family. Kokoschka thus grew up in modest lower middle-class circumstances and was taken in 1904 as an eighteen-year-old to the Viennese School of Applied Art, at the time one of the most progressive centers of artistic education in Europe. Under the direction of Felician von Myrbach, Josef Hoffmann, Kolo Moser, Alfred Roller, and a number of other artists worked as instructors; so did Franz Cizek, who developed pathfinding courses of art instruction that sought to stimulate spontaneous creativity among young people. Kokoschka's preparation as a teacher of drawing for the secondary schools led him in his third year, after the general course, to Karl Otto Czeschka and his "Technical School for Painting," which, however, concentrated chiefly on graphics. After Czeschka was appointed to the School of Applied Art in Hamburg, Bertold Löffler took over his class.

Even during the period of his studies, Kokoschka undertook a series of works for the Wiener Werkstätte, which was employing not only several of his fellow students but a number of professors of the School of Applied Art as well. Initially he produced idyllic landscape scenes, narrative cameos for postcards, and flower paintings, works that still bespeak an unquestioning

35. Oskar Kokoschka,
photographic portrait, 1909.

and dutiful adherence to the decorative style; but there were also realistic portraits in a color-keyed manner that owed very little to Impressionism.

Some of the lithographs of the Wiener Werkstätte, produced from originals by Kokoschka after 1907, are already a good deal more stylized; there are now elements of the grotesque present, and his fairy-tale-like depictions exhibit ever more stark effects of contrast. A calendar for hunters and an illustration for the souvenir program of the opening of the Cabaret Fledermaus may be counted among the latter type of production. Nature and the animal world are recurring motifs from the very beginning. They also provided the background for a "fairy tale in color slides" entitled *The Speckled Egg*, the figurines for which have partly been preserved.

With these student works Kokoschka introduced a note of sharpness into the refined and increasingly whimsical production of the Wiener Werkstätte. His book *The Dreaming Youths* (1908), an early work commissioned by the Werkstätte, already shows him to be a considerably developed, individual artistic personality (Figure 36). In the angular contours of its figures, in their hand gestures, in the self-absorbed postures of the gaunt protagonists, and in the representation of an all-pervasive wild and rampant nature, *The Dreaming Youths* represents a clear departure from the decorative ornamentation of Jugendstil. In this book a fantastic language of images dominates, one that draws the viewer, as much as the reader, into its richly symbolic dreamworld. Poetry and pictorial image complement each other, neither medium giving up its specific character and value. The concluding four lines well express the state of mind in which Kokoschka composed the text:

and I became delirious
when I began to know my flesh
and a lover of all things
when I spoke with a girl.[1]

The poem arose out of a series of interwoven dreamlike pictures in which the confusion and excitement of first erotic feelings and experiences are expressed as Kokoschka knew them during his brief relationship with a girl named Li.

I . . . felt the gestures of your young body's angular movement
and understood the shadowy words of your flesh

36. Oskar Kokoschka, *The Far Island*, proof for the lithograph in *The Dreaming Youths*, 1908.

and of your limbs hung with glass beads
and I fled from you into the gardens
climbing up step after step
until I reached the one thousandth and the last of my dread.

Images of tenderness and "soundless tranquility" are rudely interrupted by images of destruction and violent action.

—I am the circling werewolf—
. . . before you awake my howls echo all around
I consume you
men
women
half-awake listening children
the frenzied, loving werewolf in you.

Kokoschka's lithographs for *The Dreaming Youths* function in a relationship of free expression to the text. The eight lithographs were printed respectively in five or six bright colors. Their iconography consists of a series of constantly repeated elements: water, land (mostly as sea and mountainous islands), ships, fish (always red), reindeer, stags, deer, birds, and luxuriant and exotic vegetation, the stylization of which recalls medieval book illustration; the human beings appear naked or in long monochrome robes. An inner harmony between man, beast, and nature is thus suggested, something that resembles a return to the Garden of Eden. The final page, which shows the boy and the girl Li, may be seen as a paraphrase of Adam and Eve in Paradise.

It is possible that Rudolf Kalvach, Kokoschka's neighbor in the painting class, had a certain amount of influence on *The Dreaming Youths*. Their teacher, Czeschka, later recalled that when Kokoschka entered his class "he immediately began to produce things similar to Kalvach's."[2] Indeed, the latter's *Indian Fairy Tale* is in many respects similar to *The Dreaming Youths*, for example in the luxuriousness of the flora and fauna, in the sometimes clearly differentiated color fields in which the figures of the youths and girls appear, in their gestures, and in the brightly colored, flat handling of the subject matter (Figure 37). The caricaturing tendency of some of Kalvach's work also finds an echo in that of Kokoschka; nevertheless, all considerations of possible influence by Kalvach have to remain speculative as long as we are unable to date his work more precisely.[3]

Until now the remarkable parallels between *The Dreaming Youths* and the book illustrations of George Minne have been ignored. These are seen to be most marked when one considers Minne's illustrations to Maurice Maeterlinck's *La princesse Maleine*, which was published in Ghent in 1889 (Figure 38). The piece is Maeterlinck's first work for the stage, a mystical, symbolic play that incorporates in its various elements the fairy tale from the Brothers Grimm about the virgin Maleen. Similar impulses and formal

37. Rudolf Kalvach, *Indian Fairy Tale*.

affinities between the graphics of Kokoschka and Minne may be noted in the treatment of landscape, the depiction of the sea and the mountains, the stylization of persons and nature, and in the emphasis on gesture. *La princesse Maleine* appeared in a very small edition, but it is nonetheless possible that it was also known to Kokoschka through the promotion of Minne by the Secession and the Wiener Werkstätte.

Kokoschka's dream-abstracted, tranquil, or gesture-frozen forms in *The Dreaming Youths*, and his wakeful figures engaged in animated speech or dramatically gesticulating, are characteristic. They may be compared with a number of his other graphics and drawings that were made on or around the turn of the year 1907–8. In March 1908 the fortnightly Viennese journal *Erdgeist* reproduced two of Kokoschka's Indian ink drawings with biblical themes, *The Flood* and *The Narrow Path*.[4] In *The Flood* the people flee like

38. George Minne, illustration for *La princesse Maleine*, 1890.

animals from the gathering waters, and from the sharks, onto a mountainous island; *The Narrow Path*, which, according to the Sermon on the Mount leads to the narrow gate, shows men and women plodding through a dense wood, accompanied by animals; one man has gone astray and is harried by a shark appearing from the sea and by a snake, while thorns bar his way. The partly closed eyelids of the protagonists, their language of gesture, the integration of landscape and the animal world, make the drawings appear a continuation of the *Dreaming Youths* series.

The hitherto earliest verifiable graphic by Kokoschka, an *Ex Libris* for his former teacher at the Realschule, Lorenz (Leon) Kellner, also revolves around a quotation from the Bible: "And the word became flesh." In this woodcut many elements appear that recur later, among them water, fishes, birds, and luxuriant vegetation, while the long-robed angels with flowing locks are the forerunners of the gaunt girl figures, here still depicted in the Jugendstil manner. Other biblical motifs appear in some of his postcards for the Wiener Werkstätte and in other book plates.[5] Many of Kokoschka's early depictions of a mother and child recall Mary and the child Jesus (Figure 39). Another drawing reminds one of Noah, with its representation of a bearded man sitting in a boat and surrounded by pairs of animals. Star, sun, and moon bind together the details in a cosmic relationship, something that was soon to become the hallmark of many of Kokoschka's works. A similar drawing unmistakably draws its inspiration from the creation myth, where several suns and stars and a radiant half moon appear above a primeval wilderness in which the waters and the land are not yet divided, and where primitive beings innocently frolic in idyllic harmony with each other and their surroundings.

Kokoschka's work at this time was indeed imprinted with the fairy-tale quality derived from Jugendstil; yet it often eschewed the aestheticizing refinement of the Secession in favor of a more archaic language of forms. It thus became the vehicle for more archetypal moods and continually drew strength from an exuberant joy in adventure narrative with exotic elements. Especially the depiction of nature and landscape exploits exotic effects. Certainly, inspiration from Oriental and Byzantine art, which the Secessionists had in a

39. Oskar Kokoschka, *Woman and Child on a Hind*, 1908.

40. Oskar Kokoschka, title vignette from *The Dreaming Youths*, 1908.

different way absorbed and frequently exploited,[6] also played a role in Kokoschka's art. The title vignette for *The Dreaming Youths* (Figure 40), with its highly stylized mountains of two and three peaks and its bush that resembles a seven-armed candelabra, together with other idiosyncratic vegetable forms, drawn like waves around the naked boys with upraised hands, clearly makes reference to Oriental motifs. At the same time, we are here also close to the world of early medieval illuminated European manuscripts.

One of the most striking works of this type by Kokoschka is his large poster sketch for the Imperial Jubilee of 1908 (Figure 41). The poster holds fast to the strong colors of *The Dreaming Youths* and shows a woman and child with palm fronds, two bushes, again like candelabra, and a bird that recalls the symbol of the Holy Ghost hovering in the sky. The hair and beard of the large figure in the foreground is given the styling of the ancient Assyrian kings. The gestures recall those of archaic scenes of worship and emphasize the markedly sacral character of the sketch. That his concept was quite unthinkable for a ceremonial imperial procession at the turn of the century may be seen if one studies the form the procession actually took.

Art from beyond the bounds of Europe, the importance of which was only recognized by Europeans themselves at the turn of the century, and those epochs of western art that did not stand in the tradition of classical antiquity or of the Renaissance, opened up new horizons to which Kokoschka's work, during the period of his artistic studies, was more closely oriented than that of his student contemporaries. It is possible also that the big Gauguin exhibition that took place in the Galerie Miethke in March and April of 1907 had a correspondingly significant influence on him.[7] At this show were exhibited 6 wood sculptures, 4 ceramics, 21 pastels, some drawings, lithographs, and woodcuts, as well as a total of 41 oil paintings, most of them having been produced on St. Dominique, Martinique, and Tahiti. Kokoschka may have

41. Oskar Kokoschka, *Jubilee Procession*, 1907–8.

42. Paul Gauguin, title page of
Noa-Noa, 1897.

been less intrigued by Gauguin's style and his painterly technique than by
the subject matter, and especially by the magical charm of the South Sea
Islands. Gauguin had already published his autobiographical narrative *Noa-
Noa* in 1897, which was illustrated by a series of pictures of his exotic island
life (Figure 42). When Kokoschka first came into the public eye, "Gau-
guin" was one of the catchwords of contemporary criticism: "Gauguin and
van Gogh seem to have gone to his head. It is truly frightful," remarked the
reviewer for the *Illustrierten Wiener Extrablatt*.[8] For Richard Muther, Koko-
schka's work aroused associations of "primitive Indian art, an ethnographic
museum, Gauguin gone mad."[9]

If one is looking for the evocation of an exotic world of nature, a world of
strange plants, and animals, the verbal images of *The Dreaming Youths* cer-
tainly provide a case in point. At the same time, in such works, Kokoschka's
intellectual affinity with monism at this period is plain to see. In successive
stages, the descriptions of natural moods take over the story, and flora and
fauna become the chief protagonists of the narrative:

> Waves break over the woods
> and go on through the rootless
> red-blooming
> and innumerable airy branches
> that plunge to the depths like hair saturated in sea water
> and from there the green billows spread forth
> and the appalling sea of the undepths and
> man-eating fishes
> seize hold of the overcrowded galley.

An animated nature communes with the dreaming narrator:

> I wait beside a stony Peruvian tree
> its many-fingered leafy branches reach out like anxious arms
> and the fingers of thin
> yellow figures
> which, in the star-blazoned undergrowth,
> move imperceptibly like the blind.

We are presented with "breathing sea forests," and with "snowed-in woods" that stand rigidly like "astonished boys," with snowcapped mountains that "harbor within themselves fairy tales as old as they are"; something speaks to the narrator "as if the speech came from heavily scented flowers." Bodily sensations can resemble those of a plant: "my body is like a tree, like a moist tongue." Man and nature encounter each other as sentient beings: "the green tree loves you . . . the sea grass on which you lie loves you."

The animals accompany the dreaming one as friends, also as adversaries: the fishes and the speaking birds, the otters, the gnats, and the snakes. At the meeting with the girl, the reindeer and the "little red fish" are present—"the hoof of a reindeer resounds and throws up in all the white woods / twinkling snow-stars." At the very beginning of *The Dreaming Youths* the image of the "little red fish" appears, whose "mute circle of life" will be terminated by the thrice-cutting knife. "All around me is an alien world," the poem ends, "and I was a creeping thing / as I sought out the creatures of the earth and clove to them."

In early letters, too, Kokoschka's wanderlust is evident, a feeling for the exotic and faraway lands that is at least in part to be explained by his difficulties with the Vienna of the here and now. "Dear God, I would so like to be happy; and with 100 negroes, with great works, with drums and trumpets to set off into the great unknown." [10] A letter to his school friend Erwin Lang in the winter of 1907–8 describes his mood as he worked on *The Dreaming Youths*: "I can't bear it much longer here . . . everything is so dead, as if one had never heard the cry of anguish . . . how easy it is for me to envy Isepp, who made it to the realm of radiance. Now I cannot free myself from a kind of narrow, stubborn suspense, I am often so dismal that I shout into the rumpled bedspread, simply in order to do something that seems real. 178–186 centimeters above the floor a hat goes walking and 15 centimeters below it are clothes, and these make folds as of living things, but the truth is all folds stem from the same monotonous law of the theater, and I shall buy myself a false red beard to place between the hat and clothes in order to destroy this pathetic theater of folds . . . and (Lilith) demands that one always should feel like a hero before spectators." [11] Erwin Lang was the brother of the girl named Li featured in *The Dreaming Youths*, Lilith Lang, who had just entered the School of Applied Art. A little later Kokoschka was to ask him: "Can you come with me on a three-year journey to Java, Persia, and Norway?" [12]

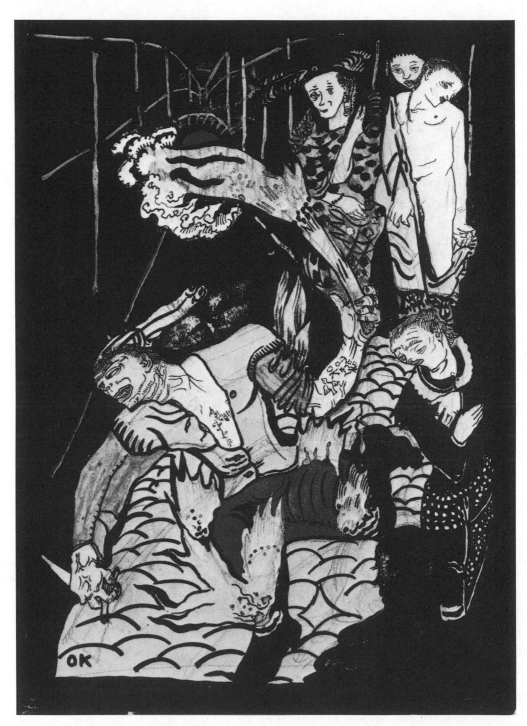

43. Oskar Kokoschka, *Running Amok*, 1909.

The high period of Kokoschka's early exoticism included the fans he did for the Wiener Werkstätte in 1908–9 which showed vegetation, animals, and children in scenes of paradisial harmony, in which "man" and "woman" discover each other. There was also a group of drawings and watercolors that were probably connected with his lost poem "The White Animal-Killer."[13] These drawings are apparently identical with the "Indian book illustrations" mentioned in 1909 by Erhard Buschbeck, later the president of the Academic Association for Literature and Music, and also with preliminary studies for a "Robinson Crusoe book" that Kokoschka's teacher Bertold Löffler wrote about; when the works were exhibited at the Kunstschau of 1909, the scientist and writer on art, Ludwig Erik Tesar, reported in his review of the exhibition on Kokoschka's "Robinsonade."[14] The drawings that could be subsumed under this thematic heading are more heterogeneous stylistically than the lithographs of *The Dreaming Youths*. The earlier works show Robinson / the Animal-Killer in a dreamlike attitude, self-absorbed, alone on his island, or forging across a river in his boat into the depths of a tropical primeval forest. Another group of studies abandons the harmony of such works, with their unifying stylization, in favor of a much coarser characterization; instead of the dreamworld we are presented with a barren, sometimes grotesquely caricatured dramatic scene—as for instance in the picture *Running Amok* (Figure 43). The strokes of the pen are harsher and less even, the graphic modeling of the figures within their contours begins to show the network of peripheral nerves that was to become characteristic of the drawings for *Der Sturm*. The color spectrum is now more modest than in the earlier works and the light intensity of the colors reduced. Vegetation and the animal world are pushed into the background; the treatment becomes more violent. The break with the style of the Robinson / Animal-Killer illustrations introduces a new phase in Kokoschka's work, which coincides with the end of his period of study at the School of Applied Art.

■ Figurative Studies and Portraits ■

The nude and figurative studies of Kokoschka's that have survived from his student days exhibit from the very beginning a tendency to emphasize contours, those of 1906, for instance, having very delicately etched outlines, the fields they enclose being covered with a light wash (Figure 44). From 1907 onward follows a series of more angular and more strongly abstract drawings that demonstrate an intense interest in gesture (Figure 45). They mark the transition to the more obviously stylized drawings that are characterized by a freer representation of the subject, and that are also more heavily washed. The attitudes of the arms and especially the hands are here the most characteristic aspects of these works, the latter being depicted with widely spread or bent fingers. Some drawings show gaunt, pubescent girls with folded

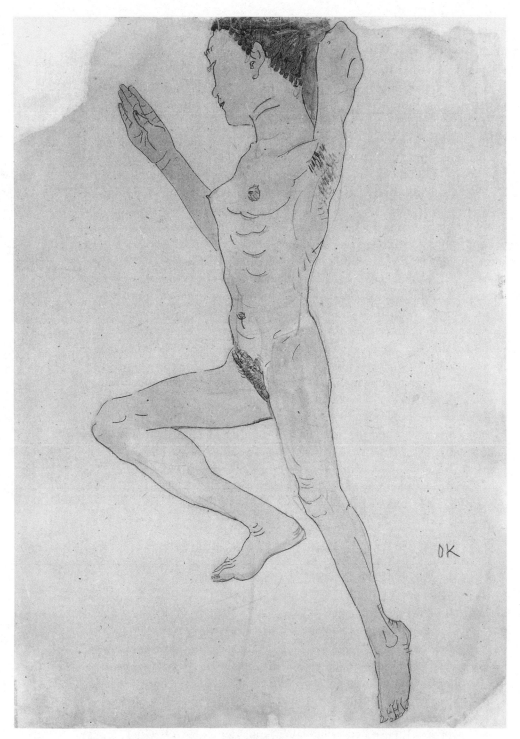

44. Oskar Kokoschka, *Nude Girl*, 1906–7.

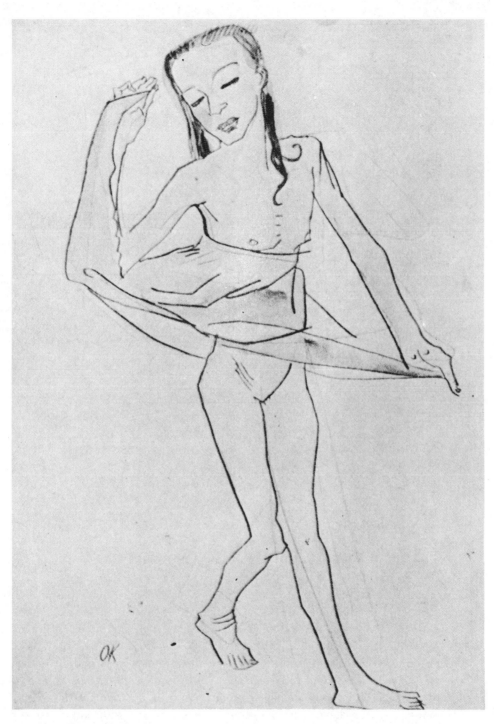

45. Oskar Kokoschka, *Standing Nude Girl with Shawl*, 1907.

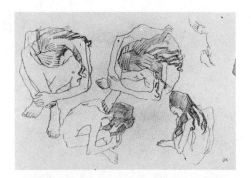

46. Oskar Kokoschka, *Squatting Girls*, 1907–8.

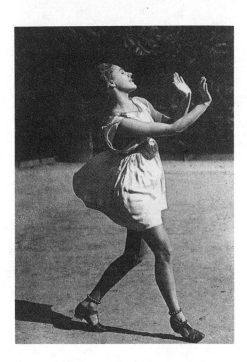

47. Grete Wiesenthal dances to music by Beethoven, 1908–9.

arms, clearly the immediate forerunners of those in the lithographs of *The Dreaming Youths* (Figure 46).

Bodily gesture, which came to have a new and fundamental importance in Symbolist and Jugendstil works, is a vital form of expression in Kokoschka's early work. Inspiration was evidently received from the art of Ferdinand Hodler, with its eurythmic language of figures. George Minne, who was so prominently represented in the Secession exhibitions, also had an impact on Kokoschka, with his passive, sculptured youths with self-absorbed gestures. Kokoschka's consciousness would also have been heightened by the expressive free dance that had already been received with enthusiasm by the Secessionists.[15] From 1907–8 Kokoschka may be counted among the admirers of Grete Wiesenthal, who gave a stunning performance of the new dance in the Cabaret Fledermaus in 1908. At the end of 1907 he wrote

ironically to Erwin Lang, Grete Wiesenthal's friend and later husband: "I am virtually never in company with Lilith Lang and Wiesenthal because I lack a dinner jacket and have no manners." [16] In February or March of 1908 Kokoschka remarked to Lang:

> Wiesenthal has five or six moments in each dance that I look forward to, almost with my whole body; I think she should refrain from conscious presentation of the theme of the dance—lest it become like Strauss's program music— and concentrate on dance figures like those in the "White Beethoven," this vague slinking about that reminds me of the movements of a dumb animal, or the unfolding of the limbs in the "Danube Waltz"; the trembling of the fingers or quivering of the thighs when she stops to listen; or, in the Beethoven figure, the terrifying displeasure expressed by means of the bending body, the gentling of a sound with a lowering of the hands and so on. These moments fill me with a dark warmth that stems from the hypersensitivity of my reactions. I have always been able to orient my innermost feelings only by such things, phenomena that could not themselves respond to me, but that allowed me to find my own equilibrium again. [17]

A little later the magazine *Erdgeist* published photographs of Wiesenthal's "White Beethoven" performance, which she danced in a white antique-style robe to the Allegretto of Beethoven's F-Major Sonata op. 6, and also of "the unfolding of the limbs" in the "Danube Waltz" (Figures 47 and 48). [18] The editor, Gustav Eugen Diehl, who had already devoted a rhapsodic article

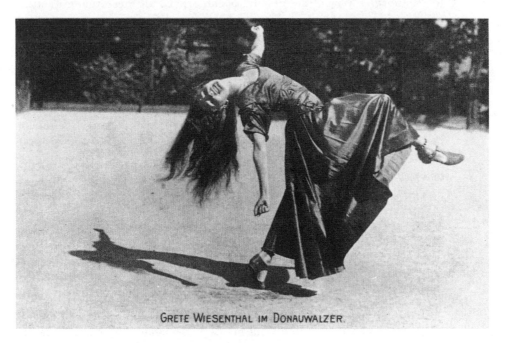

GRETE WIESENTHAL IM DONAUWALZER.

48. Grete Wiesenthal dances "The Danube Waltz."

to the art of the Wiesenthal sisters, which he described as a new religion,[19] once again praised their dancing as miraculous. The "dance figures" that had made such an impact on Kokoschka were also to be reflected in his art.

Kokoschka's poster for the Kunstschau in the summer of 1908 retains the language of figures to be found in his "fairy tale book." Gustav Klimt, to whom *The Dreaming Youths* was "dedicated with respect," had promoted Kokoschka's participation in this "Review of the achievements of Austrian art."[20] Thus it was now possible to see the book on display at the Kunstschau, together with a series of "studies" and Gobelin designs subsumed under the title of *The Bearers of Dreams*.[21] The oft-described "cabinet of horrors," as Ludwig Hevesi labeled the exhibition area devoted to Kokoschka,[22] produced reactions of outrage from the majority of critics, or at best of incomprehension, which was all the more marked in the context of the generally euphoric reception given to the Kunstschau.

When Kokoschka again designed a poster for the Kunstschau the following year, and again took part in the exhibition, the break with the art of the Secession was evident. In the intervening period the previously mentioned Robinson / Animal-Killer drawings had been completed, in which the parting of the ways with Jugendstil was already indicated. Together with Max Oppenheimer, who also had already participated in 1908, Kokoschka, Egon Schiele, and Paris von Gütersloh were among the youngest Austrian artists exhibited at the show; in contrast to that of the previous year, it offered an international survey of the new European art. Of all these young Austrian artists only Kokoschka had already left Klimt and the Secession behind him. Apart from the Robinson / Animal-Killer illustrations and studies, two further works were exhibited that mark the beginning of a new type of subject matter for Kokoschka; this was portraiture, which was soon to become central to his art. A likeness of the actor Ernst Reinhold was shown (Figure 49), together with a painted clay bust, a self-portrait whose distorted, wildly agitated features must have seemed like a depraved deformation of the human face (Figure 50). The sculpture, which "was protected by a glass tube," aroused in Arnold Clementschitsch "a kind of dread . . . like something out of a nightmare."[23]

The two portraits by Kokoschka at the Kunstschau ushered in a phase of portraiture in drawing and painting that proved to be one of the most powerful in modern Austrian art. In quick succession he did a series of portraits of members of the artistic, literary, and intellectual circles of Vienna and of the Viennese middle class, not infrequently dismaying his subjects with the results, so that many of them refused point-blank to accept the finished pictures. Several of the commissions were arranged by Adolf Loos, who supported him wholeheartedly from the Kunstschau of 1909 onward and hoped by these means to free him from his partial financial dependence on the Wiener Werkstätte.

The new approach reflected Kokoschka's intention "to make a 'nerve-mad'

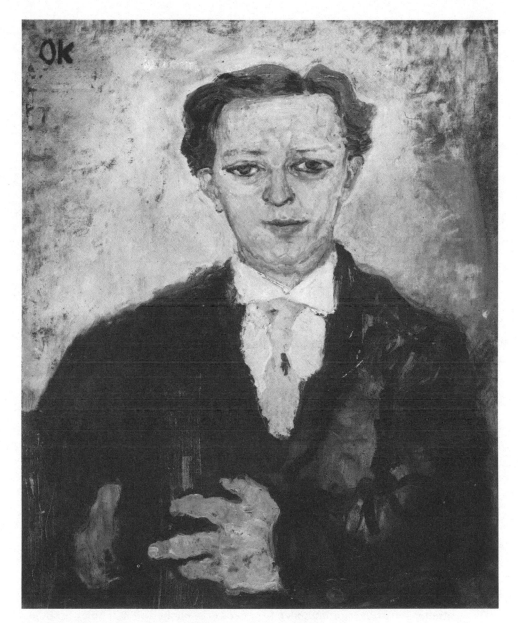

49. Oskar Kokoschka, *Portrait of Ernst Reinhold*, 1908–9.

[*nervenirrsinniges*] portrait," about which he had already written in April 1909.[24] Such works are marked by a brittleness of color and forms, which is close to Post-Impressionism, but which, in Kokoschka's hands, nevertheless becomes unique. The nerves really do appear at the surface of the skin and make of both face and hands a mirror of the spiritual and intellectual essence of the sitter's character. The heads possess the same agitated and broken-up surface structure as his clay bust self-portrait. The exterior skin of the model

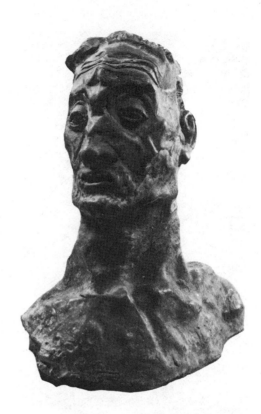

50. Oskar Kokoschka,
Self-Portrait, Bust, 1909.

seems to have been lifted off, affording a view of the network of veins, and
the whole physiognomy becomes a window on the process at work within the
psyche. The very thin layer of color helps to produce this effect, as does also
its brittle modeling and uneven ductus; and it is intensified by a peculiarity
of Kokoschka's, the scratched graphical structures, the contours of which
enhance the impression of fragility and vulnerability. The painterly character
shows a tendency to brownish and blue-green, often in pastose tones. Sev-
eral pictures allow the texture of the canvas to show through, or only partially
paint the canvas in. In pictures with very thin layers of color the aspects
to which Kokoschka attached most importance, such as the head and the
hands, are more thickly painted, and are then, typically around the eyes,
often given greater prominence by means of scratched-in hatching. Strange,
seemingly organic star forms or landscape elements are likewise sometimes
scratched in, as well as shafts of light that partly permeate the bodies. The
painterly elements of these early pictures may seem to produce an organic
whole, yet it is often one that seems in effect to corrode its own integrity.

The sensitiveness of this way of painting benefited in many cases from
a correspondingly sensitive subject. Kokoschka thus liked to paint not only
highly intellectual contemporaries, like Auguste Forel, Karl Kraus, or the
Tietzes, but also people who were marked by decadent living or illness, as in
the portraits of the Marquis of Montesquieu or Count Verona. In this phase

of his portrait painting the plasiticity of the subject matter is always reduced, thus opening up to view the soul and mind. Most of those portrayed were represented as being considerably older than in fact they were, and also as bearing a multitude of wounds that—at least externally—they did not actually possess. The *Child with the Hands of the Parents* (Figure 51) already exhibits the grave features of a mature person, and his wrinkled hands resemble those of an old man—when the picture was painted the baby was in reality barely six months old. The painting also underlines the independent power of expression with which Kokoschka liked to endow the hands. Out of the red glow that surrounds the child appear a male and a female hand, like isolated votive offerings, the representative images of the parents.

Seldom is the background of such portraits characterized; the figures are mostly set in a color-keyed, undefined spatial dimension, which precludes any relationship with the sitter's environment and thus cuts them off from space and time.

In Kokoschka's depictions there seems to be a prophetic insight at work that reveals to him hidden areas of a personality or of an individual's destiny. The most famous example is that of the portrait of Forel, which was refused by the family on the ground that it was not like enough, that it made him far too old, and showed him making a vacuous senile gesture (Figure 52). Two years later, after being partially incapacitated by a stroke, Forel took on exactly the aspect, with the same attitude of the hands, that the picture had shown. Even the circumstances in which the portrait was painted were ominous: after Kokoschka had observed the scientist for a while, he had to paint him, when the subject turned his back on him, "from memory and from my impression of him."[25]

Albert Ehrenstein called Kokoschka a "man who slits open souls; simply by painting the hands and the head he lays before us in an eerie way the spiritual profile of the subject. This cruel sort of phsychotomy is strongly reminiscent of vivisection."[26] Beneath a drawing of himself by Kokoschka, Adolf Loos wrote: "This picture is a better likeness than I am myself!"[27] Karl Kraus (Figure 53) experienced a similar sensation on contemplating his portrait by Kokoschka; he expressed this feeling in an aphorism that he published in *Die Fackel*, "*pro domo et mundo*": "Kokoschka has made a portrait of me. It is possible that those who know me will not recognize me. But certainly those who don't know me, will."[28]

A number of Kokoschka's portraits exude an aura of putrefaction. These culminate in a picture in another genre, the *Still Life with Lamb and Hyacinth*, which also dates from 1909 (Figure 54). The combination of the animal corpse with living creatures, the tortoise, the ghostly amphibian, and the bizarre mouse, juxtaposed to the classical elements of the still life, a jug, fruit, plants, and in addition the nature of the color schemes, with heavy, dully broken hues, turn it into a quintessential representation of morbidity, one that stands at the end of a long European tradition of the genre. Together

51. Oskar Kokoschka, *Child with the Hands of the Parents*, 1909.

52. Oskar Kokoschka, *Portrait of Auguste Forel*, 1910.

53. Oskar Kokoschka, *Portrait of Karl Kraus*, 1910.

54. Oskar Kokoschka, *Still Life with Lamb and Hyacinth*, 1909.

with only a few other works, this picture stands apart from the portrait paint-
ing that dominated this phase of Kokoschka's art. It seems to develop further
a similar feeling for morbidity that occurred in the painting of Anton Romako
almost forty years earlier (Figure 55).

Individual landscapes, for example *Dent du Midi* (Figure 56), once again
demonstrate Kokoschka's attitude to space and subject matter: here also,
in the graduated spaces of mountain scenery no real delineation of bound-
aries is visible. Vegetation, mountains, and atmosphere are all subtly mixed,
all different aspects of one continuum. The light—as in many of the por-
traits—instead of falling on the surface of the subjects, seems to emanate
from within them.

A comparison of the *Lamb* still life with the portrait of *Father Hirsch*
(Figure 57) demonstrates their close artistic relationship and suggests that
the long-accepted dating of the latter to 1907 should be corrected to 1909—
in common with other pictures dated to before 1909 that would appear to
belong to this group of works.[29] The caesura of this year is too marked for
one to be able to cling to the uncritically received and oft-repeated notion
of a contemporaneous appearance of *Stilkunst* (Jugendstil) and an art of ex-
treme expression in Kokoschka's earliest work. The caesura is equally clear

55. Anton Romako, *Italian Fishing Girl*, 1870–72.

56. Oskar Kokoschka, *Dent du Midi*, 1910.

if one compares the poetry and lithography of *The Dreaming Youths*, or the commissions from the Wiener Werkstätte of 1907–8 with the poster for the Kunstschau, the *Murderer* drama, or the portraits executed in 1909. That several misdatings, particularly of his early work, are attributable to Kokoschka himself is well known;[30] they have, however, all too often been lent a spurious authority by his biographers. The distorted picture that was thus handed down, especially with regard to Kokoschka's early work,[31] should be corrected in the light of his participation in the Kunstschau, and the antithetical nature of his two appearances.

Kokoschka accepts the direct inspiration of natural features much more emphatically than, for example, the German Expressionists, in whose painting it is often treated much more freely. In his portraits, also, the treatment is far less abstract than in comparable German portrait painting. In nude and figure studies the earlier stylization now recedes into the background. The contour is still important, but it is now relativized through the treatment of the internal fields and the use of wash. Gestures and bodily attitudes are more freely presented and subordinated to the exigencies of immediate expression. The poster departs from its original two-dimensionalism, its figures acquiring volume and plasticity. The angular contours of the Kunstschau poster of 1909 (Figure 58) have their antecedents in the earlier stylization of Kokoschka's figures, yet have abandoned much of their attractive delicacy in favor of forceful expression of the scene.

57. Oskar Kokoschka, *Portrait of an Old Man—Father Hirsch*, 1909.

The appellation "Pietà" for this poster is misleading, since it is not the healing and merciful power of love that it primarily expresses, but rather the struggle of the sexes carried to extremes, as Kokoschka perceived it at that time. The features of the woman consumed with terror, and the pinched and flayed body of the man, are appropriate to his drama *Murderer, Hope of Women*, which was announced by this lithograph and premiered at the summer theater of the Kunstschau. The polarity of the sexes, which is here related to the polarity of the sun and moon, became a leitmotif of a series of

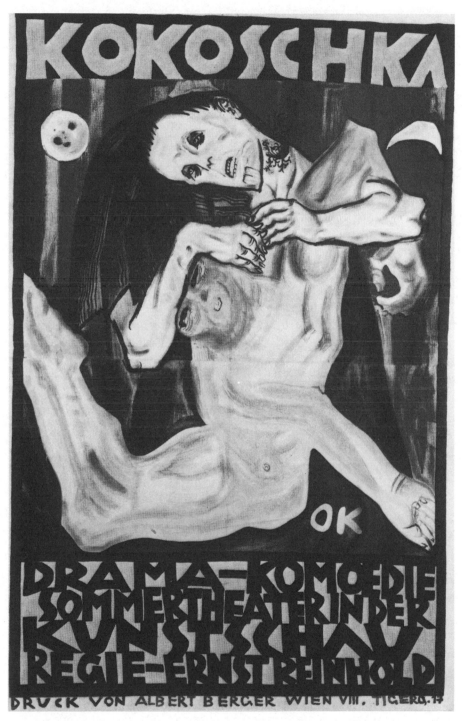

58. Oskar Kokoschka, poster for the Summer Theater of the Kunstschau, 1909.

early works for the stage by Kokoschka. From all this the question naturally arises: In what way does this literary sphere of his artistic activity relate to his painting and drawing?

■ First Dramatic Works ■

The sometimes quite arbitrary dating of Kokoschka's early works has its counterpart in the chronological ordering of the first poetry and dramas. Even the dating of his first two dramas, *The Sphinx and the Man of Straw* and *Murderer, Hope of Women*, to 1907 now seems unsustainable. In October of that year "a little fairy tale in color slides by O. Kokoschka"[32] was performed in the Cabaret Fledermaus, the content of which was diametrically opposed to that of the two dramas. This was *The Speckled Egg*, the partly preserved figurines of which have already been mentioned. It was "a mechanical play devised with figures with movable limbs . . . [that took place] inside a lighted box, the characters being manipulated by means of a spring mechanism and being made visible to the public with the help of a huge mirror."[33] Max Mell described the "compelling poetry" of the slides, the "sweet simplicity" of the "Indian fairy tale," the style of which recalled "the unpretentiousness of old woodcuts [and] oriental miniatures."[34] These fairy tale scenes, done in the manner of Jugendstil, look forward to the later lithographs of *The Dreaming Youths*.

The Speckled Egg was originally to have been shown in the opening program of the Cabaret Fledermaus, but Kokoschka was not ready with it in time. His "animated slides" were to have been seen between a dance ("Dawn Mood") by Gertrude Barrison, texts by Peter Altenberg—partly recited by Lina Vetter, Adolf Loos's first wife—and chansons by Marya Delvard, Karl Hollitzer, and others. The subsequent performance was a failure, at least partly due to the inadequacy of the technical apparatus, with the result that there was no repetition of the work.

It is highly improbable that Kokoschka was working on *The Sphinx and the Man of Straw* or *Murderer, Hope of Women* at the same time that he created *The Speckled Egg*, the poetic nature of which is so far removed from them. It would seem that the dating of these two dramas should be corrected to 1909, instead of 1907—the year, therefore, when they were first performed and their counterparts in Kokoschka's portraiture were to be seen among the works he exhibited in the Kunstschau. The date of *The Dreaming Youths* was also pushed back two years by Kokoschka to 1906, whereas the sources indicate clearly that the work should be assigned to a period shortly before its publication in 1908.[35] If Kokoschka was already working on dramatic material in 1907, nothing of such work has come down to us. The rumored premiere of *The Sphinx and the Man of Straw* in the School of Applied Art in 1907[36] is not supported by any evidence.

The premiere would seem to have taken place on March 29, 1909, in the

Cabaret Fledermaus, when the piece appeared in the program under the title of *A Grotesque*. Of this piece, which only later acquired the title *The Sphinx and the Man of Straw*, there are two considerably different versions. One appeared in 1913 with the subtitle *A Curiosity*,[37] while another, subtitled *A Comedy for Automata*, was published in 1956[38] and is apparently the earlier one. Neither of them corresponds in their cast of characters to the characters named in the program of the Cabaret Fledermaus, whose original text has thus evidently not survived. (In 1917 the completely reworked material was published as *Hiob: A Drama*).[39]

On the occasion of the premiere, almost exactly a year and a half after the failure of the "animated slides," the cabaret issued invitations to a Kokoschka matinee.[40] Significantly, the first part of the program bore the title: "I struggle with Woman," and included Kokoschka's poems for *The Dreaming Youths* and "The White Animal-Killer," recited by Ernst Reinhold (Figure 59). The "Animal-Killer" text seems to have been lost, and its later transformation into the text of *Columbus Bound*, published in 1916, has made the original form of it unrecognizable. At this reading the decoration for the stage consisted of Kokoschka's Gobelin designs of *The Bearers of Dreams*.

The second part of the matinee offered the premiere of the *Grotesque*. Its content is indeed grotesque: a certain Herr Firdusi is presented "in evening dress" and with a "huge straw-colored head" and literally has his head turned by Lilly (in the later versions, Gisele, Anima), as he follows his precept, "One should only look at women over one's shoulder."[41] Lilly, "with swaying gait, her hands piously folded," says as she comes up to the India-rubber man and Herr Firdusi: "Oh God, if I could only liberate the heart of a man, they say they suffer so terribly from the elaborate mysteries of their eroticism." Then, indicating the India-rubber man, a "snake-like being" with a top hat: "They must be worthy people, they have strong muscles." Firdusi marries Lilly, for the second time (she has already left him once), for the sake of his rubber son, who requires "in accordance with the bourgeois world order . . . for the legitimacy of birth . . . at the very least the existence of the indispensable procreator." When Firdusi discovers Lilly carrying on with the India-rubber man during the marriage ceremony—with an ardent accompanying commentary from a cockatoo and nine men (or five epileptics as the case may be)—he shoots himself. At this, one of the men intones: "The noble feelings, memories of puberty, when I failed in the test of the school of love. I could not solve the sphinx's riddle." A blubbering Lilly soon pulls herself together, orders the "dead remains" to be cleared away and "like a magnificent parade horse prances above the corpse."

The black humor of the piece, its antirealistic and shocking scenes and dialogue, as well as the arbitrary plot, bring it close to Frank Wedekind's grotesque dramas. It is, however, far more extreme. The absurd elements correspond to those in the theatrical happenings of the Dadaists eight years later, who put it on as their first performance in the Cabaret Voltaire of Zürich

59. Oskar Kokoschka, Ernst Reinhold, Max Oppenheimer, 1909.

in 1917.[42] The convention of theatrical illusion is destroyed right at the beginning of the play, when Herr Firdusi informs the audience: "I only work with our native intelligence, our nervous sensibility, and our common faith in the power of the soul's Gothic fantasy." The piece is a far cry from the poetry of *The Dreaming Youths* and is indicative of the shift from the fairy tale lithographs to the later Robinson / Animal-Killer drawings. The antagonistic relationship between the "man of straw" and the "sphinx" is dominated by vanity, the struggle for power, stupidity, and malice. Here too, for the first time, the polarization of the sexes is brought into the action in a manner that is taken to extremes in *Murderer, Hope of Women*.

The original manuscript of this drama also has been lost. The earliest version appeared in *Sturm* in July 1910.[43] Three later versions show marked differences between them.[44] Here, the affinity not only with Wedekind, but also with August Strindberg, who so oppressively depicted the struggle between the sexes in his plays, is much more in evidence than in *The Sphinx and the Man of Straw*; this is so even if the direct influence on Kokoschka of writers who were characteristic of various similar artistic tendencies around the turn of the century is not verifiable. In addition, Otto Weininger's extreme antithetical view of the sexes, which had such a great influence in Vienna, was certainly directly or indirectly exploited by Kokoschka. Just as with Weininger, the possibilities for reconciliation between the sexes are, in Kokoschka's work, virtually nonexistent. In *Sex and Character* Weininger contrasts the positive male principle to the purely negative one of the female— the mixture of these in any given individual determining those forces of attraction by means of which man and woman are delivered into each other's clutches, neither ever again being able to be free of the other. Weininger saw in abstention from the sexual act the only, albeit paradoxical, solution to the problem of the sexes. In the *Murderer* drama it is impossible for the protagonists to break out of the vicious circle of union and destruction, love and violence. The idea that a reading of Bachofen's *Matriarchy*, in which the "feminine-material" is opposed to the "male-spiritual," had already at that time had an influence on Kokoschka (as he asserted later in his autobiography), is not substantiated by the sources.[45]

In *Murderer, Hope of Women* the classification of human beings is carried further than in *The Sphinx and the Man of Straw*, so that the roles of the drama transcend personal destiny. "Man," "Woman," "Men," "Women," trigger the action—it can hardly be described as a plot, being rather a sequence of dramatic images. "Man" and "Woman" discover each other, both impelled by greed and violence. The man, who burns his mark into the woman's flesh after their first meeting, is severely wounded by the woman. In the last stages of agony, he is imprisoned in a tower; the woman again offers him her affection. She dies, while the man arises and "goes forth, red-emblazoned."[46]

> WOMAN: Oh take from me terrible hope—and let the torment engulf you. . . .
>
> MAN: Senseless yearning
> swinging from
> horror to horror, uncontrollable spinning in the void. . . .
>
> MAN: Who suckles me with blood? I drank your blood, I consume your dripping body. . . .
>
> WOMAN: You keep me bound—I seize you—and you hold me—away from me, you bleed, your love imprisons me—as with iron chains—strangled. . . .

These are excerpts from a "dialogue" that gives vivid expression to a mutual attraction that at the same time acts as an agent of mutual destruction. The polarization of the sexes is bound up with cosmic forces. "My breath makes the white disc of the sun flicker," proclaims the woman, and of the man it is said, "our master limps like the moon, rising in the East." The colors of the bodies are also contrasted, alternating white (for dying) with red (filled with life). The extremely staccato unfolding of the drama is accompanied by almost as many stage directions as spoken text, the former being designed to realize the predominantly visual effects of the action. These are achieved less through the medium of speech than through a succession of ecstatic scenes. Mime and gesture, the colors of the various stage properties, and the elaborate lighting effects are the basis of the piece's theatrical potential.

Kokoschka would probably have been influenced by the lighting effects in the Hofoper's productions designed by Alfred Roller, whose work will be discussed in more detail in connection with Schönberg. Perhaps the *Murderer* drama also shows traces of the ecstatic gesture and mime of Hugo von Hofmannstahl's *Elektra*. When Kokoschka's piece was performed at the Kunstschau, a reviewer wrote of the "elaborately tortured verbal excess, the incomprehensible ecstatic shrieks, the knots of people staggering about on the stage."[47] Four years earlier, *Elektra* was greeted with these remarks: "Terrible things happen on the stage. The women shriek and howl, and through half the play are to be seen dragging themselves around on the ground."[48]

Kokoschka's *Murderer* drama bears little relationship to the grotesque and caricaturing *Sphinx and the Man of Straw*. It is a desperate cry in the face of a murderously experienced fateful struggle between the sexes. In this context, too, there are analogous works to be considered (Figure 60), the closest being the poster for the summer theater, but also the illustrations that were published in *Sturm*. However it would be incorrect to place all the contemporary portraits in the same category. For example, the portrait of the Tietzes, which also dates from 1909, can hardly be discussed in the same breath with the content of *Murderer, Hope of Women*.[49]

It remains to be asked, what impulses were crucial in stimulating Kokoschka to express these radical ideas in the form of drama. The dual nature of his genius is in itself insufficient explanation, particularly since poetry and

60. Oskar Kokoschka, *Male Nude, Female Nude, and Dog*, 1909.

works for the stage are mostly to be found in the early years of Kokoschka's career and appear only sporadically thereafter. It seems characteristic of the first, eruptive phase of Austrian Expressionism that the accustomed media of the artists initially seemed unable to accommodate the explosive nature of what they wished to say. The *Murderer* drama, which instead of developing in the conventional manner presents a series of apocalyptic happenings, is itself evidence for this view. In a combination of color, light, gesture, speech, and song (part of the dialogue is to be performed as enraptured singing) the elemental experience that is here being conveyed is more adequately pre-

sented than within the limitations of one artistic genre. More than a drama, it is a mystery play; it is designed to communicate in the form of *Gesamt-kunstwerk* the most profound experience—directly and without that form of distancing which, in Secessionist *Gesamtkunstwerk*, is an unavoidable consequence of the aestheticization of form. At the premiere, the drama was elaborated and enhanced by Paul Zinner's music. In 1921 Paul Hindemith set *Murderer, Hope of Women* to music and realized it as an opera on the basis of the characters outlined by Kokoschka. Herwarth Walden likewise worked on an operatic version of the piece.[50] (Kokoschka's later drama, *Orpheus and Eurydice*, also was set to music by Ernst Krenek in 1925, and in 1973 the poetry of *The Dreaming Youths* inspired Gottfried von Einem's op. 41 for choir, clarinet, and bassoon.)

Only three months after the premiere of *The Sphinx and the Man of Straw* at the Cabaret Fledermaus the premiere of *Murderer, Hope of Women* followed at the summer theater of the Kunstschau. This "Kokoschka evening" took place on July 4, 1909, after numerous postponements due to inclement weather. The publicity spoke of a "drama" and a "comedy" directed by Ernst Reinhold. The titles *Murderer, Hope of Women* and *The Sphinx and the Man of Straw* were affixed to later versions, as already mentioned. The actors were recruited from Kokoschka's friends and fellow students at the School of Applied Art. The long-winded anecdotal report of this performance in Kokoschka's memoirs, together with his highly colored description of tumultuous scenes,[51] would appear to be little more than mythmaking and embroidery of the truth. The many detailed press reports of the evening speak solely of an ambivalent reception of the evening's entertainment by the audience—which was nevertheless enough to enhance Kokoschka's reputation as "enfant terrible" of the Kunstschau.

While the few newspaper reports that have survived of the earlier *Grotesque* (*The Sphinx and the Man of Straw*) performance in the Cabaret Fledermaus indicate an interested and positive reception of the piece, despite its admitted peculiarities, the *Murderer* drama at the Kunstschau was almost unanimously panned. One reviewer saw in it "a mockery of common sense,"[52] while the *Neue Freie Presse* viewed the show as "an artist's practical joke."[53] The critic Paul Frank remarked on the author's "truly astonishing disregard of his actors."

> From the first to the last word he makes them shout at the top of their voices without mercy. The words are often quite irrelevant to the action. The greatest emphasis is placed on onomatopoeic elegance, with the result that the most bizarre pearls of wisdom are flung to the four winds. . . . This Kokoschka evening is pervaded with the same notion as his painting: namely the breathing of new life into long dead and outmoded art forms.[54]

Indeed, it was true that the ecstatic, symphonic character of the piece paid very little attention to the exigencies of stage production. Its importance

lay far more in its conceptual originality. In *Murderer, Hope of Women* Kokoschka had devised a model for a "unified work of art" that Lothar Schreyer in his *Memories of "Sturm" and Bauhaus* retrospectively saw as the contemporary challenge of theater art, "in which all the resources of the stage, that is words, sounds, movements, and forms of color, were subsumed in the integrity and unity of a self-contained artifice."[55] The piece, moreover, can be regarded as the first Expressionist drama in its absolutist representation of the individual experience; in its disregard of an external logic in the development of the plot, which is solely determined by the psychological processes at work within the protagonists; and in the exaggerated expression of each artistic means that it uses. This extreme radicalism of the *Murderer* drama has ensured that up to the present day its presentation on the stage is generally considered too risky to attempt.

▪ In the Circle of *Der Sturm* ▪

In spite of the initial rejection of Kokoschka's work by the public and most of the critics, it would be wrong to regard him as an isolated or tragically misunderstood artist. From the very beginning a number of people promoted him, providing him with moral and material support. The Wiener Werkstätte under Josef Hoffmann and Kolo Moser (until 1908), and their business director Fritz Wärndorfer, through their alliance with the School of Applied Art, made use of Kokoschka's designs early on, and in greater quantity than was the case for any of his fellow students. Through such works Kokoschka obtained his first private commissions, including those for a series of book plates. Many of his teachers and members of the Wiener Werkstätte acquired drawings by Kokoschka at that time. With the publication of *The Dreaming Youths* and his participation in the Kunstschau, together with his appearance at the Cabaret Fledermaus and at the Kunstschau's summer theater of 1909, he very soon became well known to the Viennese public. Adolf Loos, certainly Kokoschka's most important patron, smoothed his path to a degree that can hardly be overestimated. Many of the early portraits were for commissions arranged by Loos, who apparently acted as a buyer of last resort in the event that the person who commissioned the picture was not satisfied with the result. Loos took Kokoschka with him on a journey to Switzerland at the end of 1909 and the beginning of 1910, the resulting productions including the portraits of Auguste Forel, Count Verona, the Duchess Rohan de Montesquieu, the Marquis de Montesquieu, and the *Dent du Midi* landscape. Loos introduced his protégé to his own clients and suppliers of commissions, and also into literary circles, which led to the portraits of Karl Kraus and Peter Altenberg; he also had his own portrait painted by Kokoschka (Figure 61) and that of his mistress at the time, Bessie Bruce.

Kraus, who was repeatedly painted or drawn by Kokoschka, consistently

61. Oskar Kokoschka, *Portrait of Adolf Loos*, 1909.

promoted his work in the pages of *Die Fackel*. At the end of 1909 a notice appeared in the magazine to the effect that "a publisher was sought"[56] for "The White Animal-Killer." Kraus also printed the two detailed articles on Kokoschka by Ludwig Erik Tesar, who had already written a commentary in depth on the artist's Kunstschau exhibits in a newspaper article of 1909.[57] In *Die Fackel*, Tesar's "O.K. An Interview"[58] appeared in 1910, and in the following year "The Case of O.K. and Society,"[59] shortly after Franz Grüner's article "O. Kokoschka."[60] Through Kraus and Loos, also, the contact with Herwarth Walden was established, which was to prove so decisive for Kokoschka's later development. Karl Kraus and Herwarth Walden had maintained a close intellectual relationship since 1909, which resulted, in the following year, in Kraus giving a reading in Berlin and Walden giving one in Vienna. Only six months after Walden had arranged representation for *Die Fackel* in Berlin for Germany as a whole, he brought out the first number of his own journal, *Der Sturm*, which contained contributions by Kraus and Loos.

At Walden's invitation, Kokoschka went to Berlin in 1910. He spent most of that year in the German capital. Walden arranged the important contact with the Galerie Cassirer, which put on his first exhibition in Germany in June

1910, consisting of 27 paintings and 27 drawings. (Walden's own exhibitions under the auspices of *Der Sturm* began only in 1912.) The Cassirer exhibition brought Kokoschka to the notice of Karl Ernst Osthaus, founder and director of the Folkwang Museum in Hagen. He invited him to exhibit immediately after the Berlin show. In autumn of the same year Osthaus acquired Kokoschka's portrait of the Duchess of Montesquieu, the first acquisition of his painting by the museum. Contemporaneously with Kokoschka's exhibition in Berlin, Walden published the text of *Murderer, Hope of Women* in *Der Sturm* and then, in several successive issues, the drawings for the drama.

These illustrations still exhibit an affinity with the later Robinson / Animal-Killer drawings, although in their concentration on the structural outlines of the figures presented they have lost all traces of decorativeness (Figure 62). Man and woman appear naked throughout, and are depicted in complicated bodily attitudes with sweeping, aggressive gestures. The *Murderer* drawings are characterized by the presentation of the body in a manner designed to express the experience of the soul. In *The Dreaming Youths* occur the lines:

> my unbridled body
> my body heightened with blood and color
> creeps into your leaf-covered huts
> roams through your villages
> crawls into your souls
> wanders at large through your bodies.

The "body heightened with blood and color" is an image formulated by Kokoschka in words long before it occurs in his art. In the stage directions to the *Murderer* drama, too, the body is the focus of the action. "The Man . . . with bloody, open wounds" was turned into a self-portrait by Kokoschka for a poster for *Der Sturm* in Berlin. Whether the actors at the premiere of *Murderer* were covered with paint, as Kokoschka maintains in his memoirs, is not confirmed by the contemporary press reviews; it is hardly likely that they would have remained silent about such a peculiarity, which could only have heightened the sensational effect of the performance. Kokoschka's comments do however have a relevance to his drawings:

> The faces and bodies, insofar as they were left naked, I had painted over. My knowledge derived from the Ethnology Museum helped me here. I had seen how primitive peoples, no doubt to ward off the horror of death, painted onto the prepared skulls the features of the living—changes of expression, the creases and furrows of laughter or anger—in order to make them appear as still alive. In a similar way I also decorated the arms and legs with the skein of nerves, and outlines of muscles and tendons.[61]

The "Man" in the *Murderer* drawings appears with a close-shaved head, like Kokoschka himself when he attended the Kunstschau of 1909, while the "Woman" is presented with hanging locks, some of them very long. The

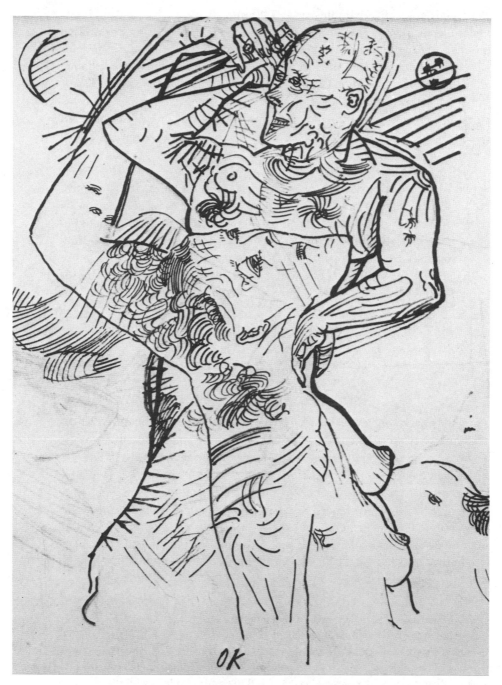

62. Oskar Kokoschka, drawing for *Murderer, Hope of Women*, around 1909.

depiction is not really of skin or the surface of the body, but rather of a network of lines that brings out the nerve-endings, the centers of energy, and the wounds. The plasticity of the body is achieved almost exclusively by means of the contour lines, while the internal fields open up the psychological, internal elements to the viewer. It makes little sense to conclude from this, as some have done, that Kokoschka is a pioneer of Cubism, whose "simultaneous projection" of the body conquered new "aspects of space and plasticity"[62] or anticipated Picasso in such discoveries.[63] In the *Murderer* drawings Kokoschka was less concerned with the problems and possibilities posed by the rendering of space and volume in the two-dimensionality of a flat surface than with transmitting, by means of pictorial devices, the theme of sexual struggle, and illustrating the excitation of body and soul, something that also gave his drama a partly pantomimic character.

Following the publication of these drawings, *Der Sturm* became the most important forum for Kokoschka's work (Figure 63). After sketches of Kraus and Loos had appeared in two of the earlier numbers, there followed further pen drawings of Herwarth Walden (Figure 64), the poets Paul Scheerbart and Richard Dehmel, the critic Alfred Kerr, the social reformer Karin Michaelis, the philologist of English Levin Ludwig Schücking, and the diseuse Yvette Guilbert—a panorama, in short, of contemporaries who were associated with *Der Sturm* or, as in the case of Guilbert, were considered interesting by members of its circle. The portraits closely resemble the earlier figurative representations—for example in the rendering of Walden with starkly etched contours for the head and with dynamic focal points of nervous energy around the eyes and temples, and with the hair and wrinkles depicted almost as scars. In *Der Sturm*, an ecstatic *Birth of Christ* also appeared, the forms of which are dramatically dissolved into a dynamic of Chaos.[64] As a result of the publication of one of the drawings for *The Sphinx and the Man of Straw*, the magazine was temporarily banned on the station bookstalls of Berlin.[65] *Der Sturm* also published Kokoschka's drawing of the circus artist Archie A. Goodman, under the title *Gymnastic Evolution in the Big Tire*.[66] Three years later, Hans Arp wrote about this drawing in *Der Sturm*, clearly inspired by Kokoschka's vision of the body, and described "the transparent skin of a man with his clockwork functioning, his skeletal structure and various channels . . . the complication of anatomy reduced to something primitive, like the folds in the robes of the ancient saints."[67]

In all, 28 drawings of Kokoschka's were published in the first year's issues of *Der Sturm*. To what extent Kokoschka was identified with the journal, and reciprocally, Walden was identified with Kokoschka's art, is evident from the poster for *Der Sturm* of 1910 (Figure 65). This shows Kokoschka's shaved skull, as if in a process of decomposition, and his naked breast, with his left hand pointing to a bleeding wound on it. With this florid reference to the iconography of Christianity in the artist's representation of himself, *Der Sturm* announced a new volume number of the journal.

Umfang acht Seiten Einzelbezug 10 Pfennig

DER STURM

WOCHENSCHRIFT FÜR KULTUR UND DIE KÜNSTE

Redaktion und Verlag: Berlin-Halensee, Katharinenstrasse 5 / Fernsprecher Amt Wilmersdorf 3524 / Anzeigen-Annahme Hannover Artilleriestr 15 und Berlin W 35 Potsdamerstr. 111

Herausgeber und Schriftleiter:
HERWARTH WALDEN

Vierteljahresbezug 1,25 Mark / Halbjahresbezug 2,50 Mark / Jahresbezug 5,00 Mark / bei freier Zustellung / Insertionspreis für die fünfgespaltene Nonpareillezeile 60 Pfennig

JAHRGANG 1911 BERLIN / SONNABEND DEN 11. MÄRZ 1911 / HANNOVER NUMMER 54

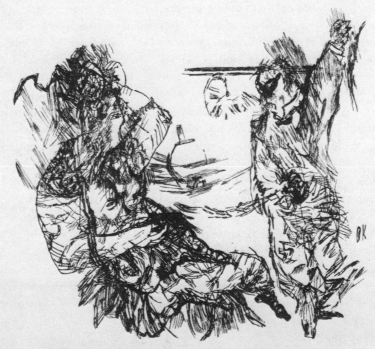

Sphinx und Strohmann / Zeichnung von Oskar Kokoschka

63. Oskar Kokoschka, *The Sphinx and the Man of Straw*, cover drawing for *Der Sturm*, March 11, 1911.

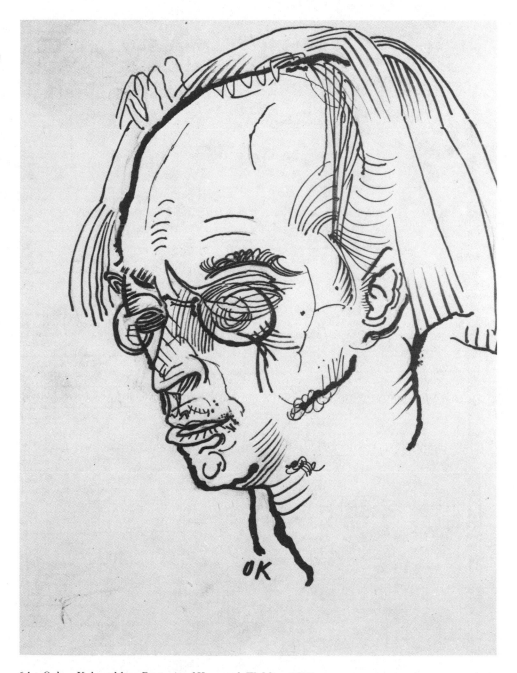

64. Oskar Kokoschka, *Portrait of Herwarth Walden*, 1910.

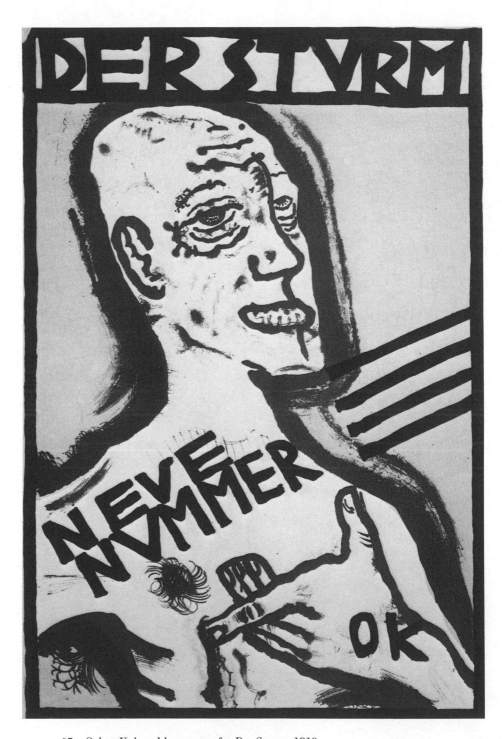

65. Oskar Kokoschka, poster for *Der Sturm*, 1910.

A series of oil paintings done during his Berlin stay show that Kokoschka continued to be preoccupied with portraiture. The portraits of Herwarth Walden, Paul Scheerbart, of the sculptor and director William Wauer, of the actor Rudolf Blümner, of the poet Peter Baum, or the lawyer Hugo Caro, extend the range of subjects beyond the confines of the *Sturm* circle; one of the few female portraits is of the actress Tilla Durieux, the wife of the art dealer Paul Cassirer. The scratched-in hatching on the subjects is often replaced in these pictures by a pronounced emphasis of the contours. The pastose, organically used colors become in some cases cooler, and the diaphanous quality of the subject tends to give way to a flatter conceptualization. Some of the pictures were evidently painted to earn much-needed money. As in Vienna, Kokoschka was perpetually in need of cash in Berlin; some of his income he regularly sent to his relations. He wrote to Adolf Loos in December 1910: "In the last few days I have painted four pictures, and am now perpetually haunted by sneering human heads, so that the whole idea of portraiture sticks in my throat." [68]

Kokoschka's association with Walden coincided with the birth of Expressionism in Berlin, and indeed contributed to it, [69] although Kokoschka did not at that time enter into any closer contact with the artists of "Die Brücke." One year after its first appearance, in 1911, *Der Sturm* already had a competitor in Franz Pfemfert's *Aktion*, which was likewise published in Berlin. Both journals saw themselves as torchbearers of the cultural revolution, although *Aktion* was considerably more politically oriented. Max Pechstein had already moved to Berlin from Dresden in 1908; Ernst Ludwig Kirchner followed him for a while in 1910, before settling in Berlin for good in 1911, as soon did other members of "Die Brücke," Karl Schmidt-Rottluf and Erich Heckel. Metropolitan Expressionism, when it appeared in Berlin, found an enthusiastic propagator in Walden.

The anarchic and Bohemian way of life of the *Sturm* circle, and its initially close relationship with Vienna, was well described by Walden in a self-mocking article entitled "Café Megalomania":

> In this hellhole . . . sit demonic figures with wildly fluttering cravats, Secessionist socks, and alcohol-free underwear . . . preening themselves and flattering each other, and hurling between them dedicatory tankards the size of beer barrels in dangerous proximity to the delicate auricles of Stefan George; and bringing German art to the brink of the abyss through wicked and decadent coffee drinking. . . . Altenberg is unfortunately not up to the journey, but Hermann Bahr comes here twice a week, and Alfred Kerr is in continuous telephonic communication with the modern clique, while Karl Kraus sends his dispatches from the *Fackel* of Vienna. . . . Oskar Kokoschka has brought with him a good deal of street dust, which is needed for one of his megapaintings. . . . [In the] night of the modern man the marrow-gnawing demolition work of the coffeehouse literati gets under way . . . and a demented drunken babble arises. [70]

Kokoschka remained in Berlin for about a year, complaining, as in Vienna, of his living conditions. To Lotte Franzos, whom he portrayed several times, he wrote in August of 1910: "For weeks I have been enduring a life filled with anxiety and requiring a huge effort of will, filled also with persistent, arbitrary obstacles and tormenting provocations to my sensibilities."[71] At the end of the year he confessed he was longing to be back in Vienna and was suffering from the "imprudent relentlessness with which my existence has been disturbed and threatened from the first to the last day of it in Berlin . . . my whole life is a hell; I was once a good, openhearted young man, and am now a malicious weakling, the object of occasionally offered sympathy."[72]

■ Vienna, 1911 ■

When Kokoschka returned to Vienna in 1911, his art was the focal point of critical controversy. The reason for this was his participation in the "Special Exhibition of Painting and Sculpture" put on by the Hagenbund in February of that year. The show organized by this artists' association with moderately modern views had brought under one roof, among others, works by the Germans Karl Hofer and Bernhard Hoetger, and the Austrians Anton Faistauer, Paris von Gütersloh, Sebastian Isepp, Anton Kolig, Franz Wiegele, and Erwin Lang. Kokoschka, who had acquired a certain prominence through the stir he had earlier created in Vienna, and also as a result of his activity in Berlin, dominated the exhibition with two rooms devoted to his work. He showed 25 paintings that documented his development since his participation in the Kunstschau of 1909. Discussion of his contributions also dominated the numerous reviews of the show, which were evenly divided between wholesale rejection and discriminating criticism. Hans Tietze, for instance, wrote at length of the "great art" produced by Kokoschka,[73] while the Ordinarius Professor for Art History at the University of Vienna, Josef Strzygowski, could only recommend it to visitors who would "feel at home in clinics for venereal disease, or who can stomach the anatomical wax figure cabinet [of the Josephinum]."[74] One of the most enthusiastic critics was the then law student, later Dadaist writer, Walter Serner. A few months after the show Serner organized for Kokoschka a one-man show in the Karlsbad Café "Park Schönbrunn," and wrote no less than four commentaries on it for the *Karlsbader Zeitung*.[75]

Kokoschka's hopes that the Moderne Galerie in Vienna would acquire one of his pictures were not fulfilled. His plan to exhibit that year in Munich also miscarried. He blamed this failure on Max Oppenheimer, whose painting at that time clearly showed the influence of Kokoschka. The poster for Oppenheimer's exhibition in the Galerie Thannhauser of Munich (Figure 66) does indeed look like a paraphrase for Kokoschka's *Der Sturm* poster of the pre-

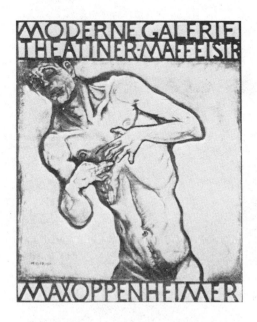

66. Max Oppenheimer, poster
for the exhibition in the Moderne
Galerie, Munich, 1911.

vious year. A series of letters indicates how furious Kokoschka was in 1911
over the success of Oppenheimer, on whom Arthur Roessler was in the pro-
cess of writing a monograph (never, however, to be published), and whose
work was exhibited early in 1912 in the Cassirer gallery in Berlin. Kokoschka
saw Oppenheimer as "his shadow," who copied his pictures "item by item," [76]
and he lobbied both Walden and Loos vigorously to expose his rival's artis-
tic dependence and the derivative nature of his work. This led to, among
other things, a polemic by Else Lasker-Schüler against Oppenheimer in *Der
Sturm*,[77] another by Karl Kraus in *Die Fackel*,[78] and later also to Hans Tietze's
condemnation of Oppenheimer.[79]

Kokoschka's artistic development in the course of this year shows a
marked change from his work since his breakthrough to Expressionism in
1909. The portraits of Baron Victor von Dirsztay (Figure 67), of the opera
singer Hjalmar Ennehjelm, and particularly of the composer Egon Wellesz
(Figure 68), which already had been exhibited in Karlsbad, make manifest
new aspects of his portraiture and herald the arrival of the so-called opaque
period. The now more sombre and less contrasted coloration of his paint-
ing does indeed present his subjects as if viewed through a glass darkly,
an effect heightened by the softer plasticity of form produced by a modeling
treatment of color. The previously mentioned transparency of Kokoschka's
pictures, which had been produced by a thin, translucent application of
color, now emanated more from the light inherent in the colors themselves,
which likewise permeated space and volume. The savage characterization
that had often led to an element of grotesque and caricature in his portraits
now yielded to a more humanizing vision. Anatomical distortions, too, are

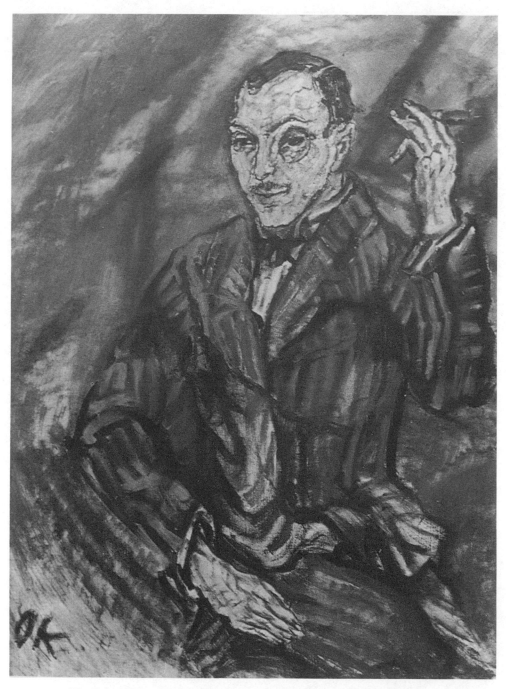

67. Oskar Kokoschka, *Portrait of Baron Victor von Dirsztay*, 1911.

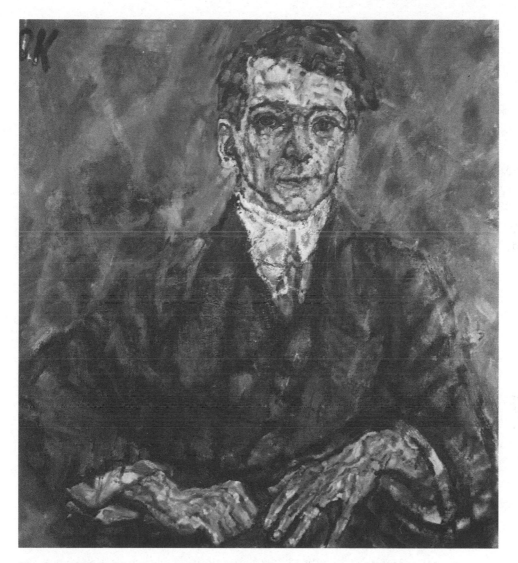

68. Oskar Kokoschka, *Portrait of Egon Wellesz*, 1911.

now less evident, and the concentration on the phenomenal aspects of the subject leads to more rounded and integrated portraits. The pictures of the opaque period are thus scarcely touched by the atmosphere of morbidity that was dominant earlier.

Changes in Kokoschka's work also are evident in his choice of subject matter. He takes up once more the religious motifs of his very first period, but now depends more heavily on the tradition of Christian iconography. Themes such as *Annunciation*, which likewise dates to the first half of this year, as well as the later *Visitation*, *Crucifixion*, *Flight into Egypt* (Figure 69), and others belong to this group of works. Kokoschka widened his spectrum of

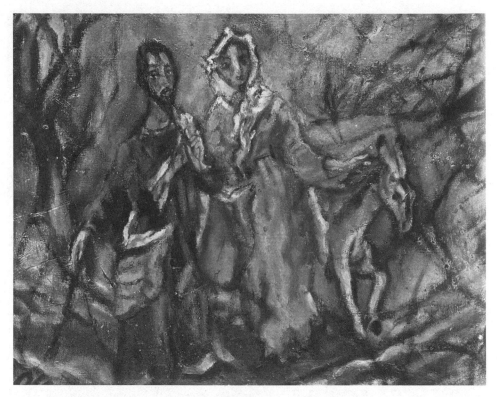

69. Oskar Kokoschka, *The Flight into Egypt*, around 1911.

figurative representation thereby, which had hitherto, as far as oil painting was concerned, been largely confined to portraiture. Only here, in his early work, can one perhaps speak of certain slight similarities with Cubist and Futurist treatments of space and form. These may be seen in some of the pictures that are impregnated with a netlike structure, where the light appears concentrated as in fibrous strands of color.

In his graphics too, the changes are extremely marked. In that year Kokoschka illustrated the story *Tubutsch* by Albert Ehrenstein, a melancholy and fantastical account of a Viennese idler, Karl Tubutsch, who is constantly thwarted in his quest for experience.[80] In September Kokoschka had completed the drawings.[81] By comparison with the ink drawings of the previous year, published in *Der Sturm*, the *Tubutsch* illustrations are far less exclusively characterized by psychophysical experience (Figure 70). As in the paintings of the same period, the form of expression is more moderate—something that is also determined by the fact that these drawings no longer concentrate exclusively on the representation of human character. The surroundings and scenery gain in importance and a narrative interest enters into the work. While the *Murderer* drawings produced a typology of the drama's antithetical elements, those of the "Man-Woman" conflict, the *Tubutsch* illus-

70. Oskar Kokoschka, drawing for an illustration for *Tubutsch*, by Albert
Ehrenstein.

trations take more account of the narrative flow of the story. A gentler plasticity that allows the body to retain its volume, and a new interest in detail, are also to be observed. The same is true of Kokoschka's contemporaneous, often lightly watercolored drawings of nudes.

The changed direction of his art is also apparent in the *Play* written, or at least begun, in 1911.[82] It appeared in 1913 in a book introduced by Paul Stefan, *Kokoschka—Plays and Pictures*. Four years later the publisher Kurt Wolff brought out a slightly altered version under the title *The Burning Thornbush* in his series *The Day of Judgement*.[83] In five short scenes the problem of the relations between "Man" and "Woman" is again treated. The material, however, is here not conceived as a "unified work of art" in Schreyer's sense, but lives far more than Kokoschka's earlier dramas from the significance of the text. Here again the fundamental idea is the tragic entanglement of the two sexes, but this time the impossibility of a solution, as stressed in the ecstatic series of scenes of the *Murderer* play, is no longer asserted. Four times the crucial question of the piece is posed: "Why are we not good?"[84] Although love between humans once again founders on the rock of "being evil," which is equated with being real, the final scene nevertheless introduces the idea of salvation. "Man" and "Woman" come together to form a *Pietà*, and the death of "Man" implies a reconciliation. The closing chorus celebrates salvation through mercy, and supplies an answer to the twice repeated question: "Why are you not good?" The sacral character of *Play* is emphasized in this scene by the halo that appears above the *Pietà*, by the raised hands of the chorus under the wreath of light as the "Man" dies, and by the sacred ceremonial of the choir and its mystical chanting.

Play, the portraits of the opaque period of Kokoschka's painting, the adoption of biblical motifs, and the changed style of the drawings all mark out 1911 as a year of development in Kokoschka's work, the main lines of which intensified in the following years: it was a development toward a vision of the world that no longer saw mankind as standing on the brink of the abyss, as in the eruptive phase of Kokoschka's art after 1909. Paintings like the *Sposalizio* (Marriage) double portrait from 1912, or the double portrait of Kokoschka with Alma Mahler, show a new, humanized self-image of the painter and a fundamental change in the attitude to relations between the sexes—even if these still exhibit a dramatic and often tragic character. The relationship with Alma Mahler that began in April 1912 played a significant part in this. A comparison between Kokoschka's sketches of Karl Kraus done respectively in 1910 and 1912 also makes the development evident, as does a glance at the poster for the Wedekind week of the Akademischer Verband of 1912, compared with the *Sturm* poster of 1910. The newly conquered feeling for space and plasticity grew in strength and led to physically compact portraits, like that of Carl Moll, or the landscapes that emphasize space, like the Tre-Croci picture of 1913. In drawing, Kokoschka had attained a new clarification of his medium; the sparing use of materials was evident, not

least in his landscapes, while in the field of printed graphics he produced three impressive series of lithographs: *The Chinese Wall*, *Columbus Bound*, and *The Bach Cantata*.

The caesura of 1911 coincided with his wider recognition as an artist. This was demonstrated both in sales to collectors like Oscar Reichel and Alfred Flechtheim, who occasionally had bought Kokoschka's work before, and in the connection to the circle of Eugenie Schwarzwald[85] and the Academic Union for Literature and Music. It was for them that Kokoschka, in January 1912, gave his subsequently famous lecture, "On the Nature of the Human Face." From 1912 he taught at the Schwarzwald School and at about the same time became an assistant lecturer at the School of Applied Art, teaching nude drawing. Thus we see that crucial changes in his life accompanied the extinction of the Early Expressionist phase of his artistic career.

EGON SCHIELE

When Gerstl was painting his final pictures in 1908, Schiele was merely an obviously very gifted young painter still totally committed to the tradition of Viennese Jugendstil. Schiele came from a modest lower middle-class family and grew up in Tulln and Klosterneuburg; in 1906 he came to Vienna to study at the Academy. He attended the old-fashioned course of instruction of the portraitist and history painter Christian Griepenkerl immediately after Richard Gerstl had left his class and joined that of Heinrich Lefler. Schiele worked his way through the traditional course, but also produced, apart from conventional portraits and nudes, a number of paintings and graphics influenced by Impressionism that are close to the style of illustration favored by *Ver Sacrum*. Landscapes, flowers, and figurative paintings, however, exhibit an increasing stylization during this year; their flat and angular abstraction contains a decidedly graphic element, in contrast to a previously very picturesque approach (Figures 71, 72). At the same time he fell under the spell of Gustav Klimt's work. In 1907 Schiele had already produced his *Water Sprites*[1] (Figure 73), which was a paraphrase of Klimt's *Water Snakes*. The following phase of refined portraits and nudes, which conspicuously honored the work of Klimt in both drawing and painting, was ended in 1909 with the intrusion of a much starker element. The luminous beauty and tranquil harmony of the works conceived up to that time were abruptly shattered, and very soon discarded altogether.

The outward sign of this change was the walkout of a group of young

71. Egon Schiele, *Reclining Female Nude, Supported by the Right Elbow*, 1908.

Academy students from Griepenkerl's class, Schiele being one of the ring-leaders of the exodus. The immediate impulse for this somewhat dramatic step was doubtless the 1909 Kunstschau, where works of the European avant-garde were shown. In the same year, in December 1909, the exhibition of the so-called New Artists opened. This nomenclature, apparently suggested by Schiele, brought the group that had left the Academy together with several other young artists, thus making a colorful and heterogeneous show. At the Kunstschau itself, Schiele had already been able to exhibit four pictures that nevertheless demonstrated little in the way of originality. Only in the New Artists' show did he appear as an artist of real individuality, indeed one not lacking in conviction and self-confidence: "The new artist is, and must be, completely himself; he must be a creator, and he must immediately, without the assistance of all of the past and tradition, be able to build the foundations for himself. . . . Each one of us must above all be himself" (Figure 74).[2]

▪ Encounter with the Self ▪

Schiele's *Nude Self-Portrait with Ornamental Drapery* of 1909[3] (Figure 75) documents his retreat from beautified appearance as celebrated in the pictures of the Secessionists. It also shows, however, that his development did not imply a sudden break with his artistic environment. It was far more the logical consequence of the intrusion of "ugliness" into Klimt's paintings that, ever since the Beethoven frieze and the faculty pictures, had provoked such indignation among his former admirers. The uncompromising realism with which Klimt had depicted "Old Age" in *Jurisprudence* (Figure 76) or *The Hostile Powers* in the Beethoven frieze (see Figure 11), was designed to illus-

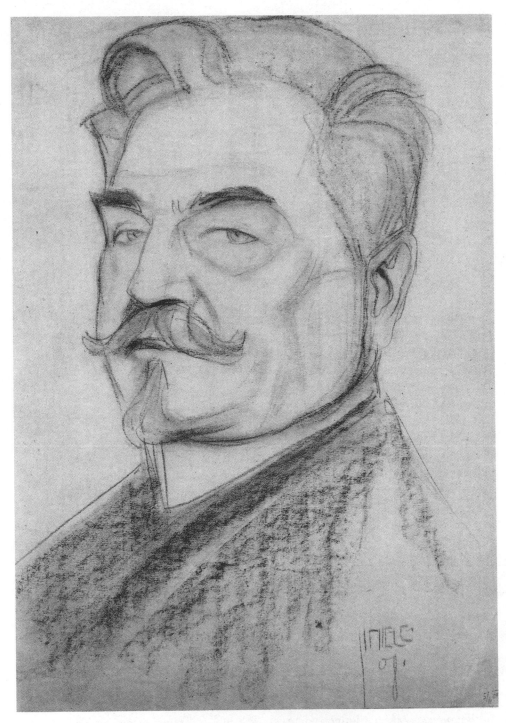

72. Egon Schiele, *Portrait of Leopold Czihaczek*, 1908.

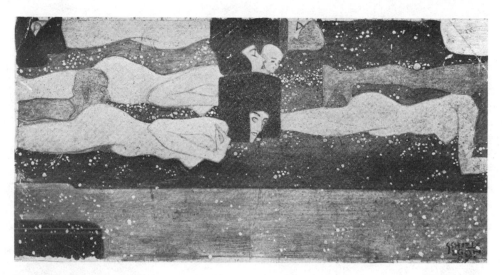

73. Egon Schiele, *Water Sprites I*, 1907.

trate a symbolic pictorial concept. Stylization and proliferating ornament stand in stark contrast to these by comparison apparently overemphasized bodies—the same being true of Schiele's 1909 self-portrait.

Figures, nudes, portraits as an evocation of mood—these were the nineteenth-century conventions taken over by Schiele from late Symbolist painting. Much of this, of course, is also present in Klimt's work. However Schiele's now burgeoning radicalism carried to its logical conclusion a form of expression that made "body" and "soul" inseparable. Thus, his attention inevitably began to focus on those areas that were taboo for a culture of aestheticism. The drawings and paintings that he now produced alter his manner of depicting himself in a way that is almost manic. They reflect a journey into the inner self that exploits every possible mode of bodily expression, that mercilessly exposes all facets of what is ostensibly ugly or diseased, and that documents every private psychological ordeal. He was continually fascinated by the complexity of the relationship between inner experience and its external projection. The human physis contained for him an abundance of possibilities of form that could be made to correspond to his innermost perceptions and their counterpart in experience. "I still believe," he wrote in 1911, "that the greatest artists painted figures."[4] For Schiele, the figure, the representation of the body, is the ultimate means of expression. The contours of a nude become the outlines of the human drama, the external surface of a naked body in watercolor becomes the landscape of the soul (Figures 77, 78).

"I yearn to experience everything", Schiele once remarked.[5] The nature of this internal experience he recorded in his self-portraits. The same purpose was achieved with almost equal effectiveness whether he was depicting a head, a half, or a whole nude. A grimace (Figure 79), a cry of pain, a tor-

74. Egon Schiele, photographic portrait.

tured face, found its counterpart in the crouching, tensed body, which might appear in the form of a cross, a phallus, or as a geometrical formation.

Many influences may be discerned in these figures: for example, George Minne's gaunt youthful figures with folded arms; Kokoschka's linear graphics, showing pubescent boys and girls; Ferdinand Hodler's complicated and richly symbolic eurythmic paintings. Schiele's pictorial structure here very often has its basis in drawing. The watercolors and paintings are also considerably less painterly than is the case with Kokoschka, or even with Gerstl. The latter underlined his nakedness in his nude self-portraits in order to emotionalize it through the painterly process—thereby using the background as a determining element in the presentation. Schiele's figure,

75. Egon Schiele, *Nude Self-Portrait with Ornamental Drapery*, 1909.

76. Gustav Klimt, male nude,
detail from a working sketch for
Jurisprudence, 1903.

on the other hand, always lives from its gestures, from its contours, and from
the treatment of the area within them. Its painterly handling also confirms
this analysis. The figure, with its stark outline, surges out of the background.
Its area shows the imprint of space, its surface reflecting a plasticity derived
from the space's effect on it, and permeation of it. With Gerstl there is a
prevailing interrelationship between the person and his surroundings that is
produced by a painterly process that has its roots in an Impressionist way of
seeing the subject; with Schiele line and flatness are emphasized, and so
a more pronounced distancing of the person from the world that surrounds
him. Schiele's early figures—and similarly his trees and flowers—conse-
quently tend to give the impression of being marooned and exiled in space
and time.

Schiele's uninhibited choice of colors considerably increased his possi-
bilities of expression, especially in his nudes. Tones of green, blue, and
yellow, for example in the area of the back, are applied immediately next to
each other, or are allowed to flow into one another. A head is colored in ex-
ploding reds and mauves, or frozen with the whiteness of a corpse. Hollows of
the knee or bones take on a life of their own in garish blue; genitals, nipples,
and lips are highlighted with vermilion; the solar plexus becomes a yellowy-
green ball. The same multiplicity of color can be applied to the representation
of a hand or a face. The expressive, heightened use of color complements the
elongation or foreshortening of a body or a part of the body, or the paroxysms
that often seem to seize hold of an entire figure, or that alternatively are ex-
pressed solely through its frenzied gaze. Schiele carried these effects to their
furthest extremes in his representations of himself. Here, caricature and

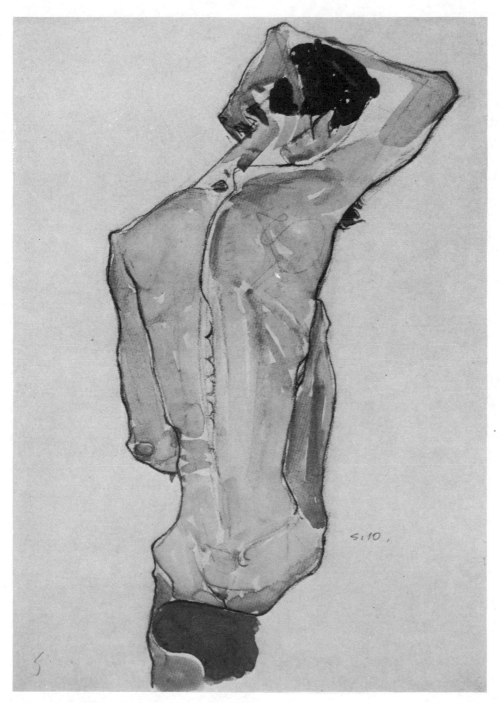

77. Egon Schiele, *Seated Male Nude, Back View*, 1910.

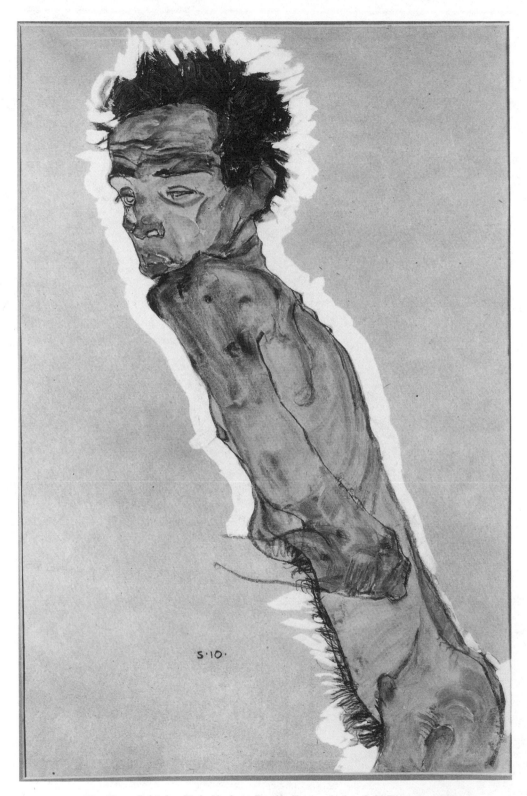

78. Egon Schiele, *Male Nude in Profile Facing Left—Self-Portrait*, 1910.

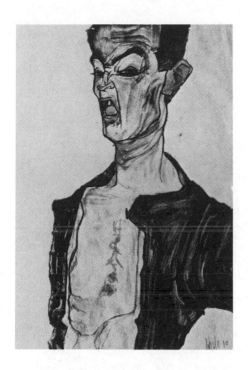

79. Egon Schiele, *Grimacing Man—Self-Portrait*, 1910.

narcissistic pose follow each other in quick succession. Always, however, it is an incandescent manner of presentation, one that seems to drive the body to physical extremes, that Schiele puts before us in his self-portraits—particularly those of 1910 and 1911.

The personal reminiscences of Schiele at that time by friends like Arthur Roessler and Heinrich Benesch (all of which were written down very much later, however) describe him by contrast as quiet, shy, and introverted. Indeed, he gave the impression of "being the messenger from another planet"[6] and was at the same time a person of most striking appearance, as may indeed be seen from his photographic portraits (see Figure 74). He also exhibited a "placid conviviality" and was described as a "master of the art of living [*Lebenskünstler*] in the fullest sense of the word."[7] Albert Paris Gütersloh called him one of the "few really good and benevolent human beings."[8] He was said "never ever to have been angry or even annoyed,"[9] was always relaxed, never vehement or passionate.[10] These are remarkable testimonials when one considers Schiele's early representations of himself. His evidently split personality (by comparison also with such opaque characterizations as "a little hesitant and a little self-confident")[11] becomes clearer from Schiele's remarks about himself, to which we will return later.

■ Body Language ■

The figures in Schiele's earlier pictures live from expressive gesture. There is hardly a single example of them where the person featured is not characterized in one way or another by such means. The whole body becomes a vehicle of expression, both when seen as a whole and in its individual details (Figure 80). In particular, the expressive features of the face and the attitude of the hands become the transmitters of a body language, in the stylization of which a large number of recurrent form motifs are to be observed. However to try to extract from this a canon of symbols that may be used to interpret Schiele's paintings [12] would seem to lead us in the wrong direction. Unlike the work of Kubin, which is permeated with multiple literary, philosophical, and symbolical allusions that frequently provide us with the key to it, in Schiele's painting we are confronted with images that grow out of a very private creative mythology of the subconscious mind. Even those letters of the artist in which he supplies explanations or information on the content of his pictures can provide little more than general orientation, and indeed reflect an extremely intuitive kind of self-interpretation. Kubin's attitude, to return to this comparison, appears far more intellectual and systematic.

The human body, which was already an important means of expression in Symbolist art, offered the new art more than just a fundamental expressive potential. Its most striking medium was expressive free dance, whose impact on Vienna has already been discussed. Schiele's enthusiasm for the art of Ruth Saint-Denis (Figure 81) has been recorded, although the account of his meeting with the dancer is almost certainly an invention. [13] She was, however, his ideal model for bodily flexibility: at Arthur Roessler's, Schiele discovered a collection of Javanese shadow puppets, with which he would occupy himself for hours, manipulating the figures with astonishing dexterity; he nevertheless was said to have remarked that the dancing of Saint-Denis was infinitely superior to what could be achieved with them. The striking contours of the stylized shadow figures on the wall fascinated him so much that Roessler offered to make him a gift of one of the puppets; Schiele chose "the grotesque form of a fierce demon with a fantastic profile." [14]

The young artist seems to have been a sophisticated mimic of the voice and bearing of well-known personalities. The convincing imitation of his teacher, Christian Griepenkerl, apparently had his audience in stitches, [15] as did his renderings of the actor Josef Kainz in different Burgtheater roles. At the beginning of his stay in Vienna, when Schiele used to accompany his uncle Leopold Czihaczek, who had a box in the Burgtheater, he was wont to reproduce whole chunks of Kainz's performance in Ernst Hardt's *Tantris the Fool* and other roles. [16]

A congenial companion in these diversions was Erwin van Osen, who exhibited with Schiele in the New Artists' show of 1909 (Figure 82). Osen, nearly ten years older than the young artist, was formerly a painter of stage

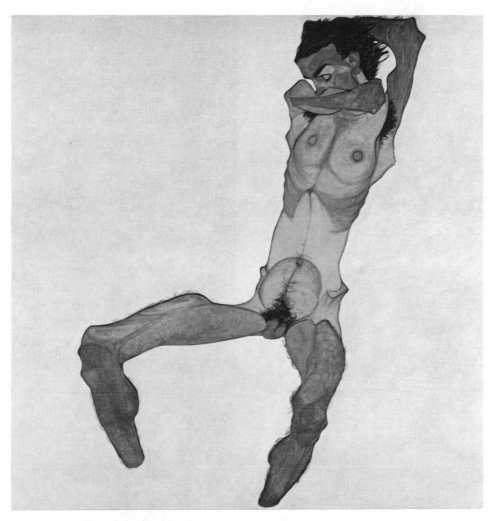

80. Egon Schiele, *Seated Male Nude—Self-Portrait*, 1910.

sets who now performed mime pieces in cabaret in tandem with the dancer
Moa. Like Schiele, he was interested in the bodily expression of the men-
tally ill; on one occasion he did drawings in the Steinhof mental clinic for a
lecture on "pathological expression in portraiture." [17] "Mime van Osen," as
he also called himself, worked with Schiele for a while in the same studio.
According to Roessler, the latter was for some time completely under the
spell of Osen and his companion, Moa (Figure 83), "a willowy dancer with
a pallid face frozen into masklike immobility under a dark crown . . . [with]
virtually unseeing, large, jet black, melancholy, and dully glimmering eyes
under brownish-blue, shadowy, long-lashed, and heavy eyelids." [18] Schiele
drew both Moa and Osen repeatedly, the latter in a whole series of bodily
attitudes and in poses of overemphasized mimicry. Many of the portraits and

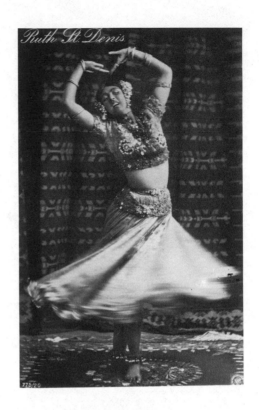

81. Ruth Saint-Denis,
photographed dancing.

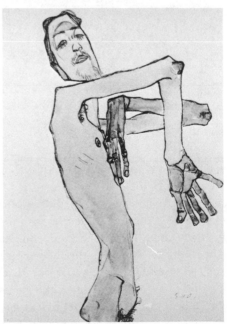

82. Egon Schiele, *Portrait of
Erwin van Osen*, 1910.

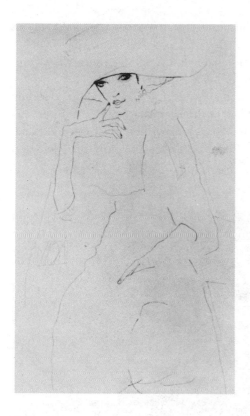

83. Egon Schiele, *Portrait of Moa*, 1911.

nude drawings of Osen from 1910 have their counterparts in Schiele's own self-portraits.

The same is true of various other portraits dating from 1910, such as those of the painter Karl Zakovsek,[19] of the gynecologist Erwin von Graff,[20] or of Schiele's promoter, Arthur Roessler[21] (Figure 84). The elongated, slender figures and limbs, the turned away head, the absence of any accompanying detail, and the unashamedly lavish painterly handling of the surface in the background of the figure, all contribute to the concentration on the picture's psychophysical content in the same way as in Schiele's self-portraits. The portraits of Graff and Roessler, together with those of Oskar Reichel[22] and the Rainer boy,[23] live in a world of tension created by bodily gesture, by the attitudes of the arms or the hands, by the positioning of the head, and by the internal structure of the physis.

Although Schiele's paintings of the previous year still showed elegant men and women in poses of self-abstraction or in dreamlike states, all picturesquely displayed as in decorative woven carpets, now the portraits appear unadorned by protective ornament and are painted exclusively in frontal poses or in profile, the subject usually fixing the viewer straight on with his gaze. This is especially the case in the portrait of Eduard Kosmack,[24] with its huge, penetrating eyes (Figure 85). Their effect is to strengthen the severely axial construction of the picture, and to underline the almost mirror-

like symmetrical arrangement of the subject, with his hands folded between
his knees. His body serves as a sort of slender pedestal for the head, which
radiates an almost hypnotic power—indeed, hypnotic powers were com-
monly attributed to Kosmack.[25] As in his self-portraits, Schiele demonizes
his subject. Many of those depicted in an ostensibly passive pose, standing
or sitting, are at the same time filled with enormous tension and extraor-
dinary energy that, apart from being conveyed by their gestures and facial
expressions, is also revealed in the treatment of their bodily presence and
their clothing.

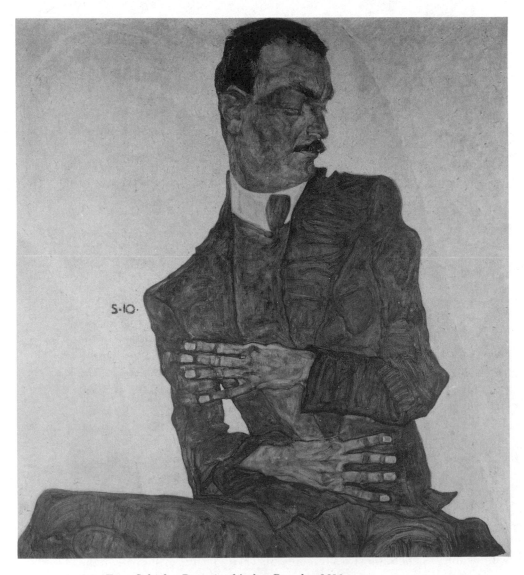

84. Egon Schiele, *Portrait of Arthur Roessler*, 1910.

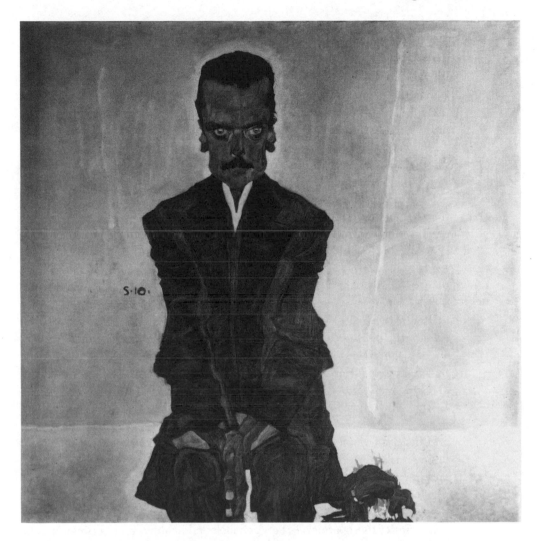

85. Egon Schiele, *Portrait of Eduard Kosmack*, 1910.

▪ "Everything Is Living Dead" ▪

After its liberation from the aestheticism of the Secession, Schiele's early art demonstrates a continual preoccupation with basic existential problems, more specifically with the polarity of life and death. Thus, even before he arrived at the melancholic interdependence of life and death depicted in his later works, this theme occurs in his early, expressive work, which is invariably invested with unease and the deepest distress. "Everything is living dead"—so runs the closing line of one of his poems—and it could stand as a motto for his work at this time.[26]

As a child, Schiele had witnessed the death of his eldest sister, and when he was fourteen, that of his father, who was mentally ill for some years before

his death. Adolf Schiele, a stationmaster and "Senior Official of the Imperial and Royal Railway," actually appears to have died from the onset of the later stages of syphilis.[27] Toward the end, he continually received imaginary guests in his home and invited them all to supper, the family being obliged to humor him in this.[28] Escaping the family's observation on one occasion, he shoveled all his share certificates into the stove and burned them.[29] The behavior of his father must certainly have been deeply disturbing for the growing Schiele— all the more so as he was evidently very fond of him. In 1913 he was still writing that he thought of his father with nostalgic affection, and still visited the places that were bound up with his memory.[30] In 1910 he wrote to his sister of "a beautiful spiritual experience; I was awake, yet still under the spell of the soul that had come to me in a dream before I awoke; while he spoke to me I was frozen and speechless." Anton Peschka also reported: "Last night [Egon] said that his father had been with him."[31] Two years later Schiele wrote of his picture *Anchorites*[32] that it was "more a kind of vision" and had been conceived out of his "experiences for several years following the death of [his] father."[33]

Beginning in 1909, Schiele began to work his experience of death, disease, and pathological behavior into his pictures. According to Roessler, "he spent months drawing and painting the children of workers. He was obsessed by the ravages of obscene suffering to which these in themselves innocent creatures were exposed."[34] Through his acquaintance with the gynecologist Erwin von Graff Schiele obtained permission to make drawings in the Viennese clinic for women at the beginning of 1910. His depictions of pregnant and diseased women and girls constitute a sort of countervision to the refined female portraits of the Secessionists. In his self-portraits, his portraits, and his ecstatically presented nudes, Schiele also revealed all the hidden, demonic, and unwholesome elements behind the facade; thus there is no fundamental difference between these and the "pathological" depictions. The obscuring of the boundaries between sick and healthy, and between normal and abnormal; the mistrust of any ostensibly smooth facade of mankind, a facade that hides not only its wounds and vulnerability, but also its darker side—all this finds expression in such pictures.

Just as Schiele had a vision of the abyss buried within the apparently secure and normal, death was evident to him in the midst of life. The theme of maternity had been treated by him continually since 1909—in three pictures of 1910 and 1911, for instance, all of which confronted newly emergent life with the prospect of death. In the two pictures *Dead Mother I* and *Dead Mother II* (Figures 86 and 87), the central focus is on the head and hands of a newborn baby, which is shown still cocooned in the amniotic sac. Its surroundings, however, are darkly somber and cover the mother like a shroud, out of which are made visible her head, turned to one side, and one hand only. In the first version of the theme,[35] both eyes are half open, the mother's hand seems to be holding the body of the child, and the heads of mother and

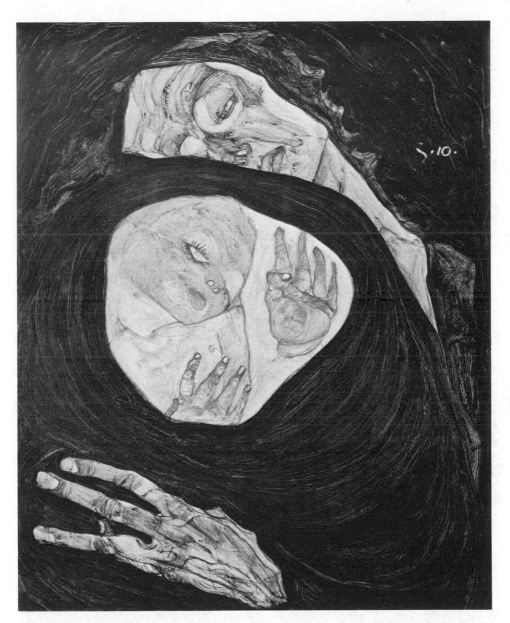

86. Egon Schiele, *Dead Mother I*, 1910.

child lean toward each other, emphasizing their interdependence. By contrast, the newborn baby of the picture painted a year later[36] seems to have been abandoned: the fundamentally more severe composition pulls the child with its wide-open eyes and open mouth into the very center of the picture, while the shawl or robe of the mother forms a clear horizontal line above. Over this, the mother's head has fallen to one side, her eyes are closed as if in death, and again, on the lower edge of the picture, her hand appears as if

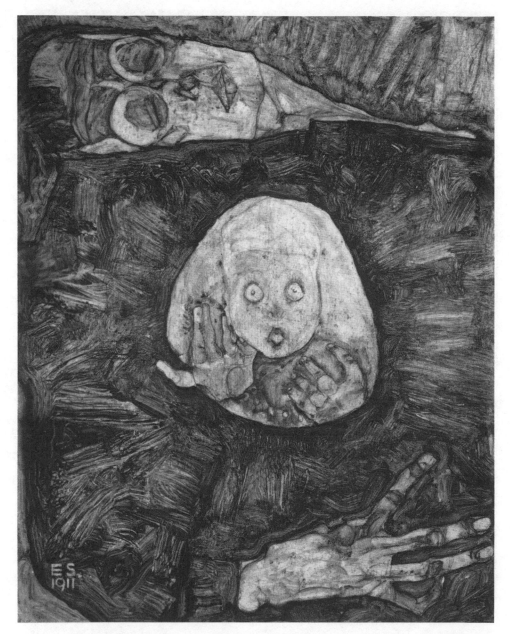

87. Egon Schiele, *Dead Mother II*, 1911.

splayed in rigor mortis. Finally, the painting *Pregnant Woman and Death*[37] features the two figures of the title, the gloomy atmosphere of the composition stemming partly from its somber coloring and the expressions on the faces of the skull-like heads.

Although the atmosphere of death is most marked in Schiele's vision-ary paintings, it is also evident in another group of his works, namely his

earlier city views or townscapes, with their dull melancholy, their interlocking, cowering houses with cavelike windows and doors, and their deserted streets—almost always encircled by the blue-black ribbon of a river. In defense against this threatening flood, the buildings seem to be taking refuge, as if on an island (Figure 88).

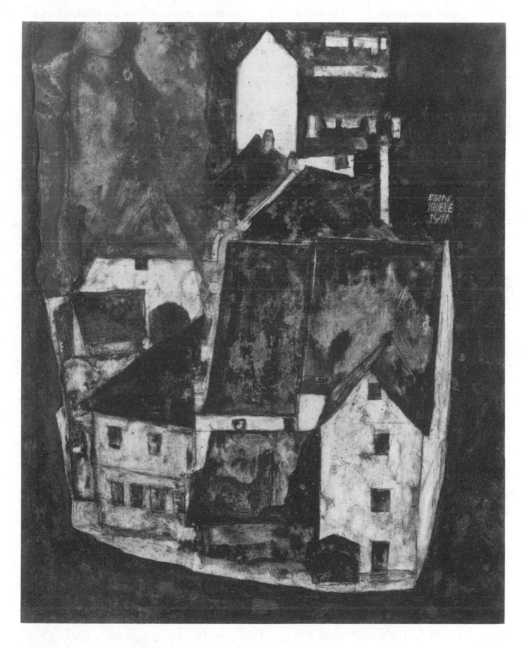

88. Egon Schiele, *Dead City III*, 1911.

■ Eros and the Nature of Being ■

"An erotic work of art is also sacred!"[38] Schiele's remark implies both a defense of his works and a recognition of the existential depths of eros. His fascination with the business of death is interchangeable with his intense preoccupation with eros and sexuality. The early Expressionist work of Schiele can ultimately be said to derive its inspiration from the eternal contradiction between eros and thanatos. His determination "to experience everything," and his untamable curiosity, naturally impelled him into taboo regions. The drawings and watercolors in which Schiele treated the female nude form the largest single part of his oeuvre. The central importance of this subject matter in his work would seem to mirror the role that it also had for Klimt. The gaunt, bony, long-limbed girls of Schiele's nudes or half nudes, their presentation with arms folded, and the often demonizing treatment of them (Figures 89, 90), set them apart, however, from the soft, self-absorbed, and tranquil nakedness of Klimt's female nudes. The frankness of Schiele's erotic works, together with his own unconventional attitude to bourgeois proprieties, resulted in a prison sentence of 24 days in 1912, preceded by a trial during the course of which one of his erotic drawings was publicly destroyed.

Schiele completed a whole series of highly expressive portraits of men, while doing comparatively few of women; but perhaps it is no wonder that he seldom got commissions to paint the portraits of ladies when one considers the fierce nature of his vision. While the female portraiture of the Viennese fin de siècle celebrated the beautiful, elegant woman, who sometimes posed in the middle of a sea of ornamentation, herself appearing as the pièce de résistance, Schiele could be expected to tear the veil from the outer facade and distort the features of his subjects. The clear demarcation between the male world, with its intellectualism that still allowed expressive experiments, and the world of the feminine, that only permitted representation of refined sensuality, was a mirror image of the underlying tension between the sexes. The resulting compulsive obsessions affected Schiele most powerfully. Only in his later years did he find his way to a less obsessive treatment of erotic themes. His early handling of nudity and indicative sexuality is far removed from the vital and primeval nakedness that appears, for example, in the painting of the "Brücke" group of Dresden. The life-giving sexuality manifest in the early pictures of Kirchner (Figure 91) or Heckel is in stark contrast to the problematic sexuality of Schiele's vision. The free sensuality of the works of the Fauves or the early German Expressionists has nothing in common with Schiele's often tragic or melancholy type of eroticism (Figure 92). However, while in the case of the French and Germans the viewpoint is almost exclusively male,[39] in Schiele's art we find a more complex type of sexuality that introspectively examines its own nature (Figure 93).

It is noticeable that the artist frequently uses props of various kinds to heighten the erotic effect of his subject. Stockings or underwear, shoes

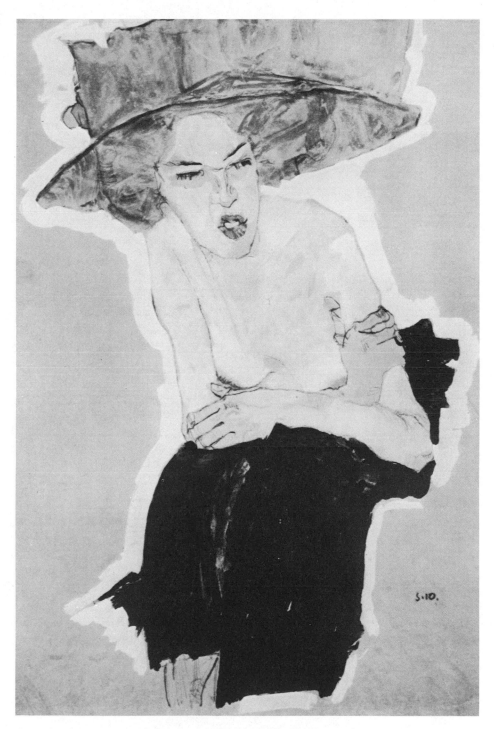

89. Egon Schiele, *The Scornful Woman—Gertrude Schiele*, 1910.

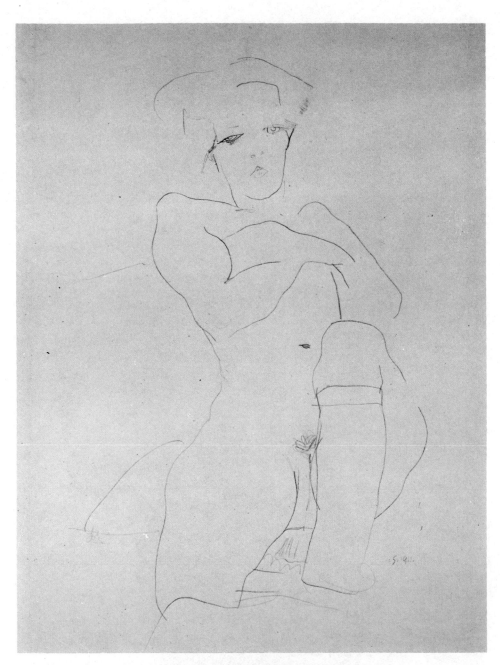

90. Egon Schiele, *Seated Female Nude*, 1911.

91. Ernst Ludwig Kirchner,
Black Girl, Reclining, 1911.

and garters, are objects of sexual fetishism, often accentuated with color
(Figure 94). A lifted skirt, or a movement of the hand, or a glance from half-
closed eyes stamps the female as the seducer, an endlessly enticing animal
being. At the same time there are also empathetic, compassionate depictions
of his mostly very young models, tender embraces and sensitive figure por-
trayals. The preference for the pubescent female is evident here—even as a
teenager Schiele had persuaded his sister, Gertrude, who was four years his
junior, to pose for him in the nude.

In his early, expressive phase of nude portrayal the dominant image is
that of the incalculable, ecstatic, or suffering being, an image similar to what
appears in the self-portraits. What characterizes these in terms of bodily
expression, of gesture and gesticulation, and of the color and form of the
paintings or drawings, is also true of the female nudes. In contrast to the
numerous nude self-portraits he painted, Schiele only rarely did paintings of
female nudes in his early work. He had in any case a large number of clients
for his erotic drawings and watercolors and could also more easily capture
the momentary image or spontaneous movement in these media. In his nudes
and nude self-portraits Schiele worked with a sureness of line that was suf-
ficient to produce a characterization of a figure through a contour or a few
deft strokes. When stylistic analyses of Schiele's work refer to an "encounter
with the rational line" that in his later work produces a particular clarity of
image in portraits or nude sketches, they generally overlook the fact that in
his early Expressionist work as well the line alone is sufficient statement of
content—a phenomenon that can ultimately be traced back to the linear, flat
style of the Secession.

The relationship between the work of Schiele and the erotic graphics of
Rodin is a topic that has been neglected by scholarship until recently. In-
deed, the impact of Rodin on Modernism in Vienna is hardly recognized.
A new study deals with Schiele's response to the Frenchman's work, and
indicates that the young Schiele probably encountered Rodin's art in an exhi-
bition at Hugo Heller's bookshop in 1908; it goes on to discuss the enduring
influence of the sculptor on his work.[40]

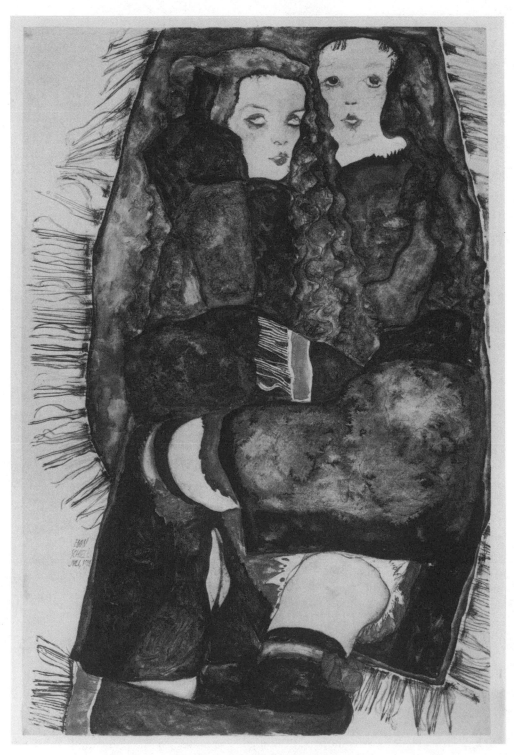

92. Egon Schiele, *Two Girls on a Blanket*, 1911.

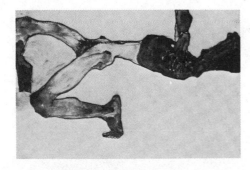

93. Egon Schiele, *Reclining Male Nude with Yellow Pillow*, 1910.

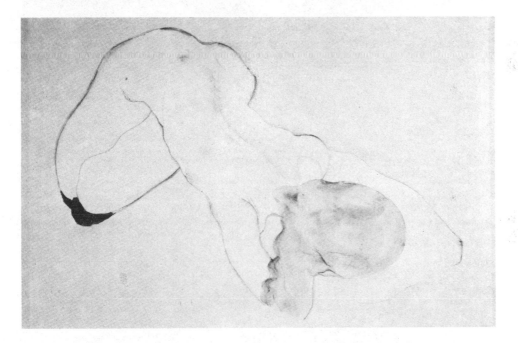

94. Egon Schiele, *Nude with Red Stockings and Yellow Hair*, 1912.

Just as Schiele's vision of eros and sexuality is markedly different from that of Fauves or the painters of "Die Brücke," the treatment of landscape is hardly comparable with their elemental sensualism. The comparison that suggests itself is rather with the work of the *Blaue Reiter* group, with their metaphysical, Neoromantic perception of nature—although there was no contact between this group of Munich artists and Schiele early in his career. Schiele's closeness to nature was indicated during his youth, not only by his numerous journeys through the Austrian Crown Lands, but also by his lengthy stays in the countryside; in Krumau (Southern Bohemia) and in Neulengbach (Lower Austria) he rented garden studios for extended periods.

Compared with the number of his figurative studies, Schiele's drawings and watercolors with themes drawn from nature are comparatively few. In

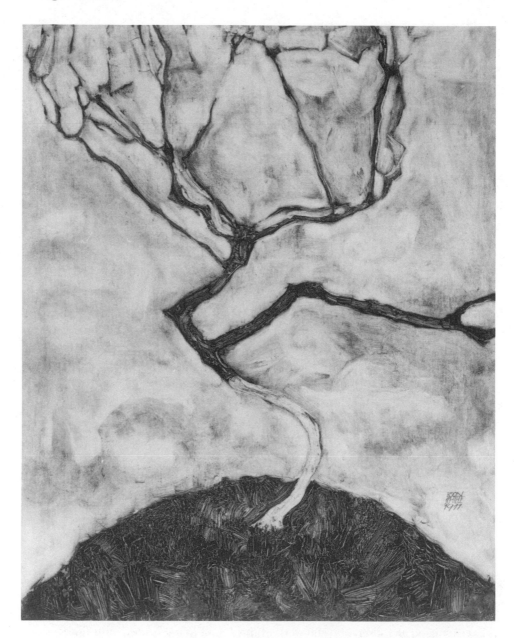

95. Egon Schiele, *Small Tree in Late Autumn*, 1911.

painting, however, the ratio is different: after figurative compositions and portraits there are a considerable number of plant and landscape pictures among his early Expressionist work. Trees and flowers provide the motifs whereby the same development as in the figurative works may be traced. The depiction of a sunflower or a tree in autumn is handled like human repre-

sentation, its stylization corresponding to the gesture and expression in his portraits and self-portraits. In particular, the sunflower becomes for Schiele an ambivalent symbol of life—two decades after the sunflower pictures of van Gogh, and virtually contemporaneously with Mondrian's studies of sunflowers. With Schiele, however, this flower is more the harbinger of death than a symbol of life.

Schiele's *Autumn Tree* of 1909[41] is analogous to his nude self-portrait with ornamental drapery of the same year, while his *Small Tree in Late Autumn* of 1911[42] corresponds to the ecstatic self-portraits that had been produced in the intervening period (Figure 95). This tree gives the impression of being marooned: it stands alone on a knoll, leafless and bare, in an environment that seems to be atmospherically agitated, yet remains without visible boundaries and is undefined; there is no other vegetation, and the tree seems to be in lonely communion with itself. It resembles in many respects one of Schiele's nudes—gaunt and slender, the branches recalling elongated limbs, more like a network of nerves than solid material, and spread in their forks like the long digits of hands. More than simply the representation of a tree, the picture appears as an icon of hieratic persuasiveness.

If one compares this painting with representations of trees dating to the period immediately following, or to a later period, Schiele's Secessionist roots become all the more apparent, as does the influence of Hodler's landscapes. The drama of life and death that is omnipresent in the figurative pictures and in the townscapes is equally the primary source of tension in his representations of nature. Just as Schiele's portraits and self-portraits were somewhat less oppressive from 1912 onward, and the figurative compositions less ecstatic, around 1912–1913 there was a tendency to produce far more eurythmic landscapes; the significance that the artist was striving to achieve no longer lies in the innate structure of vegetation, and this in turn is less obviously exploited as an allegory of existence (Figure 96).

▪ The Visionary ▪

A large group of Schiele's paintings consist of visionary figurative compositions. They differ markedly from the Symbolists' pictorial concepts, although they are indebted to Symbolism for their interest in dreamworlds, irreality, and the mystical. Symbolism, a major influence in late nineteenth-century painting, had played a vital role in the inception of Expressionism's ego-oriented point of view through its emphasis on the subjective world of mood and feeling. It drew substantially on ancient mythology for its material, or alternatively created its own myths, seeking out symbols that were appropriate for emotions or certain types of expressive statement. In contrast to this, Schiele, following the impulses of his subconscious, confined himself primarily to the expressiveness of the figure, and in the elucidation of his

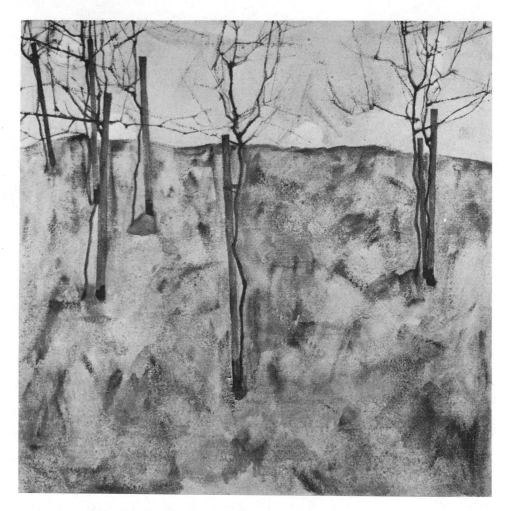

96. Egon Schiele, *Bare Trees*, 1912.

pictorial concept made use of virtually no other elements at all. His gestures
and body language, the arrangement of his color fields, the intensity of their
coloring, and the inner structure of his visionary pictures, cannot be viewed
as the result of a systematic and planned process. They allow, therefore, of
no "decoding" of the kind that can be applied to a Symbolist work.

"I paint the light that emanates from all bodies," wrote Schiele in 1911.[43]
This process, at once rooted in the real world yet decisively transcending
it, is characteristic of his early expressive work. Schiele's fascination with
the ontological manifestations of life meant that purely abstract representa-
tion did not interest him; but equally, he could never reduce the content of
his pictures to a depiction only of what was optically perceptible. To paint
the light "that emanates from all bodies" is a claim that can be traced back
to the ideas of Romanticism, to the concepts of the all-pervading life force

and the animating principle of the universe. Around the turn of the century these ideas held great fascination for many artists and were, in particular, widely available in the formulations of the works of the Theosophists. It is not known whether Schiele was acquainted with the writings of H. P. Blavatsky, Annie Besant, or Rudolf Steiner, but these figures would certainly have been discussed in the circles he frequented. In two letters (not, however, substantiated by Roessler) Schiele spoke of "astral light."[44] On such thin evidence, one can only speculate as to whether certain of Schiele's images may be explained in terms of the "astral vibrations" that extend the physical boundaries of phenomena,[45] and whether the "halos" and auras that surround some heads and bodies in his pictures may be traced to the influence of Steiner. In Symbolist and Jugendstil pictures there are "halos" that emphasize particular individuals. Impressionism and Post-Impressionism also had featured the painterly technique of extension and blurring of the definition of a figure or other representation, so that its borders fade into its surroundings. This technique reaches new heights in Expressionism, where the inner psychological processes are thereby made manifest.

Like Kokoschka, Schiele developed a remarkable sensitivity toward the personal aura of individuals. Both artists created visionary pictures, but in Schiele's work hallucinatory features are considerably stronger than is the case with Kokoschka's. Pictures from 1910 and 1911 like *Self-Seers*[46] (Figure 97), *Melancholia*,[47] *The Poet*,[48] *Death and Man*,[49] *The Prophet*,[50] *Vision and Destiny*,[51] or *Delirium*[52] have their roots in Schiele's studies of himself. They duplicate, or sometimes multiply, the original images, and bring his agitated, often naked or half-naked self-depictions into contact with their "alter egos," with groups of houses emerging from the background as from the mists of a dream, and with a dark and hostile environment that seems to swallow up the light. The mostly closed or half-closed eyes, and the unseeing, incandescent eye sockets, convey the inner psychological turmoil of the subject. Schiele's pictures of the *Dead Mother*, *Procession*,[53] *Madonna*,[54] or *Youth Kneeling before God the Father*,[55] like the group of visionary self-portraits, indicate in their titles their visionary and also repeatedly metaphysical content. The visionary self-portraits in particular are informed by a kind of ecstatic language of gesture, of form and color, that never reappeared in the following years of his artistic development.

Around 1912 certain changes were evident in Schiele's work that, in a smooth transition, led to the phasing out of his eruptive early Expressionist manner. This is most clearly to be seen in the self-portraits, which now took on comparatively lyrical features (Figure 98). As in the portraits produced at this time, the elements of fear, ecstasy, and hallucinatory vision are far less in evidence. The visionary paintings are now more of the nature of a meditation, less of a cry of distress or outrage. The demonization of the subject in nude and erotic depictions is toned down. The recurrent theme of motherhood is no longer so completely overshadowed by the presence of

death. The townscapes, however, retain for a while yet the somber atmosphere of the old houses, and Schiele's landscapes of 1912 still show his suffering-impregnated, tragic perception of nature, although no later than 1913 the representation of topographical features becomes more important, and the horizon grows broader (Figure 99). This development runs parallel to a new exploration of the relationships of space that also shows the first traces of Cubism in his work. After 1912 Schiele's graphic art exhibits a realistic approach to its subject matter and begins, for example in the portrait sketches, to demonstrate a greater preoccupation with the external physiognomy of the sitter. Taken as a whole, these changes herald a development that was to lead to the fundamentally more realistic manner of Schiele's last years (Figure 100).

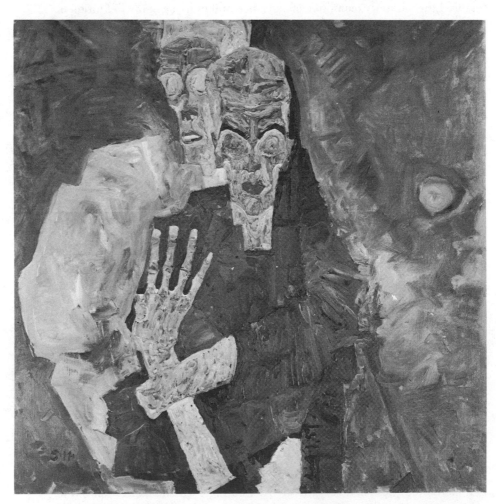

97. Egon Schiele, *The Self-Seers II—Death and Man*, 1911.

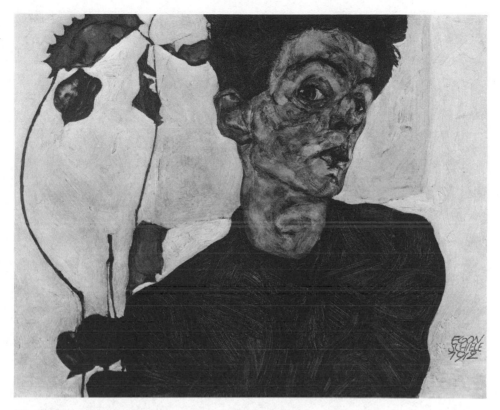

98. Egon Schiele, *Self-Portrait with Chinese Lantern Plant*, 1912.

▪ Letters and Poems ▪

In his prose, among which may be counted several letters, and in a series of poems, Schiele attempted to document the inner life of his psyche in literary form. He produced a considerable number of striking texts. Many of them are fundamental statements of literary Expressionism; at the same time, they often appear, in the roughness and incoherence of their mode of expression, as linguistically rather gauche. Unfortunately, not all the poems attributed to Schiele that have come down to us can be regarded with certainty as authentic. Arthur Roessler, who edited a book entitled *The Letters and Prose of Egon Schiele* in 1921, evidently felt obliged to supply linguistic "improvements" to the texts. These far exceed what is normally considered permissible, compiling new texts from scattered fragments, changing titles, even continually introducing whole new sentences. In the following year, Roessler published another book, with the title *Egon Schiele in Prison*, that contained an account of this episode, written in the first person; it came out in a new edition in 1945 and was long regarded in secondary literature as Schiele's own work. However Roessler substantially modified the artist's original text, so that its value as an authentic source is considerably limited.[56]

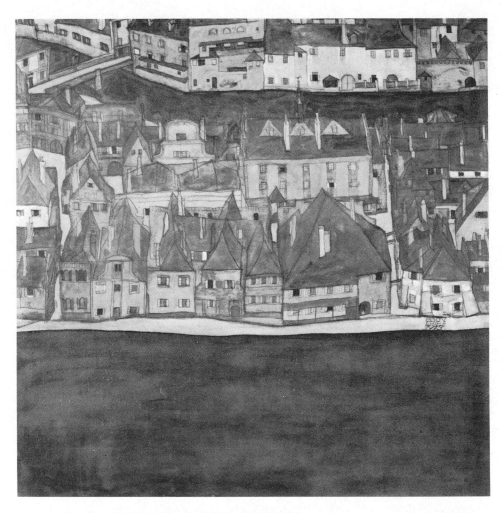

99. Egon Schiele, *The Little Town II*, 1912–13.

100. Egon Schiele, *Organic
Movement of Chair and Pitcher*,
April 21, 1912.

Schiele's poems are not precisely datable and only partly preserved in autograph; according to Roessler, they were written in the years 1909 and 1910. Comparison with the letters does not supply any reason to cast doubt on this chronology.[57] Several poems appeared between 1914 and 1916 in three numbers of the Berlin Expressionist journal, *Die Aktion*, which also published drawings and woodcuts by Schiele.[58] Roessler's edition of *The Letters and Prose of Egon Schiele*, in which most of the poetry appears, is certainly based on the artist's original texts, but can only in part be relied on as a source; changes by the editor, for example, are evident in the versions of poems published in this edition that already had appeared in *Die Aktion*.

The authentic texts of the poems are augmented by letters that have survived in which Schiele goes far beyond the simple transmission of information to the addressee. As far as his early years are concerned, Schiele revealed himself most fully in letters to his uncle, Leopold Czihaczek, to his friend and later brother-in-law, the painter Anton Peschka, and to collectors such as Carl Reininghaus or Oskar Reichel, in which he wrote down aphorisms and spoke of his personal feelings. Here, as in the poems, two themes recur above all others: his perception of himself as man and artist, and his experience of nature.

Schiele's artistic self-image is bound up with a quasi-religious sense of mission that continually finds expression in his letters: for example, on one occasion he wrote, "My pictures must be displayed in buildings like temples."[59] He felt that there was no such thing as a modern art, "but only one [art] that is everlasting."[60] He regarded his work as being produced by an inner compulsion and at the same time without any input from himself. "Artists are the chosen ones, the fruit of Mother Earth, the most disinterested of men. . . . [Their] speech is the speech of the Gods. . . . [Everything] they say needs no justification. They say it, and therefore it must be so,—out of superior intelligence."[61] At the close of a letter in which he writes at length on his views, Schiele adds the comment: "I do not think this, I rather feel it; but not I have written it, I am not to blame. A compulsion drives me, ever urging, ever increasing, that underlies all I have put into words."[62] Describing the symbolism of his painting *The Hermits*, Schiele wrote that he "had to paint the picture, whether it [was] artistically good or bad . . . I have to paint such pictures, which have value only for me. It was simply produced from my inner depths."[63] And at the end of a long screed complaining about the commercialization of art he places the exclamation: "The true artist is the man who is a vehicle for expression! . . . Pictures?—*Out* of me—not *by* me."[64]

Schiele thus perceived himself as the agent of a superior power, a vehicle for spiritual communication that was realized only through his art. When he wrote about his work in 1911, he saw it as "certainly the highest quality presently being produced in Vienna."[65] He wanted to know to whom his picture *Visionary of the Self*[66] was going to be sold, in case he shouldn't wish

101. Egon Schiele, postcard to
Arthur Roessler, probably written
December 1910.

such a person to have it: "Not everyone should have something of myself"
(Figure 101).[67] This lofty attitude of Schiele's is not so surprising when one
considers that a picture was, in his eyes, no less than the incarnation of a
personal message to mankind. He informed Heinrich Benesch that he knew
Benesch would greatly take to a certain picture of his, just as he would "take
to a fellow creature."[68] Schiele's narcissistic consciousness of being among
the elect reaches its apotheosis in a letter to his mother, with whom his
relations remained poor throughout his life: "In me, through my individual
will, all beautiful and noble influences have been united. . . . I will be the
fruit that, after its decay, still leaves behind it something eternally living; it
seems to me that your joy must be tremendous for having brought me into
the world."[69]

The sacredness of the work of art demanded also a higher sensitivity in
the way in which it was handled. Thus, Schiele considered that the sale
of a picture could never be separated from ethical considerations. "A work
of art can never be paid for, it can only be acquired."[70] This being the
case, the artist could never be properly recompensed for his creative work:
"Artists are so rich that they must throw themselves away [on mankind]."[71]
Arthur Roessler, who played an important role at the beginning in the sale
of Schiele's work, complained at one point of the one-sided nature of their
cooperation.[72] Schiele answered this with a long letter of considerable poetic
brio, all written in capital letters, in which he lamented the exchange of art
for money:

I, ETERNAL CHILD — , I BROUGHT [MY] SACRIFICES TO OTHERS, TO
THOSE ON WHOM I TOOK PITY, TO THOSE WHO WERE FAR AWAY,
OR WHO DID NOT RECOGNIZE IN ME THE SEER. I BROUGHT [MY]
GIFTS, MY CUNNING EYES, AND THE GLITTERING, TREMBLING AIR
TO THEM. I PREPARED FOR THEM THE EASY PATHS AND, — I SPOKE
NOT A WORD . . . I, ETERNAL CHILD, — FORTHWITH I CURSED THE
MONEY AND LAUGHED, AS I TOOK IT, WEEPING THE WHILE, THE

PROFFERED [REWARD], THE MASS OBLIGATION, THE BODY'S SUB-
STITUTE, THE TAINTED MONEY. [73]

From these insights Schiele went on to conclude that art cannot and should
not be "applied,"[74] an affront, if ever there was one, to the Vienna of the
Secession and the Wiener Werkstätte.

The strong impact of nature on his sensibility also drew Schiele into liter-
ary formulations. Of these there are several naively cheerful examples, like
an early letter to an unknown recipient in the summer of 1909:

> Dear Fräulein! How are you? Are you quite well and enjoying yourself? Enjoy
> divine nature and let the cool of the evening refresh you. . . . Take pleasure
> in the mass of colors in the morning and in the evening, and dream at nights
> of the great sea of stars. Trace the abundant forms of the clouds along their
> outline and feel the gathering storm. And when you come upon a stream, on
> the banks of which there are blooming meadows and dark woods, there let the
> stream tell its story, as it murmurs, ever murmurs. And listen to the birds at
> dawn, which enjoy their lives as they should be enjoyed and will be enjoyed.
> I send you my best wishes, Egon Schiele.[75]

In one of his letters to Anton Peschka, Schiele also described how he was
filled with elemental joy by the glory of springtime.[76]

Besides these examples, there are also pathos-filled poems and letters
that put into words Schiele's mystical feeling for nature. The experience of
the natural world also meant for him an encounter with God:

> Artists are quick to feel
> the great shimmering light,
> the warmth, the breath of life
> the coming into being and
> the vanishing.
> They feel
> the affinity
> of the plants
> with animals
> and of the animals
> with mankind
> and the affinity of mankind
> with God.
>
> . . .
>
> outside
> in the rampaging autumnal storm
> or high on the cliffs,
> where the noble flowers are
> for them,
> they can have a presentiment of God.[77]

It is noticeable that in the same poem Schiele compares the artist with the "prosaic, ordinary man." The difference between them is primarily manifest in their different capacities to experience nature: against the

> intellectually gifted
> to whom nature is the same
> as a conundrum of the
> sacred arts

he sets those extremely

> superficial persons
> [who] never seek to
> fathom out Nature,
> who whistle the easily learned
> operettas and read
> for pleasure
> [only] novels.[78]

Schiele speaks on one occasion of "flowers like human beings,"[79] and another time of his conviction that "As long as there are the elements, total death will not be possible."[80] The legacy of monism is evident here, and Schiele mixes this with Schopenhauerism in various ways. The perpetual circle of life is constantly celebrated by the artist:[81] "The eternal coming into being, / existing, / and passing away."[82] In the two unauthenticated letters of 1911 and 1912 published by Roessler and already mentioned, Schiele also uses Theosophical terminology. In these he writes of the "astral light" that once made him "evanesce"[83] in its rays, and that another time streamed out[84] from a figure in a painting of his entitled *Revelation*.[85]

To what extent Schiele studied the intellectual currents, the philosophy, and the poetry of his time is hard to judge. The impact of Nietzsche would seem to be evident in his work, in his belief in absolute self-becoming, say, or in the cult of the creator-genius who is seen as tragically alone and uncomprehended. Rudolf Steiner or Ernst Haeckel may also have supplied significant inspiration, together with the poets of "Jung-Wien." When one reads Schiele's statements about the inner compulsion that substitutes itself for the "I" in the creative process, one thinks of Schopenhauer. However, there is no real evidence that Schiele, in contrast, for example, to Kubin, systematically studied such literature. On the other hand, his fascination with Rimbaud *has* been recorded—perhaps stimulated by Osen, who was an admirer of the French Symbolist poet.[86] Schiele possessed a copy of K. L. Ammer's Rimbaud translations of 1907, in which he underlined principally the descriptions of color.[87] In 1910 Arthur Roessler gave him Wilhelm Worringer's *Abstraction and Empathy*.[88] In truth, Schiele always retained a certain naïveté, as may be seen from his writings and from the accounts of his contemporaries. His philosophy of life and his views were probably more the result of intercourse with friends and fellow artists than of any very thorough

reading. All these ideas, as possible sources of inspiration, were of course "in the air" at that time.

▪ Recognition ▪

In the summer of 1909, about the same time as his demonstrative walk-out from the Academy, Schiele took part in the Kunstschau, which implied for the first time recognition by the Klimt circle. In December of the same year, the New Artists exhibition at Gustav Pisko's gallery took place, which led to the first review by Arthur Roessler. Roessler was the art critic of the Social Democratic *Arbeiter-Zeitung* and soon took Schiele under his wing. Of the "unusually gifted" young painters of the time he placed Schiele above all the others.[89] In 1911 Roessler published an essay on Schiele with nine illustrations in a journal he edited called *Bildende Künstler*.[90] Arpad Weixlgärtner also wrote about Schiele on the occasion of the New Artists' show in the journal *Die Graphischen Künste*. He judged the young artist to be "exceptionally talented."[91]

The extended group of New Artists exhibited in 1909 included Anton Faistauer, Franz Wiegele, Rudolf Kalvach, Hans Böhler, and Paris von Gütersloh; the last two mentioned remained very close to Schiele. Hans Böhler and his cousin Heinrich came from the industrialist family of the same name, continually acquired works by Schiele, and occasionally supported him financially. Gütersloh, who, like Schiele had exhibited for the first time at the Kunstschau of 1909, saw in him one of the most significant representatives of the new Austrian art. His stirring *Attempt at a Preface* on Egon Schiele was printed in 1911.[92] Max Oppenheimer was another artistic colleague of Schiele's; both of them did memorable portraits of each other (Figure 102; see also Figure 152). Erwin van Osen and Anton Peschka, who later married Schiele's sister Gertrud, had already exhibited at the Pisko show—Peschka was perhaps closest to Schiele of all these. And in his moments of need, Schiele's loyal mistress, Wally Neuzil, was constantly at his side from 1911 until his marriage to Edith Harms in 1915.

From 1910 on, Schiele had in Arthur Roessler and Heinrich Benesch two enthusiastic collectors of his work who were also ever-supportive friends as he staggered from one financial crisis to another. Benesch was a senior official on the Southern Railway; he and his son Otto were perhaps the most disinterested admirers of Schiele's work, and even as an eighteen-year-old, Otto Benesch, later a director of the Albertina, was already engaging himself vigorously on Schiele's behalf.[94] Two other collectors who have already been mentioned, Oskar Reichel and Carl Reininghaus, purchased Schiele's work consistently from 1910 onward. Both of them possessed more than a dozen of his paintings.

In 1910 Schiele did portraits of many of his admirers—besides Roessler,

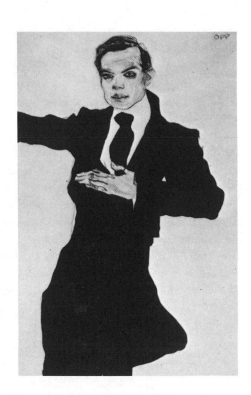

102. Egon Schiele, *Portrait of
Max Oppenheimer*, 1910.

Reichel, and Erwin von Graff as already mentioned, he also did a portrait of
the publisher Eduard Kosmack, a nephew of Adolf Hölzel and for a number
of years the editor of the now-famous journal *Das Interieur*. In 1911 Schiele's
painting of sunflowers (1909–10)[95] was illustrated in the magazine.[96] The
unfinished portrait of Otto Wagner dates to 1910;[97] Wagner also acquired,
in common with Kolo Moser and Josef Hoffmann, a number of drawings by
Schiele.[98] In the same year three postcards designed by Schiele were printed
by the Wiener Werkstätte. Josef Hoffmann also commissioned designs for his
projected Palais Stoclet, which were not, however, carried out—a stained
glass window, representing Poldi Lodzinsky,[99] and some relief metalwork.[100]
The greatest recognition for Schiele, however, must surely have been Klimt's
visit to his studio, after which, it is believed, the two artists exchanged
examples of their drawings.[101] In 1910 Schiele also participated in the Inter-
national Hunting Exhibition in Vienna. It is reported that Emperor Franz
Joseph, confronted with one of Schiele's nudes (not identified) during a visit
to the show, spontaneously exclaimed, "This is really quite awful!"[102]

 In 1911 Schiele's first one-man show was held at the Galerie Miethke, at
which time the previously mentioned commentary of Gütersloh appeared. In
the same year came the first contacts with Germany. He sold a number of
watercolors to Karl Ernst Osthaus for his Folkwang Museum in Hagen. In
Munich, the art dealer Hans Goltz, who represented the painters of the *Blaue
Reiter* group and was an important early publicist of Expressionism, agreed

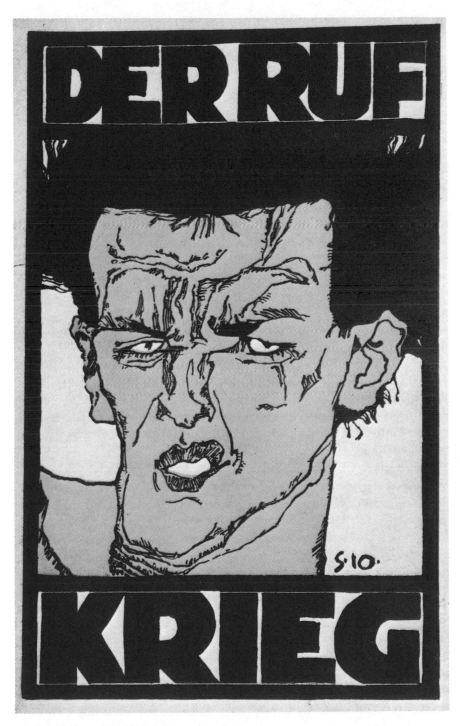

103. Cover of the magazine *Der Ruf*, no. 3 (1912), using a self-portrait of Egon Schiele from 1910.

to sell Schiele's work on commission, although the sales were extremely modest. A little later the Munich Artists' Association known as "Sema" admitted Schiele to membership. This led to the first publication of a lithograph by Schiele, in a folio of fifteen original lithographs put out by the Association.[103] Among the other contributors were Paul Klee, Alfred Kubin, and Max Oppenheimer.

In 1912 Schiele participated in three Munich exhibitions—in the Secession there, in Goltz's gallery, and that of Thannhauser; more importantly, he was represented in the great "Sonderbund-Schau" in Cologne. It was in this year, also, that the Folkwang Museum acquired his picture *Dead City*,[104] the first of his paintings to go to a public museum. Despite all this, it would be wrong to speak of a breakthrough by Schiele in Germany—positive reactions from the public or from the critics were few and far between. He also failed to get the Berlin gallery of Cassirer to take an interest in his work.[105] The suspicion arises that Oskar Kokoschka may have had a hand in this: he was himself represented by Cassirer, and apparently resented for the rest of his life the fame that Schiele acquired as an Expressionist painter, which, to his fury, equalled his own.

The grimacing head of one of Schiele's self-portraits of 1910 was used by the Academic Union for Literature and Music in Vienna in 1912 as an Expressionist motif for their publications. It appeared on the title page of their journal *Der Ruf*, in the number subtitled *Krieg* [War] (Figure 103).[106] It also appeared on the poster for two lectures by Egon Friedell and on the advertisements for two concerts put on by the Union during the Viennese Music Festival; the festival offered performances of works by Schönberg, Zemlinsky, and Schreker, among others.

In Vienna in 1912 Schiele exhibited at the Hagenbund and the Secession, and was also prominently represented in the Budapest show of "New Art from Vienna" organized by Gütersloh. As a result of Klimt's recommendation of him to August Lederer, and of getting to know Franz Hauer, Schiele acquired two important new collectors of his work. By this year, at the very latest, the 22-year-old artist was known outside his own narrow circle, and this was beginning to be reflected in the often considerable prices that his works now fetched. If 1912 is regarded as the end date—albeit within a smooth transition—of his early Expressionist work, it can also be pinpointed as the year by which recognition of the artist had achieved a solid basis. However it was also the year in which Schiele was condemned to three and a half weeks in prison, a shattering experience for him and a spiritual watershed; in the six months following his incarceration not a single painting was produced.

ARNOLD SCHÖNBERG

▪ Painting ▪

Arnold Schönberg was one of the few artists to be influenced by the work of Richard Gerstl during the latter's lifetime, Gerstl for a brief while having tutored him in painting. From his own remarks we know that Schönberg began painting as a 32-year-old in 1906. In an enumeration of those works that were produced before he got to know Kandinsky, Schönberg referred later to "all the pictures that I painted between 1906 and 1911."[1] In total, more than 60 paintings and around 200 drawings and watercolors are now known to exist.[2] Only twelve of the surviving pictures are dated, eleven of these to 1910 and one to 1912. The greater part of his works was completed in the period up to that year. After attending the gymnasium in Vienna and a spell as an apprentice banker Schönberg began to teach himself music (Figure 104). Subsequently he was tutored by Alexander von Zemlinsky, became his friend, and in 1901 married his sister; after spending two years in Berlin he returned to Vienna, and at the time he began painting was a composer receiving only sporadic commissions. His revolutionary musical ideas were appreciated primarily by his pupils, in particular by Alban Berg and Anton von Webern. Schönberg referred to the influence of Gerstl on his painting very occasionally in retrospect, and then only in a contemptuous manner. In 1907 and 1908—possibly even earlier—he was friendly with Gerstl, as the joint summer holidays the two spent in Traunkirchen testify.

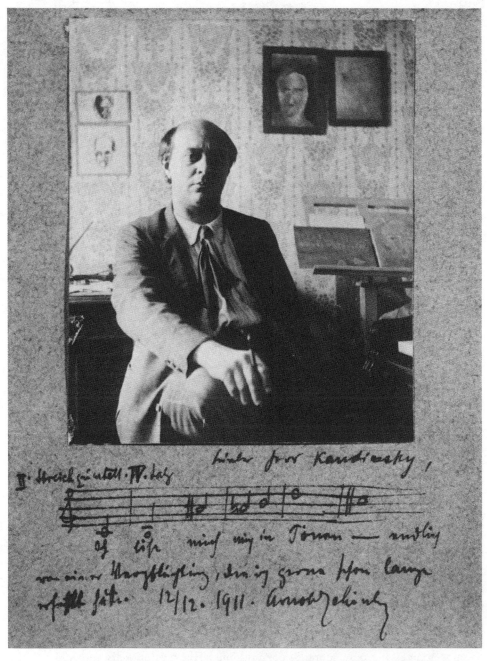

104. Arnold Schönberg, photograph, with a dedication to Wassily Kandinsky, dated December 12, 1911.

Even three decades after Gerstl's suicide Schönberg was unable to for-
give him for the fact that the painter's relationship with Mathilde Schönberg
not only led to the crisis in Schönberg's first marriage, but destroyed the
friendship between the two men:

> As far as a certain Herr Gerstel [*sic*] is concerned, the situation is as follows:
> when this gentleman appeared in my home, he was a pupil of Lefler, for
> whom his painting was apparently too radical. In reality it was by no means so
> radical, for at that time his ideal and his precept was Liebermann. In many
> conversations about art, music, and on all manner of topics, I wasted my ideas
> on him, he appearing always as someone who liked nothing better than to
> listen. Probably these conversations strengthened him in his still rather tame
> radicalism, with the result that, when he saw some totally unsuccessful at-
> tempts at painting that I had done myself and that I showed to him, he took
> their lamentable aspect as having been produced *on purpose* and shouted dra-
> matically: "Now I have learned from you how one has to paint." I think Webern
> can confirm this. Immediately afterward he began to paint in the "modern"
> way. I cannot now judge whether these pictures are any good. In any case I
> was never very enthusiastic about them.[3]

Schönberg wrote these comments in 1938. They cast light on a remark
that he had written four years earlier in his copy of Marion Bauer's book,
Twentieth Century Music, in the section discussing painterly influences on
Schönberg:

> Everything fundamental had been done by the time Kokoschka *appeared* on
> the scene. Likewise, I have never been influenced by another painter, who
> nevertheless asserted the contrary. The latter asserted that he had learned to
> paint through me (something I have never quite understood); my *Gazes* (which
> are unique in their genre) are a clear demonstration of this. Of course I also
> stand in a certain relationship to my contemporaries. But hardly to these two.[4]

Not only is the reference to the emergence of Kokoschka rather malicious,
Schönberg having developed his own artistic style prior to this, but the com-
ment on his own direct influence on Gerstl is also somewhat overplayed.
However Schönberg's radicalism in the field of music would certainly have
strengthened the radicalism of Gerstl's painting.

A substantial group of Schönberg's pictures show the efforts of a dilet-
tante to master the art of portraiture and landscape painting; they are close
to the painting of Impressionism and of the Secession. Portraits like that of
Mathilde Schönberg II[5] or the large-format treatment of Alban Berg[6] are in
their composition and technique by no means revolutionary in the context of
the Vienna of 1910. Landscapes like *Garden in Mödling* (Figure 105) dem-
onstrate in their Pointillist, but not systematic technique, in their choice of
subject, and their emphasis on light effect, the clear influence of Gerstl.[7]
Schönberg's portraits are mostly so stereotyped around the mouth and nose
"that all the sitters seem to be members of the same ill-humored family."[8]

105. Arnold Schönberg, *Garden in Mödling*.

106. Arnold Schönberg,
Self-Portrait from Behind, 1911.

In their heavy-handed awkwardness they sometimes approach the nature of caricature—for example in a small picture of Gustav Mahler.[9] Other pictures by Schönberg show a deliberate and grotesque alienation effect. He dedicated a number of derisive pictures to the figure of "the critic," who was presented as the personification of ignorance. Among Schönberg's aphorisms published in *Der Ruf* in 1912 are some that are designed to settle accounts with the newspaper commentators: "What is the difference between a journalist and a human being! (That is not intended as a frivolous question. There is, in any case, no question about it. The question is simply an exclamation.)"[10]

The numerous contemporary self-portraits by Schönberg seem to have been intended as a kind of confirmation of his identity, as the means by which the self could be fixed in pictorial form.[11] Even his full-length depiction of himself from behind[12] was described by Schönberg as a "self-portrait" (Figure 106). This pathos-ridden tragical representation shows him alone on a path, heading away from the viewer (and possibly alludes to a famous depiction of Beethoven that also shows the composer from the rear). The mockery and scorn provoked by his music because it abandoned traditional tonality, the enduring hostility toward his work in Vienna, his chronic financial problems, the convulsions in his marriage, and the suicide of Gerstl— all this led to a crisis in Schönberg's life that impelled him to try to find an outlet for his distress in painting, and to a correspondingly intensified need of the appropriately expressive means to do so.

This assessment relates not so much to his realistically intended portraits as to the hallucinatory pictures that Schönberg described as *Gazes* (Figure 107). In these small-format pictures, which Kandinsky called *Visions*, lies the essential significance of Schönberg's painting. Not faces, but the act of seeing is what they repeatedly show, so that the stress is actually laid on the

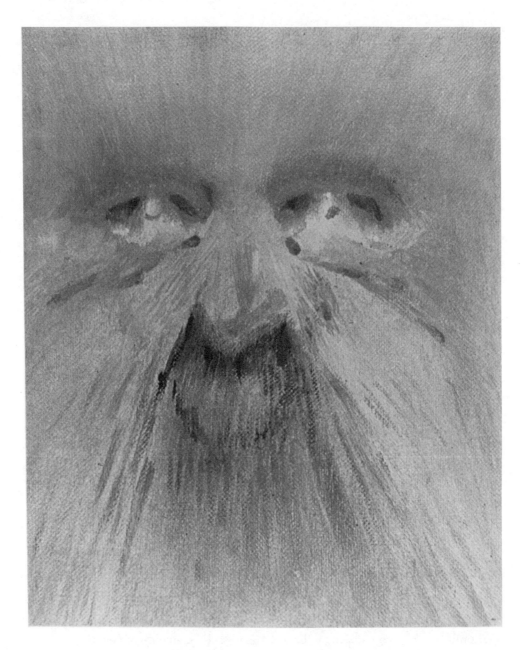

107. Arnold Schönberg, *Tears*.

108. Arnold Schönberg, *Hands*, 1910.

gaze itself. Here, the external physiognomy of a person was subordinated by Schönberg to his way of seeing: "I have never seen *faces*, but instead, when I saw people, I saw only their gaze. Thus I am able to reproduce this gaze in my depiction. A painter catches with a single glance the whole person—but I catch simply his soul."[13] Thus, in Schönberg's musical drama *The Lucky Hand* the men and women appear in the first scene with only their eyes visible, not their faces. The text of Schönberg's monodrama *Anticipation* likewise stresses the horror aroused by a "gaze": "But the shadow crawls yet! Wide, yellow eyes. (A shuddering sound.) So bulging . . . as if on stalks . . . how it stares."

One picture by Schönberg, *Red Gaze*,[14] recalls the archaic process of transforming the experience of terror by pictorial means. By representing it, it was believed, the threat could be kept at bay. This apotropaic function of the picture, which belongs to the most ancient motivations of art, is expressed, not surprisingly, in the representation of the eyes: "The periods when the eyes are most important in art are marked by spiritual crises, by tragic tensions, by a growing consciousness of the deeper layers of the soul, by a turning back into the innermost regions of the self."[15]

In addition to *Gazes*, Schönberg painted a series of much more ghostly visions. The small-format picture entitled *Hands* shows a nightmare apparition of the pincering of a structure shaped like a head by a hand emerging from the rear[16] (Figure 108). An atmosphere of oppressive anxiety also informs the depiction of *The Burial of Gustav Mahler*, with its ghostly,

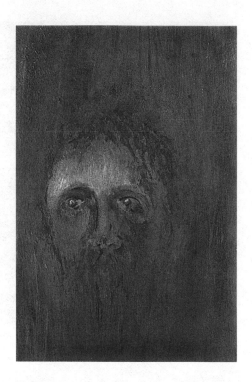

109. Arnold Schönberg, *Vision of Christ.*

will-o'-the-wisp illumination.[17] Even Schönberg's *Vision of Christ*[18] appears more like a phantom than a message of hope and salvation (Figures 109 and 110). Commenting on the first exhibition of his work, Elsa Bienenfeld described Schönberg's pictures as "very strong, very painterly, but at the same time very unnerving." She saw in them "not so much pictures as wild confessions of a tormented and oppressed human soul."[19] Looking back on her childhood, Anton von Webern's daughter spoke of how Schönberg's pictures "made an unpleasant impression on me. As a child I was literally afraid [of them]. It was positively spooky to go into the dining room of the Schönberg home," where his pictures were hung. That Schönberg himself, in contradistinction to the impression created by his pictures, seemed "friendly and quite natural" to the girl[20] speaks for the "psychotherapeutic" nature of those works. Thus they can also be seen as "the creative attempts at self-healing of a depressive individual."[21] Schönberg's visionary painting is consequently more accessible to us in the context of the circumstances that gave rise to it than in terms of purely art-historical considerations. The creative process involved bespeaks not so much a conscious rendering of the subject as a spontaneous release of the pent-up creative forces of the unconscious.

Exactly when Schönberg's *Gazes* and *Visions* were painted is impossible to determine. The earliest knowledge we have of his pictures dates to the exhibition of them in Vienna in October 1910. They would therefore seem to coincide with the period when Schönberg was also putting into words his

110. Arnold Schönberg, *Vision of Christ*

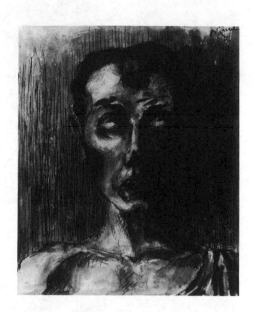

111. Alfred Kubin, *Portrait of a Man*, 1899.

ideas about creativity based on inner perception. He wrote of the artists who "often close their eyes in order to perceive what the [physical] senses cannot convey, to look at the inner workings of what only seems to appear externally. For there, inside, is the movement of the world; what reaches the outside are only the reverberations of this: the work of art."[22]

Schönberg's visionary painting arose spontaneously, without the "stylistic" influence of other painters. The affinity of Schönberg with Kandinsky is primarily a matter of artistic theory and philosophical outlook. The contemporary works of Kokoschka also have little in common with those of Schönberg, seen from the perspective of today. However their contemporaries correctly perceived similarities in the visionary-Expressionist elements in the works of the two artists. This explains the assertion made at the time that Schönberg paints "with brutal simplicity in the manner of Kokoschka."[23]

In February 1912 Schönberg noted in his journal: "Kokoschka is the real thing."[24] This clear estimation of worth was likewise extended to Kandinsky, but only with reservations to the other painters of the *Blaue Reiter*. Of their Berlin exhibition of 1911 he had written that he liked the work of Münter and Marc very well, "but the rest not much. . . . The best was Herr Nolde, whom I got to know, but whom I didn't like much."[25] Schönberg was in fact closer to the work of Kubin (Figure 111) than to that of the *Blaue Reiter* as far as general atmosphere is concerned. He also shared with Kubin his susceptibility to obsessive psychological images: "When I was little I was tormented by a picture that showed a scene from the fairy tale *The Phantom Ship* in which the captain was nailed by the crew to the topmast through his head."[26] The psychological factor, the exorcism of fear by pictorial means, was fundamental to the work of both Schönberg and Kubin. The former could have

already encountered the art of the latter in Berlin in 1902, when Kubin had his first show at Cassirer. There is, however, no other more solid evidence that Schönberg knew Kubin's work. The same goes for that of Odilon Redon, whose phantasmagoric heads look as if they could have supplied inspiration for the *Gazes*.

Literary motifs in the works of Kubin and Schönberg exhibit some very remarkable parallels. Individual scenes from Kubin's novel *The Other Side* are virtually identical with some scenes from Schönberg's opera *Moses and Aaron*.[27] Decadent frenzy, sexual orgy, murder, and manslaughter are paralleled in the two works even in their chronology. Kokoschka's drama *Murderer, Hope of Women* may also be cited as a parallel. In this play, too, "Man" and "Woman," "Men," "Women," and "Girls," come together and in so doing destroy each other.

Schönberg himself valued the *Gazes* and his visionary pictures more highly than his portraits or landscapes (Figure 112). In June 1910 he wrote to Carl Moll that he was artistically satisfied with his *Fantasies and Visions*, but not with his representations of nature (Figure 113).[28] The conviction that the depictions of his inner life were artistically more significant than his realistic pictures was mirrored in his theoretical writings on music: "At the highest level art is exclusively concerned with the description of the inner nature."[29] This dogmatic sentence from the chapter on "Consonance and Dissonance" in Schönberg's *Theory of Harmony* of 1911 applies equally to his music and his painting. In the same year, in an essay on Franz Liszt, Schönberg wrote: "A genuine sense of feeling is never afraid to clamber down ever and again into the dark realm of the subconscious in order to retrieve from there the

112. Arnold Schönberg, *Hands*.

113. Arnold Schönberg, *Landscape*.

unity of content with form."³⁰ Schönberg's very first letter to Kandinsky con-
tained the notable passage: "Art belongs however to the *unconscious*! One
must express *oneself*! Express oneself *directly*! But not one's taste, or one's
education, or one's intelligence, one's knowledge, one's ability. Not all these
non-innate qualities. But the *innate* ones, the *motivating* ones."³¹ These
views were summed up by Schönberg in his famous dictum, which indeed
could be seen as the key to his *Gazes* and *Visions*: "Art does not come from
being able to create, but from having to create."

Schönberg was an outsider and an amateur as far as painterly skills are
concerned. But he is a key figure if his visionary paintings are seen together
with his writings, his theory, and his contribution to a transformation of the
Gesamtkunstwerk. His role is central to Viennese Modernism.

■ Exhibitions: Vienna—Munich—Budapest ■

In June 1910 Schönberg suggested to Carl Moll, the artistic director of the Galerie Miethke, that he should stage a commercial exhibition of his work. Moll answered him as follows:

> It has been clear to me for a long time from numerous examples of your works that you are very gifted in the handling of color: that you have something to say both as a man and as an artist. However, in my Philistine view, one must express oneself in an artistic form when one wishes to address oneself to the public. Your artistic form of expression still seems to me to be at a very unripe stage of development—and I fear, in addition, that your hopes of material gain [from the show] would not be fulfilled if you should make a false step [at this stage].[32]

The letter is evidence of Schönberg's attempt to improve his financial position. In the same year he asked Emil Hertzka, the head of his music publisher, Universal Edition, to obtain portrait commissions for him. Moll's answer certainly led to ill-feeling on Schönberg's part. Their later relationship was also an unhappy one, as a letter from Moll sent from Milan in March 1912 testifies; in this he complains: "Now you have already spurned me for three months," and goes on to reiterate his admiration for Schönberg.[33]

The exhibition at Miethke's never took place. In October 1910 however, the well-known bookshop owned by Hugo Heller put on a show of Schönberg's work, at which 40 pictures were shown. Among them were 14 *Impressions and Fantasies*, 11 *Portraits and Studies*, 5 of them devoted to Gustav Mahler, 3 *Nocturnes*, 2 *Drawings* (self-portraits), 2 caricatures, and 5 studies and figurines for the musical drama *The Lucky Hand*.[34] At the opening the Rosé Quartet played Schönberg's String Quartet opus 7 and 10, which was commented on in detail by Paul Stefan.[35]

The Viennese *Neuigkeitsweltblatt* regretted that Schönberg seemed to value the portraits "no more highly than as 'finger exercises,' while he thinks that in his fantasy pictures he can express the entire depth of his being as an artist."[36] Just as his music had already been derided by most of the critical establishment, his painting now received the same treatment. The *Illustrirte Wiener Extrablatt* reported on October 13, 1910:

> In the Heller Art Salon, where presently an exhibition of "pictures" by Arnold Schönberg is running, the Rosé Quartet yesterday played two chamber works of the master of cacophony, both of them, including the quartet with voices, already known and appropriately judged. The congruence of the painter Schönberg with Schönberg the composer was abundantly clear last night: this music suits these pictures wonderfully well, with the result that yesterday one's ears and eyes were ravished in every sense of the word. In addition, the publication of three *Piano Pieces* by Schönberg is indeed timely, these pieces no doubt being issued by the excellent and hyperactive Universal Edition under the slogan: "We are afraid of nothing."[37]

The more discriminating Elsa Bienenfeld was the exception among the critics, writing in the *Neues Wiener Journal*.[38] The *Merker* brought out a number substantially dedicated to Schönberg somewhat later, in which there were seven illustrations of his paintings, "which immediately impress the informed observer with their remarkable color sense, but the fantastic nature of which seems more the expression of a momentary whim suitable for the sketchbook than what is demanded of a work of art."[39] On October 14, 1910, Arthur Schnitzler noted in his journal: "In Heller's Art Salon saw the Arnold Schönberg pictures. Talent unmistakable."[40] The commercial success of the exhibition was minimal. Gustav Mahler bought three of the pictures, although only after his death was it revealed by Webern that he had been the anonymous buyer.[41]

A concert by the Rosé Quartet in Munich at the beginning of January 1911 resulted in an encounter for Schönberg that was as important for him personally as for his painting. Among the audience were several members of the New Artists' Association of Munich, which later coalesced as the *Blaue Reiter* group: Franz Marc, Alexej Jawlensky, Marianne Werefkin, Gabriele Münter, and Wassily Kandinsky. Kandinsky recognized in Schönberg's music a number of points of contact with his own painting. Marc wrote to August Macke about the concert:

> A musical event in Munich has given me a great jolt; an evening of chamber music by Arnold Schönberg (Vienna). . . . The audience behaved loutishly, like school brats, sneezing and clearing their throats, when not tittering and scraping their chairs, so that it was hard to follow the music. Can you imagine a music in which tonality (that is, the keeping to a key) is completely abandoned? I continually thought of Kandinsky's great compositions. . . . Schönberg seems, like the Association, to be convinced of the imminent demise of the European laws of art and harmony and exploits the musical technique of the Orient (until now) regarded as primitive.[42]

The encounter of the Munich artists with the music of Schönberg led to his working on the periodical *Blaue Reiter* and his participation in the exhibition held under the same name. A few days after this concert, on January 18, 1911, Kandinsky wrote to Schönberg, thus initiating what was to be a lively correspondence. This led in September of the same year to the visit of Schönberg and his family to Berg am Starnberger See, near Murnau. The publication of the correspondence of the two artists corrected earlier speculation about an acquaintanceship between them having existed as early as 1906 or 1909, whereby an influence of Kandinsky on Schönberg's early painting would have been conceivable. From the exchange of letters it is clear that Schönberg first saw Kandinsky's work in 1911 and at that time also came into contact with the other artists of the *Blaue Reiter*.

In 1911 Kandinsky was most interested, among the pictures that Schönberg sent him, in those whose "roots" he described as "purely realistic."[43]

114. Wassily Kandinsky,
Impression 3—Concert, 1911.

By this he meant pictures with physical features, like a garden scene or a self-portrait. On the other hand the *Gazes* pleased him less, as he saw in them "Dematerialization—a romantic-mystical timbre (like what I, too, do)" (Figure 114).[44] The manner of Schönberg's rendering of psychic turbulence in painting apparently seemed too concrete to Kandinsky: This second "root is also a feature of Kokoschka. . . . It interests me, but it does not give me any particular frisson. It is for me too fixed, too precise."[45] Schönberg's self-portrait from behind, on the other hand, was for Wassily Kandinsky the expression of "fantasy in the harshest materials."[46]

At the end of the same year, 1911, Kandinsky included pictures by Schönberg in the *Blaue Reiter* exhibition organized by him in the Galerie Thannhauser in Munich (Figure 115). These items caused an outburst of irritation from August Macke: "And now Schönberg! I am really enraged by these green-eyed watery rolls [*Wasserbrötchen*] with their astral stares. Against the self-portrait from behind I will say nothing, but are these morsels sufficient to justify cracking up Schönberg as an important painter?"[47] And Paul Klee wrote in his diary: "Blow your mind, little man, I think your little hour has struck."[48]

Schönberg's relations with the *Blaue Reiter* were basically confined to contact with Kandinsky. In the group's periodical Kandinsky printed a contribution by Schönberg on art theory concerning the "Relationship to the Text"[49] and reproduced two of his pictures that also had been featured in the exhibition. It is possible that Schönberg himself began to have doubts as to whether he should really have participated in this avant-garde show. In March of the following year Kandinsky again invited Schönberg to take part in an exhibition, this time one organized by Herwarth Walden in the *Sturm* Gallery in Berlin.[50] Schönberg replied as follows:

> I don't think it would be wise for me to exhibit alongside professional painters. I am certainly an outsider, an amateur, a dilettante. Whether I should exhibit *at all* is in itself doubtful. Whether I should exhibit within the context of a particular group of painters, is now virtually *decided* in the negative. In any

115. Arnold Schönberg, *Vision*.

case it seems to me inappropriate to exhibit any pictures other than those in which [I] believe! And of those, one must show ten to twelve pictures, if one wants to be understood, which of course I do.[51]

On the other hand, Schönberg exhibited at a show in Budapest at the beginning of 1912 at which works by Schiele, Gütersloh, Faistauer, Kolig, Robin Christian Andersen, and Kokoschka were also to be seen.[52] Albert Paris Gütersloh had organized the exhibition. He also asked Schönberg, in an undated letter of 1911, to send his portrait of Alban Berg to Budapest: "Could you not arrange for Berg to send it? It would be good for certain narrow-minded critics to have to admit that you 'are also capable of producing that.'"[53] Gütersloh had already written in an earlier letter to Schönberg about the planned show: "It seemed to me that in the absence of phenomena such as you and Kokoschka, the picture of what might very loosely be called the art of today would be only half complete."[54] A letter from Schönberg to Kandinsky in December 1911 speaks of 24 pictures, for which he was to get a room to himself in Budapest. "I will actually exhibit no portrait or similar work, only what I call the *Impressions* and *Fantasies*."[55] Taking this together with the letter from Kandinsky previously quoted, one can conclude that

Schönberg had not been satisfied with Kandinsky's choice of pictures for the *Blaue Reiter* show. He had in fact sent Kandinsky eight of his *Fantasies*,[56] of which, however, only two were shown in Munich. Probably also, the selection of pictures for the Schönberg book of 1912, which was most likely also made by Kandinsky, had seemed to him unsatisfactory.[57]

The Budapest exhibition, under the title "New Art from Vienna, 1912," took place in the Künstlerhaus. It was accompanied by a catalogue, the introduction to which had been written by Gütersloh, this text also appearing in the *Pester Lloyd* newspaper. In the section on Schönberg, Gütersloh stressed that one had to appreciate the antiaestheticizing standpoint of the artist and the significance for him of the mystical if one was to arrive at an understanding of his work: "Only those will comprehend his pictures, who, like him, are able to experience the ghostly nature of all things directly, that is with the immediacy of hallucination and without the compromising intervention of 'beauty.' "[58]

The one-man show in Vienna in 1910, the participation in the *Blaue Reiter* show in Munich in 1911 and in the Budapest show of 1912 are the high points of the recognition of Schönberg's painting. In 1912, also, the *Blaue Reiter* periodical featured essays on his painting and it was likewise treated in the book published in honor of the composer with contributions from friends and pupils. In this there were essays on Schönberg the artist by Kandinsky and Gütersloh.[59] According to Gütersloh, Schönberg subjected "the effeminacy of painting to an ice-cold, logical gaze, and then, when the eye has been weaned from the concrete to such an extent that the north pole of understanding has been arrived at, leads it back to the borders of the prehistoric." He saw in his painting the attempt "finally to realize that condition of psychic primitiveness, that pristine form of living and being, without which an existence in the present seems to be lacking in true legitimacy."[60] For Gütersloh, with his antipositivist conception of art, Schönberg was the chief witness for the prosecution, in that his pictures asserted "that the real 'I' begins where man ceases to suspect its existence."[61]

Schönberg's admirers published this book in the year in which painting to a large extent began to lose its importance for him. After seven years in which he had painted a good deal and also exhibited his works, he now devoted himself only sporadically to this medium. *Gazes* and *Visions* consequently appeared no more.

▪ Synesthesia ▪

In only two and a half weeks during 1909, Schönberg composed the music for the High Expressionist monodrama entitled *Expectation*. The text had been written by a young medical student, Marie Pappenheim, who also sat for a portrait by Schönberg (Figure 116).[62] The only character is a woman who searches for her lover in a night-enshrouded wood, and at the end of

116. Arnold Schönberg, *Portrait of Marie Pappenheim*, 1909.

117. Max Oppenheimer, *Portrait of Arnold Schönberg*, 1909.

the piece discovers him lying dead. The passionate monologue expresses the soulful turmoil of *Expectation*, in which fear is mixed with anticipated pleasure, jealousy, and hatred. Schönberg remarked later that this monodrama could be "perceived as a fear-impregnated dream."[63] He had clear ideas about its visual presentation. In August 1910 he asked Max Oppenheimer, who already had painted the composer's portrait (Figure 117), to visit him: "I would very much like you to do the sets for my monodrama, which will be performed at the Volksoper."[64] However the planned production by Rainer Simons never took place.

More emphatically than in *Expectation*, Schönberg combined the expres-

sive possibilities of different media into a *Gesamtkunstwerk* consisting of music, speech, stagecraft, and light effects in his "drama with music" entitled *The Lucky Hand*.[65] He had already begun working on this a year before the composition of *Expectation*, in the same year (1908) in which the String Quartet opus 10 and the greater part of the George Song Cycle, *The Book of the Hanging Gardens* (op. 15), revealed a breakthrough to free atonality. Schönberg himself wrote the text for *The Lucky Hand* and also did a number of pictures and drawings for it.

The main characters are a "Man," a "Woman," and a "Gentleman." The man experiences the rejection of his love for the woman, who bestows her affections on the gentleman. In the four short and vivid scenes, rather than any plot unfolding, evocations of mood follow in quick succession like strikes of lightning. The first and the last scene of the drama, in which respectively six men and six women appear, act as a sort of frame for the two middle scenes. "With deepest pity," as the stage directions specify in the first scene, and "very softly," they approach the man who lies before them on the ground, on whose back a catlike mythical creature is sitting: a "hyena with enormous batlike wings" that "appears to have sunk its teeth into his neck." Only the eyes should be visible of the faces of the men and women. They speak to the man: "Still you long for the unattainable. . . . You, who have the celestial within you, yet yearn always for the earthly." Their lines are similar in the final scene, in which the man again lies in the same place on the ground; now, however, their tone is "complainingly harsh": "Must you again endure what you have so often already endured? . . . Do you feel only what you can touch, aware of your wounds only on your flesh, your pain only in your body?"

In the second scene the man solemnly declares his love for the woman in ecstatic formulations. He seems not to notice that the woman has transferred her affections to the gentleman and is in the process of "eloping" with him. The third scene features the man encountering rough, heavily toiling laborers; in front of them, with one blow of a hammer on the anvil, he fashions a magnificent tiara. "That is the way to make jewelry," he shouts at the workers, who make as if to fall upon him. Through an alteration of the lighting the man becomes aware of the union between the woman and the gentleman. He implores the woman on his knees to stay with him; she, however, slips away from him and pushes a stone onto him, under which he is buried. The stone should produce the same impression as the mythical creature in the first scene. After this follows the closing scene already mentioned.

This strange, highly compressed piece of action—it lasts only twenty minutes—derives its symbolic references at least in part from Schönberg's own life. The first sketches for *The Lucky Hand* date to October 1908. He finished the text in 1910 and the music in 1913.[66] Thus the composition of the work falls in the period immediately following Gerstl's affair with Mathilde Schönberg and the painter's suicide. The impact of these events is partly reproduced in *The Lucky Hand*. Schönberg himself is easily recognizable

in the figure of the man. His face and breast, as the text directs, are "disfigured by numerous bloody scars, some of them ancient"; one foot shows "on the upper surface a great open wound, as if caused by a nail." That Schönberg saw himself in this sort of light after the crisis in his marriage is evidenced by the draft of a will that was probably made around the time he started work on *The Lucky Hand* and that suggests he may have contemplated suicide at that time.[67] The woman appears in the drama as "youthfully beautiful" and may be interpreted as Mathilde; the gentleman as "elegantly and fashionably dressed, distinguished and handsome in bearing," a reference to Richard Gerstl. The peculiar scene with the workers and the piece of jewelry is perhaps a metaphor for Schönberg's creativity in an uncomprehending world. The tiara would thus stand for his own art, toward which the workers (critics?) react "menacingly" and "contemptuously," "muttering among themselves and seemingly planning an attack on the man." This symbolism can also be placed in a mythologizing framework: the man, bringer of light, Prometheus, Siegfried, Samson . . . is broken by the world, in which the temptress woman plays the diabolic role.[68] Here again the struggle of the sexes appears as a literary leitmotif of the fin de siècle, as it did in Kokoschka's contemporary dramas.

Schönberg also created a series of sketches and color designs for *The Lucky Hand*. They demonstrate, along with the directions in the text, how he conceived the presentation of the work. These sketches recall the fearful world of his *Gazes* and *Visions*. The sketches for the first scene, "Chorus and Mythical Creature," show thirteen sources of light like dots in surroundings dominated by dark blue and violet hues[69] (Figure 118). This magical, mysterious world is contrasted in the second scene, entitled "The Source of Light," with a radiant ball of light, the rays of which flood the entire stage.[70] In these and other, similar, more or less abstract paintings, Schönberg was concentrating above all on the effects of color in the staging of *The Lucky Hand*, this being of crucial importance in the conception of his work.

The stage directions also contain very precise instructions regarding the use of color, which is designed as an indispensable component of what is happening on the stage. Thus, for the third scene, the instructions read:

> As it becomes dark, the wind gets up. At first softly whispering, then swelling ever more threateningly in volume. Simultaneously with this crescendo of the wind comes a crescendo of light. It begins with weak, reddish light (from above) that is transmuted through brown into a dirty green. From this develops a dark bluish grey, followed by violet. This is cloven by an intense dark red that becomes ever lighter and more garish, in which, after it has attained the quality of blood red, more and more orange and then light yellow is mixed, until the glaring yellow light alone remains and is thrown from all sides onto the second grotto. This must already have been opened up at the commencement of the light effects, and forms a part of this crescendo, in that (more weakly than the rest of the stage) it is lit from within following the same pattern. Now it basks likewise in yellow light.

118. Arnold Schönberg, setting for Scene I, *The Lucky Hand*.

In this form of light direction Schönberg was evidently influenced by the stagings of the Viennese Opera, which broke new ground in the effects created by Alfred Roller working in conjunction with Gustav Mahler.[71]

Roller had been a professor at the School of Applied Art since 1899, was for a while the editor of *Ver Sacrum*, and played a leading role in the setting up and designing of the Secession exhibitions. At the Kunstschau of 1909 his work dominated the section on theater art, with three rooms being devoted to him. His sets for Wagner's *Tristan and Isolde*, staged at the Hofoper in 1903, caused a considerable stir. They epitomized the retreat from naturalistic scenery and the substitution for it of an overall concept that expressed the essential dramatic and musical nature of the work. Above all, it was his use of lighting in his highly stylized productions that seems to have impressed Schönberg.

The Berlin music critic Oskar Bie, writing of the Viennese production of *Tristan and Isolde*, coined the phrase "lightmusic" [*Lichtmusik*].[72] This characterization harked back to the revolutionary ideas of production developed by Adolphe Appia, who used lighting to differentiate the separate areas of the stage. His theories arose principally out of his engagement with Wagnerian music-drama and sought to create a counterpart "in fleeting light" to Wagner's "eternal melodies." Appia's article "Staging the Wagnerian Drama," published in Paris in 1895, interpreted light as the external symbol of the inner

significance of the plot and postulated for it the same expressive power as Wagner had ascribed to the *leitmotiv*.[73]

The Lucky Hand reflected Schönberg's interest in synesthetic phenomena. Synesthesis, in particular the release of optical impressions by means of sound stimuli and vice versa, fascinated fin-de-siècle poets and painters, as well as composers.[74] At about the same time that Schönberg was working on *The Lucky Hand*, that is between 1908 and 1910, Alexander Scriabin was creating his *Prometheus—the Poem of Fire*. Its performance was supposed to involve a "clavier à lumières," a light-piano, that translated the individual sounds into their appropriate colors—this in fact being the rediscovery of an idea conceived in the late Baroque period.[75] Similar considerations are to be found in the theories of Wassily Kandinsky. In his treatise on *The Spiritual in Art*, which appeared in 1912, he codified the relationship between color and the psyche. Individual colors are thus given quite specific functions, which can extend to, among other things, the release of sound perceptions. These researches further developed earlier ideas, such as those of the Italian Divisionist painters, according to whom the colors and form of a picture can communicate in the same way as "waves of melody."[76] Kandinsky's stage piece *The Yellow Sound* expressed in its very title the relations between color and sound. This work appeared in 1909; *Harmonizing Colorings* was the name given by Schönberg to the third of his Five Orchestral Pieces (op. 16), which were composed in the same year. Even in his answer to Kandinsky's first letter, Schönberg had written that what was "vital" to him was "the color (not 'beautiful' color, but expressive color in the sense of harmoniously expressive)."[77] However Schönberg never went as far as Kandinsky in codifying his perception of color values into a system.

In a talk on the drama given in Breslau, Schönberg made clear that he aimed at producing a synesthetic overall effect in *The Lucky Hand*. He referred here to his attempt with this work to "create music using the resources of the stage."[78] This is also emphasized in a letter to his music publisher Emil Hertzka, probably written in the autumn of 1913. There he revealed his ideas concerning a film version of the music drama. Schönberg saw in a "cinematic rendition" considerable advantages over the presentation on stage:

> [Because] in a film version (that work of the devil!) the unreality of the action, which is due to the poetic form in which it is cast, can be better extracted . . . my greatest wish is therefore to achieve the opposite of what the cinema usually attempts to do. I want: *the most extreme unreality*! The whole thing should work, not like a dream, but like musical chords. Like music purely and simply. It should work, not like symbol, or sense, or thought, but simply like a play of appearances consisting of colors and forms. Just as music never carries a sense with it, at least not outwardly, although it has one in its essence, so should [the piece] be merely like "sound" for the eyes; as far as I'm concerned everyone can react to it with thoughts or feelings as they would to music.[79]

It is noticeable, too, that in the same letter Schönberg wrote that all the principal scenes should be designed by a painter—in which context he men-

tioned "for example, either Kokoschka, or Kandinsky, or Roller." Schönberg also thought of giving such painters the job of coloring the film after it had been shot, in order to bring out the "play of color" of the drama as he had conceived it.

In 1895 Hermann Bahr had already written an article on "Color Music" in *Die Zeit* explicating the basis of synesthesia.[80] Both Elsa Bienenfeld's review of Schönberg's first exhibition and a number of articles in *Imago*, a journal of psychoanalysis in Vienna,[81] testify that synesthetic ideas were much in the air in the Vienna of 1910. Elsa Bienenfeld opposed the idea

> that one should understand Schönberg's pictures according to the psychological assumptions of "*audition colorée*," the concept of the immediate release of color images by means of sound stimuli that has been taken to its greatest lengths by the young French intellectuals (Rimbaud, René Ghil, Suarez de Mendoza); [but one should try to appreciate that] he wanted once to make the attempt to show how he sees men and moods in flashes of brilliant clarity and fixes them in painting through rapidly executed impressions.[82]

This comment should serve to caution us against a too one-sided interpretation of Schönberg's pictures as simply documentation of synesthetic experiences. They were apparently often regarded as such, and indeed this was sometimes the sole justification allowed them—thus, for example, Paul Stefan writing in *Merker* observed:

> Music alone is an insufficient means for him; he draws the eye of the viewer into the experience, and recently has struggled to make of the drama a *Gesamtkunstwerk*. But all this was born of the music. Only musicians, only those who know Schönberg's music and its secrets, should look at these pictures, for only they will experience them elementally as sounds transposed across all the accidental boundaries of form. It was therefore virtually essential to have the music of Schönberg ringing in one's ears as one viewed this exhibition.[83]

It is not Schönberg's painting, however, but *The Lucky Hand* that demonstrates the "transposed sound," and this primarily by means of the lighting effects. In a later letter containing explanatory comments on the production of his music drama, Schönberg wrote that *The Lucky Hand* was first and foremost "a color and light play."[84]

It should not be overlooked in this context that synesthetic approaches to music dramas, such as also are evident in the color shifts in Kokoschka's stage works, may equally well show an awareness of the possibilities of synesthesia, although occurring in the work of nonsynesthetes. Indeed, the somewhat transient preoccupation of Schönberg with synesthetic presentation possibilities raises the question "of whether Schönberg was a genuine synesthete at all, that is whether he really experienced visually the sounds he heard . . . or, certainly, whether, when he saw colors, he really experienced them aurally as well."[85]

In *The Lucky Hand*, as in his *Visions* and *Gazes*, Schönberg applied himself exclusively to the experiences of the psyche without attempting to inte-

grate these into a coherent framework of symbolism. Contemporaneously with
Kokoschka, Schönberg devised the "I drama" of Expressionism, in which
the determining factors of the "plot" are solely the subjective feelings and
subjective experience of the individual, in this case of "the Man."[86] *The
Lucky Hand* fulfilled many of the demands of Edward Gordon Craig and
Adolphe Appia for a new form of theater and of music drama that was to
free itself from anecdotal realism and make manifest the inner significance
of the action. The play realized the concept of the "integrated work of art"
that Lothar Schreyer perceived as the new challenge of the theater.[87] It was
executed in terms of the most extreme forms of expressiveness, and in an
exceptionally compressed time scale as far as the development of the action
was concerned.

The many parallels of form and content between *The Lucky Hand* and *Mur-
derer, Hope of Women* are not accidental. Kokoschka and Schönberg knew
each other from the circle of Adolf Loos. Even if Schönberg set down in
writing his first ideas for *The Lucky Hand* almost exactly a year before the
premiere of Kokoschka's drama, the development of these nevertheless took
place after the Kunstschau performance of the *Murderer* piece and its publi-
cation in *Der Sturm*; Kokoschka's drama must therefore be allowed the claim
of precedence. The relevant sources also show that Schönberg, in 1909,
wanted to arrange some sort of cooperation with Kokoschka—as he tried to
again, four years later, in the context of a possible film version of *The Lucky
Hand*. In a postcard from Max Oppenheimer to Schönberg on September 9,
1909, the artist informs Schönberg that he had spoken with Kokoschka about
the composer's plans and ideas, that these had met with the latter's approval,
and that he had promised to write to Schönberg.[88] About a month later, on
October 13, Kokoschka wrote to Schönberg: "Write to me when we can meet,
then I will bring you all the initial sketches. In any case write and tell me
how much you have already put on paper. Your OK."[89] In an undated note
that was certainly written around the same time, Kokoschka urges the com-
poser: "The Man must be something between effeminacy and brutalism. Do
you already know by heart the inner, irrepressible cries and shattering and
secret explosions and quiet physical structures? OK."[90]

▪ Theosophy ▪

Schönberg's theory of art included metaphysics. He legitimized his creative
work in his own eyes by describing it as a "deciphering method" that could
and should help people toward an insight into the mystery of existence. In
1912 Schönberg wrote to Kandinsky:

> We must become aware of the fact that we are surrounded by mystery. And
> we must have the courage to look this mystery in the eyes, without fearfully
> demanding that "an answer" to it be supplied. It is important that our cre-
> ative energy is devoted to replicating such mysteries from those that are all

around us, thus attempting not to solve the mystery of our soul, but to decipher it. What we gain in the process is not a solution, but a new ciphering or deciphering method, in itself worthless, that offers a means of creating new mysteries. For mysteries are an image of the undescribable; an imperfect, that is to say, human image. But if we but learn from this to accept the possibility of the undescribable, we draw nearer to God, since then we no longer insist that we should understand him. And since we then no longer measure him by the standards of our understanding, we will no longer criticize him, or deny him, because we cannot solve the mystery of him by means of that human inadequacy which is for us the [greatest possible] clarity.[91]

In his views about artistic creation Schönberg, like Kandinsky, was influenced by Theosophical and Anthroposophical ideas. At the beginning of this century the Anthroposophy taught by Rudolf Steiner, formerly the general secretary of the German branch of Theosophy, fascinated many artists, chiefly because of its antipositivist and mystical features. Like Steiner, Kandinsky believed that man stood on the threshold of a new era of the spirit.[92] This may be seen from his book *On the Spiritual in Art*, published in 1912, in which discussion of Steiner's "Theosophy" and the journal published by him entitled *Lucifer-Gnosis* is included.[93] That Anthroposophic terminology was used in the *Blaue Reiter* circle, or at least known there, is evidenced by the letter of Macke, which has already been quoted, and in which he refers ironically to the "astral stare" in Schönberg's pictures. The concept of the astral had a special significance in Anthroposophy in connection with the "astral body," which was regarded as a link between earthly beings and those of a higher order. Kandinsky also believed in reincarnation. He wrote to Schönberg in November 1911 that he "also had a very strong [feeling] that we will all live several times. I mean, in the flesh."[94] A very similar opinion was shared by Gustav Mahler, whom Schönberg revered.[95]

Schönberg probably had already come into contact with Theosophical ideas during his first stay in Berlin, between 1901 and 1903. In Vienna he had been more or less without work, and in Berlin he went to Ernst von Wolzogen's cabaret, Überbrettl, where he was offered the job of bandleader. (The theater had 800 seats and had been designed by the revolutionary Jugendstil architect, August Endell.) At the same time, Rudolf Steiner was holding lectures in Berlin on "Christianity as a Mystical Fact" for a circle to which Ernst von Wolzogen also belonged.[96] Later, Schönberg called his own *Theory of Harmony* a "secret science." This description chimes with the Steiner work published a short while before entitled *Secret Science in Outline*, and the *Secret Teaching* of Helena Petrowna Blavatsky, the founder of the Theosophical Society, whose book was likewise published in 1899.

Another influence on Schönberg was August Strindberg, reverberations of whose stay in Berlin still affected the intellectual circles of the city. Strindberg had developed his mystical religiosity under the impact of Swedenborg's writings, and his work was filled with it. A decade later Schönberg gave musical expression to these influences in *Jacob's Ladder*. In this he made direct

reference to Strindberg's *Jacob's Struggle* and to Balzac's *Seraphita*.[97] In the same year in which Schönberg returned to Vienna, 1903, an obituary of Otto Weininger by Strindberg appeared in *Die Fackel*.[98] In the foreword to his *Theory of Harmony* Schönberg mentions Weininger, Strindberg, and Maeterlinck, and describes their relationship to his own teaching.[99] Schönberg's deep admiration for Strindberg is also documented by the fact that in 1913 his library contained 28 volumes by this author. Kandinsky, too, stressed the importance of Maeterlinck in his book *On the Spiritual in Art*: "He led us into a world that can be described as fantastic, or rather, beyond the reach of the senses"; and he could reveal, according to Kandinsky, in a single word its "internal resonance," beside and beyond its direct meaning.[100] Schönberg's symphonic poem *Pelléas and Mélisande*, composed during his first stay in Berlin, was based on Maeterlinck's drama of the same name.

The absolute value placed on creation from the unconscious, the charismatic nature of Schönberg's personality, and its consequent influence on a circle of young people who idolized him and were fiercely loyal to him; and finally, also, Schönberg's role as a mentor, reflected a widely held belief at the turn of the century in the healing powers of the artist. It was already present in another form in the Secession, which saw artists as the healers of society. It became even more marked in Schönberg's case through the influence of contemporary mystical ideas, which in the artistic and literary circles of the day were taken up and developed with what proved to be such enduring consequences.

BETWEEN SYMBOLISM
AND EXPRESSIONISM:
ALFRED KUBIN

Vienna had significantly less importance as the intellectual and cultural background for Alfred Kubin's personal development than it had for the other artists discussed in this study. He was born into a north Bohemian military and bureaucratic family in Leitmeritz and grew up in Salzburg and Zell am See; after continual failures in his school career and four years as an apprentice to his uncle, the owner of Beer's photographic studio in Klagenfurt, the 21-year-old Kubin moved to Munich in 1898, where he studied at the Academy. His integration into the bohemian life of Schwabing and his participation in discussions about social and philosophical problems left a lasting imprint on his personality (Figure 119). The first recognition of his work was to follow principally in Germany, where numerous folios of his work were published, where his many book illustrations appeared, and where his novel *Visions from the Other Side* was published in 1909. Although by 1914 Kubin had already had ten one-man shows and had participated in numerous exhibitions in Germany, in Vienna he had exhibited only at the eighteenth Secession show of 1903 and twice elsewhere with a bigger selection of works: at the Galerie Miethke[1] in 1906 and at Hugo Heller's bookshop in 1914.

Kubin's circle of friends was also primarily recruited from Munich's artistic and literary circles; his wife was the sister of the then well-known writer Oskar Schmitz. On the other hand, with the exception of Fritz von Herzmanovsky-Orlando, he had hardly any contact with artists in Vienna. In 1905 he visited Vienna for the first time;[2] in 1908 he expressed surprise that

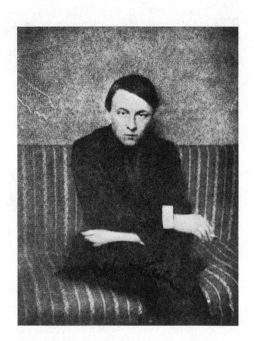

119. Alfred Kubin, photographic
portrait, 1903.

Herzmanovsky did not go to study in some other city but remained in Vienna:
"Naturally one can study more or less anywhere, but I wouldn't have thought
that [Vienna] provided the most stimulating contemporary environment."[3]
And in 1914 he was "hardly disposed to speak well of Vienna, especially
since my big show at Heller's had *no* material success *at all*; and a *succés
d'estime* in Vienna is something I can well live without."[4] Instead Kubin
moved to the Upper Austrian village of Zwickledt in the summer of 1906,
where he remained for five decades, until the end of his life. Thus reactions
to metropolitan Vienna had no very direct effect on Kubin's work.

▪ Early Works ▪

The roots of Kubin's initial subject matter, and of its artistic treatment,
stretch back a century beyond the symbolism of the fin de siècle to the work
of Francisco Goya, whose etchings, in particular, supplied him with inspira-
tion. The influence of Goya is manifest not only in several drawings by Kubin
that appear to contain direct quotations from the Spanish artist but in the
general approach of his early work. The similarities may be seen in its struc-
ture, composition, and its effects of light and shade, as well as in its cruel
irony and even voyeurism, in the case of some extremely violent depictions,
or the ostensibly absurd content of others.

According to Kubin himself, Max Klinger's etchings excited him even
more than those of Goya, and he claimed that he "shivered with pleasure"[5]
when seeing Klinger's cycle of etchings entitled *The Finding of a Glove*.
Apart from Klinger, his preferred artists at various periods were Félicien

Rops, Edvard Munch, James Ensor, and Odilon Redon[6] (Figure 120). There are also signs that he was fascinated by Rembrandt's graphics and received considerable inspiration from the art of Aubrey Beardsley and Franz von Bayros.

Despite his preference for graphics, Kubin concentrated on drawing in his early years, perhaps because of a consciousness of a stubbornly persistent

120. Odilon Redon, *The Eye*, 1882.

technical insufficiency that was easier to correct in the case of drawings than of other media. Kubin's contemporaries had already criticized him for his inadequate technique: "He can draw nudes and he cannot draw nature," wrote Richard Schaukal in his article on Kubin in 1903.[7] Kubin's own justification for giving original drawing preference over etching was that he "was inundated with ideas, all of which demanded immediately to be realized."[8] Kubin aimed to introduce the effects of aquatint and etching into his drawing— the first through the use of a technique producing spray-like effects, and the second through harshly drawn lines and hatching. The narrow black borders that are characteristic of his earlier drawings, and beneath which he put his signature, strengthen the impression of a first print from a plate; so do the numbers that are to be found on many drawings; these are not intended for the chronological numbering of works, but rather to group drawings together in various series analogous to a series of etchings. Kubin often combined his filter-spray work with a primarily gray or brown wash, which, however, he sometimes applied in pale red or blue, or with cautiously added watercolor.

This form of India ink drawing was developed by the artist from 1899 onward. In the same year he began his studies at the Academy, after coming to Munich early in the year to prepare himself in the Schmid-Reutte private school. However he only attended the academy course for a short while; he preferred to gain inspiration and ideas from existing collections or from his circle of friends.

After a culturally deprived childhood, Kubin experienced the world of art and literature opening before him in Munich almost as a revelation. Until that time, his aesthetic inspiration had been limited to the magazine *Gartenlaube*, the illustrations of which he used to copy as a pastime.[9] Kubin describes as an overwhelming experience his first visit to the Munich Alte Pinakothek, where he felt himself "transported with joy and wonder."[10] At the same time he discovered new philosophical perspectives, being deeply moved by his reading of Kant, Schopenhauer, and above all Nietzsche.[11] In Schopenhauer's idea of destiny and in Nietzsche's image of heroic isolation he discovered the counterpart to his own experience of life. Another strong influence was provided by his intercourse with the young Munich philosopher and later characterologist, Ludwig Klages. In Munich, also, he came into contact with the work of Johann Jakob Bachofen, whose writings on *The Grave Symbols of the Ancients* and *Matriarchy* enduringly affected his vision of the nature and role of women.

Kubin's psychological instability during his early years in Munich brought him continually to the verge of catastrophe. During his school days and his period as an apprentice he had undergone several nervous crises that were partly the result of conflict with his father and that culminated in suicide attempts. Around 1900 Kubin noted in a sketchbook that he was "predestined to suicide, the thought of which has always afforded me the greatest joy, and from the idea of which I still derive a sort of pure bliss. I am absolutely

convinced that my entire conscious life is nothing but the slow, but end-lessly precise and thorough preparation for this single, by no means terrible act." [12] In 1903 he wrote to a friend of his "average mood, a loathing of [my] existence," and added that he was "inwardly unfortunately completely contra-dictory—torn this way that, nihilistic." [13] In December of the same year his first fiancée died after they had been engaged for only a short while. The de-tailed confessional letter that he wrote to his sister soon afterward gave clear indication of his intended suicide. Kubin wrote to her of his "recognition that life, my life, is nothing but pain endured every conscious minute. . . . Death, nothingness, is the aim of the world, and equally of all that is in it, of the individual forces that together comprise it. . . . *I want not to be. I want to have ceased to exist.*" [14] However shortly after writing this he met the woman who later became his wife. With his marriage in 1904 he came into "more secure circumstances," [15] both spiritual and financial. The beginning of this new phase of his life meant also an emphatic caesura in his artistic development.

The works completed before 1904 are sharply differentiated from those that followed—above all in the manner in which they mirrored Kubin's grim preoccupation with death and destruction, sexuality and the world of dreams, religion and history. In their manifold literary and philosophical references they appear as a product of European Symbolism, amplified, however, by the introduction by Kubin of his deepest psychological experience into his artistic creations. They mingle a perspective of philosophical pessimism and existential disgust. It is possible to see them as both a commentary in images on the happenings and ideas of the artist's time and allegories of his problem-atic personal experience of life. Kubin's latter-day disillusion with western civilization is united with escapist exoticism; death wish unites with the cult of eroticism; a penchant for mythology and the occult unites with the rejection of positivism and rationalism.

Human and animal forms, together with all manner of intermediate beings, are the presiding powers in numerous drawings by Kubin, generally as agents of destruction, or of torment, or as grotesque elements of a nightmare (Fig-ures 121 and 122). His apparently instinctive preference for the fantastic—already evident in the childhood drawings—and his gift for caricature were thus combined in an art that seemed to rejoice in horror and dread. [16] As the point of departure and culmination of a senseless and merely excruciating biological process, woman always appears, the symbol of evil, of temptation, of folly (Figures 123, 124, and 125). Kubin shared this hatred of women with many intellectuals of his time, among them Strindberg, and especially Otto Weininger, whom he described in 1903 as "the greatest human being this century." [17] Kubin cited as justification for this bizarre judgement Weininger's book *Sex and Character*, which appeared in that year, and which expounded (at interminable length) the thesis that men and women are forever destined to mutual enmity. Kubin's work also reflects the pessimistic tendencies of

121. Alfred Kubin, *The Pursued*, around 1902–3.

122. Alfred Kubin, *Crucified Snake-Man*, 1899.

123. Alfred Kubin, *My Muse*, around 1902–3.

Bachofen's works, which influenced the intellectuals of the Klages circle. The figure of the Ur-mother who gives birth to all and devours all, which appears in many drawings, has its origin in Bachofen.

Kubin recorded in his work every kind of persecution, affliction, madness, every sort of perversion, and all the dark forces of the soul and of destiny that tortured his imagination. He is the authentic incarnation of Hieronymus Bosch in our century, whose work, indeed, he often cited in his support. The so-called "Weber portfolio," published in 1903 (and named after the publisher, Hans von Weber, Kubin's friend and patron in Munich) afforded an insight into this Bosch-like world of the imagination.[18] With this collection Kubin first became known outside the confines of his colleagues and friends. The selection of fifteen drawings excluded sexual and religious themes but brought together nonetheless some of the most savage examples of Kubin's searing personal indictment of the world and society; this was epitomized for example in the figure of *War* (Figure 126), a hooved giant seen advancing with massive strides to annihilate an entire army; or in *The Best Doctor*, whose head resembles a dead man's skull, and who nonchalantly suffocates a man lying ill; or in *Epidemic* (Figure 127), which is symbolized by a huge skeleton-man, looking eerily like a malign insect, who pours his black poison on a group of houses; or in *The Hour of Death*, represented by a clock tower that has only a falchion for a clock hand, which on the hour, every hour, cuts off one of the heads leaning out. Then there is *Horror*, which shows two schematic figures who cling to a ship that has just capsized; its broken mast is in the form of a monstrous skull rising from the stormy waters, its left eye swollen to a gigantic, staring ball. *Hunger*, *Power*, or *Knowledge* are other grotesque statements in images of horror that were to be found in

124. Alfred Kubin, *The Woman on the Horse*, 1903.

125. Alfred Kubin, *Mother Earth*, around 1901–2.

126. Alfred Kubin, *War*, around 1901–2.

the portfolio. *The Fate of Mankind*, the first drawing in the Weber portfolio, summarized Kubin's view of the world (Figure 128): in a cauldron-shaped valley stands the figure of Fate, a female with a shrouded head, rising as tall as the mountains; at her feet the amorphous masses of mankind are desperately attempting to flee, but with her rake she sweeps them back toward the precipice.

The publication of this facsimile edition was no great commercial success, but it did attract a number of reviews. In 1902 Kubin had already had a one-man show in Berlin at Cassirer's, and subsequently had many others in German towns. In 1904 he participated in the ninth "Phalanx" exhibition in Munich alongside Kandinsky and other artists. Even at this early stage a number of reactions seem to have been stimulated by the ideas given such

127. Alfred Kubin, *Epidemic*, around 1901–2.

128. Alfred Kubin, *The Fate of Mankind*, around 1901–2.

vivid expression in Kubin's work. He himself said to Hans von Müller that
he regarded his strength as lying in his "proclivity for philosophizing."[19]
His work for the magazine *Der liebe Augustin*, which was edited by Gustav
Meyrink and only survived for one year (1904), brought him further pub-
licity.[20] Various drawings by Kubin appeared in the magazine, and these
demonstrate certain facets in common with the other creators of caricature
and the grotesque who worked for *Der liebe Augustin*—for example Gino
Parin[21] or Jaroslav Panuska. One drawing by this Prague artist entitled *Decay*
is very similar to the sort of thing Kubin produced: a solitary wanderer con-
templates a dilapidated archway, into the framework of which a huge skull
has sunk its teeth.[22]

▪ Vision and Dream ▪

One of the principal features of Kubin's work is his hallucinative turn of mind
(Figure 129). In Munich this came to the fore with an intensity that was sel-

129. Alfred Kubin, *Fabulous Beast*, around 1903–5.

dom to be repeated later. In his autobiography Kubin described how he once
went into a nightclub

> in obedience to some inner prompting. Inside, something very remarkable,
> and for me decisive, happened to me spiritually. . . . As the little orchestra
> began to play, my surroundings appeared suddenly clearer and sharper, as if
> illuminated from some different angle. In the faces of the people sitting round
> about I suddenly saw animal lineaments; all sounds were curiously alien, as
> if cut off from their source; I heard only a scoffing, moaning, booming babble
> that I could not understand, but that seemed nonetheless to have a specific
> and quite ghostly inner meaning. . . . At that point my mind was invaded by

visions of black-and-white pictures—it is impossible to describe the multi-farious richness of images produced at that moment by my imagination. . . . I left the theater hastily, for the music and the many lights began to disturb me, and wandered aimlessly in the dark streets, continually assailed by images, and indeed feeling as if I had been literally ravished by some dark power that conjured up in my mind strange creatures, houses, landscapes, grotesque and horrible situations. I felt wonderfully at home and elated in my enchanted world; as I ran wearily onward, I came upon a tea room, and went in. Here also everything was unusual. Even as I entered I had the impression that all the waitresses were wax dolls, operated by some incomprehensible mechanism, and that I had surprised the few customers, who appeared to me as insubstantial as shadows, at their private satanic business. The whole of the inner regions, with the little organ and the buffet, seemed highly suspicious, like a mock-up that served only to conceal the secret heart of the place—apparently a dimly lit, byre-like bloodstained cave. What I could retain of these images, which changed with baffling rapidity while I remained completely passive, I sketched with a few indicative strokes of the pen in my notebook. On the way home the turmoil in my mind continued; the Augustenstrasse seemed to be growing into a vast ring around our city.[23]

Two decades later Kubin still saw the "original concept," the ideas behind his pictures, as produced by a "dark urge"; its execution was then however "subjected to an infinitely flexible control mechanism of the conscious mind." Especially

in the early years I was subjected to an obscure creative force that continually tormented me with its power, the pictures appeared before my "inner consciousness" as in a kaleidoscope, altering themselves in a steady stream like the billowing sea. . . . As I contemplated such waves of images I was, of course, in the grip of an *alien* power (a magic?) and I submitted myself as a human being with complete passivity to these minutes or hours (I never measured their duration), which were like a kind of drunken interlude.[24]

A further source of inspiration for Kubin lay in his dream experiences: "Night dreams as well as so-called daytime or waking dreams" were always a "rich mine" of experience for him (Figure 130). Very early on he "created good ideas out of dreams."[25] Ferdinand Avenarius was one of the critics to indicate this. In a detailed article in 1903 on Kubin in the journal *Kunstwart* he characterized the artist's work as "dream painting."[26] He postulated his thesis with the rhetorical question, "Can there in fact be any other form of vision for art than the dream?" Of Kubin he remarked that hitherto no one had so "imperturbably attempted, as he [had], to formulate his creative ideas in terms of dreams." Avenarius also expressed the hope that "such a great horde of mankind's dream images" could be retrieved, "especially since it is perhaps only in the world of dreams that the ancient secrets of sex, race, and species have left their last vivid traces." The context in which Avenarius sought to place Kubin's work, therefore, bound together the experience of

130. Alfred Kubin, *The Hand*, around 1900–1903.

the individual with that of humanity. He thus placed the greatest emphasis on the "exclusivity of the lineaments of dreams," which indeed he regarded as the hallmark of Kubin's work.

Kubin later began to take an interest in the intellectual potential of the interpretation of dreams. He wrote to Herzmanovsky in 1911 that he was "still reading Professor Sigmund Freud's stuff, very acute Jewish psychology, very interesting on infantile sexuality and analysis of dreams";[27] and again in 1914 he wrote that "Freud's discoveries are for me the most valuable of material, original and fertile. Of course they don't lead to the Holy Grail, but then *scholarship never does.*"[28] "I have been strengthened in this opinion since I got to know so many psychologists, among them a number of 'practicing' Freudians. O. Schmidt even knows Freud personally."[29] Later he again formulated his reservations with regard to attempts to unravel the significance of the dream experience in an essay devoted to the topic: "We should, however, be careful not to treat the individual phenomena purely analytically, for example according to some interesting moral or psychologizing system, in order to penetrate the secret of their meaning; we should instead leave intact their genuine, undiminished symbolic power. I consider the immediate creative vision to be much stronger and more potent than a long-winded analysis of it."[30] This statement of Kubin's on the interpretation of dreams may be extended to cover attempts at psychoanalytic interpretation of his own

work or of the artist himself. His symbolically rich pictorial discourse has always been a tempting target for such analysis.[31] However a concentration on dream, hallucination, and symbol alone is seldom sufficient to unlock the full significance of his world of images; only with the additional input of intellectual reflection did Kubin fashion his visions into specific and consciously intended artistic statements.

▪ Painting ▪

After 1904 the emphatic and in many respects monumental characteristics of Kubin's early work were replaced by an extraordinarily inventive and experimental approach to his art. Kubin may have regretted the passing of the "vivid, pale-faced, apparitions from the subconscious" that now "increasingly rarely and in weakening form occurred, until they ceased altogether,"[32] but in their place came other impulses of extreme intensity. One of these was supplied by his encounter with the work of Breughel in Vienna, offering, as he expressed it, the "elemental visionary nature of [an] art that springs direct from the unconscious."[33] The admiration for Breughel was so unqualified that Kubin began to regard his entire work to date as of dubious value, and set about the search for new forms of expression. He now began to be interested in color, and in particular in a technique of color application that Kolo Moser had demonstrated to him on his visit to Vienna in 1905. Kubin thus started experimenting with the special effects to be obtained from mixing watercolor with paste (Figure 131), and also began to paint a good deal in tempera.

His experience of light and color on a journey to the South of France and Italy in autumn of the same year had reinforced this urge to paint in color.[34] The enormous potential of the (for him) newly discovered technique was now made manifest in a series of small-format pictures, all with fantastic themes. The important role that accidental factors could play in these pictures, particularly in the admixture of paste, was an additional stimulus to his creativity. Paintings in monochrome, or alternatively with a rich color spectrum, demonstrate a new interest in refined effects. Among the mysterious representations that now occur are to be found magical forests, flowers, and birds, painted in all manner of iridescent and sparkling colors, oriental scenes, an Indian bridal carriage, and a mobile treasury. The fairy-tale exoticism of these works differs sharply from the grotesque scenes of an imagined archaic Orient in Kubin's earlier work. However there were also at this time spectral pictures showing such scenes as shipwreck, death, and decay (Figure 132). These are likewise executed in a fundamentally more realistic manner that is far removed from the style of comparable themes in earlier works.

Although in these paintings there is still an observable thematic relationship to the previously treated themes, in the tempera painting Kubin dealt with something completely new (and, indeed, not later repeated) that em-

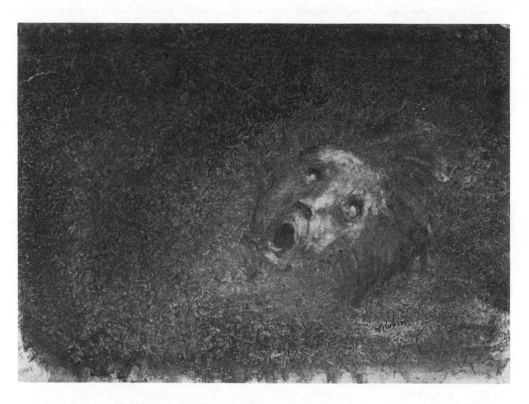

131. Alfred Kubin, *Soul of a Child*, around 1905–8.

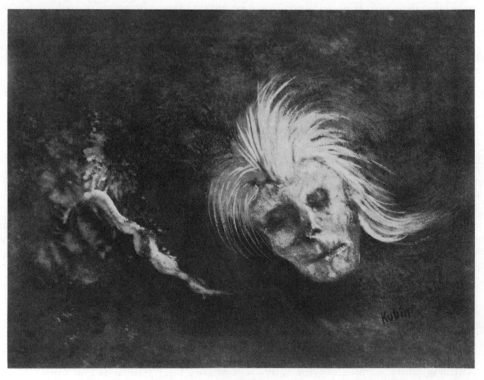

132. Alfred Kubin, *Vision*, around 1905–8.

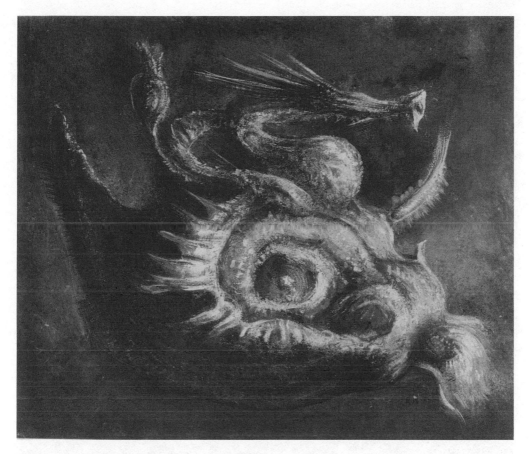

133. Alfred Kubin, *The Ox-Fish*, around 1906–8.

bodies some of the most surprising aspects of his work. The tempera pictures appear to describe an Ur-world existing on a different planet, inhabited by creatures of some extinct fauna, and undergoing cosmic catastrophes of a terrible beauty. Bizarre organic structures made up of crystal, mist, and radiated light, growths and dissected excrescences, microscopic organisms, deep-sea vegetation, hairy, glazed, or slimy forms that slowly extend themselves or are frozen in convulsions, all these float apparently weightless in space and are illuminated from some undefined light source (Figures 133, 134, and 135). Many such images recall studies under a microscope or the creatures in an aquarium.[35] With these "monstrous eruptions" (as he himself named them)[36] Kubin deliberately sought to create something parallel to the existing forms of nature that would exceed even nature herself in its fantastic richness.

It is likely that such works also reflected, directly or indirectly, Ernst Haeckel's *Art Forms of Nature*. This had been published in 1862, together with an expository portfolio depicting the world of the radiolarian, and further

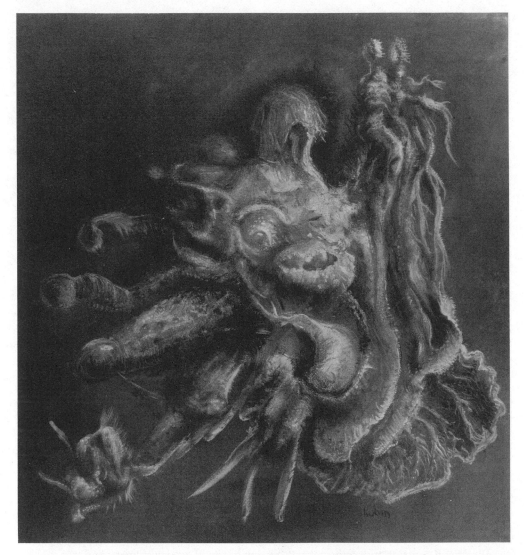

134. Alfred Kubin, *The Preserved Specimen*, around 1906–8.

editions appeared at the turn of the century.[37] In this, through its presentation of a hitherto virtually unknown sea fauna with its unique and bizarre structure, Haeckel aimed to supply "modern fine arts and the booming applied arts with a storehouse of new and beautiful motifs."[38] Haeckel's publication was eagerly taken up in Munich, and underpinned the advance of an art tending to eschew the illustrative function.[39]

With his painting at that time Kubin seems close to the most radical representatives of Munich Jugendstil. These included Hermann Obrist, with his complicated and convoluted vegetable studies, his scarlet flowers and mussel shapes, his whirlpools, sea gardens, and rocky grottoes (which already

seem to foreshadow much of what appeared in later Expressionist architectural visions); or August Endell, with his *Gesamtkunstwerk* of the "Elvira" studio and its wild ornamentation. These were the manifestations in Munich of the development since the 1890s of Art Nouveau, inspired by England and France. Tendencies similar to Kubin's nature-transcending approach to representation may be observed in the calligraphy of Adolf Hölzel, in the ecstatic landscapes and cosmos pictures of Hans Schmithals, or in the animal and plant watercolors of Karl Strathmann, with their very marked "horror vacui."[40]

A little later, Kubin took his principle of abstraction to its furthest extent in his novel, although only in verbal form. The narrator describes how he attempted

> to create new images . . . directly from the secret rhythms I had discovered; they coiled and tangled and exploded around each other. Then I went fur-

135. Alfred Kubin, *The Pupated World*, around 1905–8.

ther. I abandoned everything except the line and developed in a few months a peculiar line technique: a fragmented style, more written than drawn, that expressed the tiniest fluctuations of my mood like a highly sensitive meteorological instrument. I called this process "psychographics."[41]

The works of Odilon Redon were certainly also an inspiration to Kubin in his painting. He visited the artist in the winter of 1905 in Paris and was able "to acquire several beautiful and unusual works by the master."[42] Redon's method of working, whereby he combined Symbolism with his own dream experiences and set down the resulting synthesis in many small-format paintings ranging across the whole spectrum of color, doubtless encouraged Kubin in his experiments. The individual color accentuations standing out from a generally subdued palette in Kubin's work, the undefined space and size relationships, and the mass of suggestive polymorphic structures correspond to much that is to be found in Redon, yet Kubin's pictures go considerably further into the realms of the fantastic. In many respects they foreshadow the artistic ideas of the Surrealists, in that they present a world that is beyond what can be perceived by the senses, but that appears just as "real" as one that can be. Although such pictures are still uncanny, even threatening, in their effect, they are nevertheless far removed from the despairing nightmarish atmosphere in Kubin's early drawings.

Kubin seems to have devoted himself intensively to exploring the potential of painting from 1905 until the beginning of 1908 (Figure 136). For a while, painting gave him "as much satisfaction as my work had seldom given me before or was to give me in the future."[43] He considered "that painting with its capacity for plastic effects, which were so well adapted to rendering the bodily features, was actually, in terms of form and artistic impact, far better [as a medium] than drawing."[44] He wrote to Hans von Weber in the autumn of 1906 that he had turned to "completely new artistic problems that it would take some time for art lovers to get used to."[45] In August 1907 he informed Fritz von Herzmanovsky-Orlando that he would soon be tackling oil painting[46] and wrote to him on New Year's Day of the same year: "Here we have at present a wonderful winter, the landscape quite mysterious, phantasms of snow, and often a *single* play of color, with a marvelous grey as its basis. I am trying out the boldest impressionistic effects in my painting."[47]

When, however, the "new intoxication" of painting had faded, "all experiments of color and form became . . . wearisome"; and after he had briefly attempted to immerse himself in the "flat and harmonious technique of the Post-Impressionists,"[48] in January 1908 Kubin went back "*exclusively* to drawing."[49] Since March of that year he had been searching for a hand press for "possible copper etchings."[50] Depression, provoked by illness and the death of his father, led, however, to long phases of enforced inactivity; it seemed to Kubin that "in my drawings . . . I have achieved all that I was capable of" (Figure 137).[51] It was only after the catalytic effect of writing his

136. Alfred Kubin, *Hydrocephalus*, 1908.

137. Alfred Kubin, *Agrippina*, around 1900–1903.

novel, *Visions from the Other Side*, that he found his way back to drawing at the end of 1908.

▪ Mysticism and the Occult ▪

In his autobiography Kubin describes the "ancient church at Zell am See" and the "countless experiences . . . of mystical uplift" that he had there.[52] His proclivity for mysticism and the hallucinative experiences of his early years may be placed alongside his later interest in occult writings and practices. His fatalism, which was philosophically underpinned by the ideas he came into contact with during his time in Munich, led him to explore Far Eastern thought and beliefs as well. In 1903 he was already writing of "the blissful frisson provided by mystical art . . . in me you have potentially the purest Buddhist monk."[53] It is probable that his acquaintance with Buddhist teaching came through Gustav Meyrink. The previously mentioned journal *Der liebe Augustin*, which Meyrink edited, brought out a series of reproductions of Kubin's work in 1904, among them his drawing of *The Buddha*.[54] Through Meyrink, Kubin was initiated into occult practices.[55] A

decade later, when Kubin was inquiring of Alexander von Bernus about his experiments in alchemy, the latter recommended Meyrink's "little laboratory," since Meyrink "makes numerous alchemical experiments and knows how to read the formulas."[56] From 1907 Kubin worked on illustrations for Meyrink's novel *The Golem*,[57] "a really weird thing!"[58] When the publication of this was constantly postponed, however, Kubin turned instead to *Visions from the Other Side*.[59] By this time he had already had "bad experiences with Buddhism—insofar as I found it incompatible with a creative artistic existence."[60] In 1911 his immersion in this religion was to lead to "a Buddhist crisis."[61]

In Munich Kubin became acquainted with esoteric lore and learning through his friendship with Karl Wolfskehl, who, together with Stefan George, Ludwig Klages, and others, had formed the "Cosmic Circle." An immersion in esoteric literature followed, especially during the winter of 1907–1908, at a time when Kubin could only sporadically apply himself to artistic activity.[62] The comprehensive library that he collected over the years—at his death it amounted to 5,500 volumes—was concentrated on mystical and occult works. When the poet Alexander von Bernus held séances in Stift Neuburg near Heidelberg in the summer of 1909, both Wolfskehl and Kubin were among the participants. Bernus was cofounder of the Schwabing shadow plays and a friend of Kubin's since the latter's arrival in Munich. At these gatherings there were evidently psychic "happenings," because Kubin wrote after he returned to Zwickledt that

> here, fortunately, everything is very homey, no astral blows threaten me, no table sets itself in motion. My wife is extremely skeptical of the table phenomenon that we witnessed, being of the view that "we probably just imagined it"; then again, the blow on Karl's left shoulder was certainly due to an overwrought mental state, etc., etc. Actually the knocking seemed to come from inside and outside the table, and it levitated quite perceptibly five or six times. Still, the force of gravity was certainly overcome somehow; the knightly dubbing on the shoulder I did not experience myself, but Wolfskehl must have felt it; but whether objectively speaking it was an [unknown] force, I have no idea—I have no inclination to believe in "ghosts" in the vulgar sense; I think rather of unknown forces that are somehow released inside us, that come together and exert energy; God knows what it was.[63]

Kubin continually referred to his "deep mystical feelings"[64] in conversation with Herzmanovsky: "In general, I am more mystical than ever."[65] "I live in fact in a general aura of mysticism, without individual or specific experiences. . . . I seek exclusively a deepening of my awareness, only that."[66] Herzmanovsky himself was at that time involved in occult circles in Vienna and on several occasions asked Kubin for information about literature or personalities that had to do with occultism. However his interest was evidently far more in the sensational aspects of it than was the case with Kubin. The latter wrote to him: "I will struggle to experience this secret realm, which is

so deeply rooted in my humanity, and to pour the results of that experience into the mold of art."[67]

Kubin's casual remark to Herzmanovsky that he "had read a lot of very interesting . . . mystical and philosophical works,"[68] and similar statements, give little clue that the contents of his library were so comprehensive at that time. However a lengthy letter to his friend in February 1910 answers the inquiry of the latter regarding "books with mystical content" with a recital of the book titles of 48 authors, whose works are briefly summarized.[69] Among these are to be found German mystics like Jakob Böhme, Meister Eckehart, Johannes Tauler, and Angelus Silesius, the writings of Ruysbroeck and Swedenborg, and a long list of references to Eastern religion and philosophy, together with the secondary literature pertaining to it. Works by Görres, Kierkegaard, Bachofen, and Weininger are mentioned, alongside those of German, English, French, and Russian writers and poets. Kubin especially stressed the importance of Hofmannsthal's novella *The Fairy Tale of the 672nd Night*, Rilke's *Book of Hours*, and Strindberg's *Blue Book*, which he had apparently already urged on Herzmanovsky a year before.[70] Finally, he advocated for "the very advanced" the philosophy of Julius Bahnsen, with which he "had been occupied for four years," and who was "for *me* the Alpha and Omega of all spiritual knowledge."

The pessimism of Bahnsen, which owed a good deal to Schopenhauer, was not seen by Kubin as being in contradiction to his mysticism. A few months later he wrote of death as "the only solace for bitter hours. . . . It is precisely this ineluctable end that gives to life a grandiose, melancholy beauty. In my mystical awareness I am too much a realist and seeker after truth to be influenced by phantasms like 'eternity, immortality, the transmigration of souls' and so on."[71] In Bahnsen Kubin seemed to have found confirmation of his feelings in the form of a philosophical system. From him, also, he took the motto for the epilogue of *Visions from the Other Side*: "Man is simply a nothing with consciousness."

In his less gloomy moments Kubin was not in fact so categorical a pessimist. Looking back in his autobiography, he wrote that in 1909 "he began gradually to reject . . . that Puritan, life-negating attitude"—by which he meant that of Schopenhauer and Bahnsen—and instead "lapsed into a brittle skepticism."[72] Kubin's recommendation of authors such as H. P. Blavatsky, Annie Besant, and Rudolf Steiner must have specially interested Herzmanovsky; in 1913 the latter was a member of the "Adyar" Theosophical Society in Vienna, possibly even its vice-president.[73]

Among the more obscure writers mentioned by Kubin was Jörg Lanz von Liebenfels, whose *Theozoology* he likewise recommended. The elitist cultural attitudes and racist content of this work attracted both Strindberg and Herzmanovsky (and later Adolf Hitler); they both joined Liebenfels's "Order of the New Temple."

Kubin's letter thus provides us with an extraordinarily heterogeneous pic-

ture of the intellectual tendencies that interested him. It ranged from the Indian Vedas and Laotse through medieval mysticism to contemporary esotericism in conjunction with "the ice-cold thoughts of the philosophers."[74] As a sort of ironic reference to his painfully acquired knowledge, Kubin wrote at the end of his letter, "Is not Meyrink basically nothing but another *Simplicissimus*!!!!?" He meant by this reference to the German satirical periodical that it was really not necessary to read so much: "If one looks at the work of the demonically driven draftsman and painter with understanding, that too is a good way [to enlightenment]. It all depends *only* on the *inner* experience." In addition, Kubin was "very pleased that [Herzmanovsky] had now developed a taste for the mysteries of existence" and urged him to "practical experimentation . . . thus will it certainly not escape you that particularly in February and March the largest number of cosmic substances are in the air and sensitive people can to a greater or lesser extent tune in to them."

■ Visions from the Other Side ■

In the autumn of 1908 Kubin went on a trip to northern Italy in the company of Herzmanovsky, "and on the way home was possessed by a restless need to take up [his] drawing again." Although he felt the urge to work, he was "unable to draw anything coherent and meaningful. To unburden myself," he wrote, "I now began to work out an adventurous story and to commit it to paper. And then ideas began to flood over me, mercilessly driving me to work on it day and night, with the result that in twelve weeks my fantastical novel *Visions from the Other Side* was completed."[75]

In the novel, which is written in the first person, Kubin describes the experiences of an artist who visits a dream realm in innermost Asia that is under the hegemony of the sinister Patera. He spends three years there, undergoing all manner of grotesque and horrible experiences, before Patera is enslaved by a rich American, Hercules Bell, and the decline of the country and its capital, Perle, follows.

The many-layered symbolism of the book includes references to Kubin's attitude to his father, to whose memory the book was dedicated. In Munich Kubin had already composed a work on "The Son as World Wanderer" that sought to place the father-son relationship in a general philosophical context.[76] Among the many autobiographical features of *Visions from the Other Side* two stand out particularly: the death wish on the one hand, and the will to live on the other, which form an inescapable polarity; to express it in Nietzschean terms, the book may be seen as presenting the complementary opposites of the Dionysian and the Apollonian visions. A dualist perspective is continually apparent in *Visions from the Other Side*, not least in the final sentence that sums up the story: "The demiurge is a hermaphrodite." The motivating principle of the world, which contains within itself both the positive and the negative with equal intensity, here occupies the position in

Kubin's vision that was formerly taken by a belief in the omnipotence of a meaningless fate. To that extent, the book represents an important caesura in the development of Kubin's art. He himself was well aware of this; he considered *Visions from the Other Side* as "the turning point of a spiritual development. . . . During the time I was writing it I came to realize that the highest value lies not only in the bizarre, divine, or absurd moments of existence, but that the same secrets are buried in the embarrassing, the mundane, and the trivially insignificant. That is the main meaning of the book."[77] "One can also derive much comfort [from it], namely, and *above all*, from the perception that inconceivable wonders *happen every moment before our very eyes*."[78] In the sketchbook he was using at the time of writing *Visions from the Other Side* Kubin wrote of that "nodal point, where the completely ungraspable absurdity, the actual nature of the world, is astonishingly made manifest."[79] Kubin considered that the antithetical basis of his world view was supported by Julius Bahnsen's *"Realdialektik."*[80] A few years later he found in the philosophy of Salomo Friedlaender the idea of polarity formulated in a manner particularly congenial to his way of thinking, and was wont to refer back to this until the end of his life.[81]

Kubin did not claim any great literary merit for his book, stating that "writing was always an unsympathetic task for me," and indeed even feared that publication of *Visions from the Other Side* would damage his artistic reputation—"all the more so since people were inclined to see literary tendencies in my earlier drawings." His motivation lay far more "in the nature of the thing itself; the medium was convenient in order to set down more quickly the ideas that pressed upon me than I could otherwise have done."[82] After the completion of the manuscript his creative block in the artistic sphere was indeed overcome: "Now that the bloody book is out of the way, I am again committing pictorial follies. . . . I hope I shall never do any more writing as long as I live!"[83]

The 51 illustrations that Kubin made for the novel also mark an artistic turning point. They demonstrate his final return to graphics after a phase of multifarious activity in the field of painting. His openness to all kinds of inspiration from literature and the fine arts is reflected in the pluralistic nature of the illustrations. They partly owe something to Bosch and Breughel (Figures 138 and 139), but also include motifs from his early work. The richness of the pictorial sources, especially that of Breughel, may be seen both in details of particular drawings, and also in descriptions of different incidents in the text. Kubin had always admitted to incorporating ideas and motifs from elsewhere, as very often occurs in his work. The fantastical development of the novel's plot, together with its illustrations, show numerous parallels to works by Meyrink, Edgar Allen Poe, E. T. A. Hoffmann, and Gérard de Nerval, all of which were among his favorite reading at the time.[84] Meyrink's *Golem* had a direct impact on both the illustrations and the text of *Visions from the Other Side*.[85] At the beginning of 1908 Kubin had been

138. Alfred Kubin, illustration
for *Visions from the Other
Side*, 1909.

working on the drawings for the anticipated publication of *Golem*, from which
he extracted eleven for use in his own book.[86] While he was working on
Golem he was grieving for his father, who had died shortly before. "Meyrink's
novel . . . I create continually under the unrelenting pressure of a torturing
longing for my father—sometimes it almost seems as if spiritual suffering
[is] indispensable if I am to bring to the surface and illustrate these deeply
rooted feelings that are inside me."[87] At that time, apart from what he did for
Meyrink, Kubin had done only three book illustrations—for Poe's "The Case
of M. Waldemar."[88] This story also found an echo and a visual reflection in
his novel.[89]

While he was engaged in writing *Visions from the Other Side* Kubin con-
tinually recorded his ideas for illustrations in his sketchbook. Literary and
artistic work are thus inseparable in the context of this work. The depen-

139. Alfred Kubin, illustration
for *Visions from the Other
Side*, 1909.

dence of the book on visual ideas is sometimes so pronounced that Kubin
regarded the text, while he worked on it, as merely a "framework" to be "ex-
plicated" by the illustrations. Immediately after finishing the manuscript he
wrote to Herzmanovsky in December 1908 that he was

> already planning the illustrations, which are very many, around 50, mostly
> small ones—but the whole book is actually written around the illustrations. I
> want, in the last resort, to make such illustration as pleases me for its *absolute
> originality*. These drawings will be the best that I have done till now, and the
> explicatory text in novel form is, so to speak, merely a framework. I do not
> intend to present myself as a writer. . . . I really hope that after this book
> my drawings and my art generally will be better understood—to achieve this
> understanding is the point of the whole exercise.[90]

And in his sketchbook Kubin noted with regard to the "ungraspable ab-
surdity" of "the nature of the world" that "only with pictorial means can one
attempt to some degree to be clearly understandable."[91]

Kubin's drawings for *Visions from the Other Side* also demonstrate a change
in his working methods. Instead of a type of drawing linked to the formal
requirements of etching and aquatint that incorporates numerous technical
effects and has a perceptible tendency toward the picturesque, there is now
a much heavier emphasis on graphic features. A greater certainty in the line
and a frequent eschewing of wash or spray techniques also become evident.
The enthusiasm for experimentation of the previous years now recedes into

the background, although in his novel Kubin attempted an extremely wide range of visual expression. For this he drew on a rich store of motifs that he had used before—some of them repeatedly. In addition, there is the previously mentioned influence of Breughel's pictorial and symbolic vision, which was particularly significant for him at the time he was preparing the book. A harsh line with stark contrasts in some drawings gives way to other more loosely and softly executed illustrations, or to many-figured, not immediately assimilable compositions showing a concentration of differing motifs, or to a light and playful line with areas of clearly articulated strokes and hatching. These variations are also visible in drawings done at the same time, but not for the novel.

The mode of drawing adopted by Kubin for *Visions from the Other Side* differs most markedly from his early work in its narrative character. This is not only due to the fact that these works are illustrations for a literary text, but also to the change in the nature of his art. This change is observable in his other works of the period (Figure 140). The allegorical monumentality of a large part of the early drawings gives way to a more strongly psychologizing type of representation that is less dependent on symbol (Figure 141). Scenes of terror and hellish torment still play a large role in his work, but they are now deprived of their supertemporal quality—they are indeed, individualized and thus lifted out of the atmosphere of ineluctable fate. The renunciation of stylization in favor of realistic description of events corresponds to

140. Alfred Kubin, *Burial*, around 1909–11.

the lightening of his view of the world (Figure 142), which is also apparent in the intellectual content of his novel. It is conceivable that in the creation of the illustrations for *Visions from the Other Side* and the construction of the detailed apocalyptic scenarios of his book Kubin came to terms with the notions that so oppressed him and with his fears, and through the cathartic process of writing and drawing actually overcame them.

As soon as it appeared, *Visions from the Other Side* was received with extraordinary interest and in some quarters with great enthusiasm. Its reception also fixed the nature of Kubin's work in the public mind—for example through the mediation of critics like Hermann Esswein, Kubin's first monographer,[92] or Wilhelm Fraenger,[93] or Will Scheller, who wrote about the book in *Der Brenner*.[94] *Imago*, the journal edited by Freud "for the application of psychoanalysis to the humanities," printed a detailed review of it in 1912 by Hans Sachs.[95] In this the father-son relationship and the sexual symbolism of the novel were examined, and Sachs justified his psychoanalytic approach to criticism with reference to the dreamlike nature of the book. In the circle of Kubin's friends and acquaintances the novel was enthusiastically received, especially by his brother-in-law, Oskar Schmitz, who had

141. Alfred Kubin, *Mohammed*, around 1909–11.

142. Alfred Kubin, *Reverence*,
around 1909–11.

assuaged Kubin's original doubts and anxieties regarding publication of the
work,[96] also by Herzmanovsky ("a work of art full of tremendous depths"),[97]
by Max Dauthendey, who praised the "wonderful eeriness" of it,[98] by Franz
Marc, for whom it was "a great settling of accounts with the nineteenth cen-
tury,"[99] and by Stefan Zweig, who found it "unforgettable" and "splendidly
gripping," like a "man from the moon in our bourgeois literature."[100] Kubin
himself was carried away with the enthusiasm for his work—"my book has
thus far already hit the nail on the head for *many* people, and discussion of it
is everywhere to be heard."[101] In the already quoted letter to Herzmanovsky
with recommendations for readings in mysticism he concluded as follows:
"Ultimately the richest and most readable book about these matters is *Visions
from the Other Side*.[102]

▪ The Master of Ambivalence ▪

If 1904 marks the conclusion of Kubin's early symbolist period and intro-
duces a very open, experimental phase of his art, 1908, with the writing
of *Visions from the Other Side* and the creating of its illustrations, implied
another significant caesura in his career. What was characteristic of the next
phase was the exclusive dedication to pen-and-ink drawing, mostly without
color toning, a rapid, more flexible use of the pen, a dense, nervous concen-
tration of line, and a multiple overlay of hatching. In place of the character-

istically archetypal form of the early work comes a comparatively distanced mode of perception; fear as the motivating force behind the picture's creation becomes considerably less important. Some of the illustrations for the novel, compared with Kubin's previous drawings, seem little more than harmless pictures for ghost stories. In Kubin's work from now on, also, cynicism melts into irony, disgust into astonishment, the sinisterly absurd into the comically ridiculous. Kubin evidently regretted this development when, in 1911, he looked back on the period after the death of his father, lamenting that "a great deal of my enormous appetite for life was burned up and in place of wild oscillations of feeling came a milder approach to life." [103] "Now there were no longer the personal '*cris de coeur*' that used to burst from me, and that in a peculiar retrospective way reproduced themselves in visions." [104] Kubin wrote nostalgically to Alexander von Bernus in 1914: "Certainly I sometimes feel myself deprived of fakirlike excitements; with the onset of age one's illusions vanish, and apart from one's own death, fate has left one no other great event worthy of note." [105]

Kubin's pronounced interest in literature led in the following years to a series of book illustrations, mostly for fantastical works. Following the publication of *Visions from the Other Side* he illustrated volumes of Poe's stories, Nerval's *Aurélia*, Hauff's fairy tales, Otto Julius Bierbaum's novella *Samalio Pardulus*, E. T. A. Hoffmann's *Night Tales*, Oskar Panizza's *Council of Love*, and several other books, including Paul Scheerbart's *Lesabéndio* and a story by Dostoevsky. In these works Kubin showed that he remained open to the most diverse influences. Traditional or folksy motifs are taken up, producing sometimes a Biedermeier atmosphere. Around 1911 he became extremely interested in the work of Paul Klee, from whom he continually acquired sketches. [106] The effect of Klee on Kubin was manifest in a series of drawings in which fragile figures with thin, elongated limbs are shown in various contorted poses (Figure 143). In 1909 Kubin had already joined the New Artists' Association of Munich founded by Kandinsky. Like Klee and Max Oppenheimer (a little later also Schiele) he belonged to the Munich artists' assocation known as "Sema." In the second exhibition of the *Blaue Reiter* group at the beginning of 1912 he was represented by drawings. The art of Klee, however, like that of Kandinsky, was too Apollonian to leave a lasting impression on Kubin's work. In his treatise *On the Spiritual in Art* Kandinsky wrote of Kubin: "With irrepressible force one is drawn into the bloodcurdling atmosphere of the savage void. This power streams forth from Kubin's drawings, and also from the pages of his novel, *Visions from the Other Side*." [107] Klee went even further in his assessment of Kubin somewhat later: "He flees from the world because he cannot physically reconstruct it. He remains stuck halfway, yearning for the crystalline [purities], but cannot get free of the viscous slime of the physical world. His art understands this world as poison, as ruin. He is . . . most alive in the [depiction of] destruction." [108]

Apart from Kubin's now looser connection with Munich and continual exhibitions in that city, his works were shown in other towns of Germany, in

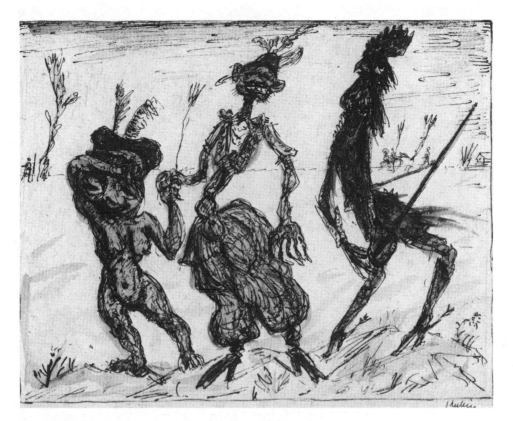

143. Alfred Kubin, *The Knight Gallus*, about 1911.

Budapest, and in Russia. In 1909 he had attempted to organize another show in Vienna, as correspondence at the time indicates.[109] An exhibition with Heller, planned for February or the autumn of 1910[110] was delayed, however; it did not take place until 1914—and then apparently without much success.[111]

The originality of his artistic concept and the expressiveness of his creative gift is most evident in Kubin's early work. The consolidation of his drawing technique at the end of the first decade of the century, when the expressive power and demonic quality of his early period was sublimated, had already begun with the illustrations for *Visions from the Other Side*. Kubin wrote in 1902: "I create not out of pleasure but in order to forget the entire loathing that I feel for myself and for the world."[112] Thus in 1908 he saw himself as the "master of the unconscious, of ambivalence, of the twilight world, and the realm of dreams,"—a characterization that also aptly describes his further development.[113]

Kubin once remarked to Alois Samhaber, the parish priest at Wernstein: "You want to take away my fear—but fear is actually my [artistic] capital." This statement may well hold the key to the question of what—to extend his own metaphor—provided the best return on that capital.

FELLOW ARTISTS

A number of artists were active in the circles of pioneering Austrian Expressionism discussed in this book, without, however, leaving a significant mark on its earliest phase of development. For example, Kokoschka's friend Erwin Lang made a series of woodcuts for the book about his future wife, Grete Wiesenthal, that appeared in Berlin in 1910 with an introduction by Oskar Bie. These graphics clearly owe much to Symbolism and Jugendstil, and the Expressionist element in them is in fact very subdued (Figure 144). The stylistic connections between Kokoschka and one of his fellow students at the School of Applied Arts, Rudolf Kalvach, has already been mentioned (see Figure 37). With some of his graphics Kalvach introduced a grotesque, caricaturing element into the refined art of the Secession and the Wiener Werkstätte. Some of his drawings also show the possible influence of George Minne, and in their stylized and emphatic hand gestures are obviously related to the work of Schiele. At the School of Applied Art itself, Kolo Moser's authoritative influence had already rendered the ecstatic line of Jugendstil more Expressionist and also foreshadowed later developments in his woodcuts (Figure 145).

In the ephemeral New Artists group, Anton Faistauer was for a while the artist with the closest affinity to his fellow student Schiele. His poster for the exhibition of 1909 looked like a paraphrase of Schiele's studies of figures and gestures done at the same time (Figure 146). A little later Faistauer turned to a very restrained sort of painting, so that in 1912 a critic could say of him: "One artist, namely Faistauer, who until a short while ago was still

144. Erwin Lang,
Butterfly, 1910.

145. Kolo Moser, *Three Women
on a Street Corner*, 1903.

following in the steps of Schiele, now appears to have learned how to produce something decent."[1]

Among the exhibitors of the New Artists, with Schiele at their head, were to be found not only Faistauer and Kalvach but also Hans Böhler and Franz Wiegele. Böhler's work was close to that of Schiele, above all in his early erotic drawings. His vividly colored paintings exhibit a painterly technique developed out of the visual experience of Impressionism, a technique that then took on certain elements of Expressionist form. Wiegele was only loosely connected with Expressionism and indeed soon oriented himself to classical models. Together with his future brother-in-law, Anton Kolig, he was later one of the pivotal figures of the "Nötsch Circle," which played a leading role in the development of so-called picturesque Expressionism in Austria. Kolig participated in the February exhibition of the Hagenbund in 1911, together

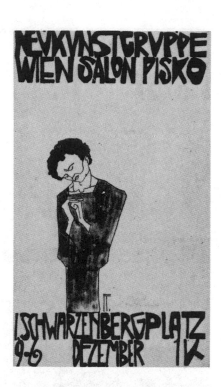

146. Anton Faistauer, poster design for the New Artists' exhibition.

147. Albert Paris Gütersloh, *Bathers*, about 1909.

148. Albert Paris Gütersloh, *Temptation of Saint Anthony*, 1910.

with artists such as Kokoschka, Wiegele, Faistauer, Lang, and Gütersloh. In his painting the main characteristic is a method of working determined by coloristic, painterly impulses, while the leitmotif of the drawings is the reticulated structure that one sees, for instance, in his studies of nude youths. Ludwig Heinrich Jungnickel also belonged to the Schiele circle, and had previously exhibited at the Kunstschau of 1908. He was primarily known

149. Albert Paris Gütersloh,
Self-Portrait, 1912.

for his animal representations, and his nudes, which resemble Schiele's, are consequently frequently overlooked.

Of Schiele's comrades among the New Artists perhaps Albert Paris Gütersloh was the most zealous propagandist of early Austrian Expressionism. As publicist and organizer he played a vital role in bringing it before the public. He again adopted the New Art slogan for the Budapest show of 1912, when works by Kokoschka, Schiele, Schönberg, Faistauer, Kolig, Andersen, and Gütersloh himself were exhibited. In 1911 Gütersloh's *Attempt at an Introduction* to the work of Egon Schiele was published, and he also did the preface to the catalogue for the Budapest exhibition, which was reprinted in *Pester Lloyd*.[2]

Albert Paris von Gütersloh, whose real name was Albert Conrad Kiehtreiber, started out as an actor and poet. In 1909 he made his debut as a novelist with *The Dancing Mad Girl*, which appeared the following year in Berlin. The dual nature of his talent, literary and artistic, led to a lifelong career in which he was active in both spheres. The few drawings that have survived from the years up to 1912 show principally an idiosyncratic artistic character that transmutes the linear composition of Viennese Jugendstil into a more or less caricaturing form of representation (Figure 147), and soon adopts the language of gesture from Kokoschka and Schiele. In watercolors of fantastic scenes (Figure 148), in depictions of religious themes, or in bizarre genre scenes, his mode of expression is extremely emphatic, as is also true of his manifestos. The combination of Expressionist, Cubist, and Realist stylistic elements that had been features of his work since 1912 (Figures 149 and 150) was soon transformed into a mingling of Biedermeier with the bizarre

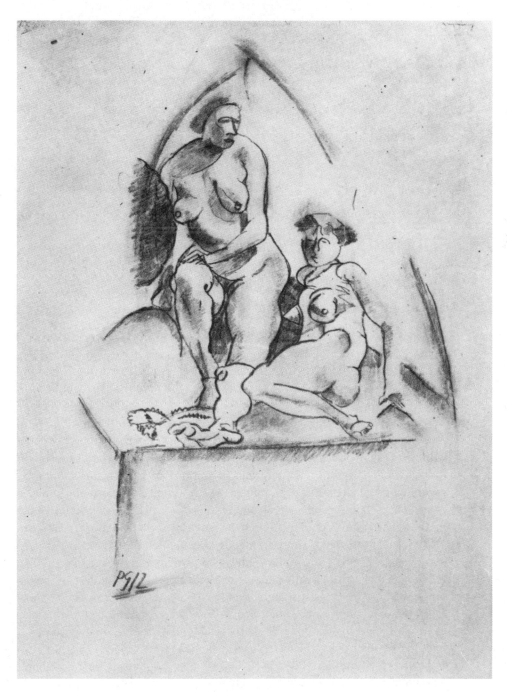

150. Albert Paris Gütersloh, *Two Nudes*, 1912.

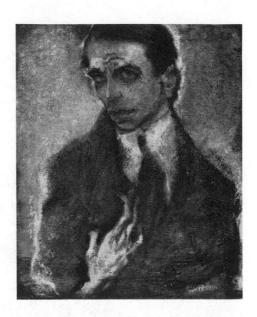

151. Max Oppenheimer,
Self-Portrait, 1910–11.

and fantastic (which thus recalls certain works of Fritz von Herzmanovsky-Orlando, also a man of dual gifts). After the Second World War Gütersloh's work was influential in laying the basis of Viennese "Magical Realism," the strength of his influence no doubt being attributable to the fact that he held a professorship at the Viennese Academy.

Max Oppenheimer (Figure 151) was a fellow student of Richard Gerstl's in Griepenkerl's class, left it at the same time as Gerstl, and studied for a while in Prague. Between 1907 and 1911 he was in Vienna, and then went to Munich and Berlin.[3] His paintings dating to 1910 bear witness to an exceptional talent that shows the influence of Kokoschka—particularly in the portraits. The similarities are evident in the coloring, the construction of the figures, the agitated contours, and in the hatching scratched into the color. In 1910 he painted Schiele's portrait in a striking pose emphasizing the gestures of the hands (Figure 152), and was himself drawn by Schiele (see Figure 102). Taken together, his portraits make a nearly comprehensive gallery of important contemporary artists, writers, and musicians (Figure 153); later he was to write about them in his book *People Find Their Painter*.[4] Oppenheimer even used his religious pictures partly as an excuse to introduce portraits of people from his circle. Thus a *Deposition from the Cross* (Figure 154) of 1910–1911 shows, on the left side, Karl Kraus, Peter Altenberg, Oskar Reichel, who bought the picture, and Heinrich Mann.

In Oppenheimer's work, always signed with the acronym "Mopp," the influence of Cubism is evident from 1912 onward as he began to introduce elements of form analysis into his work. However at this time he was closer to the Futurists, with their striving to make dynamic processes visible within a pictorial context—Oppenheimer often represented orchestras or chamber

musicians in the act of playing in order to achieve this effect. In his figurative works, which are filled with movement, he combined elements of Gothic and Mannerism (the latter with specific allusions to El Greco) to produce powerful, impassioned paintings.

In connection with Kokoschka, mention has already been made of the scandal in 1911 provoked by Oppenheimer's use of Kokoschkian stylistic idiosyncracies, and the latter's envy of Oppenheimer's commercial success. The polemic directed against Oppenheimer in *Die Fackel* and *Der Sturm*[5] also may be seen as linked to a somewhat earlier "Announcement" by Arthur Roessler in the magazine *Bildende Künstler* edited by him: "Numerous let-

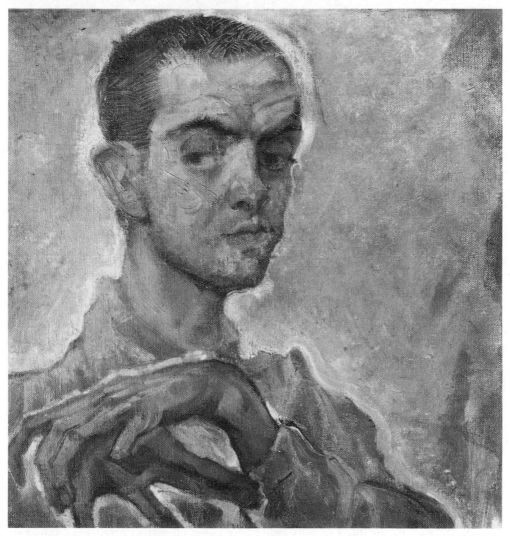

152. Max Oppenheimer, *Portrait of Egon Schiele*, 1910.

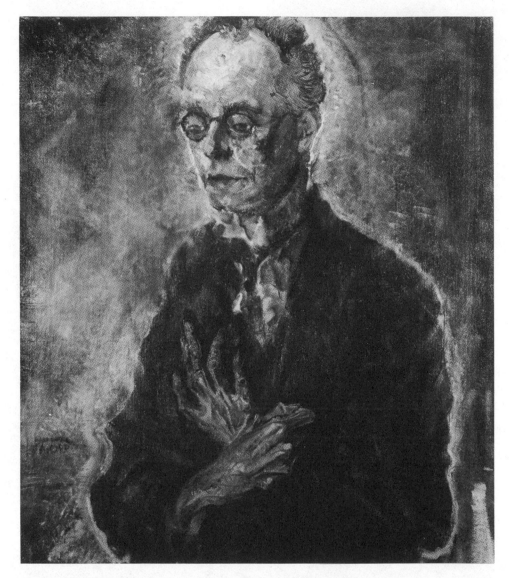

153. Max Oppenheimer, *Portrait of Franz Blei*, 1910–11.

ters that I have received prompt me to take this opportunity of informing our readers that for private reasons I have withdrawn the illustrated monograph that I have written on the painter Max Oppenheimer."[6] A little earlier Roessler had published Oppenheimer's "Autobiography" in his magazine and introduced it with numerous illustrations of the artist's work.[7] Eventually, a monograph on Max Oppenheimer, not by Roessler but by Wilhelm Michel, appeared in 1911,[8] seven years before the first monograph on Kokoschka by Paul Westheim. Probably Schönberg came closest to a fair assessment of the witch-hunt against Oppenheimer when he wrote in his journal: "Marc

showed a letter from Loos, which rails at Oppenheimer, calling him a swindler and a plagiarist of Kokoschka and warns to avoid him. It is really unjust, what they are doing against Oppenheimer: one doesn't need to label someone who is not original a swindler. . . . He is a rascal, but no swindler."[9] It was also Oppenheimer, as previously mentioned, who set up the contact between Schönberg and Kokoschka in 1909 with a view to their collaboration on *The Lucky Hand*, and who was approached by Schönberg in 1910 to do the sets for his monodrama *Anticipation*.

The network of relationships connecting the Austrian Expressionists is complex, both between the main protagonists and between the artists within

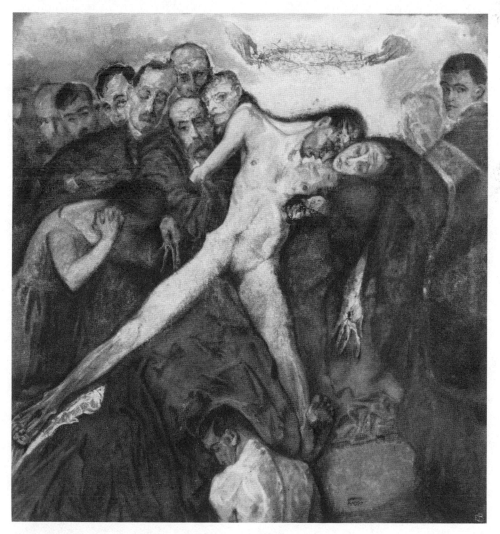

154. Max Oppenheimer, *Deposition from the Cross*, 1911.

their orbit of influence. Despite this, their pronounced individualism, which at times verged on solipsism, prevented the formation of a coherent group or any longer-term plan for mutual cooperation. This is especially true of the early phase of Austrian Expressionism; in the course of its further development, the sphere of influence of its pioneers grew apace.

BODY AND SOUL

The artistic grappling with objective reality in Austrian Expressionism, and in particular its analysis of the phenomena of the human face and the human form, is bound up with its acute awareness of the relationship between body and soul. The exploration and presentation of the nature of the individual's body is thus one of its hallmarks. This self-depiction as a form of confirmation of individual identity, but also as a self-torturing dissection of it, had much in common with the type of philosophical and intellectual inquiry that agitated fin-de-siècle Vienna. Ernst Mach's theory of the "unrecoverable self," in place of which he set the notion of the continuum of sensations, had already influenced Hermann Bahr's philosophy of Impressionism.[1] Fritz Mauthner's *Contributions to a Critique of Language*, Ludwig Boltzmann's language philosophy, the gestalt theory of Christian von Ehrenfels, and other epistemological researches reflected the attempts of science to pin down reality in a form of words. In literature, the "despairing of language" that one encounters in Kafka, Rilke, or Kraus, corresponds to a similar struggle to master the objectively existing world in terms of words. Hugo von Hofmannsthal's fictive "Lord Chandos's Letter," imagined as written to the English philosopher Francis Bacon, provides the literary expression of both Mauthner's extreme skepticism with regard to the efficacy of language and Mach's "unrecoverable self." For Wittgenstein, philosophy was simply the critique of language. His *Tractatus Logico-Philosophicus* concluded with the celebrated remark: "Whereof one cannot speak, thereof one must be silent." The

ambivalence of this reflects equally Wittgenstein's rejection of speculative metaphysics and his openness with respect to what lies beyond the capacity of our means of expression.

Just as for Karl Kraus language was the direct expression of the way a person lives his life, and for Adolf Loos architecture reflected the spiritual context of the individual's existence, so for the leading early Austrian Expressionists the human body was something that gives expression to the most profound existential realities. Their radical questioning of personal identity led to a continual preoccupation with the self, an insistence on the indivisibility of the conscious and the unconscious, the physical and the metaphysical. The potential of representative art was exploited for these purposes in a very particular way. This way was the product of both the dominating position held by the theater in Austrian culture and the new European interest in synesthetic phenomena and the dance. Added to this there was the awareness of the creative potential of cabaret and variety theater, which in the artistic field was reflected in appreciation of the interpretative power of caricature—a vivid example of this being Gustav Meyrink's magazine *Der liebe Augustin.*[2] In his 1896 essay "Classicism and the Invasion of Vaudeville," Oskar Panizza had urged the merits of a renewal of art through the inspiration of variety theater.[3] Alfred Roller also implicitly exalted the cabaret when he wrote on "Reform of the Stage" in *Merker* in 1909, describing the difficulties of repertory theater and demanding a more flexible approach to stage design.[4] It was in the context of cabaret, also, that Schönberg earned his keep during his stay in Berlin, that Kubin found hallucinatory inspiration, and that the premiere of Kokoschka's first drama took place.

A related aspect of all this was the enthusiasm with which the Secession took up the new expressive dance, even putting on performances in their own building. It was also reflected in Kolo Moser's designs (Figure 155). The critical establishment greeted with great enthusiasm the first individual performances of the Wiesenthal sisters in 1908 in the garden theater of the Kunstschau and in the Cabaret Fledermaus, the latter performance having been devised as a Secessionist *Gesamtkunstwerk* by the Wiener Werkstätte. The impact of Ruth Saint-Denis's dancing on Schiele, and of Grete Wiesenthal's (Figure 156) on Kokoschka, illustrate how important for early Austrian Expressionism expressive dance was. The determining role in Viennese culture of the theater, of dance, indeed, of spectacle in the broadest sense of the word, certainly contributed to a heightened awareness of the human body as a means of expression for the spiritual experience of the individual.

Symbolist art, too, prepared the soil for such an awareness by making the body the epitome of mood and feeling. At the same time, rhythm became important as the basis of, or as a structural element in, artistic representation. The art of Ferdinand Hodler, with its eurythmic language of figures (Figure 157), stands at the crossroads of Symbolism and Expressionism, and was received in Vienna with considerable enthusiasm. Klimt's Beethoven

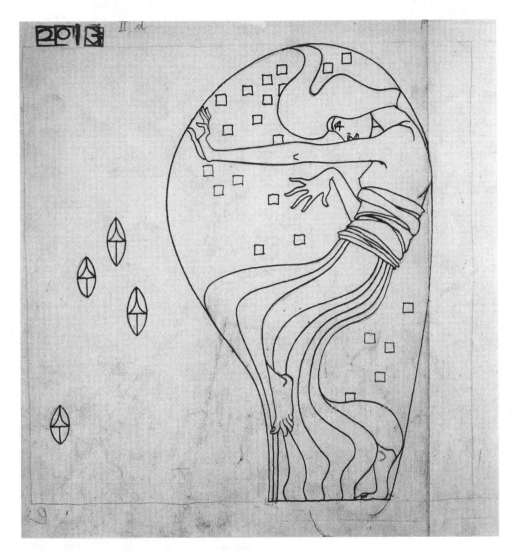

155. Kolo Moser, *Dancer*, design for metalwork for the Wiener Werkstätte, about 1904.

frieze, with its strongly rhythmic structure, likewise places special impor-
tance on the figure and on gesture (Figure 158). Depictions of dancers were
very common among the works of the Secessionists, their elegance of line,
however, soon giving way to a more expressive approach to the subject. A
photograph of Gertrude Eysoldt playing Elektra in a Berlin performance of
Hoffmannsthal's play in 1904 recalls the poses of the models in the drawings
by Schiele and Kokoschka (Figure 159).

Ludwig Hevesi, in writing of Mata Hari's appearance at the Secession in
1906, spoke of "a sort of physical saintliness" that she seemed to evoke, and
of the "aura of integrity that surrounded her."[5] In the same year Hugo von

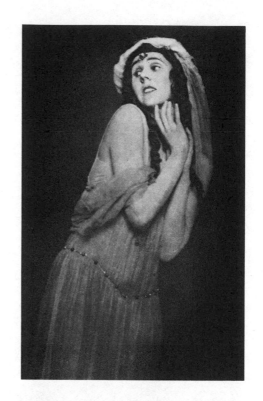

156. Grete Wiesenthal, posed
photograph.

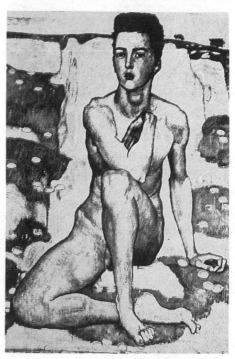

157. Ferdinand Hodler, *Spring*,
detail, 1901.

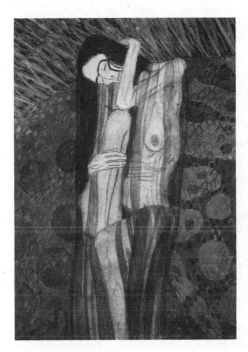 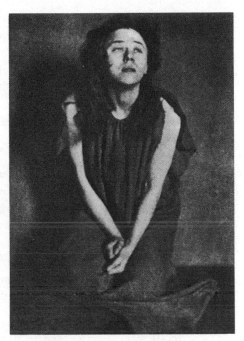

Left: 158. Gustav Klimt, *Nagging Sorrow*, from the Beethoven frieze, 1902.

Right: 159. Gertrude Eysoldt as Elektra in Hoffmannsthal's drama., 1904.

Hofmannsthal was inspired to write his essay "The Incomparable Dancer" after watching Ruth Saint-Denis, and saw in her performance "an electrifying combination of gestures, of which not a single one degenerates into a mere pose. They are . . . emanations . . . of the highest, the most refined, the most hieratic, the most ancient style."[6] Gustav Eugen Diehl, editor of the periodical *Erdgeist*, eulogized the movement of the "almost boyish . . . frail body of Grete Wiesenthal . . . for whom even our sophisticated hearts yearn" and called her art "a religion." Her performances were for him "ecstatic, obsessed, religious. Religious like the dance of the first Bacchantes."[7] Diehl was one of the most enthusiastic early promoters of the Wiesenthals' dancing. *Erdgeist* printed two detailed articles with illustrations on "The Wiesenthals in Vienna" in 1908, and then in 1909 a series of photographs that are now important source material for the period.[8] The journal's mixture of fine art, literature, music, theater, ballet, dance, and photography made it an important forum for artistic cross-fertilization from 1907 onward. In his second article, Diehl repeated his previously expressed "deep yearning" for a "temple" dedicated to the dance[9] and proclaimed: "We will be constant in our striving for a sanctuary where our small community may be blessed with the spectacle of the dancing of the Wiesenthal sisters."[10] Peter Altenberg expressed rather similar sentiments a year before, writing on Gertrude Barri-

son's appearance at the Cabaret Fledermaus: "Through her [art], the place was transformed into a temple of dance."[11]

Spectacle, music, and ritualistic evocation seemed for many of the artists, literati, and critics at this time to be summed up in expressive dance. In the poetic works of Else Lasker-Schüler, Herwarth Walden's first wife, dance is one of the dominant motifs, and is for her, as for many other writers, closely bound up with the works of Nietzsche. His fascination with rhythm and dance, and the philosophy of life associated with it, were widely influential at the turn of the century.[12] That "vitalism" and Expressionism were closely related in the literature of the period is, of course, well known.[13] A short text by the writer Karl Federn from 1903, which constitutes the introduction to Isadora Duncan's book *The Dance of the Future*, explicates a philosophy of art that makes the dance its focal point. Federn equates dance with life, meaning by the latter a transfigured, prerationalist existence that has not yet lost its creative potential. It is worth citing Federn at some length because of the messianic nature of the contemporary enthusiasm for the expressive dance that his introduction exemplifies:

> What has dance become for us, dance which was once the original source, the Ur-form of rhythm and poetry, of mysteries and all religious celebration; in which all inspiration, intoxication, all heightened awareness, and the creative richness of life, attained a delightful or savage expression? At the time when no theories [of art] existed, it was an entirely natural requirement of the sensually aroused individual, thirsting for expression with every sense he possessed. It was the innocent expression of youthful happiness, of orgiastic sensuality, or of religious fervor. It was the celebration of peoples whose poetry, whose music, and whose dance was ecstatic, whose art was divorced from neither life nor the religion that pervaded and dominated their existence. This gave to the art of the dance its high seriousness and its well-rounded style. And this seriousness—which is now mostly alien to us and is very seldom understood or appreciated—was not divorced from play, and not yet in any respect ponderous. But in the end men became aware of art, and critical theories followed. The result was that a barrier arose between art and life, a barrier that those who were well versed in art policed, and indeed anxiously preserved. Art, cut off from the life that was originally its source, became merely bloodless artificiality.[14]

The dance was also of central importance to the new theater. Edward Gordon Craig, who exhibited in the Galerie Miethke in 1905, published in the same year his essay entitled "The Art of the Theater." In this he postulated a fundamentally visually oriented drama in which "factors such as movement, rhythm, contour of color" would dominate. Thus, the purely verbal play should be replaced by a kind of "sacral dance-pantomime."[15] Kokoschka and Schönberg realized this concept of the new theater in an extremely radical form. Mime and the language of gesture were among the most important means of expression for early Austrian Expressionism, and not

160. Albert Paris Gütersloh, *Two Lunettes*, about 1909.

only in a dramatic context: they were crucial also to Kokoschka's poster design for the jubilee procession and the 1909 Kunstschau poster for *Murderer, Hope of Women*, Schönberg's *The Lucky Hand*, Schiele's contorted visages, his studies of facial and bodily convulsion or distortion, Faistauer's New Art poster, Lang's woodcuts for the Wiesenthal book, Oppenheimer's portraits, or the novel, *The Dancing Mad Girl*, by Gütersloh (Figure 160).

Ruth, the main character in Gütersloh's book, published in 1909, says of herself: "I want to become a dancer . . . not of the ballet. Oh no . . . I want to dance original dances, dances that can express a great deal. What Ruth Saint-Denis, Sachetto, Mata Hari, wanted to do."[16] Her demands for the dance are the conjoined expression of an attempt at self-realization and of a fundamental erotic conundrum that the book explores through various ramifications of the plot. However Ruth succeeds in realizing the pent-up desires within her not through dance as an art form, but in intoxicating, insensate dance performed in a pub. "She danced with her eyes closed. Danced as if she had something terrible to forget . . . her dances grew ever more awful, and ever more urgent were her dance desires."[17] Gütersloh made the dance a metaphor for the life of his "dancing mad girl." In Schnitzler's play *The Lonely Road*, similarly, Johanna Wegrat wants to be a dancer in order to escape the much too constricted world of her family—here again, therefore, dance operates as a symbol of a longed-for freedom.

Gütersloh's view that dance and gesture were an atavistic form of communication, superior in their archaic purity to the spoken word, was expounded in his *Attempt at an Introduction* to Egon Schiele:

161. Oskar Kokoschka, *Resting Dancer*, cover drawing for *Der Sturm*, November 24, 1910.

For we hardly know what to say about a work of art. People who form themselves into living tableaux in imitation of famous masterworks are closer to the spirit of those works than the gushing critics because they seem instinctively to understand that pictures are the language of gesture and demand a response in kind. And if we speak, nonetheless our words are only the displaced and accidentally accented gestures of the body, which have been forced together in the aperture of the mouth in complete ignorance of their purpose. Any picture begins to exist only if the initially stimulated pantomime of ideas begins to crystallize within the light and the place where they occur.[18]

The synesthetic potential of dance, especially in the context of its symbiotic relationship with music, was obviously of particular interest in Vienna. Hofmannsthal, in his essay, described Ruth Saint-Denis as "the incarnation of the dance, the silent music of the human body."[19] Altenberg, too, saw Gertrude Barrison's performance in Cabaret Fledermaus in 1907 as an example of "music set to the dance."[20] The interest in dance as an allusive form of expression also fitted well with the new directions being taken by musical drama at the Hofoper in Vienna. The cooperation of Mahler and Roller realized the revolutionary ideas for the *mise en scène* of Adolphe Appia, which sought to bring out the inner structure of any given work. Dance and mime,

light and color, were the new methods employed to expose the inner or spiritual reality of the action in both the performing and the fine arts (Figure 161). Their exposure of inner reality was subsequently crucial to the Expressionist approach to art—in a form whose "truthfulness" entailed the sacrifice of the aestheticism of the Secession.

AFFINITIES AND DIFFERENCES

If one takes 1909 as the crucial year for early Austrian Expressionism, the year in which the works of Schiele and Gütersloh appeared before a wider public for the first time at the Kunstschau, and in which Kokoschka and Oppenheimer were already exhibiting there for the second time, it immediately becomes apparent to what extent these young artists were the product of a single generation: Kokoschka was 23 years old, Gütersloh 22, Oppenheimer 24, and Schiele 19. Most of those who exhibited in the New Artists' show of the same year were more or less of the same age. Gerstl had died the year before, aged 25. Schönberg, however, who had his first exhibition a year later, was 35, and Kubin, who had already been living in Zwickledt for three years, was at that time 32. Thus, the artists who distanced themselves from the art of the Secession were almost all born between 1885 and 1890. On the other hand, one has to be wary of too facile an approach to the chronology of early Expressionism: Schönberg, a composer who was only fleetingly active as an artist, but whose work is nevertheless of considerable importance to our theme, was born in 1874, and Kubin in 1877. Kubin is also to be differentiated from the other artists discussed here in that the environment of metropolitan Vienna was of little cultural or artistic significance for his work, quite apart from the stylistic and thematic aspects of it that set him apart from the others.

The question thus arises of the extent to which the period of early Expressionism that is under discussion can be said to be an Austrian or a Viennese

phenomenon. If the criterion of definition is to be the place where the vast majority of the work was created, the nomenclature "early Viennese Expressionism" is generally appropriate, except in the case of Kubin. If one takes into consideration the fact that Vienna was then the focal point of a *Vielvölkerstaat* with 54 million inhabitants, however, and that its importance was not simply a matter of genius loci, but was also due to its central position as the Danubian metropolis, then it becomes harder to separate the concepts of "Vienna" and "Austria" in the fields of artistic and intellectual endeavor around the turn of the century. By the same token, with the collapse of the Dual Monarchy, a great part of the creative ferment of Vienna disappeared as well.

All the artists central to our investigation came from families of the Austrian provinces and from the Crown Lands of the monarchy. Gerstl's parents came from Neutra in southern Slovakia and from Budweis in Bohemia. Kokoschka's father was born in Prague and his mother was of Austrian peasant stock. Schiele was born in Tulln in Lower Austria, while his father's family came from northern Germany and that of his mother from Krumau in Bohemia. Schönberg's father was from Pressburg (now Bratislava) in what was then Hungary, and his mother was from Prague. Kubin came from a small northern Bohemian town called Leitmeritz. Artists from the western provinces of Austria became important only in the further development of Expressionism and Expressionist painting. It is noticeable how many of the pioneering artists of Expressionism had Slavic roots, a phenomenon that is also observable in Austrian literary Expressionism—one thinks of Franz Kafka, Max Brod, or Franz Werfel. Among the Prague literary figures, the Jewish element was particularly strongly represented; of the core group of Austrian Expressionists, Schönberg and Gerstl were of Jewish origin.

It was the cultural and artistic ambience of Vienna, however, that produced the impulses for the first, eruptive phase of Austrian Expressionism, as is evidenced by the careers of the individual artists concerned. One sees it in their opposition to the aestheticism of the Secession, to which, however, they were in many respects artistically indebted; also in their antipathy toward the *Gesamtkunstwerk* idea, which nevertheless influenced works like the *Murderer* drama or *The Lucky Hand*; and finally one sees it in the artistic ferment caused by the European avant-garde, whose works were continually exhibited in Vienna. In the same way, Vienna was an environment that reflected an acute awareness of the spiritual crisis in Europe at the beginning of this century, especially its unsolved cultural problems: these typically lay in the political and social fields (although the introspection of early Expressionism hardly touched on these themes), in the relations between the sexes, in the tension between rationalism and the new value placed on the irrational, in the enigma of reality and in doubts about its communicability, in the apparent intractability of language, and in the crisis of personal identity.

A number of unmistakable features characterize the art of European Ex-

pressionism: the presentation of spiritual experiences and processes; the immediate, subjectively heightened visual impact; the rejection of academic rules of painting justified by the inner necessities of artistic expression; the rejection of rationalism and positivism and the corresponding emphasis on emotion and subjective experience; the turning back to archaic artistic forms for inspiration, to folk art, and to the most expressive epochs of world art; the need to communicate the spiritual aspects of a subject; a generally anti-bourgeois attitude; a fiercely impulsive language of form; the rejection of refinement and formalization in favor of stark contrasts; a harshly colored palette; and an apparently distorting manner of representation.

These characteristics are all present in Austrian Expressionism, although with differing degrees of emphasis. It exhibits, for instance, a somewhat stronger insistence on the external features of inner reality, in particular when representing the human body. The features reveal in themselves, or allow to show through, the spiritual and mental realities that lie behind the physical facade of the subject as they are experienced by the artist. This approach differentiates many pictures by Austrian artists from those of the Fauves or of German Expressionism (Figures 162, 163, and 164), with their fundamentally more abstract language of form, their orientation toward aboriginal forms of art and the creations of primitive societies, and with their revolutionary concept of living. In France and Germany the elemental experience of color was in marked contrast to the legacy of the Secession and the Wiener Werkstätte in Austria, with its colorful preciosity. Symbolism, too, was of considerably greater significance for Austrian Expressionism through its emphasis on subjective mood and sensual experience, which found expression in both figures and objects, and its tendency to conceive of a picture as the conveyor of a spiritual message; also, its recourse to the world of unreality, of dreams, and of mysticism. Early Austrian Expressionism shared with the *Blaue Reiter* group in Munich an interest in metaphysics. Its occult and mystical tendencies and its exploration of the unconscious, however, were also bound up with hallucinatory experience. It frequently consisted of personal

162. Maurice Vlaminck, *Bridge in Chatou*, 1905.

163. Erich Haeckel, *Red Houses*, 1908.

164. Henri Matisse, *Self-Portrait*, 1906.

statements and representations of the self that could take on narcissistic and pathological characteristics.

The preoccupation with both the individual artist's own body and other human bodies was a cardinal feature of these painters' work (as, in a different way, it has been of Austrian art since the 1950s). Sexuality and death, eros and thanatos, are the presiding powers of a large part of the artistic creation of Expressionism, which thus simultaneously mirrored both the fascination and disgust of the artist (Figures 165 and 166). In France and Germany, on the other hand, the treatment of sexuality was often much freer and life-enhancing, lacking the self-torturing quality of the Austrians. However French and German artists dealt with the theme almost exclusively from the male viewpoint. In Austria, an awareness of the male-female struggle led to a more intense concentration on the problems of sexual identity. Fear, night-

165. Alfred Kubin, *Self-Observation*, around 1901–2.

mares, and madness express the mood of many early Expressionist works. The further development of Expressionism leads finally to a humanism that is still, nonetheless, essentially tragic in its understanding of the world.

The overstepping of traditionally fixed boundaries between artistic media is likewise a significant aspect of early Austrian Expressionism—to be seen, for instance, in Kubin's *Visions from the Other Side* (written in 1908), in Kokoschka's dramas (1909), in Schönberg's painterly phase (after 1906), in his drama *The Lucky Hand* (begun in 1908), in Gütersloh's novel *The Dancing Mad Girl* (1909), and in Schiele's poetry (1909–10). In the staging of the dramatic pieces, myth, ritual, and ecstasy are more important than logical development of the plot; scenery, lighting, and color are just as important as speech, if not more so. The idiosyncratic exploitation of myth is itself a

166. Oskar Kokoschka, *Female Nude with Stockings, Supporting Herself with Her Arms*, about 1909.

further aspect of Austrian Expressionism that distinguishes it both from the French and German versions.

Equally marked is the difference between early Austrian Expressionism and Italian Futurism. The euphoria with regard to progress, the cult of the machine and worship of speed, the strongly Cubist element in their work, and the decidedly political tone of the Italian artists found no echo in Austria. Features of Futurist style were only incidentally absorbed.[1]

The numerous convergences of intention and execution that may be perceived in the works of different artists should not, however, mislead us into thinking that early Austrian Expressionism is either a unified phenomenon or one that was created and developed by a homogeneous group of artists. The foregoing studies have attempted to demonstrate in each case their individuality and specific artistic personalities. Thus it has been shown that there existed neither groups that held together for any length of time nor any that managed a prolonged studio cooperation; nor were there manifestos representing a common viewpoint, and only a few artistic proclamations were issued. The time for such things lay in the past, in the "heroic" period of the Viennese Secession.

Generalizations about the characteristics of early Austrian Expressionism apply with differing emphases to the work of Kokoschka, Schiele, and Kubin, and with greater reservations to that of Gerstl. His contribution to Expressionism is the one most clearly rooted in a European context, being developed from an encounter first with Divisionism and Impressionism, then with van Gogh and Munch. He avoided pathos and symbol, also gesture and mysticism; later he renounced sophisticated and refined articulation of form—but not psychological interpretation and self-depiction. His dissolution of form brought Gerstl rapidly to the boundaries of realistic representation, and in this respect he appears as a forerunner of the later, abstract phase of Expressionism.

Those of Gerstl's works that are central to our theme were possibly produced after 1904, but principally in 1907 and 1908 (the year in which his career was brought to an abrupt end by his suicide in the autumn); Kokoschka's breakthrough to Expressionism took place in 1909, however, as did Schiele's, although in a more restrained way. Schönberg began to paint in 1906, but there is no evidence that his visionary pictures, with their Expressionist elements, were created before 1910. After 1910, *Gazes* or *Visions* were no longer produced by Schönberg. In the case of Schiele, the end of the eruptive, early Expressionist phase of his work may be dated to 1912, and in the case of Kokoschka to 1911–12—always bearing in mind that such generalizations inadequately take into account the fluid boundaries between phases of an artist's development. A number of artists in Schiele's and Kokoschka's circle were doing somewhat similar work at this time without approaching either of them in the intensity and artistic depth of their work—the exceptions being some individual pictures by Oppenheimer.

Kubin's special position is partly due to the fact that he passed his formative years in Munich and later retreated to Upper Austria, so his work does not specifically reflect the impact of the unique conditions of Vienna; but it is also due to the particular importance of Symbolism in his art, especially in the early work up to 1904; to the subsequent experimental nature of his activity, above all in painting; to the caesura of 1908, when *Visions from the Other Side* was written and its pen-and-ink illustrations created; and to the rapidly apparent change of outlook and mood in his drawings thereafter. The importance of Kubin for early Expressionism lies not only in the atmosphere of most of his work prior to this change and in the emphatic expressiveness of form in his art, but also in the numerous similarities of subject and intellectual approach that he shares with the other artists discussed here—above all in the concentration on the polarity of eros and thanatos, on the struggle between the sexes, on mysticism, self-doubt, and skepticism about mankind in general.

With Kubin, visionary and hallucinatory elements are generally sublimated in philosophy, but in Schönberg's work they are given direct expression. The same is partly true of Kokoschka's early portraiture, and of the "visionary" and other pictures by Schiele. Schiele and Kokoschka have a number of factors in common in this early phase of their careers that in turn may be traced back to their artistic roots in the style of the Viennese Secession, as well as to the example of Klimt, the influence of Ferdinand Hodler and George Minne, and a shared fascination with gesture and dance—all this quite apart from the general characteristics of early Expressionism that have already been mentioned. Klimt's painting made the breakthrough to the inclusion of ugliness in art—one of the greatest taboos of the Secession; this, together with the realization of the expressive power of the contour or of gesture already foreshadowed in Klimt's work, had considerable impact on both Kokoschka and Schiele. In the figures of *Weak Humanity* and of *Nagging Care* in the Beethoven frieze, in the faculty pictures, but also in the somewhat affected *Expectation* of the Stoclet frieze, or in his painting *Hope II* of 1907–8, Klimt exploited the body, a gesture, or simply a way of holding the hands, for expressive effect—a phenomenon that clearly left its mark on the younger artists. Schiele's more linear "Gothic" style and Kokoschka's more painterly "Baroque" manner then began to exhibit increasingly different stylistic profiles as their art developed.

Kokoschka's temporal precedence to Schiele in their respective breakthroughs to Expressionism is not disputed. However the time scale is much shorter than was previously assumed. The age difference of four years should also be taken into account, because at this very early stage of an artist's development short spans of time are naturally of great significance. The persistent attempts of various monographs on Kokoschka to present him as quite unconnected with Schiele, artistically speaking, may be traced back to Kokoschka himself,[2] and indeed continues even today. (Thus we read in the commentary

to the first volume of an edition of Kokoschka's letters that "Schiele's patron Otto [*sic!*] Reichel also owned a number of pictures by Kokoschka. This may perhaps be the reason that Kokoschka and Schiele are often mentioned in the same breath, although there was no connection between the two, as is also evidenced by Kokoschka's exiguous correspondence with Egon Schiele."[3] An Austrian art magazine in 1984 succumbed to the polemic of individual Kokoschka hagiographers against Schiele by publishing without comment an article that contrasted the "pornography" of Schiele to the "holy" art of Kokoschka—whose superiority, of course, "a few select Viennese [!] had always appreciated.")[4]

The rivalry between Schiele and Kokoschka also is evident from the reaction of the former to Otto Benesch's foreword to the catalogue to Schiele's exhibition in the Gallery Arnot in 1915. Benesch discussed his work in the context of the art of Klimt and Kokoschka, and replied to Schiele's criticisms of the latter: "Kokoschka is not so 'bad' that it can be regarded as a sin to mention his name . . . in the same context as your own."[5] However Schiele later tried to involve Kokoschka in a large exhibition in the Secession in 1918, an invitation that was turned down.

Exactly in what way Kokoschka participated in the New Art exhibition of 1912 is unclear. The Budapest show organized by Gütersloh mentions Schiele in the catalogue, together with Schönberg, Gütersloh, Faistauer, Kolig, and Andersen, but not Kokoschka. However his presence is attested by a newspaper article that appeared three weeks after Gütersloh's piece in *Pester Lloyd*.[6] It is possible, therefore, that Kokoschka's work was exhibited separately from the group at a later date.

The nomenclature New Art [*Neukunst*] was only briefly applied to Austrian Expressionism, and indeed was an accidental name that was used, when at all, with variable conceptual significance.[7] After 1911 the word "Expressionism" began to establish itself internationally. In that year it was used as a collective description for a group of French painters who exhibited in the Berlin Secession, and was subsequently applied by Herwarth Walden in a pan-European context; the phrase remained rather vague and imprecise for some time, however, just as "Expressionism" in France at the end of the nineteenth century was already in vogue, but with differing meanings attached.[8] In Austria it was a long time before it was accepted as a stylistic term, as can be seen from the fact that Hermann Bahr's book entitled *Expressionism*, written in 1914 and published in 1916, was more of a treatise on the philosophy of art than a historical documentation or a stocktaking of works in the genre.[9]

The characteristics of early Austrian Expressionism, and the different periodization of its development, raise the question of its position within European Modernism. The "time lag" of several years before the founding generation of the Secession absorbed the new impulses of the Arts and Crafts movement and Art Nouveau in Austria may also be observed in the case of

Expressionism—if one takes 1905 as the crucial year for German Expressionism and for the Fauves. This "time lag" becomes even more apparent if one takes into account the active periods of Expressionist forerunners such as van Gogh or Munch. It is principally Gerstl who stands in the current of European Modernism, as already described, and whose achievements may also be placed within the same time span as those of his German fellow artists. However the attachment to intellectualism and symbol in early Austrian Expressionism, and the relatively determined retention of naturalistic surface appearances, are in contradistinction to the classical concept of Modernism, as is the atmosphere of the end of an era in many Austrian works, which seem still to be impregnated with the fin-de-siècle elements. The "spiritual closeness to nature,"[10] together with a cautiously used differentiated palette, distinguish the works of Kokoschka and Schiele from those of German and French Expressionism. They are also differentiated by their pathos, which appears in double guise in early Austrian Expressionism: as the expression of a personally experienced suffering, and as the reflection of the specific meaning with which the artist endows his individual creations. These differentiating features of Expressionism should caution us not to lump it together with the already rather catchall concept of Modernism. The (in any case obsolete) perception of a linear progression of the development of art from Symbolism through Jugendstil to Expressionism serves a purpose only if it helps us to understand Austrian Expressionism—and particularly its early, eruptive phase—as a phenomenon peculiar to Austrian art: certainly it may justly be placed in the context of the artistic and cultural upheaval of Europe generally, but equally it cannot be pigeonholed in some rigid and arbitrary art historical framework of development.

ART HISTORY
AS THE HISTORY
OF IDEAS

As has been apparent throughout this investigation, in the artistic and intellectual climate of the fin de siècle there were powerful currents of metaphysics and mysticism that came to the surface in the form of a strong interest in Eastern religion and philosophy, in Theosophy and Anthroposophy, in the occult and spiritualism, or in a speculative philosophical metaphysic. "Life-philosophy" and monism, together with a neo-Romantic stream of thought, were widely popular and often joined with the tendencies already mentioned. In addition, there was the extraordinary impact of Arthur Schopenhauer, Richard Wagner, and Friedrich Nietzsche. The resulting inherently contradictory combination of impulses and ideas proved to be a great catalyst for literature, music, and the fine arts; at the same time, it unfortunately led to the sort of turbid and disillusioned attitude toward life and society that combined with the political consequences of the First World War to prepare the way for Fascism.[1]

Alfred Kubin's letter of 1910 provides a typical example of how, for this artist, Christian mysticism was shot through with Schopenhauerian pessimism, and how the writings of Blavatsky or Steiner could be mentioned in the same breath as the racist dogma of Lanz-Liebenfels, or those of Görres and Kierkegaard could be swept together with the outpourings of Otto Weininger. Comprehensive source material enables us to reconstruct the intellectual and philosophical influences on Kubin far more precisely than is the case with Gerstl, Kokoschka, or Schiele; nonetheless, it seems clear that they too were

strongly affected by the ideas that were in the air at the time. There are a few hints that Gerstl became involved in these influential aspects of the Zeitgeist as well, even if the effects are not immediately apparent in his work—we know of his visit to the house where Weininger committed suicide, and of his reading of Moebius's book *On the Physiologically Determined Feeble-mindedness of Women*. For Kokoschka, of course, the struggle between the sexes was a dominant theme of his early Expressionist works. The effect of Weininger's treatise, *Sex and Character*, which mingled deep insights with crackpot theories, may be observed equally on Kokoschka and Schönberg, and is bound up with the complex and many-faceted fin-de-siècle sense of sexual struggle that found expression in the works of Strindberg or Wedekind, for instance. In August Strindberg's obituary of Weininger in *Die Fackel*, "Idolatry, Gynaeolatry," he asserted, among other things, that: "According to the latest analysis, female love consists of 50% lust and 50% hatred. That may sound extremely unlikely, but it *is* so."[2] As already mentioned, Schönberg's *Theory of Harmony* was dedicated to Weininger (as well as to Strindberg and Maeterlinck); for Kubin, Weininger in 1903 was deemed to be "the greatest man of the century."[3]

In Symbolist art there had already been a mixing of the ingredients of dream, unreality, and the mystical, while Theosophical ideas had influenced its conception and execution. It would be illuminating to investigate Viennese Jugendstil from the point of view of this aspect. In the first year of *Ver Sacrum*, for example, Kolo Moser created the decoration for a poem by Arno Holz, "Seven billion years before my birth, I was an iris."[4] To what extent Klimt, particularly in his faculty pictures, was giving expression to Theosophical ideas or was influenced by Schopenhauerian pessimism has long been a topic of scholarly discussion.[5] Klimt's contemporaries had already hinted as much, without, however, producing any concrete evidence. Franz Servaes characterized his work in 1900 as "the fruits of a profound and serious view of the world" and saw it as "virtually the quintessence of the Darwinian age, seen in the light of modern Theosophy."[6] Klimt's rendition of *Philosophy* appeared to the architect and theoretician of art, Ferdinand von Feldegg, to be rooted in Theosophy, which gave expression to "the flowering of youthly wisdom."[7]

Frank Kupka, who spent some time in Vienna before going to Paris in 1894, was also influenced by Theosophy and mysticism and indeed seems to have worked as a spiritualist medium.[8] Erich Mallina, who taught at the Vienna School of Applied Art, produced Symbolist work with a visionary mystical content that bears witness to his absorption of ideas derived from Far Eastern religion, and strives to represent cosmic harmony and the music of the spheres; he too was a member of the Theosophical Society. Fascination with mysticism led Gustav Meyrink to a brief membership in the Theosophical Lodge in Prague, founded in 1891.[9] Prague, traditionally the center of Jewish mysticism and cabalistic and astrological activity, and at the same

time the focal point of the nationality struggle between Germans and Czechs, was at the turn of the century a center of "Marcionism"—the name given to the vision of an abortive creation that borrowed heavily from the ideas of an early Christian heretic named Marcion.[10] "The Demiurge is a Hermaphrodite," Kubin's closing sentence in his novel *Visions from the Other Side*, is the expression of a quarrel with the deity that can be observed in many fin-de-siècle Austrian artists and writers. The result is a strong interest in metaphysics, combined with a gnawing anxiety about a world full of discord.

Gustav Mahler, who came from Kalischt, in Bohemia, was likewise a disciple of Theosophy. If one places his work in the context of his philosophy, his art appears as "an anticipation of destiny."[11] Alma Mahler recounts in her memoirs how she wrote to Annie Besant and asked to be taken by her as a student at Benares—which of course did not happen.[12] Schönberg's relationship to Theosophy and Anthroposophy has already been discussed, together with his concurrence with Kandinsky in these matters. Piet Mondrian was also strongly influenced by Theosophy in the course of his artistic development.[13] Kandinsky's spirituality played an essential part in opening the way for him to abstract painting and bolstered its theoretical basis;[14] indeed, a spirituality that was free of dogma was generally crucial to the development of modern art.

A metaphysical basis for creativity is common to many Expressionist artists. Van Gogh's yearning for religious comfort led him to create pictures, as he makes clear in his letters.[15] Edvard Munch desired of his pictures that "they should be understood as sacred, and people should raise their hats in front of them, as in a church."[16] For Franz Marc, the function of art was "to create symbols that belong on the altars of the coming religion of the spirit."[17] Schiele saw in the products of artists "the language of the gods"[18] and viewed his own works as sacral creations: "My pictures must be displayed in a building like a temple."[19] In Kubin we see the occult variant of this attitude; for him "many works of art were . . . accumulators of astral energy."[20] In Kokoschka's work, his involvement with religious phenomena may be traced from his earliest productions. The language of gesture in his art, as in his stage works, has hieratic-ritualistic features. Only Gerstl fails to conform to the same pattern, even if his early half nude self-portrait does remind one of an archaic adoration pose. The act of creation, which for the Expressionists stemmed from "inner necessity," required thus no further justification. It was legitimized through its metaphysical instigation and character.

The direct and indirect impact of Schopenhauer was derived principally from his concept of a driving power beyond mind, before which the intellect is forced to retreat. The implications are evident in Schiele's exclamation: "Pictures?—*Out* of me—not *by* me,"[21] or in his assertion that he "had to paint [a] picture, whether it was artistically good or bad."[22] Kubin cites the "overpowering . . . pressure of a dark creative force,"[23] and Schönberg observed that "art does not come from being able to create, but from having to

create." In his *Theory of Harmony* of 1911, Schönberg developed this idea into a theory of art: "The creativity of an artist is instinctive. Consciousness has little influence on it. An artist feels that what he does is dictated to him, as if he did it only by virtue of some power within him whose laws he does not understand. He is simply the executor of an unidentifiable will, of the instinct, of his unconscious. . . . He feels only the urge, which he is bound to obey."[24] In Schönberg's circle this view was adopted wholesale, although Webern added to it in a way that Schönberg, with his sense of his own missionary role, would never have approved: "I am simply the tool of a higher power. I myself am nothing."[25]

Denial of will, psychologism, and the concept of salvation also had effects on fin-de-siècle artists as a result of being filtered through the works and theories of Richard Wagner. The culture of the senses, of which Wagner was the presiding genius, had grown out of Romanticism, and provided a set of attitudes opposed to rationalism and positivism. In Austria it was fused with a deeply rooted tradition of Baroque sensualism.

The way in which the Schopenhaurian-Wagnerian principle of driving force melded with Freud's theories of the unconscious and the atavistic may be seen in the preceding quotation from Schönberg, where even the terminology seems to echo Freud. After the appearance of his *Interpretation of Dreams* in 1900 and the institution of the psychological "Wednesday Society" in 1902, Freud's ideas also permeated literary and artistic circles.[26] Instances of Freudian influence can be seen in the work of Arthur Schnitzler, Hugo von Hoffmannsthal, and Karl Kraus. Hermann Bahr's *Dialogue of the Tragic* indicates a familiarity with Freud's *Studies in Hysteria*. Bahr expands and metamorphoses Freud's ideas about theater in ancient Greece, seeing in tragedy a means—now superceded, as he believes, of achieving a collective "abreaction":

> Tragedy, in fact, is designed to do exactly what those two doctors [Freud and Breuer] do: it reminds a people that has become sickly through culture of what it does not wish to be reminded; of its evil passions, which it conceals; of the originally primitive nature of man, which, under the veneer of culture, still squats and crepitates; it looses the chains of the primitive creature and lets the beast run free until it has vented all its spleen; and mankind, liberated from the lingering fumes and vapors, and appeased through the catharsis of the emotions, can become once more amenable to the customs of civilization.[27]

The cathartic function of tragedy, which is achieved through the presentation on the stage of what otherwise, through civilization and culture, can only be suppressed, is also an uncalculated feature of Kokoschka's dramas.[28] They have a precedent in Hofmannsthal's *Elektra*, which itself exhibits the direct influence of psychoanalysis. (Of the artists discussed in the present work, only Oppenheimer portrayed Sigmund Freud—in a figurative likeness that is in no way related to Expressionism.)

The artistic programs of the Secession show a steady retreat of its members from the overt engagement with society that was originally one of the prime motivations for founding it. In place of late Secessionist aesthetic narcissism, early Austrian Expressionism posited a metaphysically grounded subjectivism of the creative artist, underpinned by uncompromising psychological realism. It substituted for the doctrine of world improvement (or, later, the attainment of individual grace) through aesthetic means the subjective assimilation of the world through introspection. This approach joined with an enduring Austrian Catholic tradition that held the external world is merely appearance and the real world cannot be discerned at all. For Gütersloh, this made the artist himself a sort of priest: "The genuine creator . . . appeals to us, like religion, to have the strength to see our very existence as hypothetical." The "great, secret purpose" of art, in Gütersloh's view, is to "make us mistrustful of our own organs (which nonetheless transmit to us, in banal form, quite other 'natural' and 'understandable' phenomena). . . . It [art] is directed against our godless sense of security and arrogance, against our knowledge, against our reverence for that [apparently] incontrovertible mechanism: man."[29] Even the strict positivism of an empirical-rational view of the world, which represents the opposite view as expressed in the work of Mach, Boltzmann, Mauthner, and others, may be understood in the context of the dualism of appearance and reality because the thought of such scientists encompassed elements of philosophical doubt in the fields of cognition and perception. It is no accident that the scientific forebear of positivism is Catholic rational theology, which is rooted in the traditions of logic and scholasticism. Later, Wittgenstein was to write in his *Tractatus*: "The subject does not belong to the world, but is a boundary of the world."[30]

The despair of language that found expression in Austrian scientific theory as well as in literature reflected in many cases an attitude of resignation. In the field of medicine it is analogous to the "therapeutic nihilism" that characterized a branch of the Viennese Medical School before the turn of the century, and that placed a far higher value on diagnosis than on treatment. In politics, a similar phenomenon was manifest in an inability to take action, a paralysis that stemmed from the stalemate produced by steady pressure of opposing forces: "Either no action at all or action . . . that leaves things much as they are." This was seen as typical of the Austrian character as it had gradually been molded by events from the beginning of the nineteenth century.[31] The cultural flowering of the Austrian fin de siècle thus took place in the "hortus conclusus," in a sealed-off garden, to employ the metaphor commonly used to describe a culture that had increasingly cut itself off from sociopolitical realities.[32] The suffocating beauty of this garden, which was achieved at the expense of the sublimation of the "hostile powers," produced the ferocity of Expressionism, which was to enable the culture to breathe again.

Atavistic release, ecstasy, the realizing of the potential of the creative

individual, were also the preconditions for the renewal of life stipulated by Friedrich Nietzsche. The antirational current of the nineteenth century was considerably strengthened by the contribution made by Nietzsche's thought, and it became a distinctive feature of Expressionism as well. Above all, the concept of heroic isolation, of the tragically misunderstood creative genius, influenced many artists. It can be seen in Schiele's perception of artists as "the chosen ones"[33] and of himself as being necessarily sacrificed on the altar of art,[34] and in his assertion that "Whoever demands that a work of art should be explained to him should not be indulged, since he is too limited to appreciate it."[35] It is also evident in the attitude of Kubin, who was exposed to Nietzschean influences as a member of the Klages circle in Munich, and again in Schönberg's elitist sense of mission. Hermann Bahr's *Dialogue of the Tragic* also reflects the impact of Nietzsche. Gustav Mahler placed a poem by Nietzsche from *Also Sprach Zarathustra* at the heart of his Third Symphony. The apocalyptic language of Zarathustra—and of Jesus—was applied by Adolf Loos, above all in his treatise *Ornament and Crime* (which also expresses the healing role of art for societal ills, a role Loos still believed in): "Every age has its style, so why should our age alone be denied one? By style the people mean ornament. To this I say: Do not weep! . . . See, the time is near that all shall be accomplished. Soon the streets of the cities will shimmer like white walls: like Zion, the holy city, the capital of Heaven. Then all shall be fulfilled."[36]

Nietzsche's personality embodied the combination of creativity and spiritual obsession that held so great a fascination for the Symbolists. The corresponding oppositional viewpoints of cultural criticism were embodied in such works as Cesare Lombroso's *Genius and Madness*[37] and Max Nordau's thousand-page-long *Degeneracy*.[38] In contrast to Lombroso, who researched the productive effects of mental illness on creativity, Nordau believed that creative genius is only possible in the context of complete mental and bodily health—a view that anticipates in many respects the later attitude to culture of National Socialism.

Monism is also part of the intellectual and spiritual background of the fin de siècle, a reduction of all existence to a single principle in which the dualism between the spiritual and the material is finally laid to rest. The new scientific discoveries regarding space and time, the structure of the atom, and especially the convertibility of mass into energy, were taken to be empirical confirmation of the validity of monism. Ernst Haeckel, whose works on *The Radiolaria* and *The Artistic Forms in Nature* had a particularly marked effect on German Jugendstil,[39] was also a leading proponent of monism in its populist philosophical guise. His influence is evident on Hermann Bahr, whose enthusiastic pantheism in respect of the works of Segantini has already been quoted. Of Klimt's pictures Bahr wrote in 1908 that "his painting reproduces our monism."[40] A monistic way of thinking also lies behind Ferdinand von Feldegg's interpretation of Klimt's *Philosophy*, which he saw not as repre-

senting "the sum of individual 'exact' sciences but as a unified science of the world; not the learning based on what the senses can grasp, but one based on the ultrasensorial ungraspable."[41] In her book *The Dance of the Future*, Isadora Duncan cited Charles Darwin and Ernst Haeckel as her mentors; when she invited the latter to a performance of Parsifal in Bayreuth, for which she had created the choreography, he referred to her dance as an expression of monism.[42]

Monism's proclamation of all-embracing unity answered the need for a re-assertion of integrity felt by a society riven by the divisions in the sciences, a crisis in personal identity, and societal conflicts that, in different ways, affected many very disparate areas of life. On the other hand, the vague and contradictory nature of monism may be seen in Gütersloh's characterization of Schönberg in 1912. He described him as a "painterly opponent of monism,"[43] while Schönberg himself, in a lecture on Gustav Mahler in the same year, adopted a terminology in which monistic features mingled with those of Theosophy; he asserted, for instance, that the essence of a work of art is that it should express "the yearning of mankind for its future form," and "for an immortal soul, for dissolution in the universe, the yearning of these souls for their god."[44] Kubin, in his autobiographical sketch of 1911, demonstrated a skeptical attitude to this "dissolution in the universe" when he noted at the end: "I am not particularly concerned as to whether, in the opinion of those who profess to know something about it, death leads to nothing, or to universal consciousness, or to some new special form of life."[45] In the same year Schiele wrote: "As long as there are elements, total death is not possible."[46] Works of art were also perceived by Schiele as "just like any other authoritative life form."[47] In the case of Schiele, as in that of Kokoschka, one can speak of a conception of nature and the world that is highly intellectual and that at the same time takes the form of transcendentalism. It is expressed both in their artistic creations and in their prose and poetry, being already evident in Kokoschka's *The Dreaming Youths*.

Notwithstanding all these influences, it would be wrong to see these artists as embodying a specific ideology or philosophy. In neither monism nor Theosophy, Nietzsche nor Schopenhauer, Weininger nor Freud, are the creative impulses of Austrian Expressionism to be found. On the other hand, it is important to be aware of the intellectual, spiritual, and philosophical context within which it developed, a context that left its mark, in individual and frequently in contradictory ways, on the artists concerned.

In its multilayered early phase, Austrian Expressionism may also be compared with the fundamental spiritual and artistic outlook of early Romanticism. In both cases there is an evident hostility to rationalism and positivism and an acute awareness of spiritual crisis in a time of revolutionary cultural change. Many aspects of early German Romanticism are analogous to those of early Expressionism—in which regard, however, the special position of Gerstl should once again be stressed, because such considerations apply to

him only to a very limited extent. The characteristics of Romanticism that are also relevant to Expressionism include the high value placed on feeling, introspection, and dream; the interest in the fantastic, the exotic, and in visions; an avowal of unsolved contradictions, of the subjective, and the irrational; the mystique of nature; the missionary task of creative activity; and the precedence given to invisible reality over the visible; also, the abandonment of the idea of form representing an organic whole; the discovery of color as an individual means of expression; the use of symbol and metaphor; the capacity of persons and objects to evoke mood; the characteristics of an art of ideas with a philosophical, ethical, and literary orientation; and finally the experience of the inner conflicts of human existence, an awareness of the unfulfilling nature of contemporary reality, and a yearning for transcendental experience.[48] The philosophy of identity in early Romanticism[49] also had its counterpart in early Austrian Expressionism.

Georg Lukács, in his influential studies, was later to "accuse" Expressionism of a "Romantic opposition to capitalism."[50] As a consequence of its irrationalism and individualism, Expressionism, despite its "revolutionary impetus . . . failed to provide a concrete analysis of the phenomena it criticized or a convincing alternative vision for a future society."[51] But if one looks for "sociopolitical achievements" or "insight into economic legitimacy"[52] in Expressionism—or in our case, early Austrian Expressionism—one is certainly bound to be disappointed. Its affinity with early German Romanticism makes it clear that the eruptive phase of Austrian Expressionism can have nothing to do with the type of mass alteration in society that is the province of politics and economics. Its response to situations of personal conflict could only be individual and personal. It was this that led to a dramatic opening up of areas of human experience hitherto safely kept under wraps.

Consideration of early Expressionist works involves consideration of the intellectual and spiritual conundra of the age that produced them; the relevance of these works to our own times, however, is reflected in the enormous interest they still arouse. Such an interest also reflects something very fundamental and enduring, namely the perception of works of art and their spiritual profundity as vital to man's understanding of himself and his relationship to the world.

Notes

▪ O N E : Early Expressionism ▪

1. On the history of style, see Josef Adolf Schmoll, known as Eisenwerth, "Stil-pluralismus statt Einheitszwang: Zur Kritik der Stilepochen- Kunstgeschichte," in *Argo: Festschrift für Kurt Badt*, ed. Martin Gosebruch and Lorenz Dittmann (Cologne, 1970). Also available in Eisenwerth, *Epochengrenzen und Kontinuität: Studien zur Kunstgeschichte* (Munich, 1985), pp. 11–31. On the question of style at the turn of the century, see Richard Hamann and Jost Hermand, *Stilkunst um 1900* (Berlin, 1967).

▪ T W O : On the Reception of Modern Painting in Vienna ▪

1. Berta Zuckerkandl, *Zeitkunst* (Vienna, 1908).

2. Hermann Bahr, *Secession* (Vienna, 1900), p. 232.

3. Richard Muther, *Studien und Kritiken*, 2 vols. (Vienna, 1900, 1901) 1: 203f.

4. Catalogue of the first Secession exhibition, Mar.–June 1898. On the Secession exhibitions, see M. Nebehay, *Gustav Klimt: Dokumentation* (Vienna, 1969).

5. *Ver Sacrum* 1 (August 1898): 24.

6. Bahr, *Secession*, p. 15.

7. Catalogue of the third Secession exhibition, Jan.–Feb. 1899.

8. Ludwig Hevesi, *Acht Jahre Sezession* (Vienna, 1906; reprint, Klagenfurt, 1984), p. 102.

9. *Ver Sacrum* 2, no. 11 (1899).

10. Bahr, *Secession*, p. 206.

11. Ibid., p. 88.

12. Catalogue of the seventh Secession exhibition, Mar.–June 1900.

13. Hevesi, *Sezession*, p. 242.

14. Alice Strobl, *Gustav Klimt: Die Zeichnungen*, 4 vols. (Salzburg, 1980) 1: 147–51; Peter Vergo, "Gustav Klimts *Philosophie* und das Programm der Universitätsgemälde," in *Klimt-Studien: Mitteilungen der Österreichischen Galerie* 22–23 (1978–79): 94–97.

15. Quoted by Hermann Bahr in *Gegen Klimt* (Vienna, 1903), p. 36.

16. Hevesi, *Sezession*, p. 250. On this topic, see also Edwin Lachnit, "Neuentdeckte Dokumente zum Professorenstreit um Klimts *Philosophie*," *Wiener Jahrbuch für Kunstgeschichte* 29 (1986): 205–20.

17. Catalogue of the eighth Secession exhibition, Nov.–Dec. 1900.

18. See *George Minne en de Kunst rond 1900*, exhibition catalogue, Museum voor Schone Kunsten (Ghent, 1982), pp. 175–79, 194–99.

19. Zuckerkandl, *Zeitkunst*, pp. 47–52.

20. Catalogue of the ninth Secession exhibition, Jan.–Feb. 1901.

21. Hevesi, *Sezession*, p. 184.

22. Franz Servaes, *Giovanni Segantini: Sein Leben und sein Werk* (Vienna, 1902), p. 260.

23. Bahr, *Secession*. pp. 19f.

24. Muther, *Studien*, 1: 99.

25. Catalogue of the twelfth Secession exhibition, Nov.–Dec. 1901.

26. Hevesi, *Sezession*, p. 356.

27. Muther, *Studien*, 2: 276.

28. Catalogue of the fifteenth Secession exhibition, Nov.–Dec. 1902.

29. See Marian Bisanz-Prakken, *Gustav Klimt: Der Beethovenfries* (Salzburg, 1977).

30. Catalogue of the fourteenth Secession exhibition, Apr.–June 1902.

31. Hevesi, *Sezession*, p. 383.

32. See Bisanz-Prakken, *Beethovenfries*.

33. Quoted by Bahr in *Gegen Klimt*, p. 67.

34. Ibid., p. 70.

35. Ibid., p. 72.

36. Ibid.

37. Catalogue of the sixteenth Secession exhibition, Jan.–Mar. 1903.

38. Nebehay, *Klimt*, p. 304.

39. Hevesi, *Sezession*, p. 419.

40. Catalogue of the nineteenth Secession exhibition, Jan.–Mar. 1904.

41. Hevesi, *Sezession*, pp. 452f.

42. *Hodler und Wien: Neujahrsblatt der Zürcher Kunstgesellschaft, 1950*. Contributions by Hans Ankwicz-Kleehoven and others.

43. Kolo Moser after visiting Hodler in Geneva, 1913, quoted in ibid., p. 32.

44. Hevesi, *Sezession*, flyleaf.

45. Zuckerkandl, *Zeitkunst*, p. 150.

46. Walther Maria Neuwirth, "Die sieben heroischen Jahre der Wiener Moderne." *Alte und moderne Kunst* 9, no. 74 (1964): 28–31.

47. Bahr, *Secession*, p. 71.

48. Andreas Lehne, "Zur Rezeption Segantinis," *Mitteilungen der Gesellschaft für vergleichende Kunstforschung in Wien* 34, no. 1 (1982): 1–5.

49. Eva Badura-Triska, "Galerie Miethke," in *Wien um 1900: Kunst und Kultur* (Vienna, 1985), pp. 533f.

50. *Neue Freie Presse*, Jan. 26, 1906, p. 6.

51. *Paul Gauguin*, exhibition catalogue, Galerie Miethke, introduction by Rudolf Adalbert Meyer (Vienna, Mar.–Apr. 1907).

52. *Vincent van Gogh*, exhibition catalogue, Galerie Miethke, introduction by Arthur Roessler (Vienna, Jan. 1906).

53. *Goya*, exhibition catalogue, Galerie Miethke, foreword by Carl Moll (Vienna, Mar.–Apr. 1908).

54. *Toulouse-Lautrec*, exhibition catalogue, Galerie Miethke, foreword by H. O. Miethke (Vienna, Oct.–Nov. 1909).

55. *Aubrey Beardsley*, exhibition catalogue, Galerie Miethke (Vienna, Dec. 1904–Jan. 1905).

56. Ludwig Hevesi, *Altkunst-Neukunst: Wien, 1894–1908* (Vienna, 1909; reprint, Klagenfurt, 1986), p. 518.

57. Ibid., pp. 527–29.

58. Franz Servaes, "Streifzug durch die Wiener Malerei," in *Kunst und Künstler* 8 (1909–10): 587–98.

59. Gabriele Hammel, "Janus lacht: Neue Galerie des Kunsthistorischen Museums—kurze Bemerkung zu einer längeren Geschichte," *Parnass* 4, no. 2 (1984): 24–29.

60. Oskar Reichel and others, "Anton Romako," in *Bildende Künstler: Monatsschrift für Künstler und Kunstfreunde* 2 (1911): 51–66; idem, untitled, in *Privatsammlung Dr. Oskar Reichel*, exhibition catalogue, Galerie Miethke (Vienna, Feb. 1913).

61. *Der Hagenbund*, exhibition catalogue, Historisches Museum der Stadt Wien (Vienna, 1975).

62. Michael Worbs, *Nervenkunst: Literatur und Psychoanalyse in Wien der Jahrhundertwende* (Frankfurt am Main, 1983), pp. 143f.

63. *Kunstschau*, exhibition catalogue (Vienna, 1908).

64. *Internationale Kunstschau*, exhibition catalogue (Vienna, 1909).

65. Arthur Roessler, "Neukunstgruppe: Ausstellung im Kunstsalon Pisko," *Arbeiter-Zeitung*, Vienna, Dec. 7, 1909, pp. 7f.

66. Quoted in Christian M. Nebehay, *Egon Schiele, 1890–1918: Leben, Briefe, Gedichte* (Salzburg, 1979), p. 97.

▪ T H R E E: "Mementos of Beauty" and "Hostile Powers" ▪

1. Bahr, *Secession*.

2. Max Burckhard, "Ver Sacrum," *Ver Sacrum* 1 (1898): 2f.

3. Unattributed quotation, ibid., 5.

4. Berta Zuckerkandl, "Der Dilettantismus—Die neue Volkskunst," *Ver Sacrum* 7 (1898): 8.

5. Adolf Loos, "Die potemkischen Dörfer," ibid., 16.

6. Adolf Loos, "Wohnungsmoden," *Frankfurter Zeitung*, no. 340. (Dec. 8, 1907): 1. Quoted in Burkhard Rukschcio and Roland Schachel, *Adolf Loos: Leben und Werk* (Salzburg, 1982), p. 110.

7. *Hans Makart: Triumph einer Schönen Epoche*, exhibition catalogue (Baden-Baden, 1972), p. 50.

8. *Die Fackel*, no. 384–85 (Oct. 13, 1913): 4.

9. Gustav Klimt, foreword to the *Kunstschau* catalogue (Vienna, 1908).

10. Bahr, *Secession*, p. 37.

11. See Manfred Wagner, "Der Jugendstil als Zukunftsvision," in Peter Berner, Emil Brix, and Wolfgang Mantl, eds., *Wien um 1900—Aufbruch in der Moderne* (Vienna, 1986), pp. 152–56.

12. Explication of Klimt's Beethoven frieze in the catalogue of the fourteenth Secession exhibition.

13. *Experiment Weltuntergang: Wien um 1900*, exhibition catalogue, Kunsthalle (Hamburg, 1981).

14. Arthur Schnitzler, *Der einsame Weg* (1904) final act.

15. Robert Musil, *Die Schwärmer*, third act, in *Gesammelte Werke* (Reinbek b. Hamburg, 1978), 6: 288.

16. *Die Fackel*, no. 315–16 (Jan. 26, 1911): 31.

17. Alessandra Comini, *Egon Schiele's Portraits* (Berkeley, 1974), pp. 1ff.

18. Michael Pabst, *Wiener Grafik um 1900* (Munich, 1984).

19. Werner Hofmann, quoted in Edwin Lachnit, "Review of Patrick Werkner, *Physis und Psyche*," *Kunsthistoriker: Mitteilungen des österreichischen Kunsthistorikerverbandes* 4, no. 3–4 (1987): 81.

20. Pabst, *Wiener Grafik*, passim. See also Peter Haiko and Mara Reissberger, "Ornamentlosigkeit als neuer Zwang," in Alfred Pfabigan, ed., *Ornament und Askese im Zeitgeist des Wien der Jahrhundertwende* (Vienna, 1985), pp. 110–19.

21. Hevesi, *Sezession*, pp. 368–70.

22. Ibid., pp. 516–23.

23. Hevesi, *Altkunst-Neukunst*, pp. 280–82.

24. Ibid., pp. 279f.

25. *Neue Freie Presse*, Jan. 26, 1906, p. 6.

26. Hevesi, *Altkunst-Neukunst*, pp. 282–84; Hugo von Hofmannsthal, "Die unvergleichliche Tänzerin," in *Gesammelte Werke: Prosa* (Frankfurt am Main, 1951), 2: 256–63. First publication: 1906, in *Die Zeit*.

27. *Die Fackel*, no. 216 (Jan. 9, 1907): 20f.

28. On this, see Patrick Werkner, "De 1910 a nos jours: Affinités dans les arts plastiques autrichiens," in *Face à face: L'art en Autriche du baroque à nos jours*, exhibition catalogue, Palais des Beaux-Arts (Brussels, 1987), pp. 30–35.

29. Adalbert Franz Seligmann, "Die Kunstschau, 1908," *Neue Freie Presse*, no. 15727 (June 2, 1908): 14. Quoted in Werner J. Schweiger, *Der junge Kokoschka* (Vienna, 1983), p. 68.

30. Adalbert Franz Seligmann, *Kunst und Künstler von gestern und heute: Gesammelte Aufsätze* (Vienna, 1910), p. 82.

31. Albert Paris Gütersloh, "Neukunst," *Pester Lloyd* 59, no. 3 (Jan. 4, 1912): 3. Gütersloh's text also appeared in a Hungarian translation in *A Neukunst Wien*, exhibition catalogue (Budapest, Müvészház, 1912). Information kindly supplied by Werner J. Schweiger.

32. *Die Fackel*, no. 1 (April 1899).

33. *Die Fackel*, no. 360–62 (Nov. 7, 1912): 22.

34. Arnold Schönberg, "Frühe Aphorismen," *Die Musik* 9 (1909–10). Quoted in *Experiment Weltuntergang*, p. 220.

■ F O U R : **Richard Gerstl** ■

1. Nirenstein later changed his name to Otto Kallir, the name that appears in the citations that follow. See Otto Kallir, "Richard Gerstl (1883–1908): Beiträge zur Dokumentation seines Lebens und Werkes," *Mitteilungen der Österreichischen Galerie* 18, no. 62 (1974): 125.

2. Published in Kallir, "Gerstl," pp. 137–40, 141–44.

3. Vienna, Archiv der Akademie der bildenden Künste, classification list no. 2046.

4. K. Lyka, in Thieme-Becker, *Allgemeines Lexikon der bildenden Künstler* (Leipzig, 1924), 17: 284.

5. See Note 3.

6. Ibid.

7. Kallir, "Gerstl," p. 141.

8. Ibid., p. 139.

9. Ibid., p. 141.

10. Ibid., p. 143.

11. Leipzig, 1900.

12. *Die uns verliessen*, exhibition catalogue, Österreichische Galerie (Vienna, 1980), pp. 99f.

13. Kallir, "Gerstl," p. 142.

14. Carl von Lützow, *Geschichte der kaiserlich königlichen Akademie der bildenden Künste* (Vienna, 1870), p. 170.

15. Walter Wagner, *Geschichte der Akademie der bildenden Künste in Wien* (Vienna, 1967), p. 377.

16. *Der Hagenbund*, exhibition catalogue, Historisches Museum der Stadt Wien (Vienna, 1975).

17. Vienna, Archiv der Akademie der bildenden Künste. V. A. 437–1908. Published in Almut Krapf-Weiler, "Richard Gerstl," *Wien um 1900*, p. 73.

18. Kallir, "Gerstl," p. 138.

19. Ibid., pp. 142f.

20. Catalogue of the ninth Secession exhibition, pp. 28f.

21. Muther, *Studien*, 1: 108f.

22. Hevesi, *Sezession*, pp. 311f.

23. *Ver Sacrum*, no. 4 (1901): 81.

24. Georg Rudolf Lind, "Hermann Bahr und die spanische Geisteswelt," in Margret Dietrich, ed., *Hermann-Bahr-Symposion in Linz 1984* (Linz, 1987), p. 62.

25. *Giovanni Segantini, 1858–1899*, exhibition catalogue, Museum des 20. Jahrhunderts (Vienna, 1981).

26. Quoted from the *Journal of Arnold Schoenberg Institute, Los Angeles* 2, no. 3 (1978): 234.

27. Kallir, "Gerstl," p. 143.

28. Otto Breicha, in *Richard Gerstl*, exhibition catalogue, Secession (Vienna, 1966), unpaginated.

29. Kallir, "Gerstl," p. 132.

30. Anton von Webern seems to have had a hand in this. In January 1912 Schönberg noted in his journal, after the two had apparently quarreled because of Webern's attitude (he had not attended the premiere of Schönberg's First String Quartet in

Berlin), that his wife had "naturally gone too far; for she needs for various reasons (G) [Gerstl], that things should be patched up with Webern." Quoted in H. H. Stuckenschmidt, *Schönberg: Leben—Umwelt—Werk* (Zürich, 1974), p. 155.

31. The son of the subject of the *Portrait of G. P.* told Otto Kallir in 1931 that his family had "thrown out" various pictures by Gerstl. Kallir, "Gerstl," p. 167.

32. Wolfgang Born, "Richard Gerstl," *Belvedere: Zeitschrift für Kunst und künstlerische Kultur* 10, no. 11 (1931). Quoted in Kallir, "Gerstl," p. 172. On the other hand, Otto Breicha, "Kursorisches zum Fall Gerstl," in *Richard Gerstl: 1883–1908*, exhibition catalogue, Historisches Museum der Stadt Wien (Vienna, 1983), p. 16, dates the picture to 1902.

33. Kallir, "Gerstl," no. 54. Here and in the following references, in the absence of a catalogue of the complete works, the numbers used are those of the painter's estate in Kallir, "Gerstl," pp. 145–67, which still provides the most comprehensive listing of his works. For works not on this list, the numbering of the 1983 Vienna Gerstl exhibition catalogue, *Richard Gerstl: 1883–1908*, will be adopted.

34. Kallir, "Gerstl," no. 45.

35. Ibid., no. 35.

36. Ibid., no. 2.

37. Ibid., no. 42.

38. Ibid., no. 22.

39. Ibid., rear side.

40. Ibid., no. 24.

41. Ibid., no. 5.

42. Ibid., no. 39, 40, rear sides.

43. Otto Breicha, "Gerstl, der Zeichner," *Albertina Studien* 3, no. 2 (1965): 92–101.

44. Kallir, "Gerstl," no. 57, 60, 61, 62.

45. Ibid., no. 58 (with portrait, dated September 15, and undated portrait on verso), no. 59 and 63, dated Sept. 29.

46. Ibid., p. 131.

47. Gerstl exhibition catalogue (1983), no. 13.

48. Kallir, "Gerstl," no. 26.

49. Gerstl exhibition catalogue (1983), no. 12.

50. Ibid., no. 9.

51. Kallir, "Gerstl," no. 4.

52. Ibid., no. 44.

53. Ibid., no. 46.

54. Ibid., no. 41.

55. For consideration of the possible stylistic influence of Munch on Gerstl, see Hans Bisanz, "Edvard Munch und seine Bedeutung für den mitteleuropäischen Expressionismus" (Ph. D. diss., Vienna, 1960), pp. 53–60.

56. Hans Moldenhauer and Rosaleen Moldenhauer, *Anton von Webern. Chronik seines Lebens und Werks* (Zürich, 1980), p. 595, n. 15.

57. Kallir, "Gerstl," no. 52.

58. Ibid., no. 47.

59. Ibid., no. 31.

60. Ibid., no. 48.

61. Ibid., no. 51.

62. Ibid., no. 40.

63. Ibid., no. 3.

64. Ibid., no. 11, 21.

65. Ibid., no. 11.

66. An eyewitness of Gerstl's method of painting on the Traunsee still recalled in 1931 "how he smeared the colors on the canvas with a small palette knife." Quoted in Kallir, "Gerstl," p. 167.

67. Ibid., no. 29.

68. Ibid., no. 33.

69. Ibid., no. 49.

70. Ibid., p. 167.

71. In this sense, Werner Hofmann's rhetorical question of whether "in these paintings the desperation of the future suicide is not foreshadowed as an exceptional intensification of creativity" is to be answered in the negative. In *Experiment Weltuntergang*, p. 213.

72. First press information on Richard Gerstl on the occasion of his collective exhibition in the Neue Galerie, Vienna. Kallir, "Gerstl," p. 131. Taken from Born, "Richard Gerstl," Heimo Kuchling, *Richard Gerstl, 1883–1908* exhibition catalogue, Galerie Würthle (Vienna, undated), and Breicha, Gerstl exhibition catalogue, 1966.

73. Kallir, "Gerstl," p. 131, n.

74. Werner Hofmann, "Der Wiener Maler Richard Gerstl," *Kunstwerk* 10, no. 1–2 (1956–57): 100. On the other hand, Otto Breicha, without giving his source, asserted in 1965 that "Gerstl was intermittently occupied with Pointillism during 1906 and 1907" ("Gerstl, der Zeichner," p. 96). He dated the Kahlenberg picture, again without supporting evidence, to early 1907 and believed that Gerstl's "spotting technique lasted at least until the summer of 1907" (ibid.). Breicha later dropped such differentiations, but nevertheless dated the *Half Nude Self-Portrait* to 1902 (in the Gerstl catalogue, 1983, p. 16), while Born had dated it to 1904 in "Richard Gerstl."

75. Born, "Richard Gerstl."

76. Harald Sterk, *Österreichische Porträts: Das Bildnis in der Gegenüberstellung von malerischer und photographischer Interpretation* (Vienna, 1982). The photographic portrait of Gerstl reproduced here has been dated to the summer of 1903, although there is no supporting evidence.

77. Otto Kallir was still writing to Schönberg about Gerstl on Sept. 9, 1944, apparently unaware of this relationship. Schönberg noted on the margin of the letter: "Talent is destiny—very talented, to remind me of this just at this moment." (Schönberg was 70 in the same month.) Quoted in Stuckenschmidt, *Schönberg*, p. 424.

78. See note 72 above.

79. See note 28 above.

80. See note 32 above.

81. For example, there is no article on Gerstl in Kindler's twelve-volume *Malerei-Lexikon* of 1976.

82. Hoffmann, "Richard Gerstl," p. 100.

83. See Gerhard Schmidt, *Neue Malerei in Österreich* (Vienna, 1956), p. 14.

▪ F I V E : Oskar Kokoschka ▪

1. Oskar Kokoschka, *Die träumenden Knaben* (The Dreaming Youths) (Vienna, 1908). Also printed in Oskar Kokoschka, *Dichtungen und Dramen: Das schriftliche Werk*, vol. 1, ed. Heinz Spielmann (Hamburg, 1973), pp. 8–16.

2. Letter from C. O. Czeschka to H. Ankwicz-Kleehoven, Hamburg, Sept. 11, 1952. Quoted in Schweiger, *Kokoschka*, p. 25.

3. See *Expressive und dekorative Grafik in Wien zwischen 1905 und 1925: Rudolf Kalvach, Hedwig Meiler*, exhibition catalogue, Museum für angewandte Kunst (Vienna, 1979).

4. *Erdgeist* 3, no. 6 (1908): 175, 178.

5. Ivan Fenyö, *Oskar Kokoschka: Die frühe Graphik* (Vienna, 1976).

6. Jaroslav Leshko, "Klimt, Kokoschka, und die mykenischen Funde," *Mitteilungen der Österreichischen Galerie* 13 (1969): 18ff.

7. See *Paul Gauguin*, exhibition catalogue.

8. *Illustrirtes Wiener Extrablatt* 37 (June 2, 1908): 6. Quoted in Schweiger, *Kokoschka*, p. 68.

9. Richard Muther, "Die Kunstschau," *Die Zeit* 7 (June 6, 1908): 1f. Quoted in Schweiger, *Kokoschka*, p. 74.

10. Letter to Erwin Lang, Vienna, probably at the end of 1907. Oskar Kokoschka, *Briefe*, vol. 1, *1905–1919*, ed. Olda Kokoschka and Heinz Spielmann (Düsseldorf, 1984), p. 7.

11. Ibid., pp. 7f.

12. Letter, probably written in February or March 1908. Ibid., p. 9.

13. On this, see Note 37 below.

14. Schweiger, *Kokoschka*, p. 105.

15. Patrick Werkner, "Kokoschka's frühe Gebärdensprache und ihre Verwurzelung im Tanz," in *Oskar-Kokoschka-Symposion der Hochschule für angewandte Kunst in Wien, March 1986* (Salzburg, 1986), pp. 82–99. Abbreviated version printed in *Parnass* 4 (Linz, 1986).

16. Kokoschka, *Briefe*, p. 6.

17. Ibid., pp. 8f.

18. *Erdgeist* 4, no. 10 (1909): 358ff.

19. *Erdgeist* 3, no. 1 (1908): 19–21.

20. Gustav Klimt, in his opening speech for the Kunstschau, 1908. *Kunstschau*, exhibition catalogue (Vienna, 1908), p. 4.

21. *Die Traumtragenden* (The Bearers of Dreams) were perhaps sketches for the lithographs of *The Dreaming Youths*. They were possibly identical with the outlines for six 200 × 220 cm. embroidered tapestries for the Palais Stoclet in Brussels, which, however, were rejected by the future owner. See Werner J. Schweiger, *Wiener Werkstätte: Kunst und Handwerk, 1903–1932* (Vienna, 1982), p. 52.

22. Hevesi, *Altkunst-Neukunst*, p. 313.

23. Arnold Clementschitsch, *Wege und Irrwege eines Malers* (Klagenfurt, 1947), pp. 91f.

24. Letter to Emma Bacher, Apr. 4, 1909. Kokoschka, *Briefe*, p. 10.

25. Karl Gruber, "Zur Entstehung von Kokoschkas Forel-Bildnis," *Das Kunstwerk* 5, no. 3 (1951): 60f. One thinks also of Kokoschka's account of a hallucination

that he experienced some years before his war service and that was associated with the attacks of giddiness that afflicted him after he was wounded: Oskar Kokoschka, "Vom Erleben," in *Oskar Kokoschka*, exhibition catalogue (Bregenz, 1976), p. 136. See also the sixth of the scenes done for Alma Mahler in 1914, showing a man with his breast pierced by a bayonet, which Hans Spielmann in *Die Fächer für Alma Mahler* (Hamburg, 1969), p. 29, interprets as a premonition on Kokoschka's part of his wounding in the war.

26. Albert Ehrenstein, *Menschen unter Affen* (Berlin, 1925). Quoted in *Oskar Kokoschka* (Bregenz, 1976), p. 46.

27. Vienna, Albertina, Adolf-Loos-Archiv, inventory number 999.

28. *Die Fackel*, no. 300 (Apr. 9, 1910): 25.

29. Only Herbert Giese, in "Einige Bemerkungen Zum Frühwerk Oskar Kokoschkas," *Wien um 1900*, pp. 67–72, expresses doubts about the dating of Kokoschka's painting to before 1909. Since the appearance of the German edition of this book and other publications marking the centenary of Kokoschka's birth, this dating has been generally accepted. See Heinz Spielmann, "Kokoschka's Kindheit und früheste Gemälde," in *Oskar-Kokoschka-Symposion der Hochschule für angewandte Kunst in Vienna, March 1986* (Salzburg, 1986), pp. 17–42.

30. See Schweiger, *Kokoschka*, passim.

31. For example, in Fritz Schmalenbach, *Oskar Kokoschka* (Königstein, 1967). See idem, "Der junge Kokoschka," in *Argo*, pp. 386–400.

32. Announcement in *Wiener Tagblatt* 41 (Oct. 27, 1907): 11. Quoted in Schweiger, *Kokoschka* p. 42.

33. Otto Kamm, "Oskar Kokoschka und das Theater" (Ph.D. diss., Vienna, 1958), pp. 101f.

34. Max Mell, "Chaos der Kindheit," *Die Zukunft* 16 (Aug. 15, 1908): 252. Quoted in Schweiger, *Kokoschka*, p. 44.

35. Schweiger, *Kokoschka*, pp. 46f.

36. Edith Hoffmann. *Kokoschka: Life and Work* (London, 1947), p. 54.

37. Oskar Kokoschka, *Dramen und Bilder*, intro. Paul Stefan (Leipzig, 1913). In the edition of his written works, Kokoschka's dramas appear in vol. 1, although they are unfortunately haphazardly edited. For example, no distinction is made between Kokoschka's *Schauspiel* (Play) of 1911 (see n. 82 below) and its reworked version *Der brennende Dornbusch* (The Burning Thornbush), published in 1917. (The same applies to the first volume of the edition of Kokoschka's letters, p. 389.) Also, Kokoschka's poem *Der gefesselte Kolumbus* (Columbus Bound), first published in 1916, appears erroneously under the title "Der weisse Tiertöter" (The White Animal-Killer); this text dates to 1909 and has not survived, although it was incorporated into the "Kolumbus" poem.

38. In *Wort in der Zeit: Österreichische Literaturzeitschrift* 2, no. 3 (1956): 145–48.

39. *Hiob: A Drama* (Berlin, 1917).

40. Schweiger, *Kokoschka*, pp. 44f.

41. Quotations hereafter in the *Wort in der Zeit* version.

42. Hugo Ball, *Die Flucht aus der Zeit* (Munich, 1931), pp. 159f.

43. *Der Sturm*, no. 20 (July 14, 1910): 155f.

44. Horst Denkler, "Die Druckfassungen der Dramen Oskar Kokoschkas,"

Deutsche Vierteljahrsschrift für Literaturwissenschaft und Geistesgeschichte 40, no. 1 (1966): 90–108. Henry I. Schvey, *Oskar Kokoschka: The Painter as Playwright* (Detroit, 1982).

45. Oskar Kokoschka, *Mein Leben* (Munich, 1971), p. 62. Also Donald E. Gordon, "Oskar Kokoschka and the Visionary Tradition," in Gerald Chapple and Hans H. Schulte, eds., *The Turn of the Century: German Literature and Art, 1890–1915* (Bonn, 1981), pp. 40ff. See also Hans Bisanz, in *Oskar Kokoschka, Die frühen Jahre: Zeichnungen und Aquarelle*, exhibition catalogue, Historisches Museum (Vienna, 1982), pp. 10–17, and Georg Jäger, "Kokoschka's *Mörder, Hoffnung der Frauen*: Die Geburt des Theaters der Grausamkeit aus dem Geist der Wiener Jahrhundertwende," *Germanisch-Romanische Monatsschrift*, New Series 32, no. 2 (1982): 216ff.

46. Quoted after the version in *Der Sturm*, no. 20 (July 14, 1910).

47. *Neues Wiener Journal* 17 (July 5, 1909): 4. Quoted in Schweiger, *Kokoschka*, p. 111.

48. Quoted in Jäger, "Kokoschka's *Mörder*," n. 82. Jäger also refers to the affinity between Hofmannsthal and Kokoschka.

49. As is attempted by Schvey, *Oskar Kokoschka*, p. 45.

50. Georg Brühl, *Herwarth Walden und "Der Sturm"* (Leipzig, 1983), p. 107.

51. Kokoschka, *Leben*, pp. 64ff.

52. *Neues Wiener Journal* 17 (July 5, 1909): 4.

53. July 5, 1909, p. 8. This and the following quotation are from Schweiger, *Kokoschka*, pp. 112 and 113f.

54. Paul Frank, "Kokoschka," *Wiener Allgemeine Zeitung* 30 (July 7, 1909): 3.

55. Lothar Schreyer, *Erinnerungen an Sturm und Bauhaus* (Munich, 1956), p. 21.

56. *Die Fackel*, no. 292 (Dec. 17, 1909), after p. 32.

57. See Patrick Werkner, "Ludwig Erik Tesars Kunstkritik in der *Fackel*, 1910–11," in *Erziehung. Weg zu menschenwürdigen Leben: Schwazer Tesar-Symposion* (Innsbruck, 1989), pp. 25–27.

58. *Die Fackel*, no. 298–99 (Mar. 21, 1910): 34–44.

59. *Die Fackel*, no. 319–20 (Mar. 31, 1911): 31–39.

60. *Die Fackel*, no. 317 (Feb. 28, 1911): 18–23.

61. Kokoschka, *Leben*, p. 64.

62. Hans M. Wingler and Friedrich Welz, *Oskar Kokoschka: Das druckgraphische Werk* (Salzburg, 1975), p. 14 and n. 10.

63. Bisanz, *Oskar Kokoschka*, p. 14.

64. *Der Sturm*, no. 43 (Dec. 12, 1910).

65. Brühl, *Herwarth Walden*, p. 211.

66. *Der Sturm*, no. 26 (Aug. 25, 1910).

67. Hans Arp, "Von Zeichnungen aus der Kokoschka-Mappe," *Der Sturm*, no. 190–91 (Dec. 1913): p. 151.

68. Letter, Dec. 23, 1910. Kokoschka, *Briefe*, p. 15.

69. Eberhard Roters, "Bildende Kunst: Malerei," in Eberhard Roters, ed., *Berlin 1910–1933: Die visuellen Künste* (Berlin, 1983), p. 61.

70. *Der Sturm*, no. 82 (Oct. 1911).

71. Letter from Elberfeld of Aug. 6, 1910. Kokoschka, *Briefe*, p. 12.

72. Letter to Lotte Franzos from Berlin, Dec. 24, 1910. Ibid., p. 15.

73. Quoted in Schweiger, *Kokoschka*, pp. 188ff.

74. Ibid., pp. 168ff.

75. Ibid., pp. 197ff.

76. Letter to Herwarth Walden, May–June 1911. Ibid., p. 19.

77. *Der Sturm*, no. 89 (Dec. 1911): 710; no. 94 (Jan. 1912): 752.

78. Karl Kraus, "Kokoschka und der andere," *Die Fackel*, no. 339–40 (Dec. 30, 1911): 22.

79. Hans Tietze, "Ausstellung der Sammlung Dr. Oskar Reichel in der Galerie Miethke," *Fremdenblatt*, no. 55 (Feb. 25, 1913): 16.

80. Albert Ehrenstein, *Tubutsch* (Vienna, undated—1911).

81. Letters of Kokoschka, Sept. 13, 26, and 28, 1911. Kokoschka, *Briefe*, pp. 23f.

82. The earliest mention of the drama occurs in the protocol of the Akademischer Verband für Literatur und Musik, Nov. 11, 1912. Schweiger, *Kokoschka*, p. 223.

83. Oskar Kokoschka, *The Burning Thornbush* (Leipzig, 1917).

84. Quotation from the 1913 version.

85. On E. Schwarzwald, see Murray G. Hall, "Adolf Loos und 'Frau Doktor': Die Vereinstätigkeit der Eugenie Schwarzwald," *Aufbruch: Der Künstlerkreis um Adolf Loos zur Jahrhundertwende* (Linz, 1985), pp. 92–99.

▪ S I X : Egon Schiele ▪

1. Rudolf Leopold, *Egon Schiele: Gemälde, Aquarelle, Zeichnungen* (Salzburg, 1972), catalogue 82.

2. Egon Schiele, "Manifesto" for the Neukünstler-Ausstellung (Vienna, 1909), appearing in a slightly altered version in *Die Aktion*, no. 70 (1914). Quoted in Nebehay, *Schiele*, p. 97. Schiele's punctuation has been amended to conform with current practice, here and in the following quotations, when this renders the text more easily readable.

3. Leopold, *Egon Schiele*, catalogue 135.

4. Letter to Leopold Czihaczek, Sept. 1, 1911. Quoted in Nebehay, *Schiele*, p. 182, no. 251.

5. Ibid.

6. Arthur Roessler, *Erinnerungen an Egon Schiele* (Vienna, 1948. Expanded edition; originally published Vienna, 1922), p. 5.

7. Heinrich Benesch, *Mein Weg mit Egon Schiele* (New York, 1965), p. 13.

8. In "Erinnerungsbuch an Egon Schiele," unpublished MS, Vienna, Albertina, Egon-Schiele-Archiv, no. 508.

9. Benesch, *Mein Weg*, p. 13.

10. Roessler, *Erinnerungen*, p. 6.

11. Benesch, *Mein Weg*, p. 11.

12. Comini, *Schiele's Portraits*, passim.

13. Fritz Karpfen, "Tanzende Sterne." Undated newspaper extract from *Weltpresse*, Vienna, in Albertina, Egon-Schiele-Archiv, no. 863.

14. Roessler, *Erinnerungen*, p. 36.

15. Nebehay, *Schiele*, p. 65, n. 16.

16. Ibid., n. 15.

17. Apparently commissioned by the lecturer, Dr. Kornfeld. Letter from Erwin Osen to Schiele, Aug. 15, 1913. Quoted in Nebehay, *Schiele*, p. 270, no. 570.

18. Roessler, *Erinnerungen*, p. 39.

19. Leopold, *Egon Schiele*, catalogue 148.

20. Ibid., catalogue 147.

21. Ibid., catalogue 153.

22. Ibid., catalogue 154.

23. Ibid., catalogue 160.

24. Ibid., catalogue 152.

25. Nebehay, *Schiele*, p. 120.

26. Ibid., p. 143, no. 167.

27. Comini, *Schiele's Portraits*, p. 9.

28. Ibid., p. 11.

29. Nebehay, *Schiele*, p. 15.

30. Ibid., p. 264, no. 544.

31. Ibid., pp. 134f., no. 112.

32. Leopold, *Egon Schiele*, catalogue 203.

33. Letter to Carl Reininghaus, after Feb. 27, 1912. Quoted in Leopold, *Egon Schiele*, p. 510.

34. Arthur Roessler, "Egon Schiele," *Bildende Künstler*, no. 3. (1911): 114.

35. Leopold, *Egon Schiele*, catalogue 167.

36. Ibid., catalogue 176.

37. Ibid., catalogue 198.

38. Letter to Czihaczek, Sept. 1, 1911, in Nebehay, *Schiele*, p. 182, no. 251.

39. See Carol Duncan, "Virility and Domination in Early Twentieth-Century Vanguard Painting," in Norma Broude and Mary D. Garrard, eds., *Feminism and Art History: Questioning the Litany* (New York, 1982), pp. 293–313.

40. See Albert Elsen, "Drawing and a New Sexual Intimacy: Rodin and Schiele," in Patrick Werkner, ed., *Egon Schiele: Art, Sexuality, and Viennese Modernism* (Palo Alto, 1993).

41. Leopold, *Egon Schiele*, catalogue 138.

42. Ibid., catalogue 199.

43. Letter to Czihaczek, Sept. 1, 1911, in Nebehay, *Schiele*, p. 182, no. 251.

44. See Notes 83 and 85 below.

45. Comini, *Schiele's Portraits*, pp. 44f.

46. Leopold, *Egon Schiele*, catalogue 161.

47. Ibid., catalogue 165.

48. Ibid., catalogue 172.

49. Ibid., catalogue 173.

50. Ibid., catalogue 171.

51. Ibid., catalogue 175.

52. Ibid., catalogue 170.

53. Ibid., catalogue 185.

54. Ibid., catalogue 186.

55. Ibid., catalogue 118a. See Johannes Dobai, "Egon Schiele's 'Jüngling vor Gottvater kniend,'" in *Beiträge zur Kunst des 19. und 20. Jahrhunderts: Jahrbuch des Schweizerischen Instituts für Kunstwissenschaft 1968–69*.

56. See Jane Kallir, *Egon Schiele: The Complete Works* (New York, 1990), pp. 127ff. Leopold, *Egon Schiele*, pp. 248, 666, regards the text as a forgery by Roessler; see also Nebehay, *Schiele*, pp. 191ff. and passim, where Schiele's original text and Roessler's changes are repeatedly compared. Schiele's writings have hitherto attracted comparatively little attention from literary historians. See H. Denkler, "Malerei mit Wörtern: Zu Egon Schieles poetischen Schriften," in R. v. Heydebrand and K. G. Just, eds., *Wissenschaft als Dialog: Studien zur Literatur und Kunst seit der Jahrhundertwende* (Stuttgart, 1969), pp. 271–88. See also Johannes Käfer, "Egon Schiele als Dichter," in "Erinnerungsbuch an Egon Schiele." Extracts quoted in Nebehay, *Schiele*, p. 533. Nebehay's book supplies the basic research for Schiele's literary texts. The following quotations from letters are taken in each case from those written up to 1912 (with the exception of a letter to his mother, Mar. 31, 1913). Editions of Schiele's writings include *Egon Schiele, Schriften und Zeichnungen* (Innsbruck, 1968); *Egon Schiele, Die Gedichte* (Vienna, 1977); *Egon Schiele, Ich ewiges Kind* (Vienna, 1985). Lastly, Michael Huter has examined the Schiele texts in relationship to the "Viennese Language Crisis." See Huter in Werkner, *Egon Schiele*.

57. The earliest evidence of Schiele's literary activity is to be found in a letter to Roessler, May 25, 1911, in which he informs him: "When I have got around to writing something I don't yet know what, I'll send it to Vienna for the 'Interieur,' O.K.?" Quoted in Nebehay, *Schiele*, p. 176, no. 222.

58. Summary in Leopold, *Egon Schiele*, p. 680.

59. Letter to Czihaczek, Sept. 1, 1911, in Nebehay, *Schiele*, p. 182, no. 251.

60. Ibid.

61. Undated notes for a poem, quoted in Nebehay, *Schiele*, pp. 143–45, no. 168.

62. Letter to Czihaczek, Mar. 5, 1909. Quoted in ibid., p. 110, no. 84.

63. Letter to Reininghaus, after Feb. 27, 1912, in Leopold, *Egon Schiele*, p. 510.

64. Letter to Arthur Roessler, Jan. 6, 1911. Quoted in Nebehay, *Schiele*, p. 164, no. 171.

65. Letter to Oskar Reichel, Jan. 31, 1911. Quoted in ibid., p. 165, no. 176.

66. Leopold, *Egon Schiele*, catalogue 161.

67. Letter to Arthur Roessler, Dec. 1910. Quoted in Nebehay, *Schiele*, p. 140, no. 151.

68. Letter to Heinrich Benesch, Aug. 7, 1911. Quoted in ibid., p. 179, no. 242.

69. Letter to Marie Schiele, Mar. 31, 1913. Quoted in ibid., p. 252, no. 483.

70. Letter to Czihaczek, Sept. 1, 1911, in ibid., p. 182, no. 251.

71. Ibid.

72. Letter of Arthur Roessler, Jan. 4, 1911. Quoted in Nebehay, *Schiele*, p. 163, no. 169.

73. Letter to Roessler, Jan. 6, 1911, in ibid., p. 164, no. 171.

74. Letter to Czihaczek, Sept. 1, 1911, in ibid., p. 182, no. 251.

75. July 6, 1909. Quoted in Nebehay, *Schiele*, p. 110, no. 87.

76. Letter to Anton Peschka, after May 23, 1911. Quoted in ibid., p. 175, no. 218.

77. Undated notes for a poem, in ibid., pp. 143–45, no. 168.

78. Ibid.

79. Letter to Peschka, after May 23, 1911, in ibid., p. 175, no. 218.

80. Letter to Czihaczek, Sept. 1, 1911, in ibid., p. 182, no. 251.

81. Letter to Czihaczek, March 5, 1909, in ibid., p. 110, no. 84.

82. Undated notes for a poem, in ibid., pp. 143–45, no. 168.

83. Letter to Oskar Reichel, Sept. 1911. Quoted in Arthur Roessler, *Briefe und Prosa von Egon Schiele* (Vienna, 1921), p. 157.

84. Leopold, *Egon Schiele*, catalogue 195.

85. Letter to Hermann Engel, Sept. 1912, in Roessler, *Briefe und Prosa*, p. 157.

86. Otto Benesch, "Egon Schiele und die Graphik des Expressionismus, in *Continuum: Zur Kunst Österreichs in der Mitte des 20. Jahrhunderts* (Vienna, 1957). See also Comini, *Schiele's Portraits*, p. 47.

87. Comini, *Schiele's Portraits*, p. 204, n. 67. See also the Rimbaud quotation from an admirer of Schiele in a letter, June 7, 1911, in Nebehay, *Schiele*, p. 177, no. 226.

88. Hans Bisanz, "Egon Schiele—Kunst und Gedankenwelt," in *Egon Schiele—Zeichnungen und Aquarelle*, exhibition catalogue, Historisches Museum der Stadt Wien 1981, p. 11.

89. Arthur Roessler, "Neukunstgruppe: Ausstellung im Kunstsalon Pisko," Vienna *Arbeiter-Zeitung*, Dec. 7, 1909, p. 8.

90. Roessler, "Egon Schiele," p. 114.

91. Arpad Weixlgärtner, "Ausstellungen Wien," *Mitteilungen der Gesellschaft für vervielfältigende Kunst*, no. 1 (1910): 55. Supplement to *Die graphischen Künste* 33 (Vienna, 1910).

92. Albert Paris von Gütersloh, *Egon Schiele: Versuch eine Vorrede* (Vienna, 1911); also in *In memoriam Egon Schiele*, ed. Arthur Roessler (Vienna, 1921); also quoted in Nebehay, *Schiele*, pp. 153f., n. 11.

93. Max Oppenheimer, *Menschen finden ihren Maler* (Zürich, 1938), p. 34.

94. *Egon Schiele*, intro. Otto Benesch, exhibition catalogue, Galerie Arnot (Vienna, 1915); also quoted in Nebehay, *Schiele*, pp. 317f., no. 728.

95. Leopold, *Egon Schiele*, catalogue 139.

96. *Das Interieur* 12 (1911): 8.

97. Leopold, *Egon Schiele*, catalogue 151.

98. Letter to K. L. Strauch, June 5, 1910. Quoted in Nebehay, *Schiele*, p. 132, no. 104.

99. Leopold, *Egon Schiele*, catalogue 143.

100. Letter to Strauch, June 5, 1910, in Nebehay, *Schiele*, p. 132, no. 104.

101. Postcards from Schiele to Roessler, Nov. 27, 1910, quoted in Nebehay, *Schiele*, p. 139, no. 141, and Jan. 4, 1911, ibid., p. 163, no. 170.

102. "In memoriam Egon Schiele," unpublished MS, thought to be by Johannes Fischer, p. 4, recto, in Vienna, Albertina, Egon-Schiele-Archiv, no. 340. See Nebehay, *Schiele*, pp. 119, 122, n. 15.

103. *Male Nude (Self-Portrait) I*. See Otto Kallir, *Egon Schiele*, no. 1, b2.

104. Leopold, *Egon Schiele*, catalogue 222.

105. Postcard from Roessler to Schiele, Aug. 2, 1911. Nebehay, *Schiele*, p. 179, no. 240.

106. *Der Ruf*, no. 3 (1912).

■ **S E V E N** : **Arnold Schönberg** ■

1. Note affixed to Schönberg's copy of Marion Bauer's *Twentieth Century Music* (New York, 1933), p. 207, in Schoenberg Estate, Los Angeles. Quoted in *Schoenberg as Artist. Journal of the Arnold Schoenberg Institute, Los Angeles* 2, no. 3 (1978): 236. Annex to the same in *Journal of the Arnold Schoenberg Institute* (October 1979): 278, and *Journal of the Arnold Schoenberg Institute* 5, no. 1 (1981): 74f.

2. Eberhard Freitag, "Schönberg als Maler" (Ph.D. diss., Münster, 1973). The oeuvre catalogue in this publication mentions 62 paintings, 102 drawings and watercolors (including groups of sketches) as well as 14 figurines and stage-sets. The exhibition catalogue *Arnold Schönberg: Das bildnerische Werk/Paintings and Drawings* (Vienna: Museum des 20. Jahrhunderts, 1991) lists 268 catalogue numbers.

3. Arnold Schönberg, "Malerische Einflüsse," handwritten note, Feb. 11, 1938, in Schoenberg Estate, Los Angeles. Published in *Schoenberg as Artist*, pp. 234f.

4. Bauer, *Twentieth Century Music*, p. 207.

5. Missing in *Schoenberg as Artist*; Freitag, "Schönberg als Maler," oeuvre catalogue, G 39.

6. *Schoenberg as Artist*, no. 249.

7. Ibid., no. 142.

8. Freitag "Schönberg als Maler," p. 44.

9. *Schoenberg as Artist*, no. 76.

10. *Der Ruf*, ed. Akademischer Verband für Literatur und Musik (Vienna, February 1912), p. 46.

11. Eberhard Freitag, "Expressionism and Schoenberg's Self-Portraits," in *Schoenberg as Artist*, pp. 164–72.

12. *Schoenberg as Artist*, no. 7.

13. Schönberg, "Malerische Einflüsse," in *Schoenberg as Artist*, pp. 234f.

14. *Schoenberg as Artist*, no. 246.

15. Dagobert Frey, "Dämonie des Blickes," *Akademie der Wissenschaften und Literatur. Abhandlungen der geistes- und sozialwissenschaftlichen Klasse*, no. 6 (Wiesbaden, 1953), p. 291.

16. *Schoenberg as Artist*, no. 245.

17. Ibid., no. 237.

18. Ibid., no. 133.

19. Elsa Bienenfeld, "Eine Bilderausstellung von Arnold Schönberg," *Neues Wiener Journal*, Oct. 9, 1910, pp. 13f.

20. Maria Halbich-Webern in conversation with Ernst Hilmar, 1976, in *Anton von Webern zum 100 Geburtstag*, ed. E. Hilmar (Vienna, 1983), p. 96.

21. Peter Gorsen, "Arnold Schönberg als Maler der 'Visionen,'" in *Schönberg-Gespräch* (Vienna, 1984), p. 67.

22. Schönberg, "Frühe Aphorismen," in *Experiment Weltuntergang*, p. 220.

23. Bienenfeld, "Eine Bilderaustellung," pp. 13f. In Eberhard Freitag, *Arnold Schönberg in Selbstzeugnissen und Bilddokumenten* (Reinbek, 1973), p. 64, there is a painting of Schönberg's entitled *Erinnerung an Kokoschka* (Memory of Kokoschka). In *Schoenberg as Artist* this picture is titled *Vision* (Eyes) (no. 130). The picture carries no legend (information kindly supplied by Jerry McBride, Arnold Schoenberg Institute, University of Southern California), so the basis of the reference to Kokoschka in the title remains unclear.

24. Arnold Schönberg, *Berliner Tagebuch*, ed. Josef Rufer (Frankfurt am Main, 1974), p. 15.

25. Letter of Schönberg to Kandinsky, Dec. 14, 1911. Quoted in *Arnold Schönberg—Wassily Kandinsky. Briefe, Bilder, und Dokumente einer aussergewöhnlichen Begegnung*, ed. Jelena Hahl-Koch (Salzburg, 1980), p. 53.

26. Arnold Schönberg, "Notes on the Four String Quartets" (Los Angeles, 1936). Quoted in *Die Streichquartette der Wiener Schule: Schönberg, Berg, Webern, Eine Dokumentation*, ed. Ursula von Rauchhaupt (Hamburg, undated—1971), p. 165.

27. Karl H. Wörner, *Die Musik in der Geistesgeschichte: Studien zur Situation der Jahre um 1910* (Bonn, 1970), pp. 88–90, 169.

28. Letter, June 16, 1910, *Schönberg: Universal Edition*, exhibition catalogue (Vienna, 1974), no. 134, pp. 205f.

29. Arnold Schönberg, *Harmonielehre* (Leipzig, 1911), p. 15.

30. Arnold Schönberg, "Franz Liszts Werk und Wesen," *Allgemeine Musikzeitung*, Oct. 20, 1911, pp. 1008f. Quoted in Freitag, *Arnold Schönberg*, p. 69.

31. Letter, Jan. 24, 1911, *Schönberg—Kandinsky*, p. 21.

32. Letter, June 18, 1910, *Schönberg: Universal Edition*, no. 133, p. 205.

33. Letter, Mar. 22, 1912, ibid., no. 182, p. 222.

34. Illustration of the résumé for the exhibition of 1910, in *La Musica, la pittura, l'epoca di Arnold Schönberg*, exhibition catalogue (Venice, 1978).

35. Paul Stefan, "Schönberg-Abend," *Der Merker* 2, no. 2 (1910–11): 79.

36. *Neuigkeitsweltblatt*, Oct. 11, 1910. Quoted in *Schönberg: Universal Edition*, no. 136, pp. 206f.

37. Quoted in Freitag, "Schönberg als Maler," p. 6.

38. Bienenfeld, "Eine Bilderausstellung," pp. 13f.

39. Richard Specht, in *Der Merker* 2, no. 17 (1910–11): 700.

40. Arthur Schnitzler, *Tagebuch, 1909–1912* (Vienna, 1981), p. 184.

41. Letter from Webern to Schönberg, Sept. 10, 1911. Quoted in H. H. Stuckenschmidt, "*Bilder und Schicksale*," in *Hommage à Schönberg: Der Blaue Reiter und das Musikalische in der Malerei der Zeit*, exhibition catalogue (Berlin, 1974), p. 60.

42. Letter, Jan. 14, 1911. Quoted in *Auguste Macke—Franz Marc, Briefwechsel* (Cologne, 1964), pp. 40f.

43. Letter, Nov. 16, 1911. *Schönberg—Kandinsky*, p. 35.

44. Ibid.

45. Ibid. In his essay on Schönberg's pictures, Kandinsky expresses his reaction to them similarly: "Schönberg's pictures fall into two categories: those that are painted directly from nature, humans, landscapes; the others, intuitively perceived heads that he describes as *Visions*. Those in the first category Schönberg himself describes as finger exercises, and places no great value on them, and is reluctant to exhibit them. Those in the second category (which are as rare as those in the first) he paints in order to give expression to his changes of mood and feeling that find no musical outlet. These two categories are completely different. They stem from the same inner spirit, which sometimes responds to the external forms of nature, and at other times to the internal forms." Wassily Kandinsky, "Die Bilder," in *Arnold Schönberg: Beiträge von Alban Berg et al.* (Munich, 1912; reprint, Wels, 1980), p. 59. In this book, which is similar to a festschrift, six of Schönberg's pictures were also reproduced: a self-portrait, the self-portrait from behind, a picture of a woman, and two grotesque visions.

46. Ibid.

47. *Briefwechsel Macke—Marc*, p. 99.

48. Stuckenschmidt, *Schönberg*, p. 188.

49. *Der Blaue Reiter*, ed. Wassily Kandinsky and Franz Marc (Munich, 1912); new documentary edition by Klaus Lankheit (Munich, 1965), pp. 65–70.

50. Letter, Mar. 4, 1912. *Schönberg—Kandinsky*, p. 61.

51. Letter, Mar. 8, 1912. Ibid., p. 63.

52. Kokoschka's participation is not evident from Gütersloh's text (see Chapter 3, n. 31), but is confirmed by E. Lázár, "Drei Künstler," *Budapester Presse* 2, no. 21 (Jan. 25, 1912). Reference by W. J. Schweiger.

53. Quotation from *Schönberg: Universal Edition*, no. 176, p. 219.

54. Ibid.

55. Letter, Dec. 14, 1911. *Schönberg—Kandinsky*, p. 54.

56. Ibid.

57. See note 45 above.

58. Gütersloh, "Neukunst," 3.

59. See note 45 above; Albert Paris Gütersloh, "Schönberg der Maler," in *Arnold Schönberg: Beitrage*, pp. 65–74.

60. Ibid., pp. 68f.

61. Ibid., p. 72.

62. *Schoenberg as Artist*, no. 244.

63. Letter from Schönberg to Ernst Legal, Apr. 14, 1930. Quoted in Sieghart Döhring, "Schönbergs Erwartung," in *Arnold Schönberg: Internationaler musikwissenschaftlicher Kongress* (Berlin, 1974), p. 36.

64. Quoted in Stuckenschmidt, *Schönberg*, p. 121.

65. Textual quotations follow *Schönberg—Kandinsky*, pp. 104–25.

66. Ibid., p. 104.

67. Schoenberg Estate, Los Angeles. Reference in Jane Kallir, *Arnold Schoenberg's Vienna* (New York, 1984), p. 28.

68. See Wörner, *Musik*, pp. 147ff.

69. *Schoenberg as Artist*, no. 159.

70. Ibid., no. 162.

71. See Alfred Roller, "Bühnenreform?" *Der Merker* 1, no. 5 (1909–10): 193–200.

72. Stuckenschmidt, *Schönberg*, p. 54.

73. See Rüdiger Görner, "Über die 'Trennung der Elemente': Das Gesamtkunstwerk—ein Steinbruch der Moderne?" *Maske und Kothurn* 29, no. 1–4 (1983): p. 101.

74. *Vom Klang der Bilder: Die Musik in der Kunst des 20. Jahrhunderts*, exhibition catalogue, Staatsgalerie (Stuttgart, 1985).

75. Louis Bertrand Castel pursued similar aims in 1723.

76. Vittore Grubicy de Dragon, quoted in the exhibition catalogue *Post-Impressionism* (London, 1979), p. 272.

77. Letter, Jan. 24, 1911. *Schönberg—Kandinsky*, p. 21.

78. Arnold Schönberg, talk in Breslau on *Die Glückliche Hand* 1928, in ibid., p. 131.

79. Ibid., pp. 127ff.

80. Hermann Bahr, "Color Music," in Gotthard Wunberg, ed., *Die Wiener*

Moderne: Literatur, Kunst, und Musik zwischen 1890 und 1910 (Stuttgart, 1981), pp. 232ff.

81. H. v. Hug-Hellmuth, "Über Farbenhören: Ein Versuch, das Phänomen auf Grund der psychoanalytischen Methode zu erklären," *Imago: Zeitschrift für die Anwendung der Psychoanalyse auf die Geisteswissenschaften*, ed. S. Freud, 1, no. 3 (1912): 228–64; Oskar Pfister, "Die Ursache der Farbenbegleitung bei akustischen Wahrnehmungen und das Wesen anderer Synästhesien," ibid., 265–75; Eduard Hitschmann, "Zum Farbenhören," ibid., 4, 401.

82. Bienenfeld, "Eine Bilderausstellung," p. 13f.

83. Stefan, "Schönberg-Abend," 79.

84. Letter from Schönberg to Ernst Legal, Apr. 14, 1930, *Schönberg—Kandinsky*, p. 126.

85. Gerhard Wohlgemuth, "Schönberg und die Künste," in *Arnold Schönberg, 1874–1951*, ed. Mathias Hansen and Christa Müller (Berlin, 1976), p. 157.

86. See John Crawford, "*Die Glückliche Hand*: Schoenberg's Gesamtkunstwerk," *The Musical Quarterly* 60, no. 4 (1974): 583–601.

87. Schreyer, *Erinnerungen*, p. 21.

88. Kallir, *Schoenberg's Vienna*, p. 90, n. 34.

89. Kokoschka, *Briefe*, p. 10.

90. Ibid.

91. Letter, Aug. 19, 1912, *Schönberg—Kandinsky*, p. 69.

92. Letter, Aug. 22, 1912, ibid., p. 72.

93. Wassily Kandinsky, *Über das Geistige in der Kunst* (On the Spiritual in Art) (Neuilly-sur-Seine, 1952), p. 42. See Sixten Ringbom, *The Sounding Cosmos: A Study in the Spiritualism of Kandinsky and the Genesis of Abstract Painting* (Helsingfors, 1970); idem, "Kandinsky und das Okkulte," in *Kandinsky und München*, exhibition catalogue, Städtische Galerie im Lenbachhaus (Munich, 1982), pp. 85–101; idem, "Die Steiner-Annotationen Kandinskys," ibid., pp. 102–5. See also *The Spiritual in Art: Abstract Painting, 1890–1985*, exhibition catalogue, Los Angeles County Museum of Art (Los Angeles, 1986).

94. Letter, Nov. 16, 1911, *Schönberg—Kandinsky*, p. 36.

95. Richard Specht, *Gustav Mahler* (Berlin, 1913), p. 39; Constantin Floros, *Gustav Mahler*, vol. 1, *Die Geistige Welt Gustav Mahlers in systematischer Darstellung* (Wiesbaden, 1977), pp. 105–18.

96. Hartmut Zelinsky, "Der 'Weg' der *Blauen Reiter*," in *Schönberg—Kandinsky*, pp. 223–70. Here the Theosophy of Schönberg is also discussed in detail.

97. Letter to Richard Dehmel of Dec. 13, 1912. Quoted in Josef Rufer, *Das Werk Arnold Schönbergs* (Kassel, 1959), p. 103. Relevant also is Wörner, *Musik*, pp. 171ff.

98. August Strindberg, "Idolatrie, Gynolatrie: Ein Nachruf," *Die Fackel* 144 (Oct. 17, 1903): 1–3.

99. Schönberg, *Harmonielehre*, p. 15.

100. Kandinsky, *Über das Geistege*, pp. 44ff.

▪ **EIGHT: Between Symbolism and Expressionism: Alfred Kubin** ▪

1. *Eugen Spiro and Alfred Kubin*, exhibition catalogue, Galerie Miethke (Vienna, February 1906).

2. Alfred Kubin, "Autobiographische Skizze," first published in Kubin's portfolio *Sansara: Ein Zyklus ohne Ende* (Munich, 1911); republished in Alfred Kubin, *Aus meinem Leben: Gesammelte Prosa*, ed. Ulrich Riemerschmidt (Munich, 1974), p. 33.

3. Fritz von Herzmanovsky-Orlando, *Der Briefwechsel mit Alfred Kubin: 1903 bis 1952*, ed. Michael Klein (Salzburg, 1983), letter, Jan. 9, 1908, p. 10.

4. Ibid., letter, Mar. 28, 1914, p. 75.

5. Kubin, *Leben*, p. 25.

6. Ibid., p. 28.

7. Richard Schaukal, "Ein österreichischer Goya," *Wiener Abendpost*, Jan. 3, 1903, p. 7.

8. Kubin, *Leben*, p. 31.

9. Ibid., p. 21.

10. Ibid.

11. Ibid., pp. 52f.

12. Quoted in *Alfred Kubin: Das zeichnerische Frühwerk bis 1904*, exhibition catalogue, Staatliche Kunsthalle (Baden-Baden, 1977), p. 102. This catalogue, prepared by Christoph Brockhaus, laid the basis for a new consideration of Kubin's early work.

13. Letter to Hermann Hinterhuber, May 4, 1903. Quoted in ibid., p. 17.

14. Letter to Maria Kubin-Bruckmüller, Feb. 22, 1904. Quoted in ibid., pp. 19f.

15. Kubin, *Leben*, p. 32.

16. See Paul Raabe, *Alfred Kubin: Leben, Werk, Wirkung* (Hamburg, 1957), illustration after p. 16.

17. Herzmanovsky-Orlando, *Briefwechsel*, letter, Oct. 8, 1903, p. 7.

18. Facsimile reprints of drawings by Alfred Kubin, published by Hans von Weber, Munich, undated.

19. Letter, Feb. 22, 1906. Quoted in Anneliese Hewig, *Phantastische Wirklichkeit: Interpretations studie zu Alfred Kubins Roman "Die Andere Seite"* (Munich, 1967), p. 20.

20. *Der liebe Augustin*, Berlin-Vienna-Leipzig (1904).

21. Ibid., no. 16, p. 247, no. 24, p. 401.

22. Ibid., no. 16, no page number.

23. Kubin, *Leben*, pp. 26–28.

24. Alfred Kubin, "Das Schaffen aus dem Unbewussten," in Otto Kankeleit, *Die schöpferische Macht des Unbewussten* (Berlin, 1933); republished in Alfred Kubin, *Aus meiner Werkstatt: Gesammelte Prosa*, ed. Ulrich Riemerschmidt (Munich, 1973), p. 46.

25. Kubin, *Leben*, p. 44.

26. *Kunstwart* 16, no. 11 (1903): 593–96.

27. Herzmanovsky-Orlando, *Briefwechsel*, letter, Oct. 7, 1911, p. 70.

28. Ibid., letter, Nov. 25, 1914, p. 90.

29. Ibid., letter, Dec. 22, 1914, p. 98.

30. Kubin, *Werkstatt*, p. 8.

31. The most detailed discussion is in Wolfgang K. Müller-Thalheim, *Erotik und Dämonie im Werk Kubins: Eine psychopathologische Studie* (Munich, 1970). He sums up as follows: "From a perusal of all anamnestical materials one comes to the conclusion that Alfred Kubin suffered from a neuropathic-psychopathic con-

stitution; he traveled a long and difficult road of neurotic development, but in the end, through the experience of happier personal circumstances, found the key to self-confirmation. At crucial points in his artistic career exceptional psychopathic conditions with schizoid-hysterical aspects were evident, together with experiences of a hallucinatory or visionary nature. There is no evidence of psychosis, all thought processes and ideas were still capable of assimilation, and there is no indication of schizophrenia or of mental defects at any time" (p. 53).

32. Kubin, *Leben*, p. 33.

33. Ibid.

34. Ibid., p. 34.

35. Ibid., p. 36.

36. Ibid., pp. 36f.

37. Ernst Haeckel, *Die Radiolarien* (Berlin, 1862); idem, *Kunstformen der Natur* (Leipzig, 1899).

38. From the foreword to *Kunstformen der Natur*.

39. *Jugendstil floral-funktional in Deutschland, Österreich, und den Einfluss-gebieten*, exhibition catalogue, Bayerisches National-Museum (Munich, 1984). See in particular pp. 46–108.

40. Peg Weiss, *Kandinsky in Munich: The Formative Jugendstil Years* (Princeton, N.J., 1979). See fig. 95 in relation to Schmithals. *Kandinsky und München: Begegnungen und Wandlungen, 1896–1914*, exhibition catalogue, Städtische Galerie im Lenbachhaus (Munich, 1979).

41. Alfred Kubin, *Die Andere Seite: Ein phantastischer Roman*, with 51 drawings and a plan (Munich, 1909, 1975), p. 140.

42. Kubin, *Leben*.

43. Ibid., p. 36.

44. Ibid., p. 35.

45. Herzmanovsky-Orlando, *Briefwechsel*, p. 327.

46. Ibid., letter, Aug. 12, 1907, p. 8.

47. Ibid., letter, Dec. 31, 1907, p. 9.

48. Kubin, *Leben*, p. 38.

49. Herzmanovsky-Orlando, *Briefwechsel*, letter, Jan. 22, 1908, p. 12.

50. Ibid., letter, Mar. 2, 1908, p. 14; letter, Dec. 6, 1908, p. 17.

51. Ibid., letter, Mar. 2, 1908, p. 14.

52. Kubin, *Leben*, p. 8.

53. Herzmanovsky-Orlando, *Briefwechsel*, letter, Oct. 8, 1903, p. 7.

54. *Der liebe Augustin*, no. 22 (1904): 371.

55. Christoph Brockhaus, "Rezeptions- und Stilpluralismus: Zur Bildgestaltung in Alfred Kubins Roman *Die Andere Seite*," *Pantheon* 32, no. 3 (1974): 272–88, n. 69.

56. *Worte der Freundschaft für Alexander von Bernus* (Nürnberg, 1949), letter, Dec. 8, 1914, p. 105.

57. On this see Brockhaus, "Rezeptions- und Stilpluralismus"; Siegfried Schödel, "Studien zu den phantastischen Erzählungen Gustav Meyrinks" (Ph.D. diss., Erlangen, 1965); Manfred Lube, *Gustav Meyrink: Beiträge zur Biographie und Studien zu seiner Kunsttheorie* (Graz, 1980).

58. Herzmanovsky-Orlando, *Briefwechsel*, letter, Jan. 9, 1908, p. 10.

59. Hewig, *Phantastische Wirklichkeit*, p. 13; M. Klein, in Herzmanovsky-Orlando, *Briefwechsel*, pp. 330, 334f.

60. Herzmanovsky-Orlando, *Briefwechsel*, letter, Jan. 22, 1908, p. 11.

61. Kubin, *Leben*, pp. 54ff. See also the consideration of Kubin from a Buddhist and Theosophical point of view in Lama Anagarika Govinda, "Psychologische Richtlinien: Versuch einer Deutung der *Anderen Seite*," *Die Einsicht: Vierteljahresschrift für Buddhismus* 4 (Konstanz, 1951), pp. 14–23; and Franz Ettig, "Die Astraldämonie Alfred Kubins," *Hain der Isis* (1931): 52–57, 69–73.

62. Kubin, *Leben*, p. 39.

63. *Für A. v. Bernus*, letter, Jul. 14, 1909, p. 102. Also, slightly altered, in *In memoriam Alexander von Bernus*, ed. Otto Heuschele (Heidelberg, 1966), p. 30.

64. Herzmanovsky-Orlando, *Briefwechsel*, letter, May 22, 1909, p. 27.

65. Ibid., letter, Sept. 28, 1909, p. 32.

66. Ibid., letter, Nov. 11, 1909, p. 37.

67. Ibid., letter, Jan. 9, 1908, p. 10.

68. Ibid., letter, Feb. 1, 1910, p. 41.

69. Ibid., letter, Feb. 8, 1910, pp. 43–46. See also M. Klein's detailed commentary on this, ibid., pp. 346–54.

70. Ibid., letter, Apr. 2, 1909, p. 26.

71. Ibid., letter, June 14, 1910, p. 53.

72. Kubin, *Leben*, p. 52.

73. Herzmanovsky-Orlando, *Briefwechsel*, p. 328.

74. Kubin, *Leben*, p. 43.

75. Ibid., p. 40.

76. Ibid., p. 25. This text is only partly preserved. See Hewig, *Phantastiche Wirklichkeit*, p. 16.

77. Kubin, *Leben*, p. 41.

78. Herzmanovsky-Orlando, *Briefwechsel*, letter, June 14, 1910, p. 52.

79. Quoted in Brockhaus, "Rezeptions- und Stilpluralismus," p. 278.

80. Julius Bahnsen, *Der Widerspruch im Wissen und Wesen der Welt: Princip und Einzelbewährung der Realdialektik* (Leipzig, 1882).

81. See, for example, Kubin's essay of 1920, "Salomo Friedlaender, Schöpferische Indifferenz: Ein Hinweis," republished in Kubin, *Werkstatt*, pp. 166–70.

82. Kubin, *Leben*, p. 41.

83. Herzmanovsky-Orlando, *Briefwechsel*, letter, Jan. 10, 1909, p. 22.

84. Richard A. Schroeder, "Alfred Kubin's *Die Andere Seite*: A Study in the Cross-Fertilization of Literature and the Graphic Arts" (Ph.D. diss., Indiana University, Bloomington, 1970).

85. See note 57 above.

86. The evidence is in a letter from Kubin to Hans von Müller, Dec. 30, 1908. Quoted in Hewig, *Phantastiche Wirklichkeit*, p. 13.

87. Herzmanovsky-Orlando, *Briefwechsel*, letter, Jan. 9, 1908, p. 10.

88. Edgar Allen Poe, "Die Tatsachen im Falle Waldemar," *Arena* 3 (1908): 965–73; Alfred Marks, *Der Illustrator Alfred Kubin: Gesamtkatalog seiner Illustrationen und buchkünstlerischen Arbeiten* (Munich, 1977), A 5.

89. Hellmuth Petriconi, *Das Reich des Untergangs* (Hamburg, 1958), p. 119.

90. Herzmanovsky-Orlando, *Briefwechsel*, letter, Dec. 23, 1908, p. 21.

91. Brockhaus, "Rezeptions- und Stilpluralismus," p. 278.

92. Hermann Esswein, *Alfred Kubin: Der Künstler und sein Werk* (Munich, 1911).

93. Wilhelm Fraenger, "Alfred Kubin," *Xenien* 5 (December 1912): 703–8.

94. *Der Brenner* 3, no. 17 (1913): 783–92.

95. Hanns Sachs, "*Die andere Seite*," *Imago* 1, no. 2 (1912): 197–204.

96. Herzmanovsky-Orlando, *Briefwechsel*, letter, Jan. 10, 1909, p. 21. See also Oskar A. H. Schmitz, *Brevier für Einsame: Fingerzeige zu neuem Leben* (Munich, 1923). See in particular pp. 31–152.

97. Herzmanovsky-Orlando, *Briefwechsel*, letter, June 1909, pp. 28 and passim.

98. Letter, June 13, 1909. Quoted in Raabe, *Alfred Kubin*, p. 32.

99. Letter, Nov. 7, 1913. Quoted in Hewig, *Phantastiche Wirklichkeit*, p. 11.

100. Letter, Oct. 15, 1909. Quoted in Raabe, *Alfred Kubin*, p. 33.

101. Herzmanovsky-Orlando, *Briefwechsel*, letter, Nov. 11, 1909, p. 38.

102. Ibid., letter, Feb. 8, 1910, p. 46.

103. Kubin, *Leben*, p. 39.

104. Ibid., p. 42.

105. *Für A. v. Bernus*, letter, Dec. 8, 1914, p. 106. Similarly to Herzmanovsky in a letter, Dec. 10, 1914, in Herzmanovsky-Orlando, *Briefwechsel*, p. 94.

106. After Kubin's first visit, Klee wrote in his journal: "Kubin, the patron, was here. He was so enthusiastic that he enraptured me. We sat together and looked at my drawings with admiration! With real admiration! Entranced, actually!! He is without doubt a fascinating man, an outrageous mimic!" Paul Klee, *Tagebücher, 1898–1918*, ed. Felix Klee (Cologne, 1957), extract 888, Jan. 1911, p. 264; see Jürgen Glaesemer, "Paul Klees persönliche und künstlerische Begegnung mit Alfred Kubin," *Pantheon* 32, no. 2 (1974): 152–62. Reprinted in *Paul Klee: Das Frühwerk, 1883–1922*, exhibition catalogue, Städtische Galerie im Lenbachhaus (Munich, 1980), pp. 63–79.

107. Wassily Kandinsky, *Über das Geistige*, p. 44.

108. Klee, *Tagebücher*, extract 958, 1915, p. 326.

109. Letter from Stefan Zweig to Kubin, Oct. 15, 1909, in Raabe, *Alfred Kubin*, p. 33.

110. Herzmanovsky-Orlando, *Briefwechsel*, letter, Sept. 28, 1909, p. 31.

111. Ibid., letter, Mar. 28, 1914, p. 75. Karl Kraus indirectly publicized Kubin's show in *Die Fackel* by pillorying a review of it: *Die Fackel* 15, no. 395–97 (Mar. 28, 1914): 29f.

112. Letter to Hermann Hinteruber, May 4, 1903. Quoted in *Alfred Kubin*, exhibition catalogue (1977), p. 17.

113. Herzmanovsky-Orlando, *Briefwechsel*, letter, Jan. 9, 1908, p. 10.

▪ N I N E : Fellow Artists ▪

1. Friedrich Stern, "Wiener Kunstausstellungen: Secession—Hagenbund," *Neues Wiener Tagblatt*, Nov. 11, 1912. Quoted in Nebehay, *Schiele*, p. 231, no. 412.

2. Gütersloh, "Neukunst," 3.

3. Almut Krapf-Weiler, "Max Oppenheimer," in *Wien um 1900*, pp. 536f.

4. Oppenheimer, *Menschen*, p. 34.

5. See Chapter 5, notes 77 and 78.

6. *Bildende Künstler: Monatsschrift für Künstler und Kunstfreunde* (1911): 402.

7. Ibid., no. 5: 218ff.

8. Wilhelm Michel, *Max Oppenheimer* (Munich, 1911).

9. Entry of Feb. 2, 1912, in Berlin, on Marc's visit of Jan. 28. Quoted in Schönberg, *Tagebuch*, p. 15.

∎ T E N : **Body and Soul** ∎

1. See Patrick Werkner, "Hermann Bahr und seine Rezeption Gustav Klimts: Österreichertum, 'Sinnliches Chaos,' und Monismus," in *Hermann-Bahr-Symposion*, pp. 65–76.

2. Hevesi, *Sezession*, p. 180.

3. Quoted in Walter Schmäling, "Der deutsche Expressionismus, 1910–1918," in *Handbuch der Literaturwissenschaft* 19 (Wiesbaden, 1976), p. 268.

4. Roller, "Bühenform?" 193–200.

5. Hevesi, *Altkunst-Neukunst*, p. 279.

6. Hofmannsthal, "Tänzerin," *Werke*, p. 261.

7. Gustav Eugen Diehl, "Die Damen Wiesenthal in Wien," *Erdgeist* 3, no. 1 (1908): 21.

8. Idem, "Wiesenthal," *Erdgeist* 4, no. 10 (1909): 358.

9. Diehl, "Die Damen Wiesenthal," *Erdgeist* 3, no. 1 (1908): 21.

10. Gustav Eugen Diehl, "Die Damen Wiesenthal in Wien," *Erdgeist* 3, no. 3–4 (1908): 91.

11. Peter Altenberg, "Kabarett 'Fledermaus,'" *Wiener Allgemeine Zeitung* 28, no. 8873 (Oct. 22, 1907): 4f. Quoted in Werner J. Schweiger, *Wiener Werkstätte: Kunst und Handwerk, 1903–1932* (Vienna, 1982), p. 139.

12. Andrea Bandhauer, "Die Motive der Bewegung und des Tanzes in Else Lasker-Schülers Werk" (Ph. D. diss., Innsbruck, 1984).

13. Gunter Martens, *Vitalismus und Expressionismus: Ein Beitrag zur Genese und Deutung expressionistischer Stilstrukturen und Motive* (Stuttgart, 1971).

14. Beginning of the introduction by Karl Federn to Isadora Duncan, *Der Tanz der Zukunft / The Dance of the Future: Eine Vorlesung* (Leipzig, 1903), p. 5.

15. Quoted in Hamann and Hermand, *Stilkunst*, pp. 477ff.

16. Albert Paris Gütersloh, *Die tanzende Törin* (Vienna, 1973), p. 164.

17. Ibid., pp. 280f.

18. Gütersloh, *Versuch eine Vorrede*.

19. Hofmannsthal, "Tänzerin," *Werke*, 2: 260.

20. Alterberg, "Kabarett 'Fledermaus,'" 4f.

∎ E L E V E N : **Affinities and Differences** ∎

1. For a comparison of Futurism and Expressionism, see Patrick Werkner, "Österreichischer Expressionismus," in *Wien um 1900*, pp. 97–104.

2. Leopold, *Egon Schiele*, pp. 673f.

3. Kokoschka, *Briefe*, p. 388.

4. J. P. Hodin, "Kokoschka und Schiele: Eine Streitfrage," *Alte und moderne Kunst* 29, no. 192–93 (1984): 46f.

5. Nebehay, *Schiele*, pp. 332 f, no. 738.

6. See Chapter 3, note 31, and Chapter 7, note 52, and Gütersloh's letter to Schönberg, quoted in *Schönberg: Universal Edition*, no. 176, p. 219.

7. Arthur Roessler, *Kritische Fragmente. Aufsätze über österreichische Neu-
künstler* (Vienna, 1918).

8. See Donald E. Gordon, "On the Origin of the Word 'Expressionism,'" *Jour-
nal of the Warburg and Courtland Institutes* 29 (1966): 368–85; Fritz Schmalen-
bach, "Das Wort 'Expressionismus,'" *Neue Zürcher Zeitung*, Foreign Edition, no. 69
(Mar. 3, 1961): 20 and no. 258 (Sept. 21, 1962): 9.

9. Hermann Bahr, *Expressionismus* (Munich, 1916).

10. Schmalenbach *Oskar Kokoschka*, p. 5.

▪ TWELVE: Art History as the History of Ideas ▪

1. Klaus Jeziorkowski, *Empor ins Licht: Gnostizismus und Licht-Symbolik in
Deutschland um 1900*, in Chapple and Schulte, *The Turn of the Century*, pp. 171–96;
Zelinsky, "Der Weg."

Here it seems sensible to draw attention to a term that is difficult to translate into
English. *Geistesgeschichte*—the history of ideas—is a term that is of wide-ranging
importance to the formulation of the problems and themes discussed in this book.
Geistesgeschichte is associated in German art history with Max Dvořak, a represen-
tative of the Viennese school of the history of art, who published his *Kunstgeschichte
als Geistesgeschichte* in 1924. His title soon became synonymous with an art histori-
cal perspective that concentrated on the philosophical and intellectual content of
any given work of art. In the introduction to his book *Oskar Kokoschka—Variations
on a Theme*, published in 1921, Dvořak demonstrated his instinctive rapport with
Expressionism. Indeed, the author's essays collected under the title *Kunstgeschichte
als Geistesgeschichte* are impregnated with its spirit, and their approach to their sub-
jects appears to have been inspired by an Expressionist form of consciousness. In
particular, an essay "On El Greco and Mannerism," translated in Gert Schiff, ed.,
German Essays on Art History (New York, 1988), pp. 191–205, reads like a manifesto
for the painters of Expressionism. It is surely high time that Dvořak's pioneering
work in this field was better appreciated. Little of his work has been translated into
English, so many scholars were long denied access to the first examples of the Vien-
nese form of art historical writing that introduced and assimilated to the history of
art the themes and methodology of cultural history.

2. Strindberg, "Idolatrie, Gynolatrie," 1–3.

3. Herzmanovsky-Orlando, *Briefwechsel*, letter, Oct. 8, 1903, p. 7.

4. *Ver Sacrum*, 1, no. 10 (1898).

5. See Strobl, *Gustav Klimt*, 1: 147–51.

6. Franz Servaes, "Gustav Klimts *Philosophie*," in *Illustrierte Zeitung*, no. 2974
(June 28, 1900): 952. Quoted in Strobl, *Gustav Klimt*, p. 151.

7. *Architekt* 6 (1900): 23–26. Quoted in Strobl, *Gustav Klimt*.

8. *Frank Kupka*, exhibition catalogue (Zürich, 1976), pp. 49ff.

9. Lube, *Gustav Meyrink*, p. 57.

10. William M. Johnston, *Österreichische Kultur - und Geistesgeschichte: Gesell-
schaft und Ideen im Donauraum 1848 bis 1938* (Vienna, 1974), pp. 275ff.

11. Floros, *Die Geistige Welt*, pp. 105–7.

12. Alma Mahler, *Mein Leben* (Frankfurt am Main, 1960), p. 57.

13. Robert P. Welsh, "Mondrian and Theosophy," in *Piet Mondrian: 1872–1944*.

Centennial Exhibition, exhibition catalogue, Solomon R. Guggenheim Museum (New York, 1972).

14. Ringbom, *The Sounding Cosmos*; Klaus Lankheit, "Die Frühromantik und die Grundlagen der gegenstandslosen Malerei," *Neue Heidelberger Jahrbücher*, New Series (1951), pp. 55–90.

15. Van Gogh, letter, September 1888. Quoted in Robert Rosenblum, *Die moderne Kunst und die Tradition der Romantik* (Munich, 1981), p. 98.

16. Edvard Munch, *Tagebuch*, 1889. Quoted in Schmalenbach, "Der junge Kokoschka," p. 390.

17. Franz Marc, "Die 'Wilden' Deutschlands," in Lankheit, ed., *Der Blaue Reiter*, p. 7.

18. Undated notes for a poem. Quoted in Nebehay, *Schiele*, pp. 143–45, no. 168.

19. Letter to Czihaczek, Sept. 1, 1911. Quoted in ibid., p. 182, no. 251.

20. Herzmanovsky-Orlando, *Briefwechsel*, letter, Oct. 7, 1911, p. 69.

21. Letter to Roessler, Jan. 6, 1911. Quoted in Nebehay, *Schiele*, p. 164, no. 171.

22. Letter to Reininghaus, after February 27, 1912, in Leopold, *Egon Schiele*, p. 510.

23. Kubin, "Das Schaffen," *Werkstatt*, p. 46.

24. Schönberg, *Harmonielehre*, p. 464.

25. Letter to Arnold Schönberg from Stettin, July 3, 1912. In Hilmar, ed., *Anton von Webern*, p. 65.

26. Worbs, *Nervenkunst*, pp. 125ff.

27. Hermann Bahr, *Dialog von Tragischen* (Berlin, 1904), pp. 23f.

28. See Jäger, "Kokoschka's *Mörder*," who points out the relationship with Bahr and also with Antonin Artaud and his "Theater of Cruelty," with its therapeutic function of a "collective voiding of abscesses."

29. Gütersloh, "Neukunst," 3.

30. Ludwig Wittgenstein, *Tractatus logico-philosophicus* (Frankfurt am Main, 1969), p. 632.

31. Norbert Leser, "Der zeitgeschichtliche Hintergrund des Zeitraums 1895–1918," in *Wien um 1900*, pp. 490f.

32. Carl E. Schorske, *Wien—Geist und Gesellschaft im Fin-de-Siècle* (Frankfurt am Main, 1982).

33. Undated notes for a poem. Quoted in Nebehay, *Schiele*, pp. 143–45, no. 168.

34. Letter to Roessler, Jan. 6, 1911, in ibid., p. 164, no. 171.

35. Letter to Czihaczek, Sept. 1, 1911. Quoted in ibid., p. 182. no. 251.

36. Adolf Loos, "Ornament und Verbrechen," in Loos, *Trotzdem, 1900–1930* (Vienna, 1982), pp. 79f.

37. Cesare Lombroso, *Genio e follia* (1864), German translation, *Genie und Irrsinn in ihre Beziehungen zum Gesetz, zur Kritik und Geschichte* (Leipzig, 1887).

38. Max Nordau, *Entartung*. 2 vols. (Berlin, 1892–93).

39. Haeckel, *Die Radiolaren; Kunstformen der Natur*.

40. Hermann Bahr, *Tagebuch, 1905–1908* (Berlin, 1909), entry for June 3, 1908, p. 197.

41. *Architekt* 6 (1900): 23–26. Quoted in Strobl, *Gustav Klimt*.

42. Bandhauer, "Die Motive," p. 115.

43. Gütersloh, "Neukunst," 3.

44. Arnold Schönberg, "Mahler," in *Gesammelte Schriften*, vol. 1, *Stil und Gedanke Aufsätze zur Musik*, ed. Ivan Vojtech (Frankfurt am Main, 1976), p. 18.

45. Kubin, *Leben*, p. 44.

46. Letter to Czihaczek, Sept. 1, 1911, in Nebehay, *Schiele*, p. 182, no. 251.

47. Letter to Benesch, Aug. 7, 1911. Quoted in ibid., p. 179, no. 242.

48. *Lexikon der Kunst*, ed. Ludger Alscher and others, vol. IV (Leipzig, 1977), pp. 177ff.

49. See Lankheit, "Die Frühromantik," pp. 55–90.

50. Georg Lukács, "Grösse und Verfall des Expressionismus" (1934), in Lukács, *Probleme des Realismus* (Berlin, 1955), p. 173.

51. Martens, *Vitalismus*, p. 289.

52. Lukács, "Grösse und Verfall," p. 173.

Select Bibliography

Exhibition catalogues are preceded by an asterisk.

■ Primary Sources ■

Books (see also *Individual Artists*)

Bahr, Hermann. *Dialog vom Tragischen*. Berlin, 1904.
———. *Expressionismus*. Munich, 1916.
———. *Gegen Klimt*. Vienna, 1903.
———. *Secession*. Vienna, 1900.
———. *Tagebuch*. Berlin, 1909.
Hermann Bahr, Prophet der Moderne: Tagebücher, 1888–1904. Reinhard Farkas, ed. Vienna, 1987.
Hermann Bahr. Zur Überwindung des Naturalismus: Theoretische Schriften, 1887–1904. Gotthard Wunberg, ed. Stuttgart, 1968.
Kulturprofil der Jahrhundertwende: Essays von Hermann Bahr. Heinz Kindermann, ed. Vienna, 1962.
Ball, Hugo. *Die Flucht aus der Zeit*. Munich, 1931.
Bie, Oskar. *Grete Wiesenthal*. Berlin, 1910.
Duncan, Isadora. *The Dance of the Future / Der Tanz der Zukunft: Eine Vorlesung*. Leipzig, 1903.
Ehrenstein, Albert. *Tubutsch*. Vienna, 1911.
Faistauer, Anton. *Neue Malerei in Österreich: Betrachtungen eines Malers*. Zurich, 1923.
Haeckel, Ernst. *Die Radiolarien*. Berlin, 1862.

Haeckel, Ernst. *Kunstformen der Natur.* Leipzig, 1899.

Hevesi, Ludwig. *Acht Jahre Sezession.* Vienna, 1906. Reprint, Klagenfurt, 1984.

————. *Altkunst-Neukunst: Wien, 1894–1908.* Vienna, 1909. Reprint, Klagenfurt, 1986.

Kandinsky, Wassily. *Über das Geistige in der Kunst.* Munich, 1912.

Kandinsky, Wassily, and Franz Marc, eds. *Der Blaue Reiter.* Munich, 1912.

Loos, Adolf. *Sämtliche Schriften.* Vol. 1. Vienna, 1962.

————. *Spoken into the Void.* Cambridge, Mass., 1982.

Muther, Richard. *Studien und Kritiken.* 2 vols. Vienna, 1900–1901.

Schreyer, Lothar. *Erinnerungen an Sturm und Bauhaus.* Munich, 1956.

————. *Expressionistisches Theater.* Hamburg, 1948.

Seligmann, Adalbert Franz. *Kunst und Künstler von gestern und heute: Gesammelte Aufsätze.* Vienna, 1910.

Stefan, Paul. *Das Grab in Wien: Eine Chronik, 1903–1911.* Berlin, 1913.

Weininger, Otto. *Geschlecht und Charakter.* Vienna, 1903. Reprint, Munich, 1980.

Wiesenthal, Grete. *Die ersten Schritte.* Vienna, 1947.

Zuckerkandl, Berta. *Zeitkunst.* Vienna, 1908.

Periodicals

Die Aktion: Wochenschrift für Politik, Literatur, Kunst. Franz Pfemfert, ed. Berlin, 1911–.

Bildende Künstler: Monatsschrift für Künstler und Kunstfreunde. Arthur Roessler, ed. Vienna, 1911.

Erdgeist: Illustrierte Halbmonatsschrift. Gustav Eugen Diehl, ed. Vienna, 1906–.

Die Fackel. Karl Kraus, ed. Vienna, 1899ff. Reprint, Frankfurt am Main, 1977.

Imago: Zeitschrift für die Anwendung der Psychoanalyse auf die Geisteswissenschaften. Sigmund Freud, ed. Vienna, 1912–.

Der Merker: Österreichische Zeitschrift für Musik und Theater. Vienna, 1909–.

Der liebe Augustin. Berlin, 1904.

Der Ruf. Akademischer Verband für Literatur und Musik in Wien, ed. Vienna, 1912.

Der Sturm: Wochenschrift für Kultur und die Künste. Herwarth Walden, ed. Berlin, 1910–.

Ver Sacrum: Organ der Vereinigung bildender Künstler Österreichs. Vienna 1898–1903.

Exhibition Catalogues (see also *Individual Artists*)

**Secession.* Vienna, 1898–1905.

**Hagenbund.* Vienna, 1902ff.

**Galerie H. O. Miethke.* Vienna, 1904ff.

**Kunstschau, Wien, 1908.*

**Internationale Kunstschau, Wien, 1909.*

**A Neukunst Wien, 1912.* Budapest, 1912.

▪ General Works ▪

**Le arti a Vienna della Secessione alla caduta dell'impero asburgico.* Venice: Palazzo Grassi, 1984.

*Austrian Expressionists. New York: Galerie St. Etienne, 1964.

*Austria's Expressionism. New York: Galerie St. Etienne, 1981.

Bisanz-Prakken, Marian. Gustav Klimt: Der Beethovenfries. Salzburg, 1977.

Bouillon, Jean Paul. Klimt: Beethoven. New York, 1987.

Breicha, Otto, and Gerhard Fritsch, eds. Finale und Auftakt: Wien, 1898–1914, Literatur—Bildende Kunst—Musik. Salzburg, 1964.

Brühl, Georg. Herwarth Walden und "Der Sturm." Leipzig, 1983.

Chipp, Herschel B. "A Neglected Expressionist Movement—Viennese, 1910–1924." Artforum 1, no. 9 (1963): 21–27.

Comini, Alessandra. The Fantastic Art of Vienna. New York, 1978.

Dankl, Günther. Die "Moderne" in Österreich: Zur Genese und Bestimmung eines Begriffs in der österreichischen Kunst um 1900. Vienna, 1986.

Di Stefano, Eva. Il Complesso di Salomè: La donna, l'amore, e la morte nella pittura di Klimt. Palermo, 1985.

*Experiment Weltuntergang: Wien um 1900. Hamburg: Kunsthalle, 1981.

*Expressive und dekorative Grafik in Wien zwischen 1905 und 1925: Rudolf Kalvach, Hedwig Meiler. Vienna: Museum für angewandte Kunst, 1979.

*Face à face: L'art en Autriche du baroque à nos jours. Brussels: Palais des Beaux-Arts, 1987.

Fenz, Werner. Koloman Moser. Salzburg, 1984.

Forsthuber, Sabine. Moderne Raumkunst: Wiener Ausstellungsbauten, 1898–1914. Vienna, 1991.

Fuchs, Heinrich. Die österreichischen Maler der Geburtsjahrgänge 1881–1900. 2 vols. Vienna, 1976–77.

Fuchs, Rainer. Apologie und Diffamierung des "österreichischen Expressionismus": Begriffs- und Rezeptionsgeschichte der österreichischen Malerei 1908 bis 1938. Vienna, 1991.

*German and Austrian Expressionism, 1900–1920. Bloomington: Indiana University Art Museum, 1977.

Gordon, Donald E. Expressionism: Art and Idea. New Haven, 1987.

———. Modern Art Exhibitions: 1900–1916. 2 vols. Munich, 1974.

———. "On the Origin of the Word 'Expressionism.'" Journal of the Warburg and Courtauld Institutes 29 (1966): 368–85.

Hamann, Richard, and Jost Hermand. Expressionismus. Berlin, 1975.

———. Stilkunst um 1900. Berlin, 1967.

*Der Hagenbund. Historisches Museum der Stadt Wien, 1975.

Hammel, Gabriele. "Janus lacht: Neue Galerie des Kunsthistorischen Museums—kurze Bemerkung zu einer längeren Geschichte." Parnass 4, no. 2 (1984): 24–29.

Heller, Reinhard. "Recent Scholarship on Vienna's 'Golden Age,' Gustav Klimt and Egon Schiele." The Art Bulletin 59, no. 1 (1977): 111–18.

Hodler und Wien: Neujahrsblatt der Zürcher Kunstgesellschaft, 1950.

Hofmann, Werner. Gustav Klimt und die Wiener Jahrhundertwende. Salzburg, 1970. Translated as Gustav Klimt. Boston, 1972.

———. Moderne Malerei in Österreich. Vienna, 1965. Translated as Modern Painting in Austria. Vienna, 1965.

*Jugendstil floral—funktional in Deutschland, Österreich, und den Einflußgebieten. Munich: Bayerisches Nationalmuseum, 1984.

*Kandinsky und München. Munich: Städtische Galerie im Lenbachhaus, 1982.

Klimt—Schiele—Kokoschka. Brussels: Palais des Beaux-Arts, 1981.

Klimt-Studien: Mitteilungen der Österreichischen Galerie 22–23, no. 66–67 (1978–79).

Körperzeichen: Österreich. Winterthur: Kunstmuseum, 1982.

Lexikon der Kunst. Ludger Alscher et al., eds. 5 vols. Leipzig, 1968–78.

Erich Mallina, 1873–1954. Vienna: Hochschule für angewandte Kunst, 1980–81.

George Minne en de kunst rond 1900. Ghent: Museum voor Schone Kunsten, 1982.

Moderne Galerie in Wien: Sammlungskataloge. Vienna, 1903, 1907.

Nebehay, Christian M. *Gustav Klimt—Dokumentation*. Vienna, 1969.

Neue Galerie in der Stallburg: Sammlungskatalog. Vienna, 1967.

Novotny, Fritz. *Der Maler Anton Romako*. Vienna, 1954.

Österreichische Aktzeichnungen von Klimt bis heute. Vienna: Secession, 1969.

Österreichische Avantgarde, 1900–1930: Ein unbekannter Aspekt. Vienna, Galerie nächst St. Stephan etc., 1976–77.

Österreichische Malerei, 1908–1938. Graz: Künstlerhaus, 1966.

Pabst, Michael. *Wiener Grafik um 1900*. Munich, 1984.

Post-Impressionism. London: Royal Academy of Arts, 1979–80.

Powell, Nicolas. *The Sacred Spring: The Arts in Vienna, 1989–1918*. Greenwich, Conn., 1974.

Ronte, Dieter. "Österreichische Kunst." In *Museum moderner Kunst, Wien*. Vienna, 1984, pp. 54–64.

Rukschcio, Brukhard, and Roland Schachel. *Adolf Loos: Leben und Werk*. Salzburg, 1982.

Rosenblum, Robert. *Modern Painting and the Northern Romantic Tradition*. London, 1975.

Schmalenbach, Fritz. "Das Wort 'Expressionismus.'" *Neue Zürcher Zeitung*, Fernausgabe, no. 69 (March 11, 1961): 20.

―――. "Das Wort 'Expressionismus': Eine Ergänzung." *Neue Zürcher Zeitung*, Fernausgabe, no. 258 (Sept. 21, 1962): 9.

Giovanni Segantini: 1858–1899. Vienna: Museum des 20. Jahrhunderts, 1981.

Schmidt, Gerhard. *Neue Malerei in Österreich*. Vienna, 1956.

Schmidt, Rudolf. *Das Wiener Künstlerhaus: Eine Chronik, 1861–1951*. Vienna, 1951.

Schmied, Wieland. *Nach Klimt: Schriften zur Kunst in Österreich*. Salzburg, 1979.

Schweiger, Werner J. *Wiener Werkstätte: Kunst und Handwerk, 1903–1932*. Vienna, 1982. American edition: *The Wiener Werkstätte*. New York, 1984.

Selz, Peter. *German Expressionist Painting*. Berkeley, 1957.

Shedel, James S. *Art and Society: The New Art Movement in Vienna, 1897–1914*. Palo Alto, 1981.

Sotriffer, Kristian. *Malerei und Plastik in Österreich von Makart bis Wotruba*. Vienna, 1963.

―――, ed. *Der Kunst ihre Freiheit: Wege der österreichischen Moderne von 1880 bis zur Gegenwart*. Vienna, 1984.

Strobl, Alice. *Gustav Klimt: Die Zeichnungen*. 4 vols. Salzburg, 1980–89.

Traum und Wirklichkeit: Wien, 1870–1930. Vienna: Künstlerhaus, 1985.

Vergo, Peter. *Art in Vienna, 1898–1918: Klimt, Kokoschka, Schiele, and Their Contemporaries*. Ithaca, N.Y., 1981.

*Vienna, 1900: Art, Architecture, and Design. New York: The Museum of Modern Art, 1986.

*Vienna, 1900: Vienna, Scotland, and the European Avant-Garde. Edinburgh: National Museum of Scotland of the Antiquities, 1983.

*Vienne, 1880–1938: L'Apocalypse joyeuse. Paris: Centre Pompidou, 1986.

*Viennese Expressionism, 1910–1924: The Work of Egon Schiele with Work by Gustav Klimt and Oskar Kokoschka. University Art Gallery, Pasadena Art Museum, 1963.

Vollmer, Hans, ed. Allgemeines Lexikon der bildenden Künstler des 20. Jahrhunderts. 6 vols. Leipzig, 1953–62.

Wagner, Walter. Die Geschichte der Akademie der bildenden Künste in Wien. Vienna, 1976.

Waissenberger, Robert, ed. Vienna, 1890–1920. New York, 1985.

————, ed. Wien, 1870–1930: Traum und Wirklichkeit. Salzburg, 1984.

————. Wien und die Kunst in unserem Jahrhundert. Vienna, 1965.

Werkner, Patrick. "De 1910 à nos jours. Affinités dans les arts plastiques autrichiens." In Face à face: L'art en Autriche du baroque à nos jours. Brussels: Palais des Beaux-Arts, 1987, pp. 30–35.

————. "Hermann Bahr und seine Rezeption Gustav Klimts. Österreichertum, 'sinnliches Chaos' und Monismus." In Margret Dietrich, ed., Hermann-Bahr-Symposion Linz 1984. Linz: 1987, pp. 65–76.

————. "L'espressionismo austriaco." In Le arti a Vienna della Secessione alla caduta dell'impero asburgico. Venice, 1984, pp. 153–60. Also available as "Österreichischer Expressionismus." In Wien um 1900: Kunst und Kultur. Vienna, 1985, pp. 97–104.

————. Physis und Psyche: Der österreichische Frühexpressionismus. Vienna, 1986.

————. "Verwandlung des Sichtbaren—Expression." In Kristian Sotriffer, ed., Der Kunst ihre Freiheit: Wege der österreichischen Moderne von 1880 bis zur Gegenwart. Vienna, 1984, pp. 65–100.

*Wien um 1900. Vienna: Secession / Künstlerhaus / Historisches Museum der Stadt, 1964.

*Wien um 1900: Klimt, Schiele und ihre Zeit. Tokyo: Sezon Museum of Art, 1989.

Wien um 1900: Kunst und Kultur. Vienna, 1985.

*Das Zeitalter Kaiser Franz Josephs; 2. Teil, 1880–1916. Glanz und Elend. 2 vols. Schloß Grafenegg, 1987.

▪ Cultural History / Literature / Music / Dance ▪

*Art and Dance: Images of the Modern Dialogue, 1890–1980. Boston: Institute of Contemporary Art, 1980.

Aufbruch: Der Künstlerkreis um Adolf Loos zur Jahrhundertwende. Linz, 1985.

Bandhauer, Andrea. "Die Motive der Bewegung und des Tanzes in Else Lasker-Schülers Werk." Ph.D. diss., Innsbruck, 1984.

Botstein, Leon. Judentum und Modernität: Essays zur Rolle der Juden in der deutschen und österreichischen Kultur, 1848–1938. Vienna, 1991.

Brix, Emil, and Patrick Werkner, eds. Die Wiener Moderne: Ergebnisse eines Arbeitsgesprächs der Arbeitsgemeinschaft Wien um 1900. Vienna, 1990.

Chapple, Gerald, and Hans H. Schulte, eds. *The Turn of the Century: German Literature and Art, 1890–1914.* Bonn, 1981.

Dijkstra, Bram. *Idols of Perversity: Fantasies of Feminine Evil in Fin-de-Siècle Culture.* New York, 1986.

Dvorak, Max. *Kunstgeschichte als Geistesgeschichte.* Munich, 1924.

Farese-Sperken, Christine. *Der Tanz als Motiv in der bildenden Kunst des 20. Jahrhunderts.* Munich, 1969.

Farkas, Reinhard. *Hermann Bahr: Dynamik und Dilemma der Moderne.* Vienna, 1989.

Fiedler, Leonhard M., and Martin Lang. *Grete Wiesenthal: Die Schönheit der Sprache des Körpers im Tanz.* Salzburg, 1985.

Fischer, Friedhelm W. "Geheimlehren und moderne Kunst." In Robert Bauer et al., eds., *Zu Literatur und Kunst der Jahrhundertwende.* Frankfurt am Main, 1977, pp. 344–77.

Fischer, Jens Malte. *Fin de siècle: Kommentar zu einer Epoche.* Munich, 1978.

Floros, Constantin. *Gustav Mahler.* Vol. 1. *Die geistige Welt Gustav Mahlers in systematischer Darstellung.* Wiesbaden, 1977.

Frey, Dagobert. "Dämonie des Blickes." In *Akademie der Wissenschaften und Literatur. Abhandlungen der geistes- und sozialwissenschaftlichen Klasse* 6 (1953).

Goldschmidt, Hans E. *Quer Sacrum: Wiener Parodien und Karikaturen der Jahrhundertwende.* Vienna, 1976.

Gerlach, Reinhard. *Musik und Jugendstil der Wiener Schule, 1900–1908.* Laaber, 1985.

**Der Hang zum Gesamtkunstwerk.* Zurich: Kunsthaus, 1982.

Hinze, Diana O. "Trakl, Kokoschka, und Kubin: Zur Interdependenz von Wort- und Bildkunst." *Germanisch-Romanische Monatsschrift.* Neue Folge 21 (1971): 72–78.

Janik, Allan, and Stephen Toulmin. *Wittgenstein's Vienna.* New York, 1973.

Jeziorkowski, Klaus. "Empor ins Licht: Gnostizismus und Licht-Symbolik in Deutschland um 1900." In Gerald Chapple and Hans H. Schulte, eds., *The Turn of the Century: German Literature and Art, 1890–1914.* Bonn, 1981, pp. 171–96.

Johnston, William M. *The Austrian Mind: An Intellectual and Social History, 1848–1938.* Berkeley, 1972.

Kindlers Literatur-Lexikon. 8 vols. Zurich, 1965–1974.

Lankheit, Klaus. "Die Frühromantik und die Grundlagen der gegenstandlosen Malerei." *Neue Heidelberger Jahrbücher.* Neue Folge, Jahrbuch 1951, pp. 55–90.

Le Rider, Jaques. *Der Fall Otto Weininger: Wurzeln des Antifeminismus und des Antisemititsmus.* Vienna, 1983.

——— , and Norbert Leser, eds. *Otto Weininger: Werk und Wirkung.* Vienna, 1984.

Lexikon der Weltliteratur. Gero von Wilpert, ed. 2 vols. Stuttgart, 1968, 1975.

Lube, Manfred. *Gustav Meyrink: Beiträge zur Biographie und Studien zu seiner Kunsttheorie.* Graz, 1980.

Lukács, Georg. "Größe und Verfall des Expressionismus." In *Probleme des Realismus.* Berlin, 1955, pp. 152ff.

Martens, Gunter. *Vitalismus und Expressionismus: Ein Beitrag zur Genese und Deutung expressionistischer Stilstrukturen und Motive.* Stuttgart, 1971.

Nielsen, Erika, ed. *Focus on Vienna 1900: Change and Continuity in Literature, Music, Art, and Intellectual History.* Munich, 1982.

Paulsen, Wolfgang. *Deutsche Literatur des Expressionismus*. Berne, 1983.

————, ed. *Österreichische Gegenwart: Die moderne Literatur und ihr Verhältnis zur Tradition*. Berne, 1980.

Pfabigan, Alfred, ed. *Ornament und Askese im Zeitgeist des Wien der Jahrhundertwende*. Vienna, 1985.

Ringbom, Sixten. *The Sounding Cosmos: A Study in the Spiritualism of Kandinsky and the Genesis of Abstract Painting*. Helsingfors, 1970.

Rothe, Wolfgang. *Tänzer und Täter: Gestalten des Expressionismus*. Frankfurt am Main, 1979.

————, ed. *Expressionismus als Literatur: Gesammelte Studien*. Berne, 1969.

Schorske, Carl E. *Fin-de-siècle Vienna: Politics and Culture*. New York, 1980.

Segel, Harold B. *Turn-of-the-Century Cabaret*. New York, 1987.

Sotriffer, Kristian, ed. *Das größere Österreich: Geistiges und soziales Leben von 1880 bis zur Gegenwart*. Vienna, 1982.

Tanz 20. Jahrhundert, Wien. Vienna: Österreichisches Theatermuseum, 1979.

Timms, Edward. *Karl Kraus, Apocalyptic Satirist: Culture and Catastrophe in Habsburg Vienna*. New Haven, 1984.

Vom Klang der Bilder: Die Musik in der Kunst des 20. Jahrhunderts. Stuttgart: Staatsgalerie, 1985.

Wagner, Nike. *Geist und Geschlecht: Karl Kraus und die Erotik der Wiener Moderne*. Frankfurt am Main, 1982.

Wellek, Albert. "Farbenhören/Farbenmusik." In *Die Musik in Geschichte und Gegenwart*, vol. 3. Kassel, 1954.

Die neue Körpersprache—Grete Wiesenthal und ihr Tanz. Vienna: Hermesvilla, 1985–86.

Worbs, Michael. *Nervenkunst: Literatur und Psychoanalyse im Wien der Jahrhundertwende*. Frankfurt am Main, 1983.

Wörner, Karl H. *Die Musik in der Geistesgeschichte: Studien zur Situation der Jahre um 1910*. Bonn, 1970.

Wunberg, Gotthard, ed. *Die Wiener Moderne: Literatur, Kunst, und Musik zwischen 1890 und 1910*. Stuttgart, 1981.

Zeichen des Glaubens—Geist der Avantgarde: Religiöse Tendenzen in der Kunst des 20. Jahrhunderts. Berlin: Schloß Charlottenburg, 1980.

▪ **Individual Artists** ▪

(Select publications relevant to the early phase of Austrian expressionism. For artists not mentioned here, see under *General Works*)

Gerstl

Born, Wolfgang. "Richard Gerstl." *Belvedere: Zeitschrift für Kunst und künstlerische Kultur* 10, no. 11.

Breicha, Otto. "Gerstl, der Zeichner." *Albertina Studien* 3, no. 2 (1965): 92–101.

————. *Richard Gerstl: Bilder zur Person*. Salzburg, 1991.

Hofmann, Werner. "Der Wiener Maler Richard Gerstl." *Kunstwerk* 10, no. 1, 2 (1956–57): 99–101.

Kallir, Otto. "Richard Gerstl, 1883–1908: Beiträge zur Dokumentation seines

Lebens und Werkes." *Mitteilungen der Österreichischen Galerie* 18, no. 62 (1974): 125–93.

Krapf-Weiler, Almut. "Richard Gerstl." In *Wien um 1900: Kunst und Kultur*. Vienna, 1985, pp. 73–78.

**Richard Gerstl: 1883–1908*. Vienna: Galerie Würthle, 1957.

**Richard Gerstl*. Vienna: Secession / Innsbruck: Tiroler Kunstpavillon, 1966.

**Richard Gerstl: 1883–1908*. Vienna: Historisches Museum der Stadt, 1983.

**Richard Gerstl—Oskar Kokoschka*. New York: Galerie St. Etienne, 1992.

Gütersloh

Doderer, Heimito von. *Der Fall Gütersloh: Ein Schicksal und seine Deutung*. Vienna, 1930.

Gütersloh, Albert Paris. *Bekenntnisse eines modernen Malers*. Vienna, 1926.

———. *Die tanzende Törin*. Berlin, 1910.

———. *Egon Schiele: Versuch einer Vorrede*. Vienna, 1911.

———. "Neukunst." *Pester Lloyd, Morgenblatt* 59, no. 3 (Budapest, Jan. 4, 1912): 1–3. Hungarian translation in *A Neukunst Wien, 1912*. Budapest, 1912.

———. "Schönberg der Maler." In *Arnold Schönberg: Beiträge von Alban Berg et al*. Munich, 1912. Reprint: Wels, 1980.

Hutter, Heribert. *Albert Paris Gütersloh: Beispiele*. Vienna, 1977.

**Albert Paris Gütersloh: Aquarelle—Zeichnungen*. Vienna: Albertina, 1970.

**Albert Paris Gütersloh: Retrospektive*. Baden b. Wien: Frauenbad, 1982.

Kokoschka

Breicha, Otto, ed. *Oskar Kokoschka—Vom Erlebnis im Leben*. Salzburg, 1976.

Bultmann, Bernhard. *Oskar Kokoschka*. Salzburg, 1960.

Denkler, Horst. "Die Druckfassungen der Dramen Oskar Kokoschkas." *Deutsche Vierteljahresschrift für Literaturwissenschaft und Geistesgeschichte* 40, no. 1 (1966): 90–108.

Dvorak, Max. *Vorrede: Oskar Kokoschka, Variationen über ein Thema*. Vienna, 1921.

Fenjö, Ivan. *Oskar Kokoschka: Die frühe Graphik*. Vienna, 1976.

Gatt, Giuseppe. *Oskar Kokoschka*. Florence, 1970.

Giese, Herbert. "Einge Bemerkungen zum Frühwerk Kokoschkas." In *Wien um 1900: Kunst und Kultur*. Vienna, 1985, pp. 67–72.

Goldscheider, Ludwig. *Kokoschka*. Vienna, 1966.

Gordon, Donald E. "Oskar Kokoschka and the Visionary Tradition." In *The Turn of the Century: German Literature and Art, 1890–1915*, ed. Gerald Chapple and Hans H. Schulte. Bonn, 1981, pp. 23–52.

Gruber, Karl. "Zur Entstehung von Kokoschkas Forel-Bildnis." *Das Kunstwerk* 5, no. 3 (1951): 60–61.

Hodin, Josef Paul. *Oskar Kokoschka: Sein Leben—seine Zeit*. Frankfurt am Main, 1968.

Hoffmann, Edith. *Kokoschka: Life and Work*. London, 1947.

Hoffmann-Curtius, Kathrin. "Frauenbilder Oskar Kokoschkas." In Ilsebill Barta et al., eds., *Frauen—Bilder—Männer—Mythen: Kunsthistorische Beiträge*. Berlin, 1987, pp. 148–78.

Jäger, Georg. "Kokoschkas *Mörder, Hoffnung der Frauen*: Die Geburt des Theaters der Grausamkeit aus dem Geist der Wiener Jahrhundertwende." *Germanisch-romanische Monatsschrift*. Neue Folge 32, no. 2 (1982): 215–33.

Kamm, Otto. "Oskar Kokoschka und das Theater." Ph.D. diss., Vienna, 1958.

Kokoschka, Oskar. *Briefe*. Olda Kokoschka and Heinz Spielmann, eds. Vol. 1, 1905–1919. Düsseldorf, 1984.

———. *Dichtungen und Dramen: Das schriftliche Werk*. Heinz Spielmann, ed. Vol. 1. Hamburg, 1973.

———. *Dramen und Bilder*. Leipzig, 1913.

———. *Mein Leben*. Munich, 1971.

———. *Schriften, 1907–1955*. Hans M. Wingler, ed. Munich, 1956.

———. *Vier Dramen*. Berlin, 1919.

Oskar-Kokoschka-Symposion der Hochschule für angewandte Kunst in Wien, 1986. Salzburg, 1986.

Leshko, Jaroslav. "Klimt, Kokoschka, und die mykenischen Funde." *Mitteilungen der Österreichischen Galerie* 13, no. 57 (1969): 18ff.

Lischka, G. J. *Oskar Kokoschka, Maler und Dichter: Eine literarästhetische Untersuchung zu einer Doppelbegabung*. Berne, 1972.

Rathenau, Ernest, ed. *Oskar Kokoschka: Drawings, 1906–1965*. Coral Gables, Fla., 1970.

Schmalenbach, Fritz. "Der junge Kokoschka." In *Argo: Festschrift für Kurt Badt*, ed. Martin Gosebruch and Lorenz Dittmann. Cologne, 1970, pp. 386–400.

———. *Oskar Kokoschka*. Greenwich, Conn., 1967.

Schumacher, Hans. "Oskar Kokoschka." In Wolfgang Rothe, ed., *Expressionismus als Literatur*. Berne, 1969.

Schvey, Henry I. *Oskar Kokoschka: The Painter as Playwright*. Detroit, 1982.

Schweiger, Werner J. *Der junge Kokoschka*. Vienna, 1983.

Secci, Lia. "Die lyrischen Dichtungen Oskar Kokoschkas." *Jahrbuch der Deutschen Schillergesellschaft* 12 (1968): 457–92.

Tesar, Ludwig Erik. "Oskar Kokoschka. Ein Gespräch." *Die Fackel*, no. 298–99 (March 21, 1910): 34–44.

———. "Der Fall Oskar Kokoschka und die Gesellschaft." *Die Fackel*, no. 319–20 (March 31, 1911): 31–39.

Werkner, Patrick. "Kokoschkas frühe Gebärdensprache und ihre Verwurzelung im Tanz." In *Oskar-Kokoschka-Symposion der Hochschule für angewandte Kunst in Wien, 1986*. Salzburg, 1986, pp. 82–99.

———. "Ludwig Erik Tesars Kunstkritik in der *Fackel*, 1910/11." In Anton Hütter and Eberhard Sauermann, eds., *Erziehung, Weg zu menschenwürdigem Leben: Schwazer Tesar-Symposion*. Innsbruck, 1989, pp. 25–27.

———. "Was bleibt vom Kokoschka-Jubiläumsjahr?" *Kunsthistoriker. Mitteilungen des österreichischen Kunsthistorikerverbandes* 4, no. 1–2 (1987): 34–35.

Westheim, Paul. *Oskar Kokoschka*. Berlin, 1918.

———. *Oskar Kokoschka*. Berlin, 1925.

———. *Der Zeichner Kokoschka*. Berlin, 1961.

Whitford, Frank. *Oskar Kokoschka: A Life*. New York, 1986.

Wingler, Hans M. *Oskar Kokoschka: Das Werk des Malers*. Salzburg, 1956. Translated as *Oskar Kokoschka: The Work of the Painter*. Salzburg, 1958.

———. *Oskar Kokoschka: Ein Lebensbild*. Berlin, 1956.

—————, and Friedrich Welz. *Oskar Kokoschka: Das druckgraphische Werk*. Salzburg, 1975.

**Oskar Kokoschka*. Bascl: Kunsthalle, 1947.

**Oskar Kokoschka*. Vienna: Künstlerhaus, 1958.

**Kokoschka: A Retrospective Exhibition*. London: Tate Gallery, 1962.

**Oskar Kokoschka*. Hamburg: Museum für Kunst und Gewerbe / Kunstgewerbeverein, 1965.

**Oskar Kokoschka: Aquarelle und Zeichnungen*. Stuttgart: Staatsgalerie, 1966.

**Kokoschka: Prints and Drawings*. London: Victoria and Albert Museum, 1971.

**Oskar Kokoschka zum 85. Geburtstag*. Vienna: Österreichische Galerie, 1971.

**Oskar Kokoschka*. Bregenz: Künstlerhaus, 1976.

**Oskar Kokoschka, 1886–1980*. Rome: Palazzo Venezia, 1981–82.

**Oskar Kokoschka, Die frühen Jahre: Zeichnungen und Aquarelle*. Vienna: Historisches Museum der Stadt, 1982–83.

**Oskar Kokoschka*. Zürich: Kunsthaus / London: Tate Gallery / New York: The Solomon R. Guggenheim Museum, 1986.

**Oskar Kokoschka*. Ghent: Museum voor Schone Kunsten / Liège: Salle Saint Georges, 1987.

**Oskar Kokoschka*. Vienna: Kunstforum Länderbank, 1991.

Kubin

Bisanz, Hans. *Alfred Kubin: Zeichner, Schriftsteller, und Philosoph*. Salzburg, 1977.

Breicha, Otto, ed. *Alfred Kubin, Weltgeflecht. Ein Kubin-Kompendium: Schriften und Bilder zu Leben und Werk*. Munich, 1978.

Brockhaus, Christoph. "Rezeptions- und Stilpluralismus: Zur Bildgestaltung in Alfred Kubins Roman *Die andere Seite*." *Pantheon* 32, no. 3 (1974): 272–88.

Esswein, Hermann. *Alfred Kubin: Der Künstler und sein Werk*. Munich, 1911.

Fraenger, Wilhelm. "Alfred Kubin." *Xenien* 5 (Dec. 1912): 703–8.

Glaesemer, Jürgen. "Paul Klees persönliche und künstlerische Begegnung mit Alfred Kubin." *Pantheon* 32, no. 2 (1974): 156–62.

Herzmanovsky-Orlando, Fritz von. *Der Briefwechsel mit Alfred Kubin: 1903 bis 1952*. Michael Klein, ed. Salzburg, 1983.

Hewig, Anneliese. *Phantastische Wirklichkeit: Interpretationsstudie zu Alfred Kubins Roman "Die andere Seite."* Munich, 1967.

Horodisch, Abraham. *Alfred Kubin, Book Illustrator*. New York, 1950.

Kubin, Alfred. *Die andere Seite: Ein phantastischer Roman*. Munich, 1909. Translated as *Visions from the Other Side*. New York, 1967.

—————. *Aus meinem Leben: Gesammelte Prosa*. Ulrich Riemerschmidt, ed. Munich, 1974.

—————. *Aus meiner Werkstatt: Gesammelte Prosa*. Ulrich Riemerschmidt, ed. Munich, 1973.

—————. *Dämonen und Nachtgesichte: Eine Autobiographie*. Munich, 1959.

Lippuner, Heinz. *Alfred Kubins Roman "Die andere Seite."* Berne, 1977.

Marks, Alfred. *Der Illustrator Alfred Kubin: Gesamtkatalog seiner Illustrationen und buchkünstlerischen Arbeiten*. Munich, 1977.

Müller-Thalheim, Wolfgang K. *Erotik und Dämonie im Werk Kubins: Eine psychopathologische Studie*. Munich, 1970.

Raabe, Paul. *Alfred Kubin: Leben, Werk, Wirkung.* Hamburg, 1957.

Rhein, Phillip H. *The Verbal and Visual Art of Alfred Kubin.* Riverside, Ca., 1989.

Sachs, Hanns. *"Die andere Seite." Imago: Zeitschrift für die Anwendung der Psycho-analyse auf die Geisteswissenschaften,* ed. Sigmund Freud. 1, no. 2 (1912): 197–204.

Schmied, Wieland, and Alfred Marks. *Der Zeichner Alfred Kubin.* Salzburg, 1967.

Schmitz, Oskar. *Brevier für Einsame: Fingerzeige zu neuem Leben.* Munich, 1923.

Schneditz, Wolfgang. *Alfred Kubin.* Vienna, 1956.

———. *Alfred Kubin und seine magische Welt.* Salzburg, 1949.

Schroeder, Richard Arthur. "Alfred Kubin's "Die andere Seite": A Study in the Cross-Fertilization of Literature and the Graphic Arts." Ph.D. diss., Indiana University, Bloomington, 1970.

Seipel, Wilfried. *Alfred Kubin, der Zeichner.* Vienna, 1988.

**Eugen Spiro und Alfred Kubin.* Vienna: Galerie Miethke, 1906.

**Gedächtnisausstellung Alfred Kubin, 1877–1959.* Munich: Bayerische Akademie der Schönen Künste und Kunstverein, 1964.

**Alfred Kubin, 1877–1965.* New York: Serge Sabarsky Gallery, 1970.

**Alfred Kubin: Frühe Zeichnungen und Aquarelle.* Vienna: Galerie Ariadne, 1973–74.

**Alfred Kubin: Frühe Werke 1900 bis 1920.* Innsbruck: Galerie im Taxispalais, 1974.

**Alfred Kubin: Das zeichnerische Frühwerk bis 1904.* Baden-Baden: Staatliche Kunsthalle, 1977.

**Alfred Kubin: Das zeichnerische Frühwerk bis 1904. Bilder und Schriften zum Leben und Werk.* Vienna: Albertina, 1977.

**Alfred Kubin: Visions from the Other Side.* New York: Galerie St. Etienne, 1983.

**Alfred Kubin: Leben—ein Abrgund.* Vienna: Österreichische Länderbank, 1985–86.

**Alfred Kubin.* Winterthur: Kunstmuseum, 1986.

**Alfred Kubin.* Munich: Städtische Galerie im Lenbachhaus / Hamburg: Kunsthalle, 1990–91.

Oppenheimer

Krapf-Weiler, Almut. "Max Oppenheimer." In *Wien um 1900: Kunst und Kultur.* Vienna, 1985, pp. 536–37.

Michel, Wilhelm. *Max Oppenheimer.* Munich, 1911.

Oppenheimer, Max. *Menschen finden ihren Maler.* Zurich, 1938.

Max Oppenheimer: Veröffentlichungen des Kunstarchivs. Berlin, 1927, no. 25–26.

Schöny, Heinz. "Mopp. Ein Wiener Porträtist von Rang: Max Oppenheimer." *Alte und moderne Kunst,* no. 196–97 (1984): 40–44.

**Max Oppenheimer—Ein österreichisches Schicksal? Ölbilder und Graphiken.* Vienna: Galerie Pabst, 1974.

Schiele

Benesch, Heinrich. *Mein Weg mit Egon Schiele.* New York, 1965.

Benesch, Otto. *Egon Schiele als Zeichner.* Vienna, 1951.

———. "Egon Schiele und die Graphik des Expressionismus." In *Continuum: Zur Kunst Österreichs in der Mitte des 20. Jahrhunderts,* ed. Institut zur Förderung der Künste in Österreich. Vienna, 1957.

Comini, Alessandra. *Egon Schiele*. New York, 1976.

———. *Schiele in Prison*. Greenwich, Conn., 1973.

———. *Egon Schiele's Portraits*. Berkeley, 1974.

Denkler, Horst. "Malerei mit Wörtern: Zu Egon Schieles poetischen Schriften." In R. v. Heydebrand and K. G. Just, eds., *Wissenschaft als Dialog: Studien zur Literatur und Kunst seit der Jahrhundertwende*. Stuttgart, 1969, pp. 271–88.

Dobai, Johannes. "Egon Schieles 'Jüngling vor Gottvater kniend.'" In *Beiträge zur Kunst des 19. und 20. Jahrhunderts: Jahrbuch des Schweizerischen Instituts für Kunstwissenschaft*, 1968–69.

Kallir, Jane. *Egon Schiele: The Complete Works*. New York, 1990.

Kallir, Otto. *Egon Schiele: Oeuvre-Katalog der Gemälde*. Vienna, 1966. American edition: *Egon Schiele: Oeuvre Catalogue of the Paintings*. New York, 1966.

———. *Egon Schiele: Das druckgraphische Werk*. Vienna, 1970. American edition: *Egon Schiele: The Graphic Work*. New York, 1970.

Karpfen, Fritz. *Das Egon Schiele-Buch*. Vienna, 1921.

Künstler, Gustav. *Egon Schiele als Graphiker*. Vienna, 1946.

Leopold, Rudolf. *Egon Schiele: Gemälde, Aquarelle, Zeichnungen*. Salzburg, 1972. Translated as *Egon Schiele: Paintings, Watercolours, Drawings*. London, 1973.

Malafarina, Gianfranco. *L'Opera di Egon Schiele*. Milan, 1982.

Mitsch, Erwin. *Egon Schiele, 1890–1918*. Salzburg, 1974.

———. *Egon Schiele: Zeichnungen und Aquarelle*. Salzburg, 1961.

Nebehay, Christian M. *Gustav Klimt, Egon Schiele, und die Familie Lederer*. Berne, 1987.

———. *Egon Schiele, 1890–1918: Leben, Briefe, Gedichte*. Salzburg, 1979.

———. *Egon Schiele: Leben und Werk*. Salzburg, 1980.

———. *Egon Schiele: Von der Skizze zum Bild*. Vienna, 1989. American edition: *Egon Schiele: Sketchbooks*. New York, 1989.

Novotny, Fritz. *Egon Schiele: Gedenkschrift zur 50. Wiederkehr des Todestages*. Vienna, 1968.

Roessler, Arthur. *Briefe und Prosa von Egon Schiele*. Vienna, 1921.

———. "Egon Schiele." *Bildende Künstler*, no. 3 (1911): 104–18.

———. *Erinnerungen an Egon Schiele*. Vienna, 1922. Expanded edition, Vienna, 1948.

———, ed. *Egon Schiele im Gefängnis: Aufzeichnungen und Zeichnungen*. Vienna, 1922.

———, ed. *In memoriam Egon Schiele*. Vienna, 1921.

Sabarsky, Serge. *Egon Schiele*. New York, 1985.

———. *Egon Schiele: Disegni Erotici*. Milan, 1981.

Salter, Ronald. "Georg Trakl und Egon Schiele: Aspekte des österreichischen Expressionismus in Wort und Bild." In Wolfgang Paulsen, ed., *Österreichische Gegenwart: Die moderne Literatur und ihr Verhältnis zur Tradition*. Berne, 1980, pp. 59–79.

Schiele, Egon. *Die Gedichte*. Vienna, 1977.

———. *Ich ewiges Kind: Gedichte*. Vienna, 1985. American edition: *I, Eternal Child: Paintings and Poems*. New York, 1988.

———. *Schriften und Zeichnungen*. Innsbruck, 1968.

Schwarz, Heinrich. "Schiele, Dürer, and the Mirror." *The Art Quarterly* 30, no. 3–4 (1967): 210–23.

Steiner, Reinhard. *Egon Schiele*. Köln, 1991.

Tietze, Hans. "Egon Schiele." *Die bildenden Künste: Wiener Monatshefte* 2 (1919): 99–110.

Wagner, Max. "Egon Schiele: Erinnerungsbuch." Unpublished manuscript, 1943–1946. Vienna: Albertina, Egon-Schiele-Archiv.

Webb, Karl E. "Trakl/Schiele and the Rimbaud Connection: Psychological Alienation in Austria at the Turn of the Century." In J. P. Strelka, ed., *Internationales Georg-Trakl-Symposion*. Albany, N.Y., 1983, and Berne, 1984, pp. 12–21.

Werkner, Patrick, ed. *Egon Schiele: Art, Sexuality, and Viennese Modernism*. Palo Alto, 1993.

Whitford, Frank. *Egon Schiele*. New York, 1981.

Wilson, Simon. *Egon Schiele*. Ithaca, N.Y., 1980.

Egon Schiele: Kollektiv-Ausstellung. Vienna: Galerie Arnot, 1915.

Gustav Klimt and Egon Schiele. New York: The Solomon R. Guggenheim Museum, 1965.

Zweite Internationale der Zeichnung: Sonderschau Egon Schiele / Paul Klee. Darmstadt: Mathildenhöhe, 1967.

Egon Schiele: Ausstellung zur 50. Wiederkehr seines Todestages. Vienna: Österreichische Galerie, 1968.

Egon Schiele: Leben und Werk. Vienna: Historisches Museum der Stadt, 1968.

Gustav Klimt, Egon Schiele: Zum Gedächtnis ihres Todes vor 50 Jahren, Zeichnungen und Aquarelle. Vienna: Albertina, 1968.

Egon Schiele and His Circle. New York: Galerie La Boëtie, 1971.

Egon Schiele and the Human Form: Drawings and Watercolors. Des Moines Art Center, 1971–72.

Egon Schiele. Munich: Haus der Kunst, 1975.

Egon Schiele, Heimkehr nach Tulln: Werke und Dokumente aus Familienbesitz. Tulln: Rathaus, 1980.

Egon Schiele: Zeichnungen und Aquarelle, 1906–1918. Vienna: Akademie der bildenden Künste, 1984.

Egon Schiele. Rome: Pinacoteca Capitolina, 1984.

Egon Schiele. Charleroi: Palais des Beaux-Arts, 1987.

Egon Schiele und seine Zeit: Österreichische Malerei und Zeichnung von 1900 bis 1930 aus der Sammlung Leopold. Zurich: Kunsthaus / Vienna: Kunstforum Länderbank, 1988–90. Translated as *Egon Schiele and His Contemporaries: From the Leopold Collection, Vienna*. Munich, 1989.

Egon Schiele. Zum 100. Geburtstag: Die Aquarelle und Zeichnungen aus eigenem Besitz. Vienna: Albertina, 1990.

Schönberg

Bogner, Dieter. "Schönberg—Hauer: Vom Chaos zur Ordnung." In *Aufbruch: Der Künstlerkreis um Adolf Loos zur Jahrhundertwende*. Linz, 1985, pp. 48–55.

Comini, Alessandra. "Through a Viennese Looking-Glass Darkly: Images of Arnold Schönberg and His Circle." *Arts Magazine*, May 1984, pp. 107–19.

Crawford, John. "*Die Glückliche Hand*: Schoenberg's Gesamtkunstwerk." *The Musical Quarterly* 60, no. 4 (1974): 583–601.

Döhring, Sieghart. "Schönbergs Erwartung." In *Arnold Schönberg: Internationaler Musikwissenschaftlicher Kongreß*. Berlin, 1974, pp. 35–40.

Freitag, Eberhard. *Arnold Schönberg in Selbstzeugnissen und Bilddokumenten*. Reinbek, 1973.

———. "Schönberg als Maler." Ph.D. diss., Münster, 1973.

Kallir, Jane. *Arnold Schoenberg's Vienna*. New York, 1984.

Kropfinger, Klaus. "Schönberg und Kandinsky." In *Arnold Schönberg: Internationaler Musikwissenschaftlicher Kongreß*. Berlin, 1974, pp. 9–14.

Reich, Willi. *Arnold Schönberg oder der konservative Revolutionär*. Vienna, 1968.

Rodean, Richard W. "An Analysis of Structural Elements and Performance Practice in Arnold Schoenberg's *Die glückliche Hand*." Ph.D. diss., Texas Tech University, 1980.

Rufer, Josef. *Das Werk Arnold Schönbergs*. Kassel, 1959.

Arnold Schönberg: Beiträge von Alban Berg et al. Munich, 1912. Reprint, Wels, 1980.

Arnold Schönberg: Berliner Tagebuch. Josef Rufer, ed. Frankfurt am Main, 1974.

Arnold Schönberg—Wassily Kandinsky: Briefe, Bilder, und Dokumente einer außergewöhnlichen Begegnung. Jelena Hahl-Koch, ed. Salzburg, 1980. Translated as *Arnold Schönberg—Wassily Kandinsky: Letters, Pictures, and Documents*. London, 1984.

Schönberg, Arnold. *Gesammelte Schriften*. Vol. 1. *Stil und Gedanke: Aufsätze zur Musik*. Ivan Vojtech, ed. Frankfurt am Main, 1976.

———. *Harmonielehre*. Leipzig, 1911.

Schoenberg as Artist. Journal of the Arnold Schoenberg Institute, Los Angeles 2, no. 3 (1978).

Schönberg-Gespräch. Vienna, 1984.

Stuckenschmidt, H. H. *Schönberg: Leben—Umwelt—Werk*. Zurich, 1984.

Vise, Stephen Solomon. "Wassily Kandinsky and Arnold Schoenberg: Parallelisms in Form and Meaning." Ph.D. diss., St. Louis, 1969.

Werkner, Patrick. "Arnold Schönbergs Malerei—amerikanische Perspektiven." *Parnass* 5, no. 4 (1985): 64–65.

Wohlgemuth, Gerhard. "Schönberg und die Künste." In *Arnold Schönberg, 1874–1951: Zum 25. Todestag des Komponisten*, ed. Mathias Hansen and Christa Müller. Berlin, 1976, pp. 151–64.

**Dipinti e disegni di Arnold Schoenberg*. Florence: 27 Maggio Fiorentino, 1964.

**Schönberg—Berg—Webern: Bilder, Partituren, Dokumente*. Vienna: Museum des 20. Jahrhunderts, 1969.

**Hommage à Schönberg: Der Blaue Reiter und das Musikalische in der Malerei der Zeit*. Berlin: Nationalgalerie, 1974.

**Schönberg: Universal Edition*. Vienna, 1974.

**Arnold Schönberg, 1874–1951*. Foyer der Frankfurter Oper, 1978. Monatshefte des Musiktheaters Frankfurt, no. 5 (1977–78).

**La musica, la pittura, l'epoca di Arnold Schönberg*. Venice: Ala Napoleonica, 1978.

**Arnold Schönberg: Das bildnerische Werk / Paintings and Drawings*. Vienna: Museum des 20. Jahrunderts, 1991.

List of Illustrations
and Sources

12. Mata Hari, posed photograph. Vienna, Österreichische Nationalbibliothek, Bildarchiv.

13. Richard Gerstl, photographic portrait.

14. Simon Hollósy, *The Rákóczi March*, 1899. Oil. Budapest, Hungarian National Gallery.

15. Richard Gerstl's letter of complaint to the Ministry of Education and Culture, July 22, 1908. Vienna, Akademie der bilden Künst, Archive.

16. Ignacio Zuloaga, *The People's Poet, Don Miguel of Segovia*, 1898. Oil. Vienna, Österreichische Galerie.

17. Max Liebermann, *The Garden of a Hospital in Edam*, 1904. Oil. Vienna, Österreichische Galerie.

18. Richard Gerstl, *Portrait of Mathilde Schönberg II*. Oil. Private collection.

19. Richard Gerstl, *Self-Portrait as a Half Nude in Front of a Blue Background*. Oil. Vienna, Rudolf Leopold Collection.

20. Richard Gerstl, *Self-Portrait, Laughing*, 1907–8. Oil. Vienna, Österreichische Galerie.

21. Richard Gerstl, *Nude Self-Portrait as a Whole Figure*, 1908. Oil. Vienna, Rudolf Leopold Collection.

22. Richard Gerstl, *Self-Portrait*, September 29, 1908. Pen, brush, India ink. Vienna, Albertina.

23. Richard Gerstl, *The Cogwheel Railway on the Kahlenberg*. Oil. Vienna, Österreichische Galerie.

24. Richard Gerstl, *Portrait of Arnold Schönberg*. Oil. Vienna, Historisches Museum der Stadt Wien.

25. Richard Gerstl, *Tree with Ladder*. Oil. Private collection.

26. Richard Gerstl, *Portrait of Alois Gerstl*. Oil. Private collection.

27. Edouard Vuillard, *Married Life*, detail, 1900. Oil. Private collection.

28. Richard Gerstl, *Portrait of Ernst Diez*. Tempera. Vienna, Österreichische Galerie.

29. Richard Gerstl, *Portrait of the Fey Sisters*, 1904–5. Oil. Vienna, Österreichische Galerie.

30. Richard Gerstl, *Nude in the Garden*. Oil. Private collection.

31. Richard Gerstl, *Portrait of Alexander von Zemlinsky*, 1907–8. Oil. Private collection.

32. Richard Gerstl, *View of the Traunsee from Altmünster*, 1907–8. Oil. Private collection.

33. Richard Gerstl, *Family Portrait of the Schönbergs*, 1907–8. Oil. Vienna, Museum moderner Kunst.

34. Richard Gerstl, *Group Portrait of the Schönbergs*, 1907–8. Oil. Private collection.

35. Oskar Kokoschka, photographic portrait, 1909.

36. Oskar Kokoschka, *The Far Island*, proof for the lithograph in *The Dreaming Youths*, 1908.

37. Rudolf Kalvach, *Indian Fairy Tale*. Oil. Vienna, Hochschule für angewandte Kunst, Archive.

38. George Minne, illustration for *La princesse Maleine*, 1890. Heliogravure. Private collection.

39. Oskar Kokoschka, *Woman and Child on a Hind*, 1908. Ink. Vienna, Albertina.

40. Oskar Kokoschka, title vignette from *The Dreaming Youths*, 1908.

41. Oskar Kokoschka, *Jubilee Procession*, 1907–8. Tempera. Vienna, Historisches Museum der Stadt Wein.

42. Paul Gaugin, title page of *Noa-Noa*, 1897. Paris, Bibliothèque Nationale.

43. Oskar Kokoschka, *Running Amok*, 1909. Gouache.

44. Oskar Kokoschka, *Nude Girl*, 1906–7. Pencil, watercolor. Vienna, Historisches Museum der Stadt Wien.

45. Oskar Kokoschka, *Standing Nude Girl with Shawl*, 1907. Charcoal, watercolor. Private collection.

46. Oskar Kokoschka, *Squatting Girls*, 1907–8. Pencil. Private collection.

47. Grete Wiesenthal dances to music by Beethoven, 1908–9. From *Erdgeist* 4, no. 10 (1909).

48. Grete Wiesenthal dances "The Danube Waltz." Photograph. Vienna, Österreichische Nationalbibliothek, Theatersammlung.

49. Oskar Kokoschka, *Portrait of Ernst Reinhold*, 1908–9. Oil. Brussels, Musées Royaux des Beaux-Arts.

50. Oskar Kokoschka, *Self-Portrait, Bust*, 1909. Ceramic, painted. Boston, Museum of Fine Arts.

51. Oskar Kokoschka, *Child with the Hands of the Parents*, 1909. Oil. Österreichische Galerie.

52. Oskar Kokoschka, *Portrait of Auguste Forel*, 1910. Oil. Mannheim, Städtische Kunsthalle.

53. Oskar Kokoschka, *Portrait of Karl Kraus*, 1910. India ink, pencil. Zürich, Feichenfeldt Collection.

54. Oskar Kokoschka, *Still Life with Lamb and Hyacinth*, 1909. Oil. Vienna, Österreichische Galerie.

55. Anton Romako, *Italian Fishing Girl*, 1870–72. Oil. Vienna, Österreichische Galerie.

56. Oskar Kokoschka, *Dent du Midi*, 1910. Zürich, Feilchenfeldt Collection.

57. Oskar Kokoschka, *Portrait of an Old Man—Father Hirsch*, 1909. Oil. Linz, Neu Galerie der Stadt Linz.

58. Oskar Kokoschka, poster for the Summer Theater of the Kunstschau, 1909. Lithograph. Vienna, Historisches Museum der Stadt Wien.

59. Oskar Kokoschka, Ernst Reinhold, Max Oppenheimer, 1909. Photograph. Vienna, Historiches Museum der Stadt Wien.

60. Oskar Kokoschka, *Male Nude, Female Nude, and Dog*, 1909. Los Angeles County Museum of Art, R. G. Rifkind Collection.

61. Oskar Kokoschka, *Portrait of Adolf Loos*, 1909. Oil. Berlin, Staatliche Museen Preußicher Kulturbesitz, Nationalgalerie.

62. Oskar Kokoschka, drawing for *Murderer, Hope of Women*, around 1909. India ink. Private collection.

63. Oskar Kokoschka, *The Sphinx and the Man of Straw*, cover drawing for *Der Sturm*, March 11, 1911.

64. Oskar Kokoschka, *Portrait of Herwarth Walden*, 1910. India ink, pencil. Harvard, Fogg Art Museum.

65. Oskar Kokoschka, poster for *Der Sturm*, 1910. Lithograph. Salzburg, Rupertinum.

66. Max Oppenheimer, poster for the exhibition in the Moderne Galerie, Munich, 1911. Lithograph. Private collection.

67. Oskar Kokoschka, *Portrait of Baron Victor von Dirsztay*, 1911. Oil. Hannover, Sprengel Museum.

68. Oskar Kokoschka, *Portrait of Egon Wellesz*, 1911. Oil. Washington, D.C., The Hirshhorn Museum and Sculpture Garden.

69. Oskar Kokoschka, *The Flight into Egypt*, around 1911. Oil. Zürich, private collection.

70. Oskar Kokoschka, drawing for an illustration for *Tubutsch*, by Albert Ehrenstein. Illustration no. 5. Pen. Mannheim, Städtische Kunsthalle.

71. Egon Schiele, *Reclining Female Nude, Supported by the Right Elbow*, 1908. Charcoal. Private collection.

72. Egon Schiele, *Portrait of Leopold Czihaczek*, 1908. Charcoal. Private collection.

73. Egon Schiele, *Water Sprites I*, 1907. Gouche, colored crayon, silver and gold paint. Private collection.

74. Egon Schiele, photographic portrait.

75. Egon Schiele, *Nude Self-Portrait with Ornamental Drapery*, 1909. Oil and silver paint. London, Marlborough F. A. Ltd.

76. Gustav Klimt, male nude, detail from a working sketch for *Jurisprudence*, 1903. Black chalk, pencil. Private collection.

77. Egon Schiele, *Seated Male Nude, Back View*, 1910. Watercolor and charcoal. Private collection.

78. Egon Schiele, *Male Nude in Profile Facing Left—Self-Portrait*, 1910. Gouache, watercolor, black crayon with white heightening. Vienna, Albertina.

79. Egon Schiele, *Grimacing Man—Self-Portrait*, 1910. Gouache, watercolor, charcoal. Vienna, Rudolf Leopold Collection.

80. Egon Schiele, *Seated Male Nude—Self-Portrait*, 1910. Oil. Vienna, Rudolf Leopold Collection.

81. Ruth Saint-Denis, photographed dancing. Vienna, Österreichische Nationalbibliothek, Bildarchiv.

82. Egon Schiele, *Portrait of Erwin van Osen*, 1910. Gouache, watercolor, charcoal. Private collection.

83. Egon Schiele, *Portrait of Moa*, 1911. Pencil. Vienna, Albertina.

84. Egon Schiele, *Portrait of Arthur Roessler*, 1910. Oil. Vienna, Historisches Museum der Stadt Wien.

85. Egon Schiele, *Portrait of Eduard Kosmack*, 1910. Oil. Vienna, Österreichische Galerie, on loan to Museum modener Kunst.

86. Egon Schiele, *Dead Mother I*, 1910. Oil and pencil. Vienna, Rudolf Leopold Collection.

87. Egon Schiele, *Dead Mother II*, 1911. Oil. Destroyed.

88. Egon Schiele, *Dead City III*, 1911. Oil and gouache. Vienna, Rudolf Leopold Collection.

89. Egon Schiele, *The Scornful Woman—Gertrude Schiele*, 1910. Gouache, watercolor, charcoal. Vienna, private collection.

90. Egon Schiele, *Seated Female Nude*, 1911. Pencil. Private collection.

91. Ernst Ludwig Kirchner, *Black Girl, Reclining*, 1911. Oil. Bremen, Kunsthalle.

92. Egon Schiele, *Two Girls on a Blanket*, 1911. Gouache, watercolor, ink, pencil. Private collection.

93. Egon Schiele, *Reclining Male Nude with Yellow Pillow*, 1910. Gouache, watercolor, black crayon. Private collection.

94. Egon Schiele, *Nude with Red Stockings and Yellow Hair*, 1912. Gouache, watercolor, pencil. Private collection.

95. Egon Schiele, *Small Tree in Late Autumn*, 1911. Oil. Vienna, Rudolf Leopold Collection.

96. Egon Schiele, *Bare Trees*, 1912. Oil. Private collection.

97. Egon Schiele, *The Self-Seers II—Death and Man*, 1911. Oil. Vienna, Rudolf Leopold Collection.

98. Egon Schiele, *Self-Portrait with Chinese Lantern Plant*, 1912. Oil and gouache. Vienna, Rudolf Leopold Collection.

99. Egon Schiele, *The Little Town II*, 1912–13. Vienna, Rudolf Leopold Collection.

100. Egon Schiele, *Organic Movement of Chair and Pitcher*, April 21, 1912. Watercolor and pencil. Vienna, Albertina.

101. Egon Schiele, postcard to Arthur Roessler, probably written December 1910. Vienna, Wiener Stadtbibliothek, Handschriftensammlung.

102. Egon Schiele, *Portrait of Max Oppenheimer*, 1910. Watercolor, ink, black crayon. Vienna, Albertina.

103. Cover of the magazine *Der Ruf*, no. 3 (1912), using a self-portrait of Egon Schiele from 1910. Vienna, Albertina, Schiele-Archiv.

104. Arnold Schönberg, photograph, with a dedication to Wassily Kandinsky, dated December 12, 1911. Munich, Gabriele Münter and Johannes Eichner Foundation.

105. Arnold Schönberg, *Garden in Mödling*. Oil. Los Angeles, Arnold Schoenberg Institute.

106. Arnold Schönberg, *Self-Portrait from Behind*, 1911. Oil. Los Angeles, Arnold Schoenberg Institute.

107. Arnold Schönberg, *Tears*. Oil. Los Angeles, Arnold Schoenberg Institute.

108. Arnold Schönberg, *Hands*, 1910. Oil. Munich, Städtische Galerie im Lenbachhaus.

109. Arnold Schönberg, *Vision of Christ*. Oil. Los Angeles, Arnold Schoenberg Institute.

110. Arnold Schönberg, *Vision of Christ*. Watercolor. Los Angeles, Arnold Schoenberg Institute.

111. Alfred Kubin, *Portrait of a Man*, 1899. Pen, India ink, watercolor. Munich, Städtische Galerie im Lenbachhaus.

112. Arnold Schönberg, *Hands*. Oil. Los Angeles, Arnold Schoenberg Institute.

113. Arnold Schönberg, *Landscape*. Oil. Los Angeles, Arnold Schoenberg Institute.

114. Wassily Kandinsky, *Impression 3—Concert*, 1911. Oil. Munich, Städtische Galerie im Lenbachhaus.

115. Arnold Schönberg, *Vision*. Oil. Los Angeles, Arnold Schoenberg Institute.

116. Arnold Schönberg, *Portrait of Marie Pappenheim*, 1909. Oil. Baden bei Wien, Franz Eckert Collection.

117. Max Oppenheimer, *Portrait of Arnold Schönberg*, 1909. Oil. Formerly Vienna, Arthur Roessler Collection.

118. Arnold Schönberg, setting for Scene I, *The Lucky Hand*. Oil. Los Angeles, Arnold Schoenberg Institute.

119. Alfred Kubin, photographic portrait, 1903.

120. Odilon Redon, *The Eye*, 1882. Lithograph. Paris, Bibliothèque Nationale.

121. Alfred Kubin, *The Pursued*, around 1902–3. Ink and wash. Vienna, Albertina.

122. Alfred Kubin, *Crucified Snake-Man*, 1899. Gouache. Munich, Städtische Galerie im Lenbachhaus.

123. Alfred Kubin, *My Muse*, around 1902–3. Ink.

124. Alfred Kubin, *The Woman on the Horse*, 1903. Pen, ink, wash. Munich, Städtische Galerie im Lenbachhaus.

125. Alfred Kubin, *Mother Earth*, around 1901–2. Ink, wash. Freiburg/Br., F. A. Morat Collection.

126. Alfred Kubin, *War*, around 1901–2. Ink, wash. Location unknown.

127. Alfred Kubin, *Epidemic*, around 1901–2. Ink, wash. Munich, Städtische Galerie im Lenbachhaus.

128. Alfred Kubin, *The Fate of Mankind*, around 1901–2. Ink, wash. Location unknown.

129. Alfred Kubin, *Fabulous Beast*, around 1903–5. Pen, watercolor, wash. Linz, Oberösterreichisches Landesmuseum.

130. Alfred Kubin, *The Hand*, around 1900–1903. Ink.

131. Alfred Kubin, *Soul of a Child*, around 1905–8. Paste colors. Linz, Oberösterreichisches Landesmuseum.

132. Alfred Kubin, *Vision*, around 1905–8. Tempera.

133. Alfred Kubin, *The Ox-Fish*, around 1906–8. Tempera. Linz, Oberösterreichisches Landesmuseum.

134. Alfred Kubin, *The Preserved Specimen*, around 1906–8. Tempera. Linz, Oberösterreichisches Landesmuseum.

135. Alfred Kubin, *The Pupated World*, around 1905–8. Tempera. Munich, Städtische Galerie im Lenbachhaus.

136. Alfred Kubin, *Hydrocephalus*, 1908. Pen, ink, watercolor. Linz, Oberösterreichisches Landesmuseum.

137. Alfred Kubin, *Agrippina*, around 1900–1903. Pen, wash, watercolor. Linz, Oberösterreichisches Landesmuseum.

138. Alfred Kubin, illustration for *Visions from the Other Side*, 1909. Ink.

139. Alfred Kubin, illustration for *Visions from the Other Side*, 1909. Ink.

140. Alfred Kubin, *Burial*, around 1909–11. Ink.

141. Alfred Kubin, *Mohammed*, around 1909–11. Ink.

142. Alfred Kubin, *Reverence*, around 1909–11. Ink.

143. Alfred Kubin, *The Knight Gallus*, about 1911. Pen, watercolor. Linz, Oberösterreichisches Landesmuseum.

144. Erwin Lang, *Butterfly*, 1910. Woodcut. From Oskar Bie, *Grete Wiesenthal* (Berlin, 1910).

145. Kolo Moser, *Three Women on a Street Corner*, 1903. Woodcut. From *Ver Sacrum* 7 (1903): 393.

146. Anton Faistauer, poster design for the "New Artists" exhibition, 1909. Private collection.

147. Albert Paris Gütersloh, *Bathers*, about 1909. Watercolor. Vienna, Rudolf Haybach Collection.

148. Albert Paris Gütersloh, *Temptation of Saint Anthony*, 1910. Watercolor. Vienna, Albertina.

149. Albert Paris Gütersloh, *Self-Portrait*, 1912. Oil. Vienna, Österreichische Galerie.

150. Albert Paris Gütersloh, *Two Nudes*, 1912. Pencil. Private collection.

151. Max Oppenheimer, *Self-Portrait*, 1910–11. Oil.

152. Max Oppenheimer, *Portrait of Egon Schiele*, 1910. Oil. Vienna, Historisches Museum der Stadt Wien.

153. Max Oppenheimer, *Portrait of Franz Blei*, 1910–11. Oil. Vienna, Museum moderner Kunst.

154. Max Oppenheimer, *Deposition from the Cross*, 1911. Oil.

155. Kolo Moser, *Dancer*, design for metalwork for the Wiener Werkstätte, about 1904. Ink. Private collection.

156. Grete Wiesenthal, posed photograph. Vienna, Österreichische Nationalbibliothek, Bildarchiv.

157. Ferdinand Hodler, *Spring*, detail, 1901. Oil. Essen, Museum Folkwang.

158. Gustav Klimt, *Nagging Sorrow*, from the Beethoven frieze, 1902. Cassein colors. Vienna, Österreichische Galerie / Vienna Secession.

159. Gertrude Eysoldt as Elektra in Hofmannsthal's drama, 1904. From *Das Theater* 1 (1904).

160. Albert Paris Gütersloh, *Two Lunettes*, about 1909. Ink and watercolor. Vienna, private collection.

161. Oskar Kokoschka, *Resting Dancer*, cover drawing for *Der Sturm*, no. 39 (November 24, 1910).

162. Maurice Vlaminck, *Bridge in Chatou*, 1905. Oil. Basel, Galerie Beyeler.

163. Erich Heckel, *Red Houses*, 1908. Oil. Bielefeld, Kunsthalle.

164. Henri Matisse, *Self-Portrait*, 1906. Oil. Copenhagen, Statens Museum for Kunst.

165. Alfred Kubin, *Self-Observation*, around 1901–2. Ink and wash. Vienna, Albertina.

166. Oskar Kokoschka, *Female Nude with Stockings, Supporting Herself with Her Arms*, about 1909. Chalk, pencil, watercolor. Private collection.

▪ Photographic Acknowledgments ▪

Photographic material was made available by the following:

Arnold Schoenberg Institute, University of Southern California, Los Angeles (Figs. 107, 110, 113)

Galerie St. Etienne, New York (Fig. 30)

Graphische Sammlung Albertina, Vienna (Fig. 78)

Historisches Museum der Stadt Wien, Vienna (Figs. 41, 44, 84, 152)

Österreichische Galerie, Vienna (Figs. 20, 28, 54, 85)

Österreichische Nationalbibliothek, Bildarchiv, Vienna (Figs. 12, 81, 156)

All other photographs: author's archive, Herold Verlag, Vienna, and Kristian Sotriffer, Vienna.

Index